T0392137

Uncollected Writings

Uncollected Writings

Writing on Art

Author

RICHARD WOLLHEIM

Edited by

GARY KEMP
ELISABETTA TORENO

OXFORD
UNIVERSITY PRESS

Great Clarendon Street, Oxford, OX2 6DP,
United Kingdom

Oxford University Press is a department of the University of Oxford.
It furthers the University's objective of excellence in research, scholarship,
and education by publishing worldwide. Oxford is a registered trade mark of
Oxford University Press in the UK and in certain other countries

Published in the United States of America by Oxford University Press
198 Madison Avenue, New York, NY 10016, United States of America

British Library Cataloguing in Publication Data
Data available

Library of Congress Control Number: 2024946764

ISBN 9780198890126

DOI: 10.1093/9780191995767.001.0001

Printed and bound by
CPI Group (UK) Ltd, Croydon, CR0 4YY

The manufacturer's authorised representative in the EU for product safety is Oxford
University Press España S.A. of El Parque Empresarial San Fernando de Henares, Avenida
de Castilla, 2 – 28830 Madrid (www.oup.es/en or product.safety@oup.com). OUP España
S.A. also acts as importer into Spain of products made by the manufacturer.

Preface

The idea for this project took shape gradually. In 2014, Mary Day Lanier Wollheim, Bruno Wollheim, Jane Miller, Jonathan Wolff, Peter Momtchiloff, and Gary Kemp began communicating about a possible volume of Richard Wollheim's not-yet-collected work—or rather, possible volumes, as we knew that there is in existence a fairly large corpus of Richard's uncollected work on multiple topics. Besides getting interested in Richard's work from his days as an undergraduate at the University of Oregon in the early 1980s—due to the influence of Garry Hagberg—and later spending a term with Wollheim as a PhD student at University College London, Kemp had just been to a conference at the WU Vienna in December 2013 entitled *Wollheim, Wittgenstein, and Pictorial Representation: Seeing-As and Seeing-In*, organized by Gabriele Mras; out of that conference came a volume published by Routledge under the same title in 2016, edited by Mras and Kemp. We express our gratitude to Mras, and to the many contributors to the conference or the volume.

Richard Wollheim was not only a well-known academic in aesthetics, politics and philosophy of mind, but a formidable journalistic and critical presence, authoring articles and reviews for a wide variety of periodicals. As we write, Bruno is working with Jane to release a volume representing this side of Richard's output, tentatively titled simply *Essays.* To represent his academic side, it was eventually decided in 2021—partly at the instigation of Peter—that we would publish three volumes of his uncollected work (work that is available, at most, only in journals, conference proceedings, or topic-oriented volumes featuring others in addition to Wollheim). Thus *Uncollected Writings* will comprise this volume, *Writing on Art*, a volume on philosophical psychology, edited by Garry Hagberg, and a volume on political philosophy, edited by Jonathan Wolff.

In addition to those just mentioned, we would like to thank Malcolm Budd, John Hyman, and Antonia Phillips for various forms of help or encouragement. We also wish to thank Warren Carter and Kim Charnley for their supportive response to the challenging task of succinctly overviewing centuries of critical art history. For early work assembling a bibliography of Richard's work, we thank Eddie Yeghiayan, and again Mary Day Lanier Wollheim and Malcolm Budd. We thank the editors at Oxford University Press for their generosity and patience, the School of Humanities at the University of Glasgow for financial assistance for the acquisition of the permission to publish licenced images, and the copyright holders and executors of Richard Wollheim's literary estate. We end these acknowledgements with an appreciation for the art institutions for their adherence to Open Access policies, thus making the images of the art in their collections freely available for

publication. Without such generous initiatives, the dissemination of images would be significantly hampered.

31 January 2024

Gary Kemp (University of Glasgow)
Elisabetta Toreno (Open University)
Bruno Wollheim (Richard Wollheim's Literary Estate)

Origins, Rights, and Permissions

With certain exceptions noted by the editors, the material of Lectures I and III (Formalism and Pictorial Organization) first appeared in the following pieces: 'On Formalism and its Kinds', published by Fundació Antoni Tàpies in 1995; 'On Formalism and Pictorial Organization' (*The Journal of Aesthetics and Art Criticism*, 59.2 (Spring 2001), pp. 127–37); and 'On Pictorial Organization' (2002, Lindley Lecture, University of Kansas). We assert the rights of Bruno Wollheim and Jane Miller as Richard Wollheim's literary executors to publish Lectures I and III, as well as Lecture II.

Oxford University Press is the original printing rights holder for:

'Style Now', which first appeared in *Concerning Contemporary Art: The Power Lectures 1968–73*, edited by Bernard Smith (Oxford: Clarendon Press, 1975), pp. 133–53; 'On Pictorial Representation', which first appeared in *The Journal of Aesthetics and Art Criticism*, 56.3 (Summer 1998), pp. 217–26; 'What Makes Representational Painting Truly Visual?', which first appeared in 2003 in the *Proceedings of the Aristotelian Society*, Supplement 77, pp. 131–47; 'Form, Elements, and Modernity: Reply to Michael Podro', which first appeared in 1966 in the *British Journal of Aesthetics*, 6.4, pp. 339–45; 'Imagination and Pictorial Understanding', which first appeared in the *Proceedings of the Aristotelian Society* 1986 (supplement 60), pp. 45–60; and 'Why Is Drawing Interesting?', which first appeared in 2005 in the *British Journal of Aesthetics*, 45.1, pp. 1–10.

'Style in Painting' first appeared in C. Van Ecky, J. McAllister, and R. Vander Vall (eds), *The Question of Style in Philosophy and the Arts* (Cambridge: Cambridge University Press, 1995), pp. 37–49. Reproduced with permission of the Licensor through PLSclear.

'Sociological Explanation of the Arts: Some Distinctions', Atti del III Congresso Internazionale di Estetica (*Proceedings of the 3rd International Congress of Aesthetics*), Venice, 3–5 September 1956, pp. 404–10, is reprinted here by permission of Professor Luigi Pareyson, Director of the Istituto di Estetica, University of Turin, Italy.

'In Defense of Seeing-In' first appeared in Hei Hecht, Robert Schwartz, and Margaret Atherton (eds), *Looking into Pictures: An Interdisciplinary Approach to Pictorial Space* (Cambridge, MA: MIT Press, 2003), pp. 3–15. Reprinted with permission of MIT Press.

'A Note on "Mimesis as Make-Believe"' first appeared in *Philosophy and Phenomenological Research*, 51.2 (1991), pp. 401–6. Reprinted with permission of John Wiley and Sons.

'Danto's Gallery of Indiscernibles' first appeared in M. Rollins (ed.), *Danto and His Critics* (Oxford: Blackwell, 1993), pp. 28–38. Reprinted with permission of Wiley-Blackwell.

'Walter Pater: From Philosophy to Art' first appeared in E. S. Shaffer (ed.), *Comparative Criticism*, vol. 17: Walter Pater and the Culture of the Fin de Siècle (Cambridge: Cambridge University Press, 1995), pp. 21–40. Reproduced with permission of the Licensor through PLSclear.

'Art, Interpretation, and the Creative Process' first appeared in *New Literary History*, 15.2) (1984), pp. 41–53, ©1984 New Literary History. Reprinted with permission of Johns Hopkins University Press.

For all other articles (listed below), we assert the rights of Bruno Wollheim and Jane Miller as Richard Wollheim's literary executors to reprint them.

'Aesthetics, Anthropology and Style: Some Programmatic Remarks' first appeared in Michael Greenhalgh and J. V. S. Megaw (eds), *Art in Society: Studies in Style, Culture, and Aesthetics* (London: Duckworth, 1978), pp. 3–14.

'A Critic of Our Time: Review of Adrian Stokes' *Greek Culture and the Ego*', Encounter, 12.4 (April 1959), pp. 41–4.

'Introduction', in *The Image in Form: Selected Writings of Adrian Stokes* (New York: Harper & Row, 1972; Harmondsworth: Penguin Books, 1972), pp. 9–31.

'Art as Symbol': review of Susanne K. Langer's *Problems of Art*, New Statesman and Nation, 54.1396 (15 Dec. 1957), p. 826.

'Professor Gombrich': review of E. H. Gombrich's *Meditations on a Hobby Horse, New Statesman*, 3.67 (January 1964), pp. 18–19.

'Wittgenstein on Art', *New Statesman*, 9.72 (September 1966), pp. 367–8.

'On Expression and Expressionism', *Revue Internationale de Philosophie*, 18 (68–9, fasc. 2–3) (1964), pp. 270–289.

'Neurosis and the Artist', *Leonardo* 8 (Oxford: Pergamon Press, 1975), pp. 155–7.

'On the Question "Why Is Painting an Art?', in Rudolf Haller (ed.), *Aesthetics* (Vienna: Hölder-Pichler-Tempsky, 1984), pp. 101–6.

'The Core of Aesthetics', *Journal of Aesthetic Education*, 25 (1991), pp. 37–45.

Contents

PART V OTHER TOPICS

Figures

Introduction

Richard Wollheim (1923–2003) wrote two monographs on the philosophy of art (*Art and its Objects*, 1968, supplemented 1980, and *Painting as an Art*, 1986); two monographs on the philosophy of mind (*The Thread of Life*, 1984, and *On the Emotions*, 1999); and two books about others (*F. H. Bradley*, 1959, and *Freud*, 1971). Along with the six supplementary essays for the 1980 revised edition of *Art and its Objects*, he produced a volume of essays of which half focus on philosophy of mind and half on aesthetics (*The Mind and its Depths*, 1994); and a volume of essays squarely on aesthetics (*On Art and the Mind*, 1974). He wrote one novel (*A Family Romance*, 1969), and a memoir of his childhood (*Germs*, 2004). In addition to producing a steady stream of academic articles from 1950, he was a formidable, erudite, and on occasion bitingly humorous presence as a man of letters, publishing articles and reviews in trade publications such as *Encounter*, *New Literary History*, *The Listener*, *New Statesman*, *The Nation*, *New Statesman and Nation*, *The Times Literary Supplement*, *The Spectator*, *London Review of Books*, and *Modern Painters*. Richard's son Bruno Wollheim and his literary executor, Jane Miller, are assembling his journalistic writings for a volume to be published presently.

This is one of three planned volumes of Wollheim's work for Oxford University Press. The others are one on political philosophy, edited by Jonathan Wolff, and one on philosophical psychology, edited by Garry Hagberg. The present volume serves two purposes. First, it contains articles some of which may be unknown to some readers: those published before 1994 that did not appear in any collection under his name, plus ones published since 1994, and therefore after any collection appeared of his work. Second, at the time of his death he was assembling a small book, which comprised two revised essays, the original versions of which appeared in 1994 ('On Formalism and Its Kinds') and 2001 ('On Formalism and Pictorial Organisation'), plus substantial new material. The whole is reproduced here (we have followed Wollheim in referring to them as 'Lectures'). Together with works of the first kind, along with his works of 1974, 1980, 1986, and 1994, we are thus provided with a complete collection of Wollheim's works in the philosophy of art.

Wollheim was a philosopher who made substantial contributions to the theory of art. What follows is a short biographical note (section I), an outline of the history of art theories (II), the basics of his main ideas in the philosophy of art (III), and a short description of the pieces in this book, including the reasons for their division

Uncollected Writings. Richard Wollheim, Gary Kemp, and Elisabetta Toreno, Oxford University Press.
© Bruno Wolheim 2025. DOI: 10.1093/9780191995767.001.0001

into five categories (IV). The first four sections thus span both contributions, art and philosophy. The final section (V) clarifies our practical solutions to technical issues. Readers with significant exposure to the dominant style of philosophy in the English-speaking world, Analytic Philosophy, will recognize the philosophical angle, and will have the opportunity to familiarize themselves with the foundations of the history of art. Those with training in the history of art may recall Wollheim's coinage of the term 'minimal art,' that came to describe the diversified field of art of the 1960s.[1] They may also have significant exposure to Continental Philosophy, the dominant style of philosophy outside the English-speaking Western world, whose main proponents also feature in the theories and methods of Western art. Section III is primarily for the first sort of reader and Section II is primarily for the second. Professional readers and specialist students may want to skip to section IV, or proceed directly to the individual pieces to which are attached more detailed descriptions, though naturally we would urge everyone to read all sections. They are not long. And setting aside the much-debated contrasts between Analytic and Continental philosophy, these two points of view are broadly consistent, indeed complementary: for Wollheim, fully to understand a work of art is partly to understand its place in history.

I. Biography

Richard Wollheim was born in London on 5 May 1923. His parents, Eric Wollheim and Constance Baker, were professionals in showbusiness: his father was a theatrical impresario and his mother had been a performer at the Gaiety Theatre. At the age of 13 he became a King's Scholar at Westminster School. When Germany attacked the Soviet Union in 1941, he felt compelled to enlist, and at Balliol College, Oxford, he was first with the Inniskilling Dragoon Guards, subsequently the Fusiliers, then a West Country regiment. His experience as a soldier was made difficult by his own intellectual inclinations, but he witnessed extraordinary moments of the war: he was part of the Normandy landing, and was taken prisoner by the Germans in 1944 only to escape five days later. He was responsible for the capture of a German officer and corporal, and participated in the liberation of the German concentration camp at Bergen-Belsen. He returned to Balliol in 1945, attaining two first-class BA degrees in history (1946) and in philosophy, politics, and economics (1948). In the same year he joined the Labour Party Commission on Advertising, also contributing to its newspaper. He also participated in the local political elections. These activities reflected his long-life commitment to social issues and the cause of socialism.

[1] Richard Wollheim, 'Minimal Art', *Arts Magazine*, 39.4 (Jan. 1965), pp. 26–32.

From 1949 to 1982, he taught philosophy at University College, London, where in 1963 he became Grote Professor of Mind and Logic and permanent head of the department. After his retirement from University College he was made an honorary fellow of UCL in 1994. He was professor of philosophy at Columbia University from 1982 to 1985, when he moved to California as Mills Professor of Intellectual and Moral Philosophy at the University of California, Berkeley. There he taught until 2002, having also been appointed chair of the philosophy Department in 1998. From 1989 until 1996 he also taught at University of California, Davis, where he was professor of philosophy and the humanities.

In addition to these posts, he held visiting lectureships elsewhere and contributed to several prestigious lecture series: the William James Lectures in Philosophy at Harvard University in 1982, expanded and published in 1984 as *The Thread of Life*; the Andrew W. Mellon Lectures at the National Gallery in Washington, DC in 1984, which became his *Painting as an Art* in 1987; the Ernst Cassirer Lectures at Yale University in 1991, which laid the foundations for his book *The Emotions* of 1999. He was also a leading figure in philosophical institutes: he was president of the (British) Aristotelian Society in 1968–9, of the British Society for Aesthetics from 1993 onwards, and of the Pacific Division of the American Philosophical Association in 2002–3. He was also an honorary affiliate of the British Psychoanalytical Society and an honorary member of the San Francisco Psychoanalytic Institute, in 1991 receiving an award from the International Society for Psychoanalysis.

In 2002, Wollheim returned to London, where he died on 4 November 2003.[2]

II. The Critical Art Historical Context

The paintings by Ingres which offer the best measure of his abilities, of his very originality, are those the substance of which results entirely from the solemnity, even from the order or the plausibility of imitation, that is to say from compositions like *The Apotheosis of Homer*, from figures like […] *The Odalisque*.[3]

To a nineteenth-century art appreciator in Europe, certain paintings by Ingres (1780–1867) such as *The Apotheosis of Homer* (Fig. I.1) represented a paradigmatic example of artistic originality: the aesthetic elevation of the sensible world to

[2] For a more comprehensive biography, we recommend Malcolm Budd, 'Richard Arthur Wollheim 1923–2003', *Proceedings of the British Academy*, 130 (2005), pp. 227–46.

[3] 'Les tableaux d'Ingres qui donnet le mieux la mesure de ses faculté, de son originalité propre, sont ceux dont la signification résulte tout entière de la solennité même de l'ordonnance ou de la vraisemblance de l'imitation, c'est-à-dire des compositions comme l'*Apothéose d'Homère*, des figures comme […] l'*Odalisque*.' Henri Delaborde, *Ingres, sa vie, ses travaux, sa doctrine: d'apres les notes manuscrites et les lettres du maitre* (Paris: H. Plon, 1870), p. 79. Our translation.

Fig. I.1 Jean-Auguste-Dominique Ingres (French, 1780–1867), *The Apotheosis of Homer*, 1827. Oil on canvas, 386 × 512 cm. Photo © Musée du Louvre, Paris (INV 5417).

conceptual heights through an underlying homage to Graeco-Roman and Italian Renaissance art, and seemingly effortless compositional control that hides the signs of the manual brushwork on the canvas. Both the characteristics and the estimation of this artistic formulation reflected classicizing standards that were culturally established and taught in the art schools; and that, from the mid-seventeenth century, became the aesthetic norms in increasingly structured enquiries on the meanings of taste and beauty. The ensuing philosophical and linguistic frameworks validated this canon, against which artistic alternatives would be subsequently measured and self-measured. Key contributors to this emerging aesthetic—and antiquarian—thinking about art include J. J. Winckelmann (1717–1768, *History of the Art of Antiquity [Geschichte der Kunst des Alterthums]*, 1764), Immanuel Kant (1724–1804, *Critique of Judgement [Critik der Urtheilskraft]*, 1790), and Friedrich Hegel (1770–1832, *Lectures on Aesthetics [Vorlesungen über die Ästhetik]*, 1818, 1820/21, 1823, 1826 and 1828/29).[4]

[4] On the mentioned texts, we suggest the translations of Johann Joachim Winckelmann, *The History of Ancient Art*, trans. Henry Lodge (Boston, MA: J. R. Osgood, 1880); Immanuel Kant, *Critique of the Power of Judgement*, ed. Paul Guyer, trans. Paul Guyer and Eric Matthews (Cambridge: Cambridge University Press, 2000); G. W. F. Hegel, *Aesthetics: Lectures on Fine Art*, ed. H. G. Hotho, trans. T. M.

This evolving discipline quickly engendered the stylistic taxonomies (what Willibald Sauerländer has called 'aesthetic historicism')[5] still used in art history today—Gothic, Renaissance, and so on. Their currency is partly justified by the fact that artistic tastes and practices in Europe from the early centuries past the first millennium CE were in a continuum of critical engagement with their own precursors. Yet these taxonomies reflect the notion, in which Hegel looms large, that human expressions—art, religion, laws, and so on—are in a teleological progression that organically captures the zeitgeist of each of their times. They therefore overlook societal and individual idiosyncrasies, and the loose chronologies of the waxing and waning phases of cultural movements.[6] From the mid-nineteenth century, the influence of Kant and others led to the proposition, key to late modernist developments, that art involves a selfless, 'disinterested' aesthetic experience.[7] This produced an emphasis on the haptic and optic properties of the medium and on the act itself of making—a development that was also motivated by the Romantic reaction to the rationality of the Enlightenment. In the twentieth century, the traditional conception of aesthetic judgement received further scrutiny in the crucible of various definitions of 'expression'—Benedetto Croce (1866–1952), cited below, is worth mentioning in this context[8]—that reflected the sociopolitical climates that erupted in the First and Second World Wars, and the cultural responses to the consolidating disciplines of psychoanalysis, psychology, and structural linguistics.

Knox, 3 vols (Oxford: Clarendon Press, 1975), vol. 1. Giovanni Bellori (1613–1696) and Charles Le Brun (1619–1690) are key forerunners of the classicizing ideal; Gotthold Lessing (1729–1781) must also be cited for questioning a foundational doctrine of Western modern art: the Horatian *ut pictura poesis*. He did so as he noted that, although striving to achieve the same objective (i.e., beauty) and effect (i.e., pleasure), painting/sculpture and poetry engage with different challenges, which relate to the concepts of, respectively, space and action. And Arthur Schopenhauer (1788–1860) because 'largely responsible for the introduction of aesthetic theory': George Dickie, *Introduction to Aesthetics: An Analytic Approach* (Oxford: Oxford University Press, 1997), p. 25. See also James Shelley, 'The Concept of the Aesthetic', in Edward N. Zalta (ed.). *Stanford Encyclopedia of Philosophy* (Spring 2022), https://plato.stanford.edu/archives/spr2022/entries/aesthetic-concept/; Mosche Barasch, *Theories of Art*, 1: *From Plato to Winckelmann* (New York and London: Routledge, 1985).

[5] Willibald Sauerländer, 'From Stylus to Style: Reflections on the Fate of a Nation', *Art History*, 6.3 (Sept. 1983), pp. 253–70 (p. 255).
[6] First delivered as a lecture in 1963, see the acute essay by Ernst Gombrich, 'Norm and Form: The Stylistic Categories of Art History and their Origins in Renaissance Ideals', in *Gombrich on the Renaissance*, vol. 1: *Norm and Form*, 4th edn (1st edn 1966; London: Phaidon Press, 1985), pp. 81–98.
[7] 'Disinterestedness' goes back to Plato (428/7 or 424/3–348 BCE). In general, it simply stands for 'impartial'. But in relation to art, it refers to the aesthetic experience of the object, in contrast with the experience of the object clouded by practical, social, religious, or moral judgements. In addition to Kant, philosophical investigators of this question include the 3rd earl of Shaftesbury (1671–1713) and Edmund Burke (1729–1797). The term 'aesthetic' as the experience of art—and consequent juxtaposition of good vs bad art—was introduced by Alexander Gottlieb Baumgarten (1714–1762) in his 1735 master's thesis *Meditationes*. See Antonia Peacocke, 'Aesthetic Experience', in *Stanford Encyclopedia of Philosophy* (2023), https://plato.stanford.edu/entries/aesthetic-experience/; Paul Guyer, '18th Century German Aesthetics', in Edward N. Zalta (ed.), *Stanford Encyclopedia of Philosophy* (Fall 2020), https://plato.stanford.edu/archives/fall2020/entries/aesthetics-18th-german/.
[8] Gary Kemp, 'Croce's Aesthetics', in Edward N. Zalta (ed.), *Stanford Encyclopedia of Philosophy* (Winter 2021), https://plato.stanford.edu/archives/win2021/entries/croce-aesthetics/.

Subsequent scrutiny came in the forms of semiotics, the Barthian/Foucauldian anti-author and Marxist sociopolitical ratifications, post-structuralist, post-modern, metacritical revisionisms and more, leading to today's standpoints that, notwithstanding their multiplicity, are united in regarding the earlier theories as manifestations of myopic Euro-anthropocentricism.[9]

This history is entwined with that of ideas about artistic merit. In the time of Michelangelo (1475–1564), works of art were in many ways still deemed products of *artes mechanicae*. But already from the period coinciding with the publication and circulation of the treatises of Leon Battista Alberti (1404–1472), especially *On Painting* (1435),[10] evaluations of the manual dexterity and the intellectual knowledge of artists were prefiguring the language and the expectations of aesthetic enquiries. With the first schools of art, sculpture and especially painting were elevated to high arts by a set curriculum and a theoretical apparatus that, together, prepared the artists to practise and propagate the classicizing standards that would underpin the characteristics of Ingres's *Apotheosis*. In the words of the influential eighteenth-century painter and academician Raphael Mengs (1728–1779):

> [N]one of the modern Painters, whose works I have seen, have sought to attain the highest perfection, nor do I believe that the Art will be ever more caried to that sublime degree of beauty and perfection in which it was found among the ancient Greeks, except by chance should arise in Italy another Athens.[11]

The nineteenth century witnessed the progressive rejection of this canon. The avant-gardes of the early twentieth century, Dadaism especially, proposed novel and radical values about art and its media. Wollheim was quick to apprehend the subsequent changes when he wrote his article 'Minimal Art' (1965), a passage of which is worth quoting at length:

> If we survey the art situation of recent times […] we find that increasingly acceptance has been afforded to a class of objects which, though disparate in many ways—in looks, in intention, in moral impact—have also an identifiable feature or aspect in common […] they have a minimal art-content: in that either they are […] undifferentiated in themselves and therefore possess very low content of any kind, or else the differentiation that they do exhibit […] comes not from the

[9] Thomas Adajian, 'The Definition of Art', in Edward N. Zalta (ed.), *Stanford Encyclopedia of Philosophy* (Spring 2022), https://plato.stanford.edu/archives/spr2022/entries/art-definition/; Michael Hatt and Charlotte Klonk, *Art History: A Critical Introduction to its Methods* (Manchester: Manchester University Press, 2006); Michael Podro, *The Critical Art Historians of Art* (New Haven, CT: Yale University Press, 1982).

[10] Leon Battista Alberti, *On Painting*, intr. and trans. John R. Spencer (1956; repr New Haven, CT: Yale University Press, 1966).

[11] Anton Raphael Mengs, *The Works of Anthony Raphael Mengs, first painter to His Catholic Majesty Charles III*, trans. from the Italian (London: R. Faulder & G. and J. Robinson, 1796), p. 21.

artist but from a nonartistic source, like nature or the factory […] Examples of the kind of thing I have in mind would be the canvases of Reihhardt or (from the other end of the scale) certain combines of Rauschenberg or, perhaps better, the non- 'assisted' ready-mades of Marchel Duchamp.[12]

The quotation from Wollheim anticipates such changes in the increasingly globalized world towards today's multi-sensory and relational practices, which transcend what were once the inevitable results of the officially endorsed painting and sculpture: the tactility and permanence, the factuality of artefacts.

It is also symptomatic of the extent to which, by 1965, the artistic and aesthetic debates had produced—and would continue to produce—wide-ranging methods to study artworks and their media. These can be broadly clustered as follows, and in the light of Wollheim's contribution to the relevant debates on the object of art as a meeting point between artist and spectator. Early empiricism produced both connoisseurship and formalism. Connoisseurship focuses on authenticity and authorship, fuelling the abiding myth-making of artistic geniuses.[13] Formalism in figurative art systematizes stylistic features, as in the distinction between linear and painterly introduced by Heinrich Wölfflin (1864–1945), and is still widely used today.[14] In addition, the iconographical–iconological is an early but still popular method for analysing figurative art, and questions regarding art's mimetic potentials—on which much of the Western artistic tradition is founded—continue to generate studies.[15] However, the term 'formalism', as Wollheim's 'On Formalism and Pictorial Organisation' (reproduced in Chapter 1 in this volume) shows, is

[12] Wollheim, 'Minimal Art', 26.

[13] Giorgio Vasari (1511–1574) is hailed as the initiator of the genre of artistic biographies: *Le Vite* (Torrentino 1550; Giunti 1568). Equally, he is seen as the villain of Western art history because his biographical method allegedly sowed the seeds of the glorification of artistic genius and of Italian art. But Vasari did not seize the opportunity in an intellectual vacuum. He responded to a growing pan-European appetite for the systematization of humanist ideals that date back to Francesco Petrarch (1304–1374) and Giovanni Boccaccio (1313–1375), whose literary works take prominence in the European library of thoughts. Artistic genius as being both Italian born and educated in ancient Graeco-Roman values—genius which would tip the balance in the competition between art and nature—must therefore be seen within the sociohistorical framework that produced humanist secularism. Consider Boccaccio's account of the Florentine painter Giotto (1266/67/76–1337): 'a genius so sublime that there was nothing produced by Nature […] that he could not depict to life […]' He 'restored to the light an art which had lain buried for many a century under the distortions of painters more concerned to dazzle the frivolous than to satisfy the *cognoscenti*.' Giovanni Boccaccio, 'Forese da Rabatta, the eminent lawyer, and Giotto the great painter, are caught in a rain-shower; the occasion prompts the one to a sally, the other to a tart riposte', in *Decameron*, trans. Guido Waldman (Oxford: Oxford University Press, 1993), VI.5, pp. 391–3 (p. 392). On the rise of the *paragone* (comparison) of art with nature, and on artistic creativity, see Barasch, *Theories of Art*, 108–309. The earliest study of the phenomenon of the myth-making of the artist-genius, and with preface by Ernst Gombrich, is Ernst Kris and Otto Kurz, *Legend, Myth, and Magic in the Image of the Artist: A Historical Experiment* (New Haven, CT: Yale University Press, 1979).

[14] Another name in the household of formalism is Alois Riegl (1858–1905).

[15] These studies are indebted to the pioneering work of Erwin Panofsky (1892–1968); see e.g. Erwin Panofsky, *Studies in Iconology* (New York: Oxford University Press, 1939) and *Meaning in the Visual Arts* (Chicago: University of Chicago Press, 1983).

complex and nuanced; and Wölfflin-derived uses of the term must not be mistaken for formalist aesthetics and its endorsement of abstract art.[16] Epistemic approaches have developed as a direct response to the effects of Marxism on social, political, and economic questions, as well as to the perceived limitations of the earlier generations of theories, and to the advancements of psychoanalysis and psychology. Thus Marxist, social, and cultural art histories—here it seems *d'homage* to introduce Ernst Gombrich (1909–2001) further discussed below—and their respective modifications such as feminist and postcolonial critiques have become normal angles of enquiry.[17] The artistic manifestations amidst the sociocultural reactions to the two world wars are steeped in, and thus require to be studied through, new attitudes from complementary disciplines such as the object-centred literary New Criticism, and the philosophical ramifications of phenomenology, logic, and philosophy of language, and more.

The formulations summarized above emerged from diverging Anglo-American and continental philosophical thoughts on art. Yet, taking cues from the belief of Richard Rorty (1931–2007) that the history of philosophy is one of 'turns', W. T. J. Mitchell has traced the extent to which they share, quite unexpectedly, cross-fertilizing positions on the fundamental questions in art history—visual studies as a whole—such as the consequences of equating artistic manifestations either to linguistic models or to mimetic expressions. Mitchell has clustered these positions and consequences into the 'pictorial turn' and the 'iconic turn'. From a critical art historical viewpoint particularly, Wollheim's enquiries are prime examples of the engrossing complexity of such positions.[18]

Furthermore, most artistic movements from the inauguration of the institutions that constitute the art industry have been inextricably part of its history, in various shades of necessity, complacency, defiance, as they evolve into today's cultural economics. Studies of artworks have always been aware of art's non-profit as well as profit-oriented backgrounds.[19] In fact, the mutual courtship between art and its industry—the New York scene from the 1930s, Arthur Danto (1924–2013) and the influential notion of the 'white cube' must be mentioned—has been catalytic for the validation of broader definitions of what constitutes both art and its media.[20] It

[16] Clement Greenberg, *Art and Culture: Critical Essays* (Boston, MA: Beacon Press, 1961) deserves mention, as does Roger Fry (1866–1934), to whose writings Wollheim dedicated much attention.

[17] To represent the exceedingly long list of worthy contributions within this area of multifaceted approaches, we select T. J. Clark, *Image of the People: Gustave Courbet and the 1848 Revolution* (Berkeley: University of California Press, 1973) and Svetlana Alpers, *The Art of Describing: Dutch Art in the Seventeenth Century* (Chicago: University of Chicago Press, 1983).

[18] W. T. J Mitchell, *Picture Theory* (Chicago: University of Chicago Press, 1994).

[19] For an introduction to the relation between art and institutions, see Carol Duncan and Alan Wallach, 'The Universal Survey Museum', *Art History*, 3.4 (Dec. 1980), pp. 448–69; Andrew McClellan, *The Art Museum From Boullée to Bilbao* (Berkeley: University of California Press, 2008).

[20] Seminal here is Arthur Danto, *The Transfiguration of the Commonplace* (Cambridge, MA: Harvard University Press, 1981), on which Wollheim comments in 'Danto's Gallery of Indiscernibles', Chapter 13 in this volume. On the white cube, see Brian O'Doherty, *Inside the White Cube: The Ideology of the*

has also been significant for the shift in studies on spectatorship from historical en-quiries into the circular relation artist/artwork/beholder—Gombrich's notion of the 'beholder's share' might be cited here[21]—to the impact of public expectations and of curatorial practices in determining artistic intentionality. As emblematized in the Institutional Theory of Art of George Dickie (1926–2020): 'A work of art is an artifact of a kind created to be presented to an artworld public.'[22] Thus unsur-prisingly, in recent decades artistic products have been contextualized within the-ories that aim to empower the spectator and allow the artworks to be experienced from heterochronicity, autotheoretical, and subject-positioning perspectives[23]—even as agents in a New Materialist dimension cognizant of biopolitical structures and micro and macro life orders, social, environmental, technological, economic, and so on. These developments postdate Wollheim's writing. However, it is im-portant to mention them here to indicate that art historical approaches are con-tinuously expanding, in response to manifold ontological debates.[24]

Wollheim's philosophy of art is also responsive to the effects of external factors such as the institutions of art and its public on art-making. And readers of his work, especially those familiar with competing theorists such as Dickie and Danto, will find ample stimulation if not provocation. But such external factors are less central to Wollheim's enquiries, which instead developed at the intersection of disciplines that naturally foreground the expressive cogency of the aesthetic phenomenon, as do many of the theories discussed above.

Gallery Space (San Francisco, CA: Lapis Press, 1986), originally published in three articles in *Artforum* (1976).

[21] Wollheim would develop a lifetime engagement with the psychological and perceptual com-plexities of the 'beholder's share', to which an entire 'part three' is dedicated in the foundational Ernst Gombrich, *Art and Illusion: A Study in the Psychology of Pictorial Representation*, 6th edn (1960; repr. London: Phaidon, 2002), pp. 153–244.

[22] George Dickie, *The Art Circle* (New York: Haven, 1984), p. 80; *Art and Value* (Malden, MA: Blackwell, 2001). Danto, Dickie, and others are important foils for Wollheim's own philosophy of art.

[23] Heterochorony posits that different cultures have different concepts of 'time', which are not always comparable; practically speaking, heterochrony problematizes the extent to which non-Western cul-tures have been inaccurately incorporated within 'the evolutionary narrative that privileges the Euro-American past'. Keith Moxey, *Visual Time: The Image in History* (Durham, NC: Duke University Press, 2013), p. 173.

[24] On late movements, see Michael Ann Holly, 'Reading Critical Theory', in *Past Looking: Historical Imagination and the Rhetoric of the Image* (Ithaca, NY: Cornell University Press, 1996), pp. 170–208; Susan Yi Sencindiver, 'New Materialism', *Oxford Bibliographies*, 3 June 2019, DOI: 10.1093/OBO/9780190221911-0016. However justifiably criticized, Object-Oriented Ontology and Speculative Realism are now solidly present in mainstream arts platforms. An overview of these theories, their artistic expressions, and objections to them is given in Dylan Kerr, 'What Is Object-Oriented Ontology? A Quick-and-Dirty Guide to the Philosophical Movement Sweeping the Art World', *Artspace*, 8 Apr. 2016, https://www.artspace.com/magazine/interviews_features/the_b ig_idea/a-guide-to-object-oriented-ontology-art-53690. See also Andrew Cole, 'Those Obscure Objects of Desire: The Uses and Abuses of Object-Oriented Ontology and Speculative Realism', *Artforum*, 53i.10, https://www.artforum.com/print/201506/the-uses-and-abuses-of-object-orien ted-ontology-and-speculative-realism-andrew-cole-52280.

III. Aesthetics: Wollheim's Theoretical Contribution

Wollheim came to the field of art theory at an inauspicious time in the English-speaking world, amidst the logical positivism and ordinary language philosophy prevalent from the 1930s into the 1960s. He was a scholar of British empiricism, socialism, and political philosophy and, as noted, wrote books on aesthetics as well as on philosophy of mind, on F. H. Bradley (1846–1924), and on Sigmund Freud (1856–1939).[25] His method of investigating art combined aesthetics with philosophy of mind, psychoanalysis and psychology, and theories of perception. From this marriage of disciplines, he developed lifelong discussions with a wide range of contemporary thinkers, many of whom are featured in this volume. Chief among them was Gombrich, one of the giants in the field of art theory. In his seminal book *Art and Illusion* (1960), Gombrich focused on the basic and venerable question of the relationship between art and reality, and presented the history of art as a history of step-by-step trials and errors of 'making and matching' with historical and sociocultural conditions.[26] Art progresses towards the semblance of naturalism—its 'illusion'—through conventional formulae, 'schemata', improved over time by dynamics such as teaching/learning, comparisons, and competitions in artistic environments, which are interconnected with sociocultural structures. Naturalism is not merely a feat of mimesis or copying, as if there were an 'innocent eye'. Indeed, the schemata are often shaped by practical considerations, as when a child lets a broomstick represent a horse (as explained in *Meditations on a Hobby Horse*, 1963).[27]

Wollheim thought of art as an historical phenomenon, including its physical human activities. Not only is it subject to change as well as extending over time, it connects makers and recipients. Indeed, its material properties—notably its 'repleteness' and 'reflexiveness' as discussed in 'On the Question "Why Is Painting an Art?"'—facilitate agreement that to some extent transcends history. This point aligns Wollheim with the connoisseurial and formal traditions that are discussed above and whose proponents, in addition to Wölfflin, include Giovanni Morelli

[25] David Hume, 'Of the Standard of Taste', in *Four Dissertations* (London: A. Millar, 1757), pp. 215–40; Richard Creath, 'Logical Empiricism', in Edward N. Zalta (ed.), *Stanford Encyclopedia of Philosophy* (Winter 2022), https://plato.stanford.edu/entries/logical-empiricism/.

[26] 'Before the artist ever wanted to match the sights of the visible world he wanted to create things in their own right [....] The matching process itself proceeds through the stages of "schema and correction"': Gombrich, *Art and Illusion*, 6th edn, 99.

[27] Gombrich interacted with James J. Gibson (1904–1979), who famously argued that perception depends on two factors: the uptake of optical information and the 'affordances' in the individual, which are the ways in which the environment allows itself to be acted upon. Gombrich more strongly stresses, as he puts it, 'the influence that our expectations can have on our perceptions. No medium of art could function if it did not so influence our perceptions through the expectations that are set up.' What this means is that the broomstick—the hobby horse—and, by extension, the schemata fulfil a functional role because they are thought to have sufficient properties to act as substitutes for the real thing. Gombrich, 'Preface to the Sixth Edition', in *Art and Illusion*, xv–xxv (p. xviii); Ernst Gombrich, *Meditations on a Hobby Horse* (London: Phaidon Press, 1963).

(1816–1891) and Bernard Berenson (1865–1959); it is discussed in several essays reproduced here (especially in Chapters 2 to 4) but also in Wollheim 1974.

The connection requires a physical medium, but of special interest in philosophical aesthetics is the mental connection that the medium makes possible. It is no accident that the mind figures in the titles of two of Wollheim's volumes largely about art—*On Art and the Mind* and *The Mind and its Depths*. The mind is in turn conceived as a natural phenomenon, to be investigated by psychologists among others. 'All art, or at any rate all great art', he says in his magnum opus *Painting as an Art*, 'presupposes a universal human nature in which the artist and audience share.'[28]

Although famously critical of modern attempts such as Dickie's above-mentioned Institutional Theory of Art, Wollheim never proposed a definition of Art as such. Yet the question 'What is art?' is front and centre—in all its complexity—in his first book on the philosophy of art, *Art and its Objects*. It is a compact but comprehensive work, with aesthetic considerations and examples across the plastic arts, and from music, poetry, and more. By the year of the publication of the first edition he had already written on some key figures in aesthetics and art criticism, from Berenson to Rudolf Arnheim (1904–2007) to others such as those in this collection—Adrian Stokes (1902–1972), Susanne Langer (1895–1985), Michael Podro (1931–2008)—and notably Gombrich, whose views as we will see presently provoked a crucial view of his own, namely his theory of pictorial representation.

An important thesis of *Art and its Objects* is that a work of art cannot be identified as a mental object (an 'ideal' object attributed by Wollheim to Croce and to Robin Collingwood, 1889–1943) and nor can it be identified as a cluster of properties directly given in perception (a 'presentational' object in the manner of Presentational Theory—not attributed to anyone in particular but as natural, given certain philosophical views). The work of art is instead a physical object—or a type of physical object, as in music, poetry, and drama. It is a thing in space and time, it endures, and its properties are sometimes hidden from view.

And it is also a bearer of meaning. It is expressive. Does a work of art therefore carry out this function by virtue of being assimilable or usefully compared to that paragon of a meaningful object, the written or spoken sentence? For an impressive variety of reasons, Wollheim resists what he calls this 'semiotic' or 'semiological' approach, despite the attractions it has held even for analytic philosophers with expertise in logic, notably Nelson Goodman (1906–1998). As Wollheim sees it in the case of painting—a full discussion appears in 'Formalism and Pictorial Organisation', Chapter 1, Lecture III—perhaps the main difference between typical

[28] Richard Wollheim, *Painting as an Art* (Princeton, NJ: Princeton University Press, 1987), p. 8.

paintings and sentences, or in general any conventional coding systems, is that in the case of paintings nothing like a syntax or grammar appears to be available.

To acknowledge this, and to infer with Susanne Langer that a work of art is not a 'discursive' symbol like a sentence, but a 'non-discursive symbol', in Wollheim's estimate, is just word-making, affording no insight into the problem of explaining what it is to have that status, of explaining artistic meaning. The idea that the symbols must be 'natural' symbols goes further, but not very far. We must instead look more closely at the experience, the perception by *both* the maker and the spectator, of a work of art. In the case, as almost always, of painting, Wollheim divides this into two distinct types of artistic meaning: pictorial representation and pictorial expression. What follows explains those two varieties of meaning, plus Wollheim's take on two further, complementary aspects of art—or rather of painting in particular: style and visual delight.

Representation

Wollheim's account is based on our primitive psychological capacity for what Ludwig Wittgenstein (1881—1951) and others have called 'aspect-perception', especially that variety called 'seeing-in'. A child sees animals or human faces *in* the clouds; similarly, one sees things in the embers of a campfire, in damp-stained walls, and so on. One is not hallucinating; one knows throughout that it is, for example, a cloud that one is looking at. That is one requirement for painting's representing some item: that the item admit of being seen-in the picture. The other is a 'standard of correctness': of the many possible items that can be seen-in a picture, something is required to select the relevant item; for this, Wollheim specifies the intention of the artist.

Thus, for Wollheim, these two requirements are such that their satisfaction is individually necessary but jointly sufficient for a picture's representing some item. The represented items can be particular (Mme Cézanne) or general (a woman); actual (Charles V) or merely possible/conceivable (Zeus); an object (a horse) or state of affairs/fact (that Icarus fell into the sea). 'Intention' is meant very broadly. The intention may be implicit or explicit, even unconscious as opposed to conscious; it can take the form of desires, beliefs, emotions, commitments, and wishes. At all events, pictorial representation is a perceptual matter: the ultimate criterion for identifying the item involves vision. If the standard of correctness is indeterminate, then there is no such thing as the representational content; if it is unknown, then the representational content is also unknown. Nevertheless, especially in cases of pictures whose subjects are general rather than particular—e.g. a jumping horse— it is common to infer correctly the representational content without having to ask about the intention or read the placard.

As mentioned above, Wollheim began to formulate the theory in response to Gombrich's *Art and Illusion*, his review of which first appeared in 1961 (an

expanded version in 1963). We are all familiar with Köhler's duck-rabbit drawing, which can be seen as a duck or as a rabbit. It seemed to Wollheim that, for all his insight, systematicity, and erudition, Gombrich came to infer that, just as one can see the drawing as a duck or as a rabbit but not both at the same time, so one cannot see the physical picture surface—the lines, brushmarks, and so on—while simultaneously seeing the representational content of the picture—the duck or the rabbit.[29] This, Wollheim maintains, is a confusion: both the duck and the rabbit are at the level of (potential) representational content, and the impossibility of seeing both simultaneously implies nothing for one's awareness of the marks (thus the ambiguity of the duck-rabbit drawing only distracts from the issue). In 1980—the year of the publication of the essay 'Seeing-In, Seeing-As, and Pictorial Representation'—Wollheim had settled on the main outline of his mature theory. Seeing-in is characterized by 'twofoldness': one sees the marked canvas, and simultaneously one sees one thing in front of another—but also such things as a duck or Henry VIII. Any time that this happens, and the artist intended it to happen, it is a case of pictorial representation. Shortly after 1980, in response to Michael Podro, came a minor change. Rather than twofoldness involving two simultaneous experiences, it was to be thought of as a single experience with two aspects or folds, the two folds coming to be called the 'configurational fold' and the 'representational fold'.[30] Twofolded seeing is phenomenologically basic, incapable of (phenomenological) definition—though of course one may point out various important facts about it.

A crucial such fact is this. Pictorial seeing is a perceptual phenomenon, but Wollheim conceived its scope as being much wider than one might initially think. For sometimes, as Wollheim puts it, one can require 'prompting'. Think of those picture-puzzles, where often one cannot see the cat in the tree until one is told that there is a cat in the tree, at which point it becomes obvious. Similarly, one cannot see what there is to see in *The Procession to Calvary* (1564) by Pieter Breughel the Elder (1525/30–1569) (see Fig. 1.1 and Chapter 5 in this volume) unless one knows in outline the surrounding stories. More subtly, according to Wollheim, one's awareness of the representational content of certain pictures can only be enhanced by knowledge of the psychology, even in-depth psychology, being played out in the scene. But there is a limit: only such factors—Wollheim calls these matters of 'cognitive stock'—which can make a difference to one's perception of the canvas can be part of its representational content.[31]

The advantage of Wollheim's theory over the broadly similar theory that pictorial seeing is a matter of 'seen resemblance' between painted surface and

[29] Some find Gombrich innocent of this mistake, e.g. Catherine Wilson, 'Illusion and Representation', *British Journal of Aesthetics*, 22 (1982), pp. 215–17.

[30] Wollheim, *Painting as an Art*, 46.

[31] 'Cognitive stock', but with a stronger social-historical angle, is foundational to Michael Baxandall's (1933–2008) 'primer in the social history of pictorial style', *Painting and Experience in Fifteenth-Century Italy* (Oxford: Oxford University Press, 1972).

subject—as promoted by Christopher Peacocke, Malcolm Budd, and Robert Hopkins—is thought by Wollheim to be at its clearest when considering such varieties as Cubism or the later work of Willem de Kooning (1904–1997); it seems forced to say that one sees the painted image on the canvas as resembling, say, a human figure, but with seeing-in there is no evident trouble. In addition, Wollheim finds there a category mistake: for instance, we may say in the presence of a painted portrait: 'That looks like Napoleon.' What we mean is that the depicted man looks like the French emperor, not that the painted surface looks like him. And finally, one can see a state-of-affairs in a picture, but it is far from evident, according to Wollheim, that one can see a picture or part of a picture as *resembling* a state-of-affairs or part of one, such as the aftermath of a storm.

More problematic for Wollheim is the genre of the trompe-l'œil, such as those of Evert Collier (1642–1708) or Leroy de Barde (1777–1828) (see Fig. I.2); these pictures apparently resist awareness of the configurational fold, and thus by Wollheim's lights are not strictly cases of seeing-in, and therefore not of pictorial representation.

Expression

Wollheim wrestled with the problem for some 25 years: what exactly is expression? It may be agreed by all that expression is a relation between the expressive thing or event and the expressed thing, some 'content' or other. It may be narrowed with minimal loss to a relation between the expressive thing and an expressed *emotion* or *feeling*, whether particular or general. But this not enough; the word 'sad' denotes sadness, but it does not express sadness, not in the sense of interest for aesthetics.

In *Art and its Objects*, Wollheim considered the idea of Leo Tolstoy (1828–1910) that to express the sadness that one felt is to present something in such a way as to make others experience that emotion, whether or not one feels the emotion on the occasion. This is unsatisfactory: one does not have to feel an emotion in order to express it. Further, the effect on the audience may be highly variable: it is not necessary that every person who sees *Guernica* (1937) by Pablo Picasso (1881–1973) feels pity or horror [URL23]. Thus, Wollheim's dual counterfactual view of expression: an object expresses E just in case (i) *if* one *were* in state E and wished to produce an object manifesting E, one *would* make something like the object; and (ii) *if* one *were* to respond emotionally to the object, one *would* feel E.

This is progress. It incorporates the evident fact that to recognize expression is in some sense a visceral matter; it is to be made aware of what it is like to feel the emotion expressed. It is compatible with physiognomic or bodily matters being involved as well as more conventional matters.

Fig. I.2 Alexandre-Isidore Leroy de Barde (French, 1777–1828), *Assemblage of Foreign Birds*, late eighteenth–early nineteenth century. Gouache, watercolour on paper mounted on canvas. 126 × 90 cm. Photo © Musée du Louvre, Paris (INV 23692).

However, this is still not quite satisfactory, since—briefly—it comes too close to affirming that what one feels as a spectator, or would feel, is the emotion itself; this seems quite wrong, since obviously one is not (for example) actually sad in hearing sad music. The dual-counterfactual view would be shelved in favour of the 'Correspondence' theory, part of which was first mentioned in the 1974 piece 'Expression', then more completely and satisfactorily in *Painting as an Art*, and with more analytic detail in his 'Correspondence, Projective Properties, and Expression in the Arts' in the 1994 volume (the earlier 'On Expression and Expressionism'— Chapter 19 of this volume—considers the 'physiognomic link' between for example scowling and anger, along with Gombrich's thoughts on the matter). The theory is gratifyingly analogous to his mature theory of pictorial representation, even if it carries at least marginally more psychoanalytic baggage. The primordial phenomenon now is the mind's tendency to 'spread' its emotions on features of the environment, as when one feels a solitary wind-battered tree high up a ridge to be reminiscent of forlornness. This is the dual nature of concepts for inner states: they are concepts for what people feel, but they also pertain to sundry features of the environment, human and otherwise. Wollheim explicitly recalls Freud and Melanie Klein (1882–1960) in discussing the likely infantile psychogenesis of the habit of spreading, of 'projection'. Recalling Emanuel Swedenborg (1688–1772) by way of Charles Baudelaire (1821–1867), Wollheim terms the phenomenon 'correspondence'. The artist makes objects which invite one to experience the same or a similar correspondence to the one that he or she perceives in the object. Thus, we get the same tandem structure as for representation: correspondence on the one hand, and on the other the correctness conditions being supplied by the artist's intention.

Style

As Wollheim explains in 'Style: Two Views' (1994) as well 'Style Now' and 'Style in Painting' (Chapters 2 and 4 in this volume), a strictly taxonomic notion of style is not useful for his purposes. By a 'taxonomic' notion, he simply means a conception of style as mentioned above, devised by critics and historians for purposes of describing and categorizing artists and their products. In many such cases, there is no essential attempt at explanation, only at keeping stylistic accounts. Wollheim wants instead a 'generative' conception, one which identifies style ultimately as a dispositional state of the painter's brain and body—of the painter's nerves, of the hands, and so on. The two views strictly are not logically in competition, but Wollheim argues not only that criticism, history, and aesthetics sometimes suffer from not being clear on the distinction, but also that the generative conception is superior thanks to its positing style as 'psychologically real'.

For such a conception has explanatory value, covering not just the 'what' but the 'how' and the 'why'. It is needed to explain the unity of a painter's work, how

it is acquired, its relative stability; and, on the other hand, it can account for some of the consequences of its breakdown. Although Wollheim dropped the reference in later works, in 'Style Now' (1972) he cited by analogy an important aspect of Noam Chomsky's theory of Universal Grammar: at a deep level, the syntax or grammar of language is unconsciously realized in the brain; one speaks in a certain way without being aware of the principles responsible. The use of the generative conception of style lies, for example, in explaining why experiences of a single picture independently of other examples of the same painter are unreliable, and that aesthetic judgements are in general holistic; for maximum justification they require knowledge of a representative sample of the painter's works and likely of others working in similar styles. It is also a crucial element of any psychological account—a biological account, one might say—of the expressiveness of a given painter's activity as an artist. Indeed, style is a precondition of expression much as Gombrich believed, although the substance and justification of the views are very different (in the later essay, 'Pictorial Style: Two Views', Wollheim propounded a 'Weak Relativisation' of style, as opposed to its 'Strong Relativisation').[32]

Visual Delight

Visual delight is not represented by any piece in this volume, but for completeness it should be mentioned, as Wollheim came to see it as important in setting out his account of painting in *Painting as an Art*. Visual delight—or at any rate a central aspect of visual delight as experienced when viewing representational pictures— consists not just in colour or shape, but in our ability to go back and forth from the picture to its subject matter. The two cross-pollinate. Wollheim quotes an essay by Marcel Proust (1871–1922), in particular his meditation on the painter Chardin (1699–1779): the transfer of pleasure must go not only from the Chardin to domesticity, but from domesticity to the Chardin, the consequence being an enhancement of the experience of both.[33] One thinks of the pleasure Proust's narrator took in finding his Aunt Léonie's bedroom in the savour of a madeleine, but more pertinently of twofoldness—the way in which, as we read in *Painting as an Art*, 'the motifs and images of painting can stir remembered sensations of smell, taste and hearing'.[34]

[32] Richard Wollheim, 'Pictorial Style: Two Views', in *The Mind and Its Depths* (Cambridge, MA: Harvard University Press, 1993), pp. 171–83.

[33] Marcel Proust, *Chardin and Rembrandt*, trans. Jennie Feldman (London: Thames & Hudson for David Zwirner Books, 2017); Helen O. Borowitz, 'The Watteau and Chardin of Marcel Proust', *Bulletin of the Cleveland Museum of Art*, 69.1 (Jan. 1982), pp. 18–35.

[34] Wollheim, *Painting as an Art*, 100.

IV. Wollheim's Legacy, and the Structure of the Volume

Apart from their having introduced us to a staggering interconnection of knowledge and ideas, why should we still talk about Richard Wollheim's theories? Partly because his theories of pictorial expression and especially of pictorial representation remain central to contemporary discussion in aesthetics. Partly because he provides a framework for discussion of particular works, as realized in *Painting as an Art*. And for less technical but still broadly theoretical reasons. In today's climate of excessive privileging of subjectivity, of auto-theoretical approaches and the tensions between pictorial and iconic turns, Wollheim's thoughts emerge as crucial reminders that works of art begin with their makers and their psychophysical impulses. Similarly, contrary to excessive social art history and the tensions between creativity and the business of art, they remind us that the makers of artworks are the architects of *loci* that connect aesthetic and psychological experiences across the ever-changing spectrum of receivers within and beyond spatial and chronological boundaries. In brief, they keep artworks safe from interpretative if not self-serving misuses.

We have divided the contents into five parts. Details of each piece can be found in the editors' comments at the beginning of the piece; here, the structure of the volume is rationalized only in the very broadest of terms.

Part I. Lectures: Pictorial Style and Representation. As we said, Wollheim intended these for a smallish book. Lecture I is substantially the Lindley Lecture, given at the University of Kansas in 2001, published by the Philosophy Department, University of Kansas, 2002. Chief among its critical targets is the view of Roger Fry, who held that 'form' is the essential feature as well as the dominant value of painting, drawing, and etching. Wollheim made minor changes to the lecture, and we have added parts from a 1995 piece published in Barcelona (see Lecture III). Lecture II—completely original—uses the outcome of the discussion of Formalism in the formulation of his more flexible idea of pictorial organization, applying it to examples from Nicolas Poussin (1594–1665), Jacob van Ruisdael (1628–1682), and Claude Monet (1840–1926). Lecture III contains material from a piece published in 2002 in the *Journal of Aesthetics of Art Criticism*; this was in turn a slightly more expansive version of the 1995 Barcelona piece, as previously mentioned. We have put the excised material in boxes at appropriate locations. The lecture itself is a criticism of the broadly 'semiological' approaches to pictorial representation, especially of Rosalind Krauss, and the 'diacritical' approach of Yve-Alain Bois; both these attempted to conceive pictures as a kind of language.

Part II. Style. Although it has not received as much attention as other aspects of his aesthetics, Wollheim conceived of this as an important topic. There are three pieces here: 'Style Now' (1975); 'Aesthetics, Anthropology and Style: Some Programmatic Remarks' (1978); and 'Style in Painting' (1995). A fourth piece—'Why is Drawing Interesting?', Chapter 24 of the present volume—might have

been included here, but we thought it best if it were given separate billing with the 'Other Topics' of Part V.

Part III. The Theory of Pictorial Representation. By contrast, Wollheim's ideas on this topic have generated a large industry of scholarly and critical activity. 'Seeing-As, Seeing-In' of 1980 and the discussion in *Painting as an Art* of 1987 are well known; further angles emerge from the pieces here: 'On Pictorial Representation' (1998); 'What Makes Representational Painting Truly Visual?' (2003); and 'In Defense of Seeing-In' (2003).

Part IV. Wollheim on Others. Wollheim was a prolific reviewer of aesthetic theories. This volume presents an array of his reviews which, together, attest to the vigour of his intellectual commitments. His 1995 reflections on the work on art of Walter Pater (1839–1894) is one example of the breadth of his attention to the assortment of ideas under the tradition of art theories (he had also written 'Walter Pater as a Critic of the Arts' in Wollheim 1974). His 1966 positive response to Michael Podro's perceptual theory anticipates his points on pictorial organization later discussed in the three lectures discussed above, and featured in this volume (Chapter 8). He had a lifelong intellectual engagement with Adrian Stokes (1902–1972), on whose ideas he wrote extensively. Here we present his observations on Stokes's *Greek Culture and the Ego* (London: Tavistock, 1958) and his Introduction to *The Image in Form: Selected Writings of Adrian Stokes* (New York: Harper & Row, 1972; Harmondsworth: Penguin Books, 1972). His early if short-lived interest in the work of Susanne Langer—author of *Philosophy in a New Key* (1942) and *Feeling and Form* (1953)—emerges from his response to her volume of essays *Problems of Art* (New York: Charles Scribner's Sons, 1957), shortly after her book was published. His 1966 discussion of *Lectures and Conversations on Aesthetics, Psychology and Religious Belief* by Ludwig Wittgenstein (Berkeley: University of California Press, 1966) is comparatively idiosyncratic. Instead of presenting an exposition or criticizing the discussion in the book, Wollheim reminds the reader that aesthetic queries are problematized by the theory and idiosyncrasies of art, and its reflexiveness whereby 'one work of art can become the subject-matter of the next tradition'.[35] In his 1991 review of Kendall Walton's *Mimesis as Make-Believe* (Cambridge, MA: Harvard University Press, 1990)—a friendly disagreement with Walton—he foregrounds his 'seeing-in' theory of representation, which also distanced him from Gombrich. An early manifestation of what would prove to be Wollheim's long-running engagement with the latter is here represented by his 1964 review of *Meditation on a Hobby Horse*. Finally, his interest in Danto is exemplified here by his essay featured in *Danto and His Critics* (Oxford: Wiley-Blackwell, 1993).

[35] Richard Wollheim, 'Wittgenstein on Art', *New Statesman*, 9.72 (Sept. 1966), pp. 367–8 (p. 367), reproduced in this book as Chapter 17.

Part V. Other Topics. The final section of this volume includes Wollheim's reflections on miscellaneous queries on art that complemented his own. The first article, dated 1956, is an early insight into his shaping notions of 'seeing-in' and of art as an extension of human psychology. The second article in this section discusses *On Not Being Able to Paint* by the psychoanalyst Marion Milner (1900–1998) (London: Heinemann, 1950). In this book, the author reflects on her frustration during her early artistic attempts, when she seemingly failed to convey in her drawings and paintings the emotions aroused in her by the sights that would prompt her efforts. Beyond the justifications implied by artistic inexperience, Wollheim's article broadens the question of the distinction between artistic objectives and results. Wollheim's interest in psychology and psychoanalysis was filtered through his attention to Freudian materials. In 1941, the literary critic Edmund Wilson (1895–1972) wrote *The Wound and the Bow* (Boston, MA: Houghton Mifflin, 1941). The title references the myth of Philoctetes, the Greek warrior abandoned by his companions on their way to Troy during the final phase of the Trojan war because of the stench of his open wound, only to be rescued because of the dexterity of his archery. This tale is proposed as a metaphor for the condition of the artist: suffering and skills are inextricably bound. Does this mean that art is the result of neurosis? That art is one positive outcome of a condition that is otherwise a pathology? Wollheim's 1975 'Neurosis and the Artist' examines this conundrum. Similarly, his 1984 'On the Question "Why Is Painting an Art?"' considers a range of popular theories, and his view of the 'essential historicity' of art in the manner found in *Art and its Objects* and in his Andrew Mellon Lectures that he was working on in 1984, and that two years later would be published as *Painting as an Art*. Also, in 1986, he replied to Anthony Savile in the two-part article co-written with the latter, 'Imagination and Pictorial Understanding', for the symposium of the Aristotelian Society. 'Art, Interpretation, and the Creative Process' (1984) sets out the framework of his views on pictorial representation as involving the beholder's 'cognitive stock'. 'The Core of Aesthetics' (1991) considers Nelson Goodman's *Languages of Art* (Indianapolis: Bobbs-Merrill, 1968). *Languages of Art*, Gombrich's *Art and Illusion*, and Wollheim's *Art and its Objects* constitute landmarks in the Anglo-American analytic philosophy on art. The article is a succinct account of Wollheim's position on art; it begins with a reflection on the slow evolution of aesthetics into a philosophical discipline. The volume ends with 'Why is Drawing Interesting?' (2005); Wollheim's answer involves the subject of the inquiry's being inextricably physiological as well as mental.

V. Technical Remarks

The compilation of the articles together with the requirements of an anthology faced us with decisions regarding their individual technical features. What we modified to create overall homogeneity is as follows.

All articles are preceded by an editorial introduction. The more substantive changes which we made in Lectures I, II, III in Part I are editorial additions only.

A standard feature of a book of this kind is a comprehensive bibliography. Instead, we chose to provide references wholly within the footnotes. Additionally, as Wollheim himself did not provide a separate list of references for any piece that appears here, we did not want to change his style of notation (though we have added some of our own, noted '[Eds]').

Wollheim's writings on art naturally make direct references to artworks; some are explicitly shown, others merely mentioned. Whilst in isolation his referencing system does not create issues, in an anthology some images appear more than once. We have therefore included the following lists.

The first is the List of Illustrations (pp. xi–xii). It lists the images reproduced as figures. In each figure number, the numeral before the decimal point indicates the chapter in which the image is located. The numeral following the decimal point refers to the image in relation to others in the same section. For example, the first two figures in the list, Figures I.1 and I.2, appear in the Introduction.

The second list, presented as an Appendix, 'List of Artworks Discussed but not Reproduced, with URLs', at the end of the book, records all the remaining artworks mentioned in the text.

In both lists we provided the full caption for each artwork; if the inventory number appears missing, it is because it is currently unavailable. Similarly, at the time of writing not all the collections have digitalized all their artworks; in such cases we have chosen to offer the most stable URL currently available for the works.

Finally, in a few instances where an article discusses pictorial conditions that appear in figures mentioned in other essays in this collection, for illustrative purposes we have signposted the reader to such images. This explains why, for example, Figure I.2 is also mentioned elsewhere in this volume.

PART I

LECTURES

1
Pictorial Form and Pictorial Organization

Below is a series of three lectures. We are following Wollheim in so terming them, but they were intended ultimately as chapters for a short book—or perhaps for a slightly longer book, with some of it not yet written. What is certain is that two of the three emerged from three previously published works: 'On Formalism and its Kinds' (1995, called here the 'Barcelona Piece'); 'On Pictorial Organization' (2002, the Lindley Lecture); and 'On Formalism and Pictorial Organization' (2001, The Journal of Aesthetics and Art Criticism*). Part I of the present lectures is almost word-for-word identical to the Lindley Lecture. Part II is almost entirely new. Much of the piece appearing in the* Journal of Aesthetics and Art Criticism *appeared also in the Barcelona piece; thus Part III draws mostly on the JAAC piece.*

We've decided in general to publish only the present lectures, but to include—in appropriate places, as editorial notes—any material from the Barcelona piece, the Lindley Lecture, or the JAAC piece which did not appear in the present lectures,.

Since at least Kant, the allure of Formalism as an explanation of the peculiar value of the plastic arts—equally so in music, less so in literature, though strong echoes can be heard in the 'New Criticism' of the twentieth century—is undeniable, all the more so in the past 150 years, with the rise of Abstraction. In the Introduction, we mentioned Heinrich Wölfflin as a major figure in studies of Western figurative art. Also important to Wollheim was Roger Fry—and to lesser degree Clive Bell and Susanne Langer—all of whose versions of Formalism were at the philosophical end of that discipline, or in philosophical aesthetics. Indeed, there are Formalists and Formalists, as Wollheim says. Wölfflin's achievement lay in drawing universal stylistic formal values from close comparisons between Renaissance and Baroque paintings, sculptures, and works of architecture. He did not venture the categorical proposition that aesthetic value in these arts is to be equated with formal value. Bell, Fry, and Langer—and it is Fry who is Wollheim's explicit target—did venture it, or at least came very close to venturing it in the case of painting. And it is not tenable. If we ask what exactly pictorial form is, what exactly we mean by 'form', we find it impossible to arrive at a genuinely satisfactory definition—one which will plausibly make good on the aesthetic value found in pictures, and which does not import matters of representational, figurative, and indeed narrative content. Even works whose interest one might adduce as non-figurative—say, the colour field painting of Mark Rothko (1903–1970)— do have representational properties, if not figurative properties: at the minimum, one rightly sees one plane as being in front of another (which Wollheim explains

Uncollected Writings. Richard Wollheim, Gary Kemp, and Elisabetta Toreno, Oxford University Press.
© Bruno Wolheim 2025. DOI: 10.1093/9780191995767.003.0001

as being sufficient for pictorial representation). This is Lecture I. In Lecture III (Lecture II will be discussed in the next paragraph) Wollheim considers and rejects the idea that formal properties can be construed as 'latent' features—features that are in the composition but not ostensibly noticeable. He is especially opposed to the possibility that they may be explained as properties akin or analogous to syntactical or grammatical properties. For, with respect to pictures, it appears that there is nothing like rules of grammar in play: Wollheim contends that if the 'semiological' view is to be a genuine theory, then there must be rules corresponding to certain basic features of syntax, and at least one visible proponent of the semiological view—Yve-Alain Bois—has failed to establish this. The idea is that Bois's failure is the nature of the case. In addition, from the Barcelona piece, we have included in Lecture III Wollheim's criticism of Erle Loran (1905–1999), and his remarks about Willem de Kooning, the content of which will not surprise readers of Painting as an Art.

Lectures I and III are primarily critical of the idea of Formalism. By contrast, the comparatively unfinished Lecture II is a positive exploration of the more general, looser idea of pictorial 'organization' (introduced in the second half of Lecture I) by means of sustained attention to certain paintings by Nicolas Poussin, Jacob van Ruisdael, and Claude Monet. What emerges is that to realize the value of pictorial organization, we must take into account the artist's intention; when we do, we find a certain interpenetration of 'good organization' with other values and desires, from sensual and tactile (Monet) to a vaguer and more rarefied interest in the human place in nature (Poussin); these can amount 'to a defiance of "good" organization', as Wollheim comments in connection with Ruisdael. [Eds]

Lecture I

1

Paintings are organized objects. That much we know, and, in an area where not much is secure, it is worth hanging on to. The organization of his painting is something of which the painter is to some degree aware, and it is something of which he wants—again to some degree—the spectator also to be aware.

Painters are inclined to talk of their paintings as 'working' or as 'not working'. Furthermore a painting that at one moment is found not to work may, at a later stage, through the ingenuity of the artist, or through sheer application, be made to work. It is inviting to think that whether a painting works or doesn't work has something to do with its organization, and this idea gains support from the fact that it is only at a late stage in the creative process that the painter will start to think about the painting's working. No serious painter starts out with the bare intention of making a painting that will work: he first sets out to make a painting for this or that reason, and then later tries to make certain that it will work.

Fig. 1.1 Pieter Brueghel the Elder (Flemish, *c.*1525/30–1569), *The Procession to Calvary*, 1564. Oil on wood, 124.3 × 170.6 cm. Photo © KHM-Museumsverband, Vienna (INV Gemäldegalerie, 1025).

<div align="center">2</div>

I start with a painting and a piece of criticism. The painting is by Pieter Brueghel, it hangs in the Vienna museum, and it is generally called *Christ Carrying the Cross to Calvary*, or *The Procession to Calvary* [Fig. 1.1]. It is dated 1564, and is therefore a work of Brueghel's maturity, and it depicts one of the three moments when Christ, on his way from prison to execution, accompanied by a large and indeterminate body of soldiers, sightseers, hostile citizens, and believers, stumbles under the weight of the Cross, which, as an exceptional punishment, he has been condemned to carry to the place where he will be crucified.

The criticism is by Roger Fry, the English Formalist critic and art historian. Fry, by upbringing a Quaker, by training a scientist, brought with him from his formation a strong belief in first principles. When an argument threatened to lead to an absurd conclusion, he showed a powerful disinclination to retrace the absurdity to an exaggeration in the premises.

The essay of Fry's that I wish to consider is entitled 'Some Questions in Esthetics', and it appears in a volume of essays called *Transformations*.[1] The essay criticizes

[1] Roger Fry, *Transformations: Critical and Speculative Essays on Art* (London: Chatto and Windus, 1926).

Brueghel's painting on general grounds, and it fixes on a particular point to drive home his argument. The general criticism is that the painting is so cluttered up with undigested detail that the spectator is obliged to crane forward in order to make out what he is looking at. In doing so, he loses all sense of the whole. And, as a flagrant example of what is generally wrong with the painting, Fry concentrates on an element that he refers to as something that 'looks like a black ring': it is be found some way up on the right hand side of the painting. Of it Fry says that it lacks 'any significance in a plastic sense'.[2] Nothing, it turns out, could, within his scheme of things, be more damning.

I don't have to say why the element is there, or what it represents. You can use your eyes to see it in the picture: a phrase that will recur. The black ring represents a crowd of citizens grouped around two unoccupied crosses. They have presumably risen early, they have made their way to the barren hillside outside the city, known as the place of the skull, and there they will wait, occasionally jostling for a better position, until the procession, which is now making slow and painful progress along the foreground of the painting, arrives. When it does, the third cross will be set up between the two that are already there, and the great event of the day, which is—or so the circle of people tells us—something not to be missed, will unfold. What these sombre figures do for the overall drama is that they bring into the present, so far given over to mere haphazard bullying and abuse, a premonition of the suffering and the terror that will be experienced for certain in the future. They are, in a critical phrase of yesterday, the 'objective correlative' to the passion of Christ.

Now, if Fry uses the phrase 'something that looks like a black ring' to designate the detail that so offends him, it is not that he has failed to recognize its representational role. He is fully aware of it. Indeed he describes what is represented by it in terms not at all dissimilar from those I have just used. Furthermore, on one level, he shares my admiration for Brueghel's introduction of the crowd of bystanders into the painting. It is, he says, 'a great psychological invention'. It sets up, he says, 'profound vibrations of feeling within us by its poignant condensation'. He compares it to an invention of Shakespeare's.

But ultimately for Fry the black ring, which is how he thinks that this part of the painting should be referred to when we are trying to evaluate the painting as a painting—is a bad thing. 'Judged as a plastic and spatial creation'—that is to say, judged by the standards appropriate to paintings—this detail is 'entirely trivial and inexpressive'. In the very act of rising to the heights of Shakespeare, Brueghel contrived to betray his mission as a painter. He has subordinated plastic considerations, which should be his true imperatives, to psychological considerations, which are irrelevant.

[2] Ibid. 15.

3

In this passage, Fry tells us that Brueghel's painting doesn't work. And as if in confirmation of the connexion I was suggesting earlier, he ascribes its failure to a fault in its organization. And he goes on to explain why the fault is a fault. In other words, he inserts his criticism of a single painting into an overall view of pictorial organization, into which he compresses a view of what pictorial organization is and a view of what it is that makes for pictorial organization.

The overall view of pictorial organization that Fry produces combines three general principles.

My names for these principles are, in descending order of generality, the Principle of Normativity (that is the most general), the Principle of Purity, and the Principle of Formalism, and a few words on each.

First, there is the Principle of Normativity, and this states that pictorial organization is a value: it is something that artists should pursue, it is something that a picture is the better for having. A step beyond thinking that a picture organized is better than a picture not organized is to think that there are better and less good ways of organizing a picture. The principle of Normativity pronounces pictorial organization a norm, at once for painter and for spectator and critic.

Secondly, there is the Principle of Purity, and this states that there are a number of aspects of a painting that are irrelevant to the organization of a picture. They have nothing to contribute to pictorial organization nor do they stand to benefit from it. On Fry's view of the matter, which is by no means peculiar to him, these irrelevant aspects include (as we have seen) psychological considerations, and also literary or narrative considerations. The likeliest thing that such considerations can do is to distract the artist from the problems of organization through involving him in what Fry disparagingly calls 'illustration': consider Brueghel and the crowd of sightseers. The Principle of Purity in effect quarantines the organization of the painting, and so, by extension, the painting itself, from issues of direct human interest.

Finally, there is the Principle of Formalism, which states that the organization of a picture is always a matter of the arrangement of, or the interrelations between, elements, or units, into which the painting may be segmented. The favoured name for such elements is 'form'. There are various views about what a form is, or how forms are to be identified. Some Formalists, including Fry, think that the elements into which a picture can be resolved are units that lie on the surface, where a sensitive critic will discern them. Others, also Formalists, think that the units of organization, which they often misleadingly call the syntax of the painting, lie below the surface, from which they have to be retrieved in special ways reminiscent of grammatical parsing.

<div align="center">4</div>

I shall now consider these principles in ascending order of generality, starting with the Principle of Formalism, and specifically with the version in which Fry subscribed to it: that is, that the organizational units, out of which pictures are composed, lie on the pictorial surface. Perhaps not everyone may spot them immediately, but there they are.[3]

However the Principle of Formalism is of little use to us unless we have a settled way of picking out the forms of a picture. We need a way of doing it for ourselves, and then we shall need assurance that, once we have done this, we—and 'we' is now a community of spectators—have all done the same thing.

A solution to this difficulty would be to develop an operational understanding of the notion of form. We should try to come up with a process, a physical process, by means of which we can, in the presence of a picture, extract the forms from its surface.

One suggestion how this might be done is that, standing in front of a painting, say of the Brueghel, we should put, or we should imagine ourselves putting, a sheet of plain glass over or parallel to its surface. The glass completely covers the surface, and it is placed in such a way that our line of vision passes through its centre, and at right angles to it. We look through the glass, and then we trace on to the glass all the lines that can be seen through it, and, somewhat unrealistically, it must be assumed that we can do this without moving our heads. The task completed, we are to remove the glass, and, as we lift it off, we find, inscribed on the glass, a total record of the forms of the picture, and hence, once we have noted how the forms are interrelated, a record of its organization, such as it is.

Where this suggestion comes from is clear enough. It comes out of the processes devised by thinkers of the Renaissance, at once to exhibit the theory, and to facilitate the practical application, of perspective, or *costruzione legittima*. An example is Dürer's 'gate'[4]. In effect, the present suggestion proposes that the process of extracting the organization from a picture is a reiteration of that very process initially used by the artist to extract the picture itself from Nature.

Now, straightforward though the proposal may sound, there are very real difficulties with it. They need to be confronted.

<div align="center">5</div>

As we start to draw on the glass, we shall, from time to time, find ourselves asking ourselves one or other of the following questions, Should we not at this point draw in a line, because, though none is visible through the glass, certain forms—that is,

[3] This section is a slightly longer version of *JAAC* section IV. He drops the idea of a survey of 'operations or processes' available to the Formalist. [Eds]

[4] Also known as 'Dürer's door'. [Eds]

what we can independently recognize as certain forms—will otherwise go unrecorded? Alternatively, is there not here a line that, though it is visible through the glass, we should not draw in, because it does not describe, or help to describe, what we can independently recognize as a form? So, standing in front of the Brueghel, with the glass in place, we are about to trace on it the lines that indicate the singular thorns in Christ's crown. Should we do so, or will that record a form where there is no form? Next, our attention turns to the clouds. Surely here there *are* forms, the forms of the clouds. Yet here and there Brueghel provides no line: rather he allows the clouds to blend, or merge, into the blue of the firmament. So do we not need, for the sake of completeness, to insert a line around them?

It goes without saying that it would be a serious matter if a process that was introduced for its operational value, like Dürer's gate, turned out to be plagued with difficulties of application.

<p style="text-align:center">6</p>

These last problems arise only because Brueghel's painting is not in a fully linear style. When a painting is not in a fully linear style, and most are not, the pictorial surface will under-determine, or it will give insufficient specification, which lines are to be inscribed on the glass.

But there is a further problem. For, even when it has been resolved how the glass is to be marked, the question arises, How are we to look at the glass, with its lines, with its marks, if it is to serve us as a true record of the forms that the picture contains?

An obvious suggestion is that we should see the lines as constituting a flat or two-dimensional pattern on the surface of the glass. This suggestion takes up on what was presumably the rationale for ever thinking of the sheet of glass as an adequate process for extracting form from painting. For, given that what the glass does best is to reproduce with great fidelity a flat or two-dimensional pattern lying on the pictorial surface, the original thought must have been that the organization of the picture is itself something flat or in two dimensions.

But to this obvious suggestion there is a powerful objection, which incidentally would have found some support from Fry himself. It is that, since we do not ordinarily look at a painting as a flat or two-dimensional surface, it is implausible that pictorial organization, which is the core of a painting, should be in the flat or two dimensional. What this objection reminds us of is the all-important fact that, unless we are otherwise manipulated by the artist, we bring to bear upon a painting a special mode of perception, which I call 'seeing-in'.[5] This mode of perception is

[5] See Richard Wollheim, *Painting as an Art: The Andrew W. Mellon Lectures in the Fine Arts for 1984* (Princeton, NJ: Princeton University Press, 1986), Lecture II, and 'On Pictorial Representation', *Journal of Aesthetics and Art Criticism*, 56.3 (summer 1998), pp. 217–26, and Chapter 5 in this volume. [Eds]

not unique to looking at pictures, and, just for this reason, it can be used to explain certain features of our pictorial experience.

Seeing-in is likely to be triggered by looking at a marked surface of any real complexity, and what is characteristic of seeing-in is its particular phenomenology, or what the experiences to which it gives rise are like for the observer who has them. When we see something in a surface, we simultaneously notice the way the surface is marked and are made visually aware of something in front of, or behind, something else. So we look at a wall stained by dirt and damp, like the wall photographed in Chicago by Aaron Siskind [Fig. 1.2], and, as well as taking in the textured surface, we see a boy carrying a mysterious box. Or we look at a frosted pane of glass like that photographed by Minor White [URL1], and, as well as taking in the textured surface, we see dancers in gauze dresses. And, in doing this, we manifestly do not look at the marked surface as a flat pattern.

Seeing-in is prior to painting both logically and historically. Logically, in that we can things in surfaces that neither are, nor are thought by us to be, paintings: historically, in that our ancestors must have engaged in these activities long before they decorated the caves in which they lived with the images of the animals they hunted. However, when seeing-in is taken up into painting, a major change occurs. Seeing-in acquires a criterion of correctness. When we look at a painting, there are certain things that can be correctly seen in it, and whatever else we might see in it is incorrectly seen in it. When we look at a certain sixteenth-century portrait, we correctly see in its surface Henry VIII of England, and, if, being old film buffs, we see Charles Laughton in it, we have made a mistake. When Proust went to the Louvre, and saw in the Ghirlandaio double portrait [Fig. 1.3], not an old Italian prelate with a polyp at the end of his nose, but his friend from the Faubourg, the genial Marquis de Lau, he too made a mistake: the difference here is that he set out to do so. By contrast, in the case of stained walls, or frosted panes of glass, anything can be seen in them with equal legitimacy. There is no room for a mistake.

A question to ask is, What is the ground, or source, of the criterion of correctness that seeing-in gains for itself when it is tied to the intentional activity of painting?

It is my view that this criterion is provided for each painting by the intention, more specifically by the fulfilled intention, of the artist. What we see in a picture is something that it is correct to see there when it concurs with the fulfilled intention of the artist. But this is not, I stress, the only view of the standard of correctness, and, for our present purposes, it suffices to recognize that there is such a standard.

Fig. 1.2 Aaron Siskind (American, 1903–1991), *Chicago 10 1948*, 1948. Gelatin silver print, 50.8 × 40.64 cm. Virginia Museum of Fine Arts, Richmond. Gift of the Aaron Siskind Foundation, 2019.4809 Photo © Virginia Museum of Fine Arts, Richmond.

Fig. 1.3 Domenico Ghirlandaio (Domenico di Tommaso Bigordi, Italian, 1448–1494), *An Old Man and His Grandson*, 1490. Tempera on wood, 62 × 46 cm. Photo © Musée du Louvre, Paris (RF 266).

From the Conclusion, §19 (de Kooning), of the 1995 Barcelona lecture

This point about correct and incorrect perception of a painting and the role of the artist's intention in deciding between them is most readily, most effectively, made in the context of figurative painting. But it applies no less cogently to abstract painting. If we consider these great works of de Kooning from the 1950s to the 1970s, we have no chance of seeing them for what they are unless we bring to the fore what we know of the artist's intentions towards the body [e.g. Untitled II, 1979 [URL2], Untitled III, 1977; eds].[6] Earlier works show us that de Kooning's sense of the body was more fully realized in these abstract works than it was in the more modelled, or overtly figurative work, such as his *Women* where the body itself is depicted. This strongly suggests that the body with which de Kooning was concerned, and which he wished to bring into his art, was a body that was regressively Conceived. It is the infantile body, racked by tumultuous sensations and overwhelming impulses, and with the most fragmented sense of what holds it together, that is his subject-matter.

I return to the dependence of painting, of representational painting, upon seeing-in, and its scope. When we see something in a marked surface, we are not confined to seeing in this surface things like boys and dancers, mysterious boxes and gauze dresses: we can equally see solid shapes and floating patches of colour. In consequence, when painting derives from seeing-in, it can assume either of two forms: it can be either figurative or abstract, and the history of art has borne this out. Since both kinds of painting invoke a form of looking that leads us, while remaining aware of the marked surface before our eyes, to see one thing in front of, or behind, another, the figurative/abstract distinction is best regarded as marking a difference within the representational: the concept of representation finding its unity in its dependence upon seeing-in.

I go back then to the objection to looking at the marked sheet of glass as giving us a record of a two-dimensional pattern, which in turn is the organization of the painting that lies the other side of the glass. We can now strengthen it like this: Given that when we look at paintings, our looking at them leads us to see what we can see in them, it is deeply implausible that their organization should be captured in something that we are supposed to see another way, or that requires us to inhibit seeing-in. Of course, what is drawn on the sheet of glass *is* a two-dimensional pattern: that goes without saying. But that it should be seen as such is another matter.

[6] The latter is not currently available online; the former only on a commercial site. Both are featured in Wollheim's *Painting as an Art*, 348–9, and of many de Kooning's pictures of the period display these features. [Eds]

From §12 (Loran), of the 1995 Barcelona lecture

In 1943 there appeared a remarkable book on Cézanne's compositional practice.[7] Its author was Erle Loran, an American artist and teacher, and Loran's immediate objective was to dispute the view that Cézanne built up spatial relations solely through colour modulation and multicoloured patches of paint. Instead Loran insisted that Cézanne's art is an art based on broad planes and on line or contour.

Loran's book was favourably reviewed by Clement Greenberg,[8] and the appeal that it made to diagrams to support its thesis has led many to think of it as a vademecum of Manifest Formalism. I think that that is quite wrong. I think that there couldn't be a subtler, or a more assuredly visual, way of demonstrating the difficulties inherent in Formalism than the way Loran uses diagrams to analyze Cézanne's greatness. It may very well be that the author himself is amongst these who do not fully appreciate the full consequences of his method.

For Loran Cézanne's achievement lay in the balance that he established, in the first instance, between the various represented volumes, and then, secondly, between the represented volumes and the space around them. But the test of this three-dimensional balance lies in the way in which this outcome is then related to, or reflected in, the two-dimensional picture-plane. And this, I maintain, is an account that goes beyond Formalism, and that it does so is exactly what Loran's method, or the use of diagrams, shows us. To establish this, I propose to follow Loran's analysis of Cézanne's *Still Life with Faience Jug* [URL3], in the collection of the Sammlung Oskar Reinhart Am Romerholz at Winterthur.

Let us begin with the simplest of the diagrams that Loran offers us (Diagram I),[9] which, arrived at by tracing round the outer contours of the large areas of the picture, gives us the basic lay-out of the picture-plane. The organization of the picture-plane remains the theme of the next two diagrams, each of which analyzes a different aspect. The first (Diagram V)[10] sets out the network of straight lines on which the balance across the picture-plane, which is a strictly two-dimensional balance, depends. In addition to the actual lines, visible on the picture-plane, dotted lines indicate the subjective, or what Loran calls the 'carry-through', lines. Horizontal and vertical lines are static, diagonal lines are dynamic. The next diagram (Diagram VII)[11] sets out the series of curved lines, on which rhythm across the surface depends.

[7] Erle Loran, *Cézanne's Composition: Analysis of his Form with Diagrams and Photographs of his Motifs* (Berkeley: University of California Press, 1963). [Eds]

[8] Clement Greenberg, 'Review of *Cézanne's Composition* by Earle Loran', in *The Collected Essays and Criticism*, vol. 2, ed. John O'Brian (Chicago: University of Chicago Press, 1986). [Eds]

[9] Loran, *Cézanne's Composition*, 40.

[10] Ibid. 42.

[11] Ibid.

Once again, Loran has used dotted lines to indicate 'carry-through' lines. Curved lines, like diagonal lines, are, Loran tells us, dynamic.

The next lot of diagrams analyze the three-dimensional content of the picture and its organization, or how tension is established between the represented volumes. In the first diagram (Diagram II),[12] the volumes are reduced to planes, but planes that stand in space and lie either behind or in front of one another. Planes that are tilted back into the represented space are, like lines that do not run parallel to the edges of the picture-plane, or like curved lines, dynamic, and set up tension, as the arrows indicate. In the next diagram (Diagram III)[13], planes have been replaced by volumes, and now we are shown a higher-order tension, or that between the volumes themselves, or positive space, and the unoccupied or negative space. I shall not take Loran's type of analysis any further, for the point that is crucial for me has already been established. And that is that, though, through the use of diagrams, he can analyze, on the one hand, how the artist organizes the picture-plane and, on the other hand, how he organizes the represented space, what, in the nature of things, Loran cannot present diagrammatically is the meeting-point of the two, which is, for him, precisely where Cézanne's pictorial achievement, indeed pictorial achievement in general, lies. The reason is this: that any diagram that Loran might construct can, at any one moment, function either as a depiction of the two- dimensional picture-plane or as a depiction of the three-dimensional scene represented on the picture-plane. What it cannot do is to function simultaneously as both. (Of course, when we look at a diagram as a depiction of the three-dimensional scene, we shall, according to my account of representation, be aware of the two-dimensional surface of the diagram. But that is not to say that we shall see the diagram as a representation of the picture-plane. And this is why what Loran calls the 'return out of depth' must elude any kind of diagrammatic demonstration.) In order to grasp just how Cézanne fused the organization of volumes and the organization of the picture-plane, we have to go back to the painting itself and experience the fusion: nothing else will do. There is no formulaic representation of the crucial stage.

Manifest Formalism can linger on. It can survive for the artist as the name of a generative ideal: it can survive for the critic as the name of a research programme. But form itself is no longer the name of a discriminable, an isolable, element in, or aspect of, a picture.

As a postscript to Loran's enterprise, I will speak about a final diagram (Diagram IV).[14] It shows you some further paths of tension running across the picture-plane. I ask you particularly to note the arrows that go from the apples on the plate to those lying on the table and then outwards to the lone apple beyond the white cloth. This particular path of tension exists, Loran suggests,

[12] Ibid. 41.
[13] Ibid.
[14] Ibid.

because of the similarity in the objects' size, shape, and colour. I suggest that we know better. It exists in part because the objects that it connects are all apples. Imagine that the table were laid out for the preparation of that delicious Swiss Christmas dish in which apples are baked with potatoes. In that case potatoes might have replaced the apples on the right. Would the arrows fly as fast? I doubt it. Even on a reduced understanding of the view, Formalism is not independent of representational, and, in this case, figurative, content.

<div style="text-align:center">

7

</div>

However, once we recognize that the sheet of glass with its tracings has no hope of giving us the organization of a picture unless we look at it with the express aim of seeing what we can see in it, we might start to ask, Does the sheet of glass, does Dürer's gate, give us the best operationalist understanding of form? For all that this procedure gives us as its output are lines, and, when we see something in a picture, we normally depend on something more than lines. So we might go on to wonder whether a better process might not be the following: By use of the relevant projective system, or that employed by the artist, we derive from the pictorial surface, either in reality or in imagination, a groundplan that corresponds to the picture. Then, on this groundplan, we construct a three-dimensional model of the represented scene, and it is this model that gives us the forms whose interrelations constitute the organization of the picture.

But this suggestion, taken literally, has one highly paradoxical consequence. For it follows that all paintings that depict the same scene but in different conditions, or from different points of view, such as some of Monet's *Grainstacks*, have the same organization. The notions of form, and of pictorial organization, seem again derailed.

To forestall this consequence, it looks as though all that is needed is a simple addition. What we need to add is a sight-line, or a perspective. The forms of a painting are such and such three-dimensional objects *seen from such-and-such a point of view*, or *cutting such-and-such profiles*, or *occluding such-and-such a space*. These are intended to be equivalent formulations.

But this new suggestion as to how to extract the forms, hence the organization, from a painting presents problems of an order that were not to be anticipated so long as the organization of the painting was held to be something two-dimensional, or the favoured operation for arriving at this record was the plane sheet of glass placed over the painting.

Initially there are the problems of under-determination, or the multiple ways in which the relevant marks on the surface fail to determine how the organization of the picture is to be recorded.

Under-determination is something we have already encountered when (one) the organization of the painting was thought to be something two-dimensional, and (two) the painting fell short of total linearity. However, when the organization of the painting is recognized to be three-dimensional, the possibilities of under-determination massively enlarge. In addition to the case where the painting is less than fully linear, there are those cases where, for instance, there is more than one projective system in use—as in the Giottesque *The Vision of Thrones* at Assisi, where oblique projection in the upper, or heavenly, register is contrasted with perspective in the lower, or terrestrial, register— or where there is just one projective system, but there are changing viewpoints—as in Matisse's *Interior at Nice*, of 1921, or in the *Nymphéas* of Monet, where the foreground of the scene is looked sharply down upon and through as from above.

However further reflexion suggests that, when pictorial organization is thought of three-dimensionally, or in terms of what we can see in the picture, the very idea of under-determination by the relevant marks on the surface, or, more precisely, the very idea of the relevant marks on the surface, becomes problematic. For now there is no clear way of ruling out, at any rate in advance, any aspect of the painting on the grounds that it does not contribute to what we see in it, hence that it does not contribute to its organization. Over and above contour, which was all that passed through Dürer's gate, there are all those undelimitable aspects of the paint-surface that represent, or reveal, or intimate, the effects of light as they model, or obscure, or dissolve, volume, and each of them has therefore some claim to be counted as formal, or to be included in any record of the forms into which the painting can be analysed.

With a question mark over the Principle of Formalism, I am ready to turn to the other two principles, the Principle of Purity and the Principle of Normativity. And I shall consider them in relation to the broad notion of pictorial organization, *where this is now freed from any necessary connexion with Formalism*. After all, there are many different ways of organizing a picture, of which the arrangement of constituent forms is only one.

<center>8</center>

So, the Principle of Purity. This principle asserts the mutual independence of pictorial organization and subject-matter, both ways round. Neither depends on the other. For many devotees of the arts, it has the appeal of austerity. However it certainly flies in the face of every pictorial tradition we know. Painters, in organizing their paintings, have drawn on subject-matter, and, in developing their subject-matter, they have made use of organization. And, since this is what painters have done, and—far more important—much of the interest of their work has depended on it, it is difficult to see what prevents that from concluding the matter.

I pick out two paintings for very disparate reasons, both of which illustrate the two-way street. The first painting is Raphael's *The Expulsion of Heliodorus*

Fig. 1.4 Raphael (Raffaello Sanzio, Italian, 1483–1520), *The Expulsion of Heliodorus from the Temple*, 1511–13. Fresco, east wall, Stanza di Eliodoro, Vatican Palace (Vatican City). Photo © Governatorato SCV–Direzione dei Musei.

[Fig. 1.4]. It is in the Vatican, and it shows the punishment wreaked on the Syrian general Heliodorus when he tried to despoil the Temple in Jerusalem of the money belonging to the widows and orphans. A heavenly rider descended, and trampled the robber underfoot, while two men flogged his battered body. I have chosen *The Expulsion of Heliodorus* because there is in existence a remarkable analysis of this painting, which makes the point that I wish to make more forcefully, and more subtly, than I could ever hope to do, and this analysis is by the most distinguished critic ever to think of himself as a Formalist, the great Swiss art-historian Heinrich Wölfflin.[15] Evidently there are Formalists and Formalists.

I select two of Wölfflin's observations. They read like throw-away observations, but they have been carefully studied. Both are about an odd element in the picture: the two boys who can be seen climbing up the column at the back of the Temple. The first observation goes from organization to subject-matter. Wölfflin observes how the boys' upward movement counterbalances the prone position of Heliodorus. 'The scales' he says, 'are tipped down on the one side and rise on the

[15] Heinrich Wölfflin, *Classic Art: An Introduction to the Italian Renaissance*, trans. Peter and Linda Murray (London: Phaidon Press, 1963), pp. 101–3.

other'. And this formal contrast, he goes on to say, gives 'real meaning' to the prostration of Heliodorus. He is not just down, but he will not get up the next moment. He is down for ever. Wölfflin's second observation picks out another function that the representation of the boys perform, also interrelating form and content. But this time the observation takes us, at least initially, from subject-matter to organization. The climbing motion of the boys, he points out, serves to lead the eye backward into the picture, towards the comparative void in the centre. If we missed this organizational element, we should also miss—and now we are being taken back from organization to subject-matter—the significance of the High Priest, who is, according to Wölfflin, the expressive heart of the work. 'The basic theme of imploring helplessness' Wölfflin tells us, 'is central in the composition.'

The second painting that I have chosen to illustrate the interweaving of subject-matter and organization, Terborch's *The Paternal Admonition* [Fig. 1.5], does so,

Fig. 1.5 Gerard ter Borch (II, Dutch, 1617–1681), *Gallant Conversation* (*The Paternal Admonition*), *c.*1654. Oil on canvas, 71 × 73 cm. Photo © Rijksmusem, Amsterdam (SK-A-404).

not, as with *The Expulsion of Heliodorus*, on the local, but on the global, level. For it shows how, when our overall view of the subject-matter of a painting changes, so too does our perception of its organization.

When Goethe introduced this painting into his great sombre novel, *Elective Affinities*, it figures there as one of three paintings that the flirtatious Luciana stages as a *tableau vivant* in order to while away the hours of boredom in her aunt's castle. As to its subject-matter, Goethe, and Luciana, he in the way he wrote her scenario, she in the way she enacted it, had no doubts whatsoever about its representational content. It depicted a modest young girl, approaching womanhood, about to be admonished for a minor fault by her noble, knightly-looking father, while her mother conceals her slight awkwardness behind her glass of wine. You can all see the scene, and you will allow the eye to divide up the picture accordingly. The girl, who has turned away to spare us her embarrassment, faces a tribunal of mother and father: the father more exigent, the mother more withdrawn, more hesitant. Modern scholarship disagrees with all this. It maintains that Goethe made an egregious mistake about what the picture represents, or what is to be seen in it. The scene is a brothel, the noble knight is an eager client, the awkward mother is the beady-eyed madame of the house, and with her back to us is an aspirant young whore who forces up the bidding for her favours. Accept this interpretation, and, with the change in the narrative that unfolds, there is a corresponding change in the pictorial organization. The client, now sandwiched between the two inhabitants of the brothel, is isolated against the dark ground. For the young girl, who still turns away from us, but no longer in modesty, or to mask from us the gentle expression that passes across her face, but now to conceal something that we do not wish to see, pairs off with the old woman who sits across from her. One is in effect the shrunken mirror image of the other. The young girl's present is the old woman's past, and the old woman's present is the young girl's future. The old woman averts her eyes from what she once was, the young woman will not allow us to see how much she recognizes what she will become.

<div align="center">9</div>

I turn now to the Principle of Normativity. On one level, this principle must be unobjectionable. It must be right to think that pictorial organization is a good thing, and a picture is better for being organized. It must be right to think that organization is something that an artist should pursue. And it cannot be altogether wrong to think that there are different ways of organizing a picture, and, though they all bring some value with them, some are more valuable than others.

However there are dangers connected with the Principle of Normativity, of which I wish to consider two. One is a misapprehension about the relationship of a painting to its organization. The other is a failure to recognize that, there are, not

merely different ways of organizing a painting—indeed every painting may be said to be differently organized --but there are different modes, or grades, of pictorial organization.

First, then, how a painting stands to its organization.

The danger I have in mind arises when, influenced by those familiar diagrams of great paintings which we find in manuals of art appreciation [...],[16] we start to think of the organization of a painting as something that can be separately identified, and that can somehow be bodily extricated from the physical context of the painting, and held up for public demonstration.

It is worth emphasizing that this transcendent way of understanding pictorial organization is not bound up with any one particular procedure for abstracting the organization of a picture from the picture. It is not, for instance, bound up with the procedure we considered earlier of placing a sheet of plane glass over the picture, and tracing the outlines of the forms on the glass. Indeed thinking about pictorial organization in an objectionable way does not require that we think of pictorial organization in terms of form. This point can be seen when we realize that the various diagrammatic representations of paintings that I have illustrated we have been looking at have been arrived through different operations. The first diagram—Degas's *New Orleans Cotton Exchange* [URL4]—was arrived by something equivalent to the Dürer gate: the second—Ingres's *La Source* [Fig. 1.6]—was arrived at by tracing—do not ask how—the movements of the eye as it wanders across the surface of the work: and the third—Crivelli's *Crucifixion* [Fig. 1.7]—is the product of some more intuitive method of capturing the dynamics of the work. We can see this when, in the last case, we substitute for the operation actually used the operation that has taken up so much of this lecture [...].[17]

Now, if it really were possible to gut in the way suggested the heart of a painting and capture it in a diagram, a remarkable conclusion would follow. That is that, if we were then to pair diagram and painting, the diagram would explain the interest, the value, of the painting. We would admire the painting because it is the fleshed-out diagram, and we would hold that the fleshing-out itself makes small contribution to the value of the painting.

If it is now said that there is no harm in thinking this, only so long as the diagram is complex enough, we are back on the same slippery slope that we tried to negotiate in connexion with form. For, short of absorbing into itself the totality of the picture, there is no point at which the diagram can be assured of claiming sufficiency for itself as an explanation of the interest that the painting holds for us.

And yet this conclusion of mine will seem excessively dismissive to some. For there will be those, even amongst the readers of this lecture, who will claim that

[16] Wollheim refers to seven examples, but we are unable to locate them. [Eds]
[17] Here Wollheim refers to the last of the seven examples. [Eds]

Fig. 1.6 Jean Auguste Dominique Ingres (French, 1780–1867), *La Source*, 1856. Oil on canvas, 163 × 80 cm. Photo ©RMN-Grand Palais (Musée d'Orsay, RF 219).

they learnt to appreciate paintings through a study of diagrams of just the sort that I have been suggesting are worthless. Are they deceiving themselves? I suggest an analogy.

We are, let us imagine, standing in a gallery in front of a painting that, for some reason or other, we have done too little to get to know. On either side of us are friends, friends who have worked harder at the painting than we have. They want to get us to see something that we haven't. Their hands move. Their fingers trace in the air arabesques, and diagonals, and rhyming shapes, sometimes following lines inscribed on the two-dimensional surface of the picture, sometimes jabbing into

Fig. 1.7 Carlo Crivelli (Italian, 1430–1495), *The Crucifixion*, 1482–92. Tempera on panel, 91.4 × 72.1 cm. Photo © Art Institute, Chicago (1929.862).

the third dimension as this is to be seen in the flat surface. All the while their fingers move only a trifle above the surface of the painting.

My suggestion then is that the diagram is the analogue to the moving fingers of our friends as they work for our benefit. If we accept this, then it would seem to

follow that the diagram has a use, just as the fingers have a use, only in combination with the picture. The picture is needed for the diagram to do something for us. The diagram in isolation is useful only if we are blessed with such powers of internal imagery that we can visualize the picture while we have only the diagram to look at, or we can visualize the diagram next time we see the picture.

I turn now to the second danger connected with the Principle of Normativity, and that is the failure to recognize that there are different modes, or grades, of pictorial organization. I believe that we can fruitfully distinguish three.

The lowest grade of pictorial organization is just that: it is a matter of finding a place for everything that the painter wants to introduce into the painting. It is a form of good housekeeping. In this respect, pictorial organization is inseparable from painting itself, every painter is necessarily an organizer in this mode, but it achieves prominence at either end of a certain spectrum. It achieves prominence within archaic or tribal, art, or art of a certain unworldliness, where the sense of orientation, or there being a right and a wrong way up, perhaps even the sense of there being a bounded surface, have not been established, and it achieves prominence again within an art, like northern Mannerism, of such extreme worldliness that it wishes at all costs not to place things in the most anticipated place. On this bottom grade, we think of paintings as organized or not, or possibly as more or less organized, but we have as yet no reason to think of them as well or ill organized.

It is only at the second grade of pictorial organization, which is incidentally that which we are likeliest to think of when we think about how paintings are organized, that thoughts of good organization versus bad organization arise. This is because pictorial organization is now undertaken for some value that it will secure for the painting. But what is distinctive, indeed definitive, of this second grade of organization is the kind of value that it aims at: it aims at what we might call an 'organizational value'. By this I mean that it aims at a value that can only be elucidated by reference to organization itself. Examples of such values would be order, harmony, symmetry, proportion, balance, tension of opposites. When any such value is intentionally realized, I say that the painting displays 'good' organization, where 'good' goes into inverted commas.

Pictorial organization of this second grade was the great achievement of the painting of Central Italy and the Netherlands in the century that included the last three quarters of the fifteenth century and the first quarter of the sixteenth century. Later ages have admired it immeasurably, but they have less often pursued it.

This second grade of pictorial organization is the locus of deep, but widely unrecognized, confusion. Consider once again Roger Fry. For Fry, having established to his satisfaction that the essence of a painting lies in the interrelations between the forms of which it is constituted, concludes, without recognizing that this is a further step to his argument, that it lies in the *harmonious* relations between the forms. In organizing his painting, the painter, Fry tells us, strives after

harmony. But two questions are thereby begged. The first is whether the painter pursues an organizational value: the second is which organizational value he pursues.

The final grade of pictorial organization is undertaken when the painter successfully arranges his painting so as to advance some further end, *and* this end is not one to be understood through the nature of organization itself: is some end internal to what the artist hopes to achieve in, or through, his painting. What is important to see is that, not merely do most of the most interesting paintings aim at this third grade of pictorial organization, but this grade can—*can*, I emphasize, nothing stronger—be realized without any concern for, and sometimes in defiance of, the second grade. A painting can be brilliantly organized for the fulfillment of the painter's own ends, which may themselves be highly pictorial, without cultivating, without even exhibiting, 'good' organization.

One thing to do at this moment would be to return to *Christ Carrying the Cross to Calvary* [Fig. 1.1], and to point out how, in all but submerging the Gospel story in the disorganized mellee of figures, Brueghel is organizing his painting in his own way to express his own sense of that common humanity, in which Christ, and Christ's followers, and Christ's tormentors, share in alike. In point of fact, one extremely interesting thing about Brueghel's arrangement of the elements is that, however much he relaxes the demands of spatial unity, he keeps a strong hold on the temporal unity of the picture as is to be observed in the way he binds together the successive parts of Christ's cortege as he deftly threads it through the mass of confused citizenry. But, to make my point, I turn instead to another great painting and another great Northern painter, both less well-known: *The Castle of Egmont* by Jacob Ruisdael [Fig. 1.8].

<div align="center">

10

</div>

Look at *The Castle of Egmont*, and you will see straight off two things about it. In the first place, you will receive the very powerful impression of an organized object. Ruisdael seems to have got the parts as he wanted them, and he seems to have put them together as he wanted to. But—and this is the second thing to be observed—the painting is just as surely without that form of organization which I am calling 'good' organization: its organization does not seem to realize an organizational value. On the contrary, *The Castle of Egmont* sits on the canvas in a peculiarly lopsided way. Those who are unconvinced—and great paintings that dispense with good organization persistently obfuscate this fact—might choose to draw a line down the middle of the canvas, and they will observe that everything that is of immediate interest, or that commands our attention, lies one side of that line. The great rose-red ruins of the castle, even more superb in decline, stand there, and, on the right side, there is minor detail. Once we recognize these

Fig. 1.8 Jacob van Ruisdael (Dutch, 1628/29–1682), *Landscape with the Ruins of the Castle of Egmont*, 1650–55. Oil on canvas, 98 × 130 cm. Photo © Art Institute, Chicago (1947.475).

two facts, we seem driven either to re-evaluate the painting or to use our eyes to see what might justify the grave asymmetry.

So the eye goes searching in the right hand part of the picture to find something that, without rectifying the imbalance, will somehow make up for it. If the eye resists initial discouragement, and persists, what it will unearth is a small jewelled scene consisting of a timbered cottage, sheep, a shepherd, flowers, and a pool whose surface is patterned with dark mysterious reflections. The scene has a completeness and a lack of drama that painting learnt from Giorgione. Does this hold its own with the castle and its stormy setting? In organizational terms, is the asymmetry justified?

Clearly Ruisdael thought so, and whether the spectator also does depends, I should say, on whether or not he can accept the revelation that small things can be as interesting as big things, and that uninteresting things can be as poignant as interesting things. It depends on whether things that the spectator finds out, or, more precisely, can have the sense that he has found out, for himself can have the same weight as things to which his attention has been directed.

To make my point, I bring forward another painting that hangs in the obscurity of a nearby room in the same museum, and which, when I first saw it, made me

Fig. 1.9 Antonio Mancini (Italian, 1852–1930), *Resting*, 1882–92. Oil on canvas, 60.9 × 100 cm. Photo © Art Institute, Chicago (1962.960).

think back to *The Castle of Egmont*. It too is organized with scant concern for 'good' organization. It has the same lopsided arrangement as *The Castle of Egmont*. But this second painting, which is called *Antonia Resting* [Fig. 1.9], and is by the bravura painter, Antonio Mancini, doesn't 'work'. But the reason for its not working is not that it lacks 'good' organization. It doesn't work, I should say, because the rationale of its 'bad' organization, of its lopsidedness, betrays a coarseness,[18] a banality, of mind.

Unlike Ruisdael, Mancini does nothing to encourage the eye to move into the right-hand side of his painting. On the contrary, he would as soon that it remained under the spell of Antonia's body, which dominates the left-hand side of the picture. If the spell is momentarily broken, and the eye wanders to the right, Mancini has seen to it that it will go visually unrewarded, and will be forced to return to its starting-point. In other words, Mancini is fully prepared to waste one half of his canvas, loading it with triviality, in order to ensure that the other half retains its relentless pull. Surely a highly talented artist, which Mancini was, could have found a more telling way of celebrating the engrossing power of sexuality than by showing it triumphant over boredom. Does not the erotic deserve to be matched against a worthier rival?

[18] Example of a tiny change over the Lindley—'coarseness' introduced, 'a certain' excised. [Eds]

11

But this is not to say that Ruisdael's way of organizing his painting does not also raise questions. It does. I have said that, if we let our eyes loose on the canvas, they will start to probe into the right-hand side, and, when they do, they will come up with things that we would otherwise never have noticed. But, after all, whatever the eye finds are all things that Ruisdael put there, so would it not have been better if Ruisdael had used a more orderly form of organization, and allowed the particularities of this dark, northern idyll to be discovered without any painstaking exploration of the picture?

To answer the question, we are brought back, as we always are when the picture is organized in any way that departs from good organization, to the artist's ends in so far as these go beyond formal organization. The answer in this particular case lies, I suggest, in whatever value there is in rewarding only the eye whose curiosity has been aroused. In this way, Ruisdael puts the spectator's eye, the eye that receives and takes in, on a par with the artist's eye, the eye that discovers and arranges. Ruisdael arranges the countryside to celebrate the very virtue for the cultivation of which a more teleologically minded age might very well have thought God had invented the landscape: visual curiosity, visual devotion.

Lecture II

1

I began my first lecture by saying that paintings are organized objects. To say of a painting that it is organized means that the artist had some kind of reason for combining its elements in the way he did. It goes without saying that we shall be able to reconstruct these reasons only if we segment the painting along the same broad lines as the artist did: a matter on which Formalists are more carefree than we might expect them to be. The notorious 'black ring', discussed in the last lecture [Fig. 1.1], was a discrete constituent for Fry, but was it also so for Breughel, or would it have struck him as an artificial abstraction out of the manifold of human activity and passivity that he patterned over the painting?

Towards the end of the lecture I said that paintings do not always aim at 'good' organization, and this I tried to explain by pointing out that there are different kinds of organization that a painter might seek for his painting, of which 'good' organization is only one. More precisely, there are different levels on which organization can be attempted, and we can helpfully identify three.

At the bottom level, organization reflects the painter's basic concern to get everything in. In the earliest works known to us, getting everything into the picture is a

matter of getting everything onto its surface, no matter the result. Ordering the elements in relation to one another takes second place to leaving nothing out. At this stage the surface of the picture will be bounded, but less as a matter of design, more as a reflexion of scarce resources. When the surface acquires bounds as a matter of design, and then to the bounded surface there attaches a right and a wrong way up, the activity becomes less improvisatory, and it remains so, until, at a much later and more self-conscious stage, experimentation with the format of the picture encourages deliberate regression, so that, for instance, the northern Mannerist artist allows elements of the picture to break out of its frame, or he relegates the principle subject-matter to the background, and allows something trivial to usurp the foreground.

On the next level, pictorial organization consists in arranging the elements of the picture so as to realize a particular kind of value, for which there is no room on the bottom level. This kind of value can be explained only through the very notion of organization. It is this that I call 'good' organization, and examples of the values that 'good' organization pursues would be harmony, symmetry, balance, tension. Something that those who stress the all-importance of these values to painting often overlook is that they are not all the same value, and that cultivation of one can interfere, or conflict, with the cultivation of another.

Pictorial organization of this second grade was the great achievement of the painting of Central Italy and the Netherlands of the central decades of the fifteenth century, and it was perfected in the early years of the next century. Later ages have admired it immeasurably, but they have less often pursued it.

Conflict of values is more apparent when we move to the third level of organization. Now the painter arranges his elements so as to realize some ends, some non-organizational ends, of his own, and, not only might these ends of his own conflict with one another, as happens on the second level, but conflict can break out between them and the values of 'good' organization. A painter, following his own leads, might feel it necessary, not just to disregard, but to defy, the demands of 'good' organization.

In this lecture, I want to consider three painters who pursued organization on this third level and in ways that brought them into conflict with 'good' organization, and then a fourth painter who, an acknowledged master of 'good' organization, is misunderstood unless we recognize how, for him, this kind of organization was valuable in large part because it could be made to serve his personal ends and purposes.

The Landscape with Ruins of the Castle of Egmond is not an isolated work in the oeuvre of Jakob Ruisdael (1628/29–1682) [Fig. 1.8], nor, if I had thought that it was, would I have felt entitled to use it as an example of how a given painter organized a painting of his, as opposed to a way in which a painting of his happened to look.

The truth is that, not only is there is a group of other works by Ruisdael that have enough in common with *The Castle of Egmont* to make it seem that the way that painting looks is not the product of coincidence, but these works can make a good claim to constitute the core of Ruisdael's oeuvre. And this should give us hope that, once we have brought this body of work into focus, we can find a more informative description of how they are organized, and then a deeper sense of the end or ends that this serves, than merely saying that they reject 'good' organization.

But, first, how are we to identify these core paintings without making use of what Ruisdael endeavoured to achieve in them? There are, I believe, certain broad properties that they have in common. Physically they are all large paintings: most of those which I shall concentrate on are paintings over 120 cm in width. They are horizontal in format. In subject matter, they are dedicated to the Dutch landscape, real or adjusted, and to the vast sky that crowns it. They are full of complex detail: trees, plants, and clouds are depicted with a remarkable knowledge of natural history. Expressively they are strong, and, for the most part, they convey a mood that ranges from a light, lingering melancholy to the sombre. They are touched by life's transience, though this is only in rare cases something that they symbolize. Finally, as well as being physically big, they are conceived of and executed on an ambitious scale. Each work has a very distinctive physiognomy, and, in this respect, Ruisdael differs from his contemporaries Jan van Goyen, Phillips de Koninck, and Aelbert Cuyp.

If, by this definition, distinct areas of Ruisdael's work are excluded, this does not imply an adverse judgment on these other works. Some of the small paintings are minor works, but just as definitely some are not: the late paintings of Haarlem, for instance, are works of immense delicacy and grace, and in these respects are without direct rivals in Ruisdael's oeuvre. However, when working on a small scale, or, for that matter, when working with a vertical format, Ruisdael was presented with different challenges, and, as far as these challenges are concerned, the bold solutions that he devised for the core works would not have been appropriate. This, I hope, will emerge. As to the exclusion of certain paintings from the core on thematic grounds, that is a matter complicated by the fact that the division of Ruisdael's work by subject-matter can be effected in various ways. Wolfgang Stechow's taxonomy, which is fairly closely followed by Seymour Slive in his magisterial *catalogue raisonnée*, is at once over-complex and does not always cut the work at the joints. The seascapes and the winter scenes exemplify real categories, and I believe that, for all their virtuosity, they are ultimately untouched by Ruisdael's deeper sense of richness and grandeur. The same goes for the strictly 'Scandinavian' waterfalls with their conifers and high mountains, and mostly vertical format. However there are other waterfall paintings, which do not have northern vegetation, and which may relate to actual experience, and to which Ruisdael has given a horizontal format, and some of these I would certainly include amongst the core works.

In fixing Ruisdael's core works, I do not attach the usual significance to what is often regarded as a key consideration: that is, chronological limits. There are reasons for this.

In the first place, Ruisdael barely had a period of immaturity. The year 1646, when he was seventeen, or eighteen at most, is the date of his earliest surviving work, and of the nine paintings that are signed and dated that year, at least five of them, of which the two called *Dune Landscape* [URL5; The Hermitage Museum, St. Petersburg] and *Landscape with a Cottage and Trees* [URL6; Kunsthalle, Hamburg] are the most accomplished, exhibit in a fully operative form what I shall shortly propose as the basic layout for his adult compositions. Furthermore Ruisdael showed himself capable of working with a larger format from the very beginning. The Hermitage *Dune Landscape* is 105.5cm × 163cm, and thus of a size that Ruisdael seldom exceeded, and from 1649 we have the *Banks of a River* [URL7; Torrie collection, University of Edinburgh, Edinburgh] which, measuring 134cm × 193cm, is the second largest painting he attempted.

Secondly, though we do not know exactly know when Ruisdael laid down his brush, there is reason to think that he went on producing what I think of as core paintings up till the mid-1680s.

Nevertheless I shall, in identifying the work that I shall discuss, respect some temporal considerations. Despite the accomplishment of the early work, I shall in effect treat 1650 as the threshold for Ruisdael's core work, but only because, after this date, the complex layout and the larger format seem to come somewhat more naturally. Furthermore there are certain late paintings, undoubted masterpieces, though they never monopolize Ruisdael's attention, which, for opposite reasons, or because of the vastness on which they were conceived, fall out of the core. In these works the wealth and detail of Nature, to which Ruisdael up till then had been so evidently committed, are now dwarfed in the interest of a greater sublimity, and Ruisdael controls our perception of the work, not through organizational complexity, but through an overall aura. Paintings that fall into this category include *The Three Great Trees in a Mountainous Landscape* [Norton Simon Museum, Pasadena; URL8] and *River Landscape with a Castle on a High Cliff* [Cincinnati Art Museum, Cincinnati; URL9], the two landscapes with cloud-covered peaks [The Old Town House, Cape Town, and The Hermitage Museum, St Petersburg; URL10], and the famous *Le Coup de Soleil* [Louvre, Paris; Fig. 1.10], with its evocation of Hercules Seghers.

With the core compositions thus identified, we are able to see that two broad principles account for the way they were put together. The first principle accounts for the work's microstructure, or the finer arrangement of its parts, and the second principle accounts for the macrostructure of the work, or the overall mode in which it is organized. The two principles work together, though not obviously so.

The first principle is something that, once it was adopted, Ruisdael never abandoned until the very late pictures. It is all but pervasive, being found in paintings,

Fig. 1.10 Jacob van Ruisdael (Dutch, 1628/29–1682), *Le Coup de Soleil*, 1660–70. Oil on canvas, 83 × 126 cm. Photo © Louvre, Paris (France), Inv. No. 1820.

major and minor, large-scale and small-scale, vertical and horizontal, and in some in, some out of, the canon. It is irrelevant to marine paintings and to winter scenes.

When a landscape painter paints on anything except a small scale, it is inevitable that he will distribute across his canvas recurrent elements of a few distinctive kinds. Each kind of element has its own characteristic configuration, and will correspond to one or other of the more familiar items that make up the countryside, and which we can see in it. The elements represent fields, woods, lakes, sand-dunes. What most landscape painters of the tradition will then attempt is to construct some hierarchical order under which these elements can be subsumed, smaller elements being contained within larger elements until ultimately a place exists for everything. This is what we find in the Central Italian painters of the Quattrocento, when they placed a carefully cultivated landscape behind a portrait, or in Ruisdael's contemporary, Koninck, when he unfolded before our eyes a vast rambling countryside of embankments, and elevated paths, and copses, and fingers of water, and the eye is carried out ever further until it ultimately reaches the far horizon, or in a later painter who owed much to Ruisdael, John

Constable, and who tried to render the English countryside in some part after the Dutch painters.

Not so Ruisdael. Ruisdael engenders a different approach. For what he does is to leave the constituent elements more or less as they are, lying side by side, un-adjusted, and then to go on to solve the problem in a piecemeal way: that is to say, for each pair of adjacent elements, he produces what seems like its own effect of balance. And, to achieve this effect, he first draws our attention to small particles with which he 'spots' the elements of the pictures. These particles also have, it hardly needs to be said, a representational function; they represent parts of what the constituents represent: they represent trees, or the flowers on bushes, or small cottages, or lines of flax, or what was evidently Ruisdael's favourite kind of agricultural detail, corn-sheaves. He then gets us to experience a proportionality between the particles that mark adjacent elements. And the word 'experience' here is all-important: for, of course, in no case has Ruisdael employed a mathematical ratio, which, holding between, say, the corn-sheaves in neighbouring fields, will harmonize them, and bestow order on the picture. We have the sense of proportionality, but no further fact of proportion.

I call this principle 'juxtaposition', and the additive way of putting a painting together that it underwrites has several consequences. One is that the spectator, instead of settling down to admire a well-constructed pattern, is kept in a state of suspense. Ruisdael is a master of rhythm, but the rhythm that he establishes is not one that the eye takes in, it is something that the eye creates through its restlessness. Secondly, any attempt that the eye might make to overlook detail, or to abstract from the figurative mass, in order to arrive at 'good' organization, is doomed to failure if the whole is to be grasped. Two masterpieces of this first mode of organization, coming from different phases of Ruisdael's development are [picture unknown] and *A Landscape with a Ruined Castle and a Church* [National Gallery, London; URL11].

The second organizational principle that Ruisdael uses, now to establish the macrostructure of the painting, I call that of 'multiple entry'. Essential to it is the way that Ruisdael provides the spectator with more than one route into the picture. And, in talking of the spectator's entry into the picture, I am referring to two different things. I am referring to the way in which the eye of the spectator who stands in front of the canvas, and whom we may call the external spectator, is led to see what it can in the pictorial surface, and I am also referring to the way in which a figure inhabiting the space of the picture, where he has been placed by the artist, will be imagined by the external spectator to move into and through the depicted scene, also in accord with the wishes of the artist: I call this figure space an internal spectator. And, in both cases, I am talking, not just of mere possibilities that the picture opens up for the spectator, but of a pressure exerted upon him by the picture to take up one or more of these possibilities, or, more likely, to take up, now

Fig. 1.11 Jacob van Ruisdael (Dutch, 1628/29–1682), *The Great Oak*, 1652. Oil on canvas, 86 × 106 cm. Photo © Los Angeles County Museum of Art (M. 91. 164. 1).

one, now another. Multiple entry into the picture is a device used by Ruisdael for the greater control of the spectator.

The simplest, or the most direct, example of multiple entry, which, as I have hinted, is already employed in some of Ruisdael's very earliest work, is provided by the great summery landscape of 1652 known as *The Great Oak* [Los Angeles County Museum, Los Angeles; Fig. 1.11]. Starting from the middle of the bottom edge of the picture, a broad sandy path winds its way ahead into a copse, and by following this path we effect our initial entry into the pictorial scene. But not very far into the scene, under the tutelary presence of the great oak itself, one path branches off to the right into the thickness of the wood while another peels off to the left, and, curling past a broken tree trunk, leads out into an open field. The far side of the oak the path continues in its original direction along the edge of the wood.

A picture exhibiting only one degree higher of complexity, but for Ruisdael a very significant degree, is the *Hilly and Wooded Landscape with a Falconer and Horseman* [ex-Wertitsch coll., Vienna; URL12] of the mid-1650s. Indeed in another respect the picture is less complex than *The Great Oak*: for, instead of the four-way intersection of paths, there is a mere forking of the ways. However, as

the title of the picture indicates, Ruisdael's predilection for hilly countryside, scarcely nourished by observation of the Dutch landscape, and often traced to his travels through the Rhineland and Westphalia in the early 1650s in the company of Nicolas Berchem, is fully indulged, so that the kind of groundplan that the picture calls for has now been eased up from the forest flat and is draped over a steep hillside. But the painting is no less insistent in the demands it makes on the spectator.

I now propose that we look at a much more complex painting dating from the early 1660s, and one which most likely had a special place in Ruisdael's affections on account of the way he has used it as a repository of a number of his favourite objects: the dead tree, the rotting footbridge, the noble farm structures, the rushing water, the fallen beeches. This is the *House and Bridge in a Hilly Wooded River Landscape* (Musée Royale des Beaux-Arts, Brussels) [Fig. 1.12], and, if we initially confine our attention to the right-hand side, we see something with very much the structure of the ex-Wertitsch painting. A path enters the depicted scene from, it is true, far over to the left-hand side, to which our gaze must momentarily shift. It then passes over a footbridge, and, shortly afterwards it breaks into two: the left-hand branch moves on in shadow until it winds round the darkened profile of a cliff and disappears, while the right-hand branch swings out to the very edge of the

Fig. 1.12 Jacob van Ruisdael (Dutch, 1628/29–1682), *Landscape with River* (*House and Bridge in a Hilly Wooded River Landscape*), *c*.1650. Oil on canvas, 135 × 179 cm. Photo © Musée Royale des Beaux-Arts, Brussels (Inv. No. 1177).

picture, and then winds its way up into a high wood of oak trees, where sheep and goats graze. The trunks of the oak trees are patterned against the sky in a manner to which we shall have to return when we consider Ruisdael's wooded landscape. As if to recall the spectator who has lost his way, nature has set up in the foreground a primitive signpost, made up of two detached trunks of beech trees, evidently the victims of beech snap disease, which indicates the two possible ways ahead. The left-hand tree points to the right, the right-hand tree points to the left, and both seem endowed with the full authority of nature. That is what we see so long as we continue as best we can to ignore the left-hand side of the painting, for which we need further preparation.

Already in the 1640s, Ruisdael had been employing variations upon the basic scheme of multiple entry. In *The Great Oak*, and the *Hilly and Wooded Landscape,* the branching of the ways occurs at a point in that part of the pictorial space which is fully visible to us, but this did not have to be so. The point at which the branching occurs has to be within the represented space, but it does not have to be in that part of it which the painter has represented: it can occur in that part of it which lies this side, the external spectator's, side of the picture plane. In such cases, the spectator is, even before he starts to take in the picture as a whole, forced to choose between different ways into it: there is no initially neutral way. And this was no late discovery on Ruisdael's part. If we compare in this respect two paintings of 1646 already considered, the St Petersburg and the Hamburg paintings, we notice a difference. For in the former painting there is a parting of the ways some brief distance into the picture, but in the latter painting the two paths have already separated before they emerge into sight at the lower edge of the picture.

In paintings of the second sort, or where the paths into the depicted scene diverge before they reach the picture plane, a further variation becomes a possibility. The artist can tier the different routes into the picture so that access into the depicted scene is not just multiple, it is layered. Early examples of this way of composing a painting are *Dune Landscape in Evening Light with a Man Driving an Ass* (Museum der Bildenden Kunste, Leipzig; URL13), and *Dune Landscape with a Steep Winding Path* (Alte Pinakothek, Munich; URL14), both of 1647, and, of probably a year later, though undated, *Le Buisson* (The Louvre, Paris; URL15). In all three cases, there is a high road into the landscape, and there is a low road.[19]

This device seems to have exerted a great appeal over Ruisdael, and, if there were a number of earlier landscape painters, centred round Paulus Brill and Jan Breughel, who anticipated Ruisdael in that schematically they used the same manner of composition, and their work was certainly familiar to Ruisdael either in the original or in graphic reproduction, the striking difference is that he put the common devices to very much his own uses. Of these uses the most significant is

[19] Here Wollheim refers to Théophile Thoré-Berger, *Le Salon de 1844: Précédé d'une Lettre à Théodore Rousseau*; but his purpose in doing so is unknown. [Eds]

that he employs the device to impose further constraints upon the external spectator, to bring additional pressure to bear upon how the spectator takes in the picture.

The most spectacular early example of layered entry into the depicted scene is a painting, which fails one of the conditions that I have specified as essential to a core work. It is small, measuring a mere 39.5 × 52.1cm. when restored to its original dimensions. Nevertheless it swells up under our eyes, which has much to do with the crisp, feathery paint-surface that was clearly aided by working on panel, and which has come down to us in a miraculous state of preservation. This is the iridescent *Bridge with a Sluice* (J. Paul Getty Museum, Los Angeles) [Fig. 1.13], dating almost certainly from 1647. So powerful is the combination of (one) a bifurcation of entry starting outside the represented part of the represented scene and then (two) the layering of the two paths thus opened up into the picture that, standing in front of it, we can easily find ourselves doing what I have suggested that we might make a deliberate effort to carry off in the case of the Brussels painting: that is to say, we can momentarily overlook part of the picture. In the case of the *Bridge with a Sluice*, so dominant is the steep climb up to the sluice gate itself, that we can initially look at the picture without even noticing that it has a right-hand section. We can, that is,

Fig. 1.13 Jacob van Ruisdael (Dutch, 1628/29–1682), *Bridge with a Sluice*, c.1648–9. Oil on panel, 39.7 × 56.2 cm (unframed). Photo © Paul Getty Museum, Los Angeles (86.PB.597).

fail to take in the lower-level entry into the picture that is there effected along the small, fast-flowing stream and the adjacent water-meadow with its complement of sheep and—something of a rarity in Ruisdael—cast shadow. There are enough resources that Ruisdael deploys in order to sustain this abduction of our attention that it is hard not to believe that we are dealing with an effect that is intended at some level of consciousness. That the right-hand side of the picture fails to gain our preliminary attention is chiefly due to the combination of a low vantage-point and the steep view that this gives us up the sandy hillock to the sluice-gate, which crowns it. But there are other resources that Ruisdael introduces of which the most potent is the refined play upon the textures of nature: the contrast between scrub and vegetation, brick and weathered wood, and, persistent in Ruisdael, the affinity between sand and water. We also find something which comes to the fore in later work: that is, the sharp silhouetting of the trees against the blue of the sky, which then in turn shines at its most intense through apertures in the upper foliage.

I now return to the Brussels painting, in order to take in the hitherto neglected left-hand side of the painting, the role of which I believe we are now in a better position to grasp. For the river valley, which dominates the left-hand side of the painting, not only provides an access to the represented scene which is alternate to the footpath, but they come into the picture from quite different directions, and they remain at quite different levels. The river, after passing under the foot-bridge, swings to the left, and then slowly bends backwards into the centre of the picture, all the while keeping well below either branch of the footpath. However a rapid comparison with the *Bridge with a Sluice* reveals that the size upon which the Brussels painting is conceived and executed means that the presence of a secondary route into the picture does more than merely destabilize the view we take of the total depicted scene, as we might say of the stream in the *Bridge with a Sluice*. In the larger painting what the river does is that it splits the depicted scene in two, and it does this by introducing, in a way worthy of Poussin, a new landscape, a further landscape, what I have called 'a landscape beyond the landscape', which, though remaining subsidiary to, nevertheless competes in human interest with, the landscape that gains our initial attention. On the far bank of the river, there is a broad expanse of grass, in brilliant sunshine, and thus the object of strongest illumination. At the far edge of the grass is a low outcrop of rock, on which there stands an ancient and generously constructed farmhouse with its outbuildings.

The Brussels painting reveals one consequence of the devices we have been considering, which is unlikely to have been something fully intended by the artist, though it looks as though it was something that he exploited. When the lower-level entry into the picture occurs at the bottom of the picture, and is deeply depressed, what is likely to occur is that the lower edge of the picture will, for some part of its length, fail to coincide with the frontal face of the depicted space. For where the frame passes over the path or stream that carries us into the picture, the eye will find itself looking, not just down, but also forward, into the represented world. We

find this effect as early on as in *The Sluice Gate,* and then over and over again in such works as [picture unknown].

I have talked thus far, in talking of the ways in which Ruisdael complicates the structure of his work, made no substantial reference to the paint surface. I now want to turn to two paintings where his stratagems cannot be separated from the fact that we are looking at painted, and not simply drawn, objects. They are the *Landscape with a Footbridge* [Frick Collection, New York; URL16], and *The Castle of Egmond* [Fig. 1.8].

The Landscape with a Footbridge rivals in its richness of paint surface the Getty *Bridge with a Sluice*, and in its complexity of construction it is more than the equal of the *House and Bridge in a Hilly Wooded River Landscape.* What is immediately apparent in this picture is that Ruisdael, having divided the picture into two, with the dislodged plank on the footbridge marking a point through which the bisecting line passes, then gives predominance to the left-hand side. He does this by the strong lighting that he brings to bear upon the sandy path, and by the emphasis upon the muscular oak-tree with its roots exposed to the air, and then by the way he turns the path so that it disappears round the cliff-face into the darkness of the wood. The broad sandy path is strongly illuminated, indeed the ochre of the path and the tall bank through which it has been cut is the strongest element in the picture, and it ascends sharply from the bottom edge of the painting before turning to the left, bends round the sharp profile of the cliff face, and then heading into the dark green tunnel formed by over-arching branches of the giant silver birch with its great root pulling out of the thin earth cover, which, pushed up against the left-hand edge of the picture, is the single most articulated object. A figure, barely visible, runs along it as if to escape from the depicted scene.

But, in the depositing of the tones, Ruisdael ensures that, not only is priority given to the left-hand side of the picture, but, within the left-hand side of the picture, it is its left-hand side that is privileged, and he then repeats the same weighting within the far more elusive right-hand side of the picture. The distant path on the far side of the river alone attracts our attention, although it is to be noted that this is somewhat compensated for by the way the right-hand side moves so far forwards. Ruisdael has given to the frontal face of the scene a wave-like façade.

In considering the macrostructure of Ruisdael's paintings, I have continuously referred to the way he directs, or controls, the spectator's viewing of the picture. But with what right have I said this? That Ruisdael represents a path entering a wood does not in itself mean that our eye has to follow that path. I completely agree: indeed recognition of that point is central to my case. For my case is that it is in virtue of a special effect, a special visual effect, that Ruisdael has at his disposal that he makes the various depicted routes into his pictures perform these dual roles: they are at once routes across the landscape, and directions that the eye follows. And, to get this point, it is useful to contrast Ruisdael's paintings with those of his student, Meindert Hobbema. For Hobbema too often represents a multiplicity

of paths or roads that wind in and out of the large feathery trees with which, rather like someone arranging flowers on a table, he decorates his landscapes. But there is no concomitant imperative lying upon the spectator to utilise these paths or roads as visual ways into the picture.

The last paintings that I want to consider are three sets of paintings, which are not altogether independent one of another, and which also show how flexible was the mold in which Ruisdael cast this work.

The first is a very impressive series of large-scale woodland scenes, some of which include an extensive stretch of water, and some of which don't. I shall concentrate on two paintings. One is a painting of the mid-1650s, the *Edge of Forest with a Grainfield* [Worcester College, Oxford; URL17] and *The Great Wood* [Kunsthistorisches Museum, Vienna; URL18]. The second is a smaller group, in which Ruisdael combines the theme of the wood and that of the waterfall. The two masterpieces in this category are *Waterfall in a Hilly Wooded Landscape* (National Gallery of Art, Washington, D.C.) [Fig. 1.14] of the very late 1650s or the early

Fig. 1.14 Jacob van Ruisdael (Dutch, 1628/29–1682), *Landscape*, c.1670. Oil on canvas, 53.2 × 60 cm. Photo © National Gallery of Art, Washington (1961.9.85).

1660s, and *Waterfall near an Oak Wood* (Rijksmuseum, Amsterdam) [Fig. 1.15] of 1665.

In both these groups of paintings, Ruisdael shows some flexibility in organizing at once the microstructure and the macrostucture of the picture, and in ways that immediately reflect the change in subject-matter, but they do not call into question what we now think of as his underlying aim.

As to microstructure, the distinction that I introduced through the clumsy terminology of 'element' and 'particle' is now brushed aside, and instead Ruisdael operates on a single unit, which is to be identified representationally. The unit is the tree trunk, which we have already observed Ruisdael experimenting with in the high oak wood in the Brussels painting. But there is no difference in the overall way in which Ruisdael achieves juxtaposition, in that it is as though Ruisdael had worked out a relation that holds between the serpentine shape of each tree trunk and that of the adjacent trunk. Of course there is in fact no such relation, but the eye is at once tantalized and ultimately satisfied by trying to compute the relation and not being able to, and remaining secure in the thought that there is an answer to what it is.

As to the macrostructure Ruisdael preserves the bare outlines of multiple entry, though without the compelling quality that we have observed in other paintings.

Fig. 1.15 Jacob van Ruisdael (Dutch, 1628/29–1682), *Landscape with Waterfall,* *c.*1668. Oil on canvas, 142.5 × 196 cm. Photo © Rijksmuseum, Amsterdam (SK-C-210).

However Ruisdael now introduces another dilemma in how we are to distribute our visual attention, which is the functional equivalent of the pull between the different paths into the picture. For he sets up a rivalry between light in the foreground and light in the background, between the light as it falls on the sandy shoals this side of the wood and light as it sparkles through the apertures between the trees against the distant sky.

It is now time to break off this consideration of individual paintings, and to see if we are in any reasonable position to suggest what I have said that we need: a characterization of what Ruisdael is attempting in the core pictures thus far looked at, that goes beyond saying that he was rejecting 'good' organization, while fully respecting that this is what he was thereby doing. My suggestion is that what we can say that a central concern of Ruisdael's was to construct his paintings that the eye would have real difficulty in encompassing them all at once. We can see how both the juxtaposition and multiple entry with its variations operate to this effect.

And, if we speculate why Ruisdael would have had an interest in producing such an effect, the answer can lie only in his desire to convey the overwhelming splendour and diversity of the divinely created world. The connexion between landscape painting and the celebration of creation is a commonplace of such theoretical writing as we find in Ruisdael's Holland. However in the writings of the two theorists who flank Ruisdael—van Mander in the early seventeenth century and Houbraken in the early eighteenth century—it is assumed that celebration of the divine handiwork will go hand-in-hand with the projection of a sense of order and of lucidity. Obviously Ruisdael, on some level of explicitness, felt otherwise. The greatness of the Divine Creation is partly registered in the fact that it ultimately resists being taken in at a single glance. If this amounts, as it certainly does, to a defiance of 'good' organization, it is defiance of one kind of organization in the interests of an end around which Ruisdael organized a body of work of great complexity.

<div align="center">3</div>

I turn next to another painter who also disregarded good organization, and it may well be that the distance that he put between himself and it may be greater than that which Ruisdael engineered for himself.[20] This second painter is Claude-Oscar Monet,[21] and specifically I want to consider the work he did after he had renounced the ambition to be 'the painter of modern life', and had devoted himself wholeheartedly to the study of Nature, and, more specifically, when this took the

[20] There is no indication in Wollheim's original text where section 2 was meant to be, or whether this ought to have been section 2 rather than 3. [Eds]

[21] He meant of course "Oscar-Claude Monet"; a slip. [Eds]

form of a series of paintings based on the theme. I shall take this to have occurred around the beginning of the 1880s, but most of the work I want to look at in detail is between 1888 and 1905. So vast is even this material that I shall confine myself to three or four of the series […]

Monet's eschewal of good organization has various sources, but it is rooted in something of which no-one could conceivably accuse Ruisdael: a refusal to interfere with the course of Nature. Ruisdael corrected Nature indefatigably. He planted on the pancake-like countryside of Holland rocky hills, and deep ravines, and rushing waterfalls. We have only to consider the liberties that he took with the Castle of Bentheim, or those which we have already considered in connexion with the mill and sluice at Swingen: certainly the *Castle of Egmont* is set in a countryside of a kind that those who lived there could scarcely have envisaged. By contrast, Monet was something of a conscientious objector in the matter of 'composing' the subject-matter of his […] paintings. Though it is absurd to think of Monet as an artless painter, parts of Nature that were awkward, or ungainly, or excessively conspicuous, pass intact into his work, and are then organized in distinctive ways that are singularly free of organizational values.

I begin with one of the earliest, and briefest, of the series that occupied the last forty years of his working life. It is made up basically of three paintings, and they are called 'Oatfields' ['Poppy Fields—eds; Fig. 1.16]. They were painted in high summer, and they depict the same scene, and from more or less the same point of

Fig. 1.16 Claude Monet (French, 1840–1926), *Poppy Field (Giverny)*, 1890–91. Oil on canvas, 61.2 × 93.4 cm. Photo © Art Institute, Chicago (1922.4465).

view. The foreground is occupied by a large field of oats, scattered with poppies, at the far edge of which, parallel to the picture plane, is a hedge of bushes, punctuated by a few trees. Through a wide gap in the hedge we see a field beyond, and then beyond that an escarpment is tinged with the blue of the distance. Just left of centre in the line of the hedgerow, there is a tree, a poplar, remarkable for its height (it towers over its neighbours), and remarkable for its shape (it has an odd, corkscrew-like twist to it), and prominent in its position. Other painters would, in their different ways, have employed some device to make the tree surrender its strange shape, or blend with it into the landscape. It would have been remodeled, or composed out of existence. Consider, for instance, what Cézanne did when he found himself in a related situation, with the large pine that he encountered near the Chateau Noir: he embedded it in a larger conglomerate [URL19].

However for Monet such manipulation of Nature was not an acceptable tactic. Nevertheless, as we stand in front of this painting, the tree's bulk—and I speak, not of the amount of canvas occupied, but of a visual effect, which may very well not be preserved in reproduction—loses its saliency. The group of pictures are wonderfully undominated wholes. They possess an integrity, an all-overness, that is so satisfying that we might forget to ask our eyes how it comes about, and, in this way, we could fail to note one of the most interesting aspects of Monet's art.

What then did Monet do, in this painting, and in a host of others, that present us with similar achievements?

Monet works upon us from two different directions. On the one hand, he convinces us, as we look at the unadjusted scene, regarding it from the outside as it were, that nothing about it could be altered: it is inevitable. At the same time, he endeavours to precipitate us into the scene so there should be no stable point of view from which its awkwardness can be observed and found wanting. Somewhat artificially, but the artifice is none the less useful for that, we can, I believe, assign to each of these two ends a corresponding means.

In trying to give a sense of the inevitability of the scene, Monet relied most heavily on what he called the *enveloppe*, which became increasingly a topic of his art, to which everything was subordinated. The *enveloppe* was the overall light that fell upon the scene, as it inundated it at one particular time of the day: it remained intact just so long as there was no observable change in the illumination. When Monet first started to concentrate on this effect, he envisaged it as lasting for half an hour, but, by the time he came to work seriously on the series that preoccupied him in the 1880s, the 1890s, and the first half of the first decade of the twentieth century, or until the Giverny garden became his world, he had reduced the period of time that he sought to capture to seven minutes, and in 1916, he spoke of an effect as lasting 'sometimes three or four minutes at the most'. The *enveloppe*, in Monet's work, is just that. It is something not to be broken open, and, so long as its integrity is preserved, so the question will not be raised whether the painting is as it should be, or whether this element should be enlarged, or that element should have been

cut down to size. If the Rouen Cathedral series makes the most self-conscious use of the *enveloppe*, it is in the paintings that seek to record unadjusted nature that its employment is most apt.

To implicate the spectator in the pictorial scene, Monet made use of a combination of different devices. I shall enumerate three, all of which come to the fore in what we can regard as the great period of Monet's creativity, beginning in the late 1880s. Exactly how these devices do for the spectator what I claim they do is not something that can be explained: it can only be grasped in front of the painting.

In the first place, there is the direction from which the scene is lit. In this matter, there is a certain amount of variety in Monet's work, but there is a normal, though not a universal, way in which the light falls. The basic preference is for backlighting, or a *contre-jour* effect. The sun is placed at the back of the painting, and the objects are illuminated from behind, though not necessarily from immediately behind. Ten o'clock, eleven o'clock, one o'clock, two o'clock, are all positions that will do for Monet. For, in each case, the result is the same.

The question therefore is, What, out of the various consequences of this way of lighting the scene, is that which gave it value in Monet's eyes? I believe the answer to be that the shadows cast reach out towards the bottom edge of the painting, and so ultimately onwards towards the spectator. These shadows can be thought of as providing him with a path, or corridor, into the pictorial space.

This particular interpretation of Monet's use of backlighting gets the strongest support from considering some special cases where, rather conspicuously, the *contre-jour* effect is abandoned. I am thinking specifically of the famous series entitled *Poplars on the Epte* [URL20]. This motif was, we know, extremely significant for Monet, who went to considerable expense in order to buy the stand of trees, and thus save them from being logged for several months until he had painted them across the seasons. Now it is to be noted that, in these paintings, except when the sky is overcast, and there is no direct illumination, the light comes unambiguously from behind the painter. It comes often from directly behind the painter, or from six o'clock. Accordingly it falls directly, frontally, on the trees and on the thick riverside vegetation out of which they grow, and trees and vegetation shimmer and sparkle in the brilliant light. How can this be? Has Monet completely changed his mind about what it takes to make—make, not compose, for that's out of the question—a painting? I believe that what the poplar paintings do is that they confirm what I have suggested is the reason why Monet valued, when he did, lighting *contre-jour*. He valued it, I have proposed, basically for the fingers of shadow that it sent out in the direction of the spectator. Were there something equivalent to shadows, Monet would have cared less about backlighting. And this is just what he found when he came to paint the *Poplar* series. For, in this series with their riverside setting—and that is the important thing about them—reflexions replace shadows, and, when they do, Monet's need for some configuration to reach out to the spectator is automatically satisfied, without any demand upon the direction of light. For, in nature,

hence in art, reflections always run directly down from the object towards the spectator, no matter where the light comes from. *Contre-jour*'s occupation is gone.

The second device that Monet uses to overcome the absence of composition by implicating the spectator in the picture is a very special type of paint-surface, which Monet evolved. It has the texture of a dry, cakey weave. It was originally employed to capture the mosaic of reflected light that we find in the front surfaces of objects lit from behind, like the grain-stacks. However Monet came to find ever more applications for it. It is used in the sky, and in fields of wild flowers, and in scenes of dusk, but, with the sudden loss that it induces in our sense of distance, in another powerful agent in toppling the spectator into the picture: or such is the visual effect. Unfortunately in many Monets this hypnotic effect has been destroyed by the over-generous application of varnish.

A third device, which has the same end in mind, are the abrupt upward or downward shifts in the lines of sight, which correspond to the artist's raising or lowering his head, while keeping the direction of the eyes themselves constant. The commonest form that this takes, and this is all but universal in the late *Waterlilies* [Fig. 1.17] is the downward plunge of vision that allows what we are shown in the bottom third or so of the canvas to creep into the painting. The spectator appears to be falling downward into his field of vision. Vertigo substitutes itself for composition.

This involvement of the sense of the body has, I believe, been underestimated in Monet's work, particularly his late work. Monet, has been my claim, organized his pictures as he did so as to avoid the tyranny of composition without falling into artlessness. Another way of putting the matter would be to say that what he wanted to do was to convey the unmediated interest of the visible world. To achieve this, he often tried to get his painting to excite some kind of undelimited, imagined movement, whether of the eye or of the body, which would stand in for all the visual excitement that a spectator would have felt as he tried to take in the scene in front of him. Consider this painting, and the way to invites us to explore—and now we barely know whether by sight or with our whole bodies—the pools of water, and the cracks in the rock, and the caves that probably lie between them. Someone who had penetrated that far into the landscape would have lost all sense of its untidiness. He would by now be part of that untidiness.

I should like to know whether Monet swam.

4

Finally I turn to one of the greatest practitioners of good organization.[22] It would be hard to think of any painter in the Western tradition who has more often, more consistently, been cited as exhibiting the virtues of design than Nicolas Poussin.

[22] Again, perhaps this should be marked section 4, or given the previous endnote, section 3. [Eds]

Fig. 1.17 Claude Monet (French, 1840–1926), *Water Lilies*, 1906. Oil on canvas, 89.9 × 94.1 cm (unframed). Photo © Art Institute, Chicago (1933.1157).

[I] do not want to call in doubt this description. But I think that it is vital to see that, in Poussin's hands, good organization is displayed as a hazardous enterprise. This does not, of course, stem from any deficiency on Poussin's part. On the contrary: it is his way of showing something, it is his way of showing the fragility of man's control over what the organized elements represent. It is therefore no coincidence that in no paintings is the fragility of organization, and Poussin's preparedness to expose this fragility, more in evidence than in the great works of the 1640s and the 1650s, when pride of representational place is taken by Nature. I show you two preeminent works of this phase: they are works that ironically have often been praised for their severe portrayal of Nature under the rule of Law. I see nothing of the sort.

But why, we must ask, should these sustained representations of Nature be the particular locus for Poussin's apprehension of order? The answer is, Because Nature, in part for what it is, in part for what it symbolizes, is identified with the

two great turbulent forces from which man has most to fear. Nature *is* the great external reservoir of untamed life at whose mercy man lives. Nature *symbolizes* the great internal reservoir of desire or instinct whose sway over him man rejects. But the compounding factor, in painting as in life, is that, in both these two struggles, one against an outer, the other against an inner, force, the only source of energy upon which man can draw is the very force against which he fights. This, I have maintained, is a persisting theme in Poussin' depiction of what we may call the moral life. Man must turn nature and instinct against itself. For this reason, he cannot be completely victorious against either enemy, and it is, I believe, to portray this fact that Poussin cultivates a certain precariousness of organization. The painter, like man, must lose a little to win a lot.

If this is a big point to swallow, and not to be settled in this room, there are more modest ways in which Poussin's capacity to improvise within the framework that his magnificent powers of design offer him, and to wring fresh significance out of what seem to function purely as formal devices can be demonstrated. Take, for instance, his grave, measured assurance in regimenting a scene into successive, receding planes. We see it in many works of which these are superb instances. Then Poussin, having done this, starts, first on a small scale, then on a larger scale, to ring a change upon what he has introduced as a method of strict organization. He does this: At a certain plane, around the very point when visual detail starts to lose acuity, there is a remarkable reversal. The landscape suddenly renews itself, and we are treated to a remote vision of classical buildings and diminutive scenes of ancient life in its full complexity. There is, as I have chosen to describe it, 'a landscape behind the landscape'.

The *Triumph of Neptune* of 1637 [URL21] is one of the earliest examples, and the great *St John on Patmos* [Fig. 1.18] of five years later shows how brilliantly Poussin had developed the device. Six years later it has attained total lyricism.

It is obvious why I have introduced this device into my lecture. It is to show, if you like, that, in the hands of a great master, organization, however strictly pursued, is never just organization. But there is a prior question: Why did Pousin introduce the landscape behind the landscape into his painting? there is, of course, no one single answer. But I want to suggest one contributing factor. These tiny scenes from antiquity produce a strange buzzing in the head. They are hard to focus upon, they are impossible to dismiss. In this respect, they exemplify the way in which thoughts, memories, hopes, wishes, fears, cam proliferate as the mind starts to take in something too much for it. There is a kind of [inattention], is there not?, which is the mind's homage to great events. In his major paintings, Poussin presents every event, biblical, historical, mythological, as a great event in formation of the human mind. The landscape behind the landscape, the exploitation of the *dernier plan*, is in part Poussin's attempt to bring into the representation of such events some testimony to our natural reaction to them.

Fig. 1.18 Nicolas Poussin (French, 1594–1665), *Landscape with Saint John on Patmos*, 1640. Oil on canvas, 100.3 × 136.4 cm. Photo © Art Institute, Chicago (1930.500).

Lecture III

In the JAAC *piece, Wollheim operates with two distinctions within Formalism: that between Normative Formalism and Analytic Formalism, and, in §III of the* JAAC *piece, Manifest Formalism (that of Fry and of Leo Steinberg and others) vs Latent Formalism (that of Yve-Alain Bois, Rosalind Krauss, and others). The former distinction is straightforward: 'Normative (or regulative) Formalism is a theory about how paintings should be. It holds that they ought to be organized in a certain way if they are to be of value, and that this organization is what we need to take account of, and is all that we need to take account of, in coming to assess or evaluate them.' (FPO 127) Whereas 'Analytic (or constitutive) Formalism is a theory about how paintings essentially are. It holds that necessarily they are organized in a certain way, and that this organization is what we need to take account of, and all that we need to take account of, in coming to understand them' (ibid.). This distinction is swallowed up by the more detailed*

discussion of Fry in Lecture I, involving the trio of commitments which Wollheim attributes to Fry—the Principles of Norms, of Purity, and of Formalism. What follows is the discussion, in the JAAC piece, of Manifest Formalism vs Latent Formalism (FPO §III, 129–30); then the Lecture proper. [Eds]]

[…] I want to introduce what […] I [refer] to as the second major distinction within Formalism: that between Manifest Formalism and Latent Formalism.

What, then, is the distinction? I shall, for ease of exposition, state it in terms of Analytic (rather than Normative) Formalism.

For Manifest Formalism, the forms that contain the essence of a painting are forms observable across its surface. In principle they are isolable from the rest of the visual array so that they can then be exhibited, by means of a diagram or other form of depiction, for our attention. The Formalism that Roger Fry advocated and Leo Steinberg resents is clearly Manifest Formalism.

By contrast, for Latent Formalism, the forms essential to a painting are not observable across its surface. They underlie the pictorial surface, from where they have to be retrieved—and, once they have been retrieved, they are capable only of purely abstract formulation. They cannot be directly exhibited or depicted. In our day Latent Formalism is best known in the version that assimilates painting to something like language, and that holds that individual paintings have an underlying syntax. On this version, the essence of a painting resides in its syntactical form.

The difference between Manifest and Latent Formalism further shows itself in the kind of analysis that each favours as the way of going from the painting to its form. It would be a simplification, but not a gross one, to say that the tool of analysis favoured by Manifest Formalism is geometry, and that that favoured by Latent Formalism is grammar.

For the rest of this essay, let it not be forgotten that both Manifest Formalism and Latent Formalism are underdeveloped methodologies. Though the two are in open dispute, and there are numerous theorists and critics of painting who fight under one banner or the other, neither methodology has in fact progressed beyond the promissory stage.

[In the following, a dual puzzle is why he speaks here of Manifest Formalism and Latent Formalism—it is not, contrary to his use of the past tense, mentioned in an earlier point in these lectures except in the material added on Loran in Lecture I—and why he speaks of that discussion as being in the last *lecture. Various possibilities come to mind, none especially promising. The lectures were far from finished. At any rate, the entirety of this Lecture is devoted to Latent Formalism. [Eds]]*

1

In the last lecture I said that there were two kinds of pictorial Formalism. I called them Manifest Formalism and Latent Formalism, and I suggested that how these terms, which derive from Freud, though, in the present context, they carry none of the psychological implications with which he endowed them, apply to paintings would be fairly obvious. I hope that this has proved, and will continue to prove, to be so.

Within those who think that the essence of a painting lies in the forms that constitute it, and their interrelations there is a division. The division runs between those who believe that these forms lie on the surface of the painting and those who believe that they lie below the surface of the painting. The first lot, who are the Manifest Formalists, further believe that the constitutive forms in a painting are to be discerned by some form of educated inspection of the pictorial surface, whereas the second lot, who are the Latent Formalists, believe that the constitutive forms can be recovered only by the exercise of some special analytical skill, to which the parsing of a sentence provides us with an analogue.

After having dwelt, in the last lecture, on the problems to which Manifest Formalism gives rise, I want in this lecture to concentrate on the less familiar issues of Latent Formalism.

2

The analogy between discovering the latent forms of a painting and the parsing of a sentence is not fortuitous. For, in considering Latent Formalism, of which there are in principle various versions, I shall confine myself to one version, which I call 'the semiological view'. This is the view that the form of a painting lies in its underlying *syntax*. Painting—is the claim—has a quasi-linguistic structure, and therefore it is only to be expected that access to this structure will be effected through a kind of quasi-grammatical analysis. It may turn out that parsing is precisely the right word for the retrieval of pictorial structure: it is, in no way, misleading.

It is important that we recognize that the question whether paintings have a syntax is not the same as the question whether paintings are organized. Nor is it, for that matter, the same question as whether paintings are latently organized, or organized below the surface. Syntax is the name of one kind of organization, one special kind of organization, which operates below the surface. The question is, Are paintings organized in this special way?

So the first question to ask is, What is this special way? What is distinctive of rules that give rise to syntactic organization?

3

Syntactic rules must meet the following requirements:

(one) they presuppose some way in which larger units can be segmented into smaller units, and ultimately into basic units;

(two) they then operate on the basic units, which they first classify under certain functional categories. In the case of language, examples of such categories are noun, verb, adverb;

(three) they order these units, classified by category, into strings of units that are well-formed, or grammatical, while all other strings are ill-formed, or ungrammatical;

(four) the rules function recursively, in that they can be endlessly reapplied to their own output so as to yield an unbounded set of further well-formed strings;

and

(five) in those cases where the strings refer, or have a semantic dimension—that is, in all cases except purely formal languages—the meaning that each string has is determined by its syntactical form plus the vocabulary, or lexicon, of the language.

4

The next question that we need to ask is whether pictures are organized by rules that satisfy all these requirements. It certainly seems far from obvious that they are: it seems far from obvious that obviously true. In fact, it does not seem obviously true that any one of these requirements is met within painting.[23] Nevertheless the semiological view has found adherents. Some uphold it as a pictorial theory, or as holding necessarily for all paintings. Others uphold it as an historical thesis, or as holding only for some paintings or for paintings painted at a certain time and place. We shall shortly see that, though, on the face of it, putting forward the semiological view as an historical thesis might seem the more modest enterprise, in fact it runs into certain difficulties that do not arise when the bolder course is followed.

I want to consider one attempt to apply the view. In 1989, at the seminar organized by the Museum of Modern Art in New York in the aftermath of the great Picasso-Braque exhibition, Yve-Alain Bois put forward the view that, after a certain date, which he gave as the autumn of 1912, Cubism, particularly Picasso's Cubism,

[23] For a vigorous and cogent attack upon the feasibility of applying the concept of syntax to painting, see Flint Schier, *Deeper into Pictures* (Cambridge: Cambridge University Press, 1986), ch. 4.

took a 'semiological turn': that is, it shed the traditional character of painting and took on, to some sizeable degree, the nature of language.[24] In this contention, Bois was supported by the critic and historian, Rosalind Krauss.[25] The two talks prompted from William Rubin, who had organized the symposium, the opinion that they had 'shown quite clearly that there is a consensus to the effect that the linguistic model says something very essential and convincing about what happens in 1912'.[26]

Bois's version of the semiological view is manifestly not a pictorial thesis possessed of the appropriate generality. Bois does not put it forward as holding true, and mecessarily true, of all paintings. On the contrary, he claims that it is true only of certain paintings executed within certain, rather narrow, historical limits. It is true that, in a later work, which is the catalogue of the Matisse and Picasso exhibition, held at the Kimbell Art Museum, Fort Worth, last year, Bois broadens these historical limits, and claims that virtually all the mature work of Picasso—and here it is markedly in contrast to the work of Matisse—is semiological in nature. But this makes no appreciable difference to the staus of Bois's claim, which is resolutely non-general. The only claim it makes about the nature of painting as such is the second-order claim that painting can function sometimes like a language, sometimes not like a language.

The problems with which Bois burdens himself with through putting forward the semiological view this way are problems that he not only doesn't resolve, but fails to acknowledge. The two major problems are these: In the first place, how does it come about that some paintings are quasi-linguistically, or syntactically, organized, whereas the greater number are not? What, in these special cases, is the source of syntacticality? Can it really be, as Bois suggests, that syntacticality is somehow willed upon the painting by the painter?[27] Secondly, with what reason are both kinds of painting thought of as paintings, given that they diverge in so important and fundamental a respect? Why do we not, for instance, think of paintings like Picasso's as painted sentences?

Strictly speaking, since this lecture is concerned with claims about the very nature of painting, it should not occupy itself with Bois's argument. But, since Bois produces as intelligent and lucid a presentation of the semiological view as any I know of, I shall stay with it.

[24] Yve-Alain Bois, 'The Semiology of Cubism', in Lynn Zelevansky (ed.), *Picasso and Braque: A Symposium* (New York: Museum of Modern Art, 1992), pp. 169–221 (with discussion and notes). See also Yve-Alain Bois, 'Kahnweiler's Lesson', reprinted in *Painting as Model* (Cambridge, MA: MIT Press, 1990), particularly pp. 82–94.

[25] Rosalind Krauss, 'The Motivation of the Sign', in Bois, *Picasso and Braque*, 261–305 (with discussion and notes).

[26] Ibid. 293.

[27] This view comes to the fore in Yve-Alain Bois, *Matisse and Picasso* (Paris: Flammarion, Paris, in conjunction with the Kimbell Art Museum, Fort Worth, TX, 1998).

5

Obviously, in staying with Bois's presentation, I have as my primary interest seeing whether he succeeds in showing that certain works under review meet the requirements of syntactic organization.[28] Even if it later turned out that this success was of minimal theoretical interest just because it could not be generalized, this fact could be bracketed, and we could at least benefit from the proof that a syntactical analysis of paintings is a feasible affair. So the question arises, Did Bois succeed in doing what he set out to do? [...] een met by the art under consideration.[29] He appears to have thought that the answer to this question is an unambiguous, Yes. Unambiguous I say, because he is insistent that, when he claims that painting is a system of signs, he is using the notion of sign in a 'rigorous', and not in a non-rigorous, way.[30]

But the correct answer is, I believe, No.

Neither in his analysis of Picasso's work of late 1912 or early 1913, nor in what he says about the object that, according to him, opened Picasso's eyes to the view of 'painting as a script'—that is, the Grebo mask that came into Picasso's possession in the summer of 1912—does Bois show that the conditions necessary for us to postulate syntax are realized. But his failure is interesting, if only for its completeness.

In the first place, Bois suggests no systematic way in which the total surface of the pictorial object could be segmented—segmented, that is, without remainder—into parts: parts that could then function as syntactical constituents. In the case of the mask, what he does is that he pulls out of the total object a few conspicuous elements, like the two cylinders, without any pretence that the whole surface can be exhaustively analyzed in terms of these or other correlative elements.

Secondly, Bois proposes no functional categories, analogous to those of grammar, under which these elements could be brought, and in virtue of which rules could be applied to them. It is revealing that the only categories that Bois himself uses are categories that apply to constituent elements solely in virtue of what they *represent*: for instance, the description of the cylinders in the Grebo mask as 'eyes'. Here we have a case where syntax is identified interms, not just of semantics, but of vocabulary.

Thirdly, Bois has no suggestion to make about what the rules would be like that, once the elements of the mask or painting had been brought under appropriate

[28] Wollheim's original has this as section 4 (subsequently sections 5, 6 and so on), when the last section was already called section 4. We have changed this to section 5, and subsequent others accordingly. [Eds.]

[29] 'een met by the art under consideration': obviously the first words of this sentence have got lost. The sentence, or perhaps the clause, included perhaps the words 'have they been met by the art under consideration'. [Eds]

[30] Bois, *Matisse and Picasso*, 302.

categories, would then have the task of concatenating these elements, or embedding one kind of element within another kind, so as to form larger wholes.

And, fourthly, and the most serious objection, though Bois seems not to consider it, he gives us no prior reason of an intuitively acceptable kind why a notion like grammaticality is called for by any of the works he has in mind: say, the Grebo mask or the paintings or the *papiers colles* that Picasso produced in the period in question. Exactly what I mean by 'a notion *like* grammaticality', or what it could conceivably be about grammaticality that would make works of pictorial art amenable, alternatively resistant, to being inserted into the mould of grammar is a point to which I shall return.

<div align="center">6</div>

From the foregoing discussion I conclude that the claim that paintings of any sort have a syntax is, and is likely to remain, unproven. I put it like this because I can think of no argument that could establish that paintings are not susceptible to a syntactical analysis.

However there is a further point to be made, and that is that, even if such a claim like Bois's, or a generalized version of it, could be made good, it would be of no great interest. That paintings are organized syntactically could not be more than a fortuitous feature of their make-up. And that is because the further claim that it is in virtue of their syntactic structure, plus something about them that corresponds to what in language is represented by vocabulary and indexical features, that paintings refer to the world is certainly false.

Let us get this issue in focus, by looking in somewhat greater detail at language, and at what syntax does for language, and how it does it. For it is from this that our understanding of these matters derives.

Take the sentence, 'The dog bit both the cat and the horse'. Then we find that we can, while retaining the same vocabulary, ring certain changes upon this base sentence: first, by merely altering the word-order within the existing structure, so that we get 'The cat bit both the dog and the horse', and 'The horse bit both the dog and the cat', and then, secondly, by altering the structure, so that now we get 'The dog bit either the cat or the horse', and 'The dog was bitten by both the cat and the horse', and 'The dog was bitten by either the cat or the horse'. Now, of these changes, we can say three things. (One) each change generates a sentence that differs in meaning from the base sentence: (two), these changes can be rung on every sentence in the language, no matter what its vocabulary, provided that it has the same structure as the base sentence, and (three), provided only that we understand the vocabulary, we shall be able to predict the changes in meaning that the new base sentences will undergo. From this it follows that, though there is clearly no meaning without vocabulary, syntax is a very powerful determinant of meaning.

Nothing like this exists in painting. Hence, even if we could prove that painting exhibited syntax, this would be an idle fact about painting.

When I say that nothing like this exists in painting, my confidence comes from such positive understanding that we have built up of how paintings in fact acquire meaning. This understanding is, I believe, substantial, and what it strongly suggests is that pictorial meaning, unlike linguistic meaning, is not grounded in structural features at all. It is grounded in the painting's power to generate in an appropriate observer certain relevant experiences.

Of course both the terms 'appropriate' and 'relevant' in this last sentence need amplification. Suffice it to say for the time being that (one) 'appropriate' here means 'appropriately informed, appropriately sensitive', and (two) 'relevant' here means 'relevant to the kind of meaning with which the artist is endeavouring to invest his painting', so that, by way of example, were the artist endeavouring to get his painting to represent a bison, the relevant experience his painting should be able to give rise to is that of seeing a bison in the painting.

I see no reason to object to the familiar point that the structural features of a painting can, and quite often do, amplify, or reinforce, or modify, pictorial meaning. So, in paleoChristian art, the magnification of the figure of the Virgin may convey her importance in the eyes of the devout. But, if we are to assess the importance of this fact, as far as Latent Formalism is concerned, two things must be noted about such cases. The first is that they are never more than peripheral. Structural features do not, nor could they, ground pictorial meaning. The second is that, in so far they do contribute to pictorial meaning, they do so, it will be appreciated, in a way altogether different from the way in which syntactical structure contributes to linguistic meaning.

For note what happens in the linguistic case. We read or listen to a sentence: we use our eyes, alternatively our ears, to discover the words. Then, drawing upon some part of our knowledge of the language, we parse the sentence we have experienced, and thus we expose its structure. *Then*, drawing upon some other part of our knowledge of the language, we assign to this structure a meaning, and this meaning is the meaning of the sentence we have read or heard. Some philosophers will say that, at both points at which we draw upon our knowledge of the language, and apply this knowledge to the sentence experienced, we are invoking rules or conventions. Other philosophers will deny this. They will say that the so-called rules and conventions of language that we hear of are artefacts of theory: they have been dreamt up by philosophers. This disagreement is immaterial to the point that I wish to make, which is this:

The understanding of a sentence, as I have described it, is fundamentally a two-stage process, and it is only to the first stage of this process, which is the discovery of the sentence under investigation, that the senses are relevant. Throughout the second stage of the process, when first one part, and then another part, of our knowledge of the language is brought to bear upon the perceived sentence, no

essential role is assigned to the senses. And, further observe, it is only in the second part of the process, that structure is invoked. Someone who knows, and someone who doesn't know, a certain language can equally complete the first stage of the process I have outlined. Only someone who knows the language can stay afloat through the second stage of the process.

None of the above is true, nor is anything corresponding to it true, of the process invoked when we come to understand a painting: even a painting that, to some degree or other, depends for its meaning upon its structure. For, in the case of the painting, the senses are required from beginning to end: the senses, that is, appropriately informed. When we look at the Byzantine or Romanesque Madonna, we understand it because of what we see. In the pictorial surface we see a woman, a mother, a mother with her child, and the disproportionality between her and the surrounding figures, whom we also see, encourages us to see her as the Mother of God. The process is essentially a one-stage process, involving perception throughout, and, when structure is invoked, the role that it plays is that it affects what we see: it modifies, or shapes, our perception.

<center>7</center>

And now I must anticipate a final counter-attack from the adherents of Latent Formalism. The claim will be that the meaning of any sign—linguistic *or* pictorial—always depends upon structural features. However it is to be noted that, in the argument to which I now turn, the structure that is invoked is not syntactical structure. Rather it is a form of structure that—or so it is alleged—is inherent in vocabulary itself. Vocabulary is an artifact of structure.

The argument I have in mind as the last show of force by Latent Formalism derives from the so-called diacritical account of meaning. This account of meaning contains a thesis, and a hidden assumption. The thesis is that every sign means what all the other signs with which it is associated do not mean. Meaning, on this view, is essentially negative, or contrastive. But much here hangs on how to understand the phrase 'with which it is associated'. To understand this phrase, we must invoke the hidden assumption, which is to the effect that all to which all signs can be grouped into sub-systems, or schemata, examples of which would be the vocabulary of colour, or the vocabulary of precious stones. Now, if it is fairly clear how, subject to one fatal proviso, the diacritical theory operates within such subsystems, it is also clear that we cannot arrange the complete vocabulary of a language into such sub-systems without remainder.

And where we can, what precisely do we find? It seems plausible enough to say that 'red' means what 'blue', and 'yellow', and 'green', and..... don't mean. Or that 'emerald' means what 'ruby', and 'diamond', and 'sapphire', and..... don't mean. But what does this tell us? What it evidently is not telling us—though it purports to—is

how meaning gets going, or how it is grounded. The core objection may be stated in the following way: If every sign gains its meaning only from what other correlative signs don't mean, how does any sign ever mean anything? Where do we start?

The content of this objection can be readily grasped by considering the very situation that some upholders of the diacritical thesis think is a good medium through which to explain the view. They think it illustrates the view: I think that it provides a *reductio* of the view.

In his contribution to the Picasso-Braque seminar, Yve-Alain Bois not only gives his support to the diacritical view,[31] he proposes to show it in action. So he asks us to consider a system of traffic lights where the lights go only red and green. Within this system, as within ours, the red light, he tells us, means 'stop', and the green light means 'go'. However Bois has chosen to give us a reduced model of the system that functions in the real world because he thinks that, cut down in this way, the system allows a better insight into the principle that underlies its operation. For what now stands out—or so it is said—is that the red light means 'stop' because—that is, only because—it is opposed to the green light, which means 'go'. Now Bois is no special partisan of the green light, and so he must hold that the analogous thing is true for it: that is, it means 'go' only because it is opposed to the red light, which means 'stop'. Some years ago, in an essay entitled 'In the Name of Picasso', Rosalind Krauss, who turned out to support Bois at the MOMA symposium, made the same point, with the same example, and the same ambiguity, when she wrote of the 'the traffic-light system where red means "stop" only in relation to an alternative of green as "go"'.

Now, we must wonder, Where does meaning start? Or, How could someone get access into the system?

Let us imagine a driver driving up to the lights, primed with the information that each light gains its meaning only through not being the other light. When he arrives at the light, it is red. It is late at night, no-one else is around, so there is no-one whose behaviour he can copy. He stops, not knowing whether this is the right thing to do. He will know this, he says to himself, when the light turns green. For, if he knows what to do then, he will then know what he should be doing now. Eventually the light turns green. But, to his chagrin, he is no better off. Nothing tells him what to do then or what he should be doing now, and all that he can do is to wait until the light turns back to red: and then, perhaps, he will be able to argue back from what he should do then to what he ought to be doing now.

But that is just to repeat the same false hope. At each change of the light, he may choose to drive on, he may choose to wait, but he has no way of knowing which is the right thing to do—and the truth of the matter is that, *if the lights are functioning as Yve-Alain Bois has programmed them, there is no right thing to do.* Red follows

[31] Ibid. 173–4. See also *Painting as Model*, 86–9, 254–5. The diacritical view is also to be found in e.g. Rosalind Krauss, *The Optical Unconscious* (Cambridge, MA: MIT Press 1993), p. 151.

green follows red: stop follows go follows stop. But there is no way preferable to any other way of correlating the two sequences.

A brief way of putting what is wrong with the diacritical account of meaning is that it confuses a consequence of meaning with the ground of meaning. Within a sub-system of a meaningful sign-system, which also lacks redundancy, any sign will mean what the other signs collectively don't mean. But that presupposes meaning: it does not explain how meaning comes about.

<div align="center">8</div>

I said a little way back that it is a weakness in Yve-Alain Bois—and it is not peculiar to him, it is, as I see it, a general deficiency in any case for a semiological view—that we are given no prior reason why we should expect a notion like grammaticality to fit, or to capture the nature of, pictorial organization. In raising this doubt, I had at the time two distinct things in mind. One relates to a more specific feature of grammaticality, the other to a more generic feature of grammaticality.

The specific feature of grammaticality is that grammaticality is structure-dependent, and I have already given weight to the objection that structural features are not fundamental to pictorial organization. But the second and more general feature of grammaticality that I had in mind as not being very shared with pictorial organization is that grammaticality is an all-or-nothing property. There are not degrees of grammaticality, or, for that matter, of ungrammaticality. However it is surely essential to the way we think about pictures that we regard them as being more or less, better or worse, organized. Pictorial organization is scalar. It doesn't just admit of degree, it insists on degree. It is this second objection that I now want to consider.

To the objection as I have framed it, there is a retort, which points to the superficiality of my formulation. True enough, it will be said, grammaticality does not admit of degree, any more than, say, truth admits of degree. Accordingly, so long as we fix our eyes narrowly on the very notion of grammaticality and its distinctive features, we shall get nowhere in appreciating the parallel between linguistic and pictorial organization. But widen our vision, and things will start to look different.

Let us reflect that, when a sentence is ungrammatical, we can always ask why it is ungrammatical. There is always a reason, and, in some cases, a variety of reasons, why it is ungrammatical, and each reason corresponds to some way in which the sentence breaches grammaticality. This, of course, is not to say that the reasons why a sentence is ungrammatical, or breaches of grammar, are strictly denumerable, but we can give broad sense to the idea of different grammatical errors, which sometimes occur singly, but which can also occur conjointly, compounding ungrammaticality when they do. Seen in this way there are close similarities between ungrammaticality and falsehood. Without there being degrees of falsehood, there

are various possible ways, not always distinguishable, from one upwards, in which a sentence can be false, because there are correspondingly ways in which it can fall short of reality. More to the point, the retort continues, the way different grammatical errors underlie ungrammaticality effectively restores the resemblance between, on the one hand, the grammaticality or ungrammaticality of a sentence and, on the other hand, the organization or lack of organization.

My own view is that this retort in fact plunges us yet deeper into the misunderstanding of pictorial organization. What gets us deeper is the assimilation of a fault in pictorial organization to a grammatical error.

But what is so wrong about that?

Are there not two facts, which are generally conceded, which strongly support the assimilation? The facts are these: In the first place, it is significantly often the case that a painter will change something in a painting that he has done on the grounds that he made a mistake, a mistake in organization, which he has now recognized, and is in a position to rectify. This, it will be recalled, was the starting-point of these lectures. Secondly, when an artist has not reached a point in his development when he can recognize such errors for himself, he characteristically places himself under the tutelage of someone whose task it is to point out these errors to him, and to indicate how they can be put right. Painting is an art that can be taught, and no painter reaches a stage when he has nothing further to learn. These are not insignificant facts about it.

But the pertinence of these facts—and facts they certainly are—depends upon their interpretation. On the face of it, all that they show is that the notion of error, or fault, has application both in the domain of language and in the domain of painting. But that is a very abstract point. For we can all recognize that a cluster of interrelated notions—error, recognition of error, and rectification of error—have a very different kind of application in different areas of human activity. They are shifting notions with shifting implications.

<div align="center">9</div>

What I propose that we should do, if we want to be clearer about the kind of error that is involved in painting and in pictorial organization is to consider certain very general features of the processes by which painting and pictorial organization are taught. There are two features to which I want to draw your attention.

The first feature is this: In the central cases, the student learns to paint, and to organize his painting, through a process in which the student learns from, indeed is encouraged to learn from, his mistakes. What happens is that the student, provided with materials with which he acquires some familiarity, goes ahead, paints his painting, and the teacher stops him when he thinks that he has gone wrong.

The contrast here is with two other pedagogies: on the one hand, teaching by precept, or where the teacher enunciates general instructions or rules, and, on the other hand, teaching by example, or where the teacher paints *his* painting, and the student tries to follow suit.

The second feature is this: That, unlike other cases where the student learns through his mistakes, such as elementary piano lessons, the teacher does not correct him by doing right what he did wrong. He does not do the equivalent of playing the right note where the student played the wrong note. Indeed the teacher may do nothing except to point out to the student that an error has been made. And, if there is something that he does, it will most likely be merely showing the student *one* right way of doing what the student did wrong. In other words, it will be more like an advanced piano lesson, where the teacher rephrases the notes just to demonstrate that there are a number of ways of doing what the student did, any of which would be better than the way he did it. Which one the student—the student of the piano and the student of painting—should follow depends on what he is after, on what further ends, if any, he is after.

10

It is this last point, framed, let me emphasize, in as deliberately vague a way as I could, that takes us, as I see it, to the heart of the matter, which is that there are different grades of pictorial organization, and these different grades of pictorial organization interact with the painter's ends in various ways.

On the lowest grade, pictorial organization is just that: it is a matter of tidying-up the painting, in which a place is found for everything. It is undertaken in the spirit of good house-keeping. Max Friedlander, the great art-historian of northern art, seems to have taken this rather minimal view of pictorial organization when he explained what he called 'composition' in the following terms: 'To the eyes there is displayed a confused and inarticulate juxtaposition of things: and to put this into order is the task of the human spirit.' It is arguable that we owe to this conception of the painter's task the great hierarchical constructions of late Gothic, early Renaissance art, as we find it in Central Italy and, above all, the Netherlands: although clearly more is going on in these great works.

The second grade of pictorial organization is that which we most readily think of when we think of how paintings are organized. Now pictorial organization is undertaken, not, as above, for its own sake, but for some value that thereby accrues to the painting. But the value in question is invariably an organizational value: that is to say, it is a value that is to be explained in terms of organization. It is a value of organization. As examples of such values, let me cite symmetry, harmony, order, design, tension, a warring of opposites. When any such value is realized, I say that the painting displays 'good' organization, where 'good' goes into inverted commas.

The third grade of pictorial organization arises when the painter successfully arranges his painting so as to advance some further end: that is to say, some end the understanding of which does not require us to refer back to the nature of organization itself. Different ends will self-evidently require different forms of organization. What is important to see is that, not merely do most of the most interesting paintings aim at this third grade of pictorial organization, but this grade can be realized without any concern for the second grade. A painting can be masterfully organized for the satisfaction of its own ends without cultivating, without exhibiting, good organization.

This takes us back to Jacob Ruisdael's *The Castle of Egmont*, on which the last lecture ended, and on which the next will begin. For it exhibits what, in the last lecture, seemed like a paradox, and now at least be on the way to no longer seeming so: masterful organization without good organization.

PART II
STYLE

2

Style Now (1975)

In 1972, Wollheim delivered a lecture at the University of Sidney, following an invitation by the University's Power Institute. What is, or what is the importance of a style? Wollheim begins by considering and rejecting the view of Morris Weitz (1916–1981); he takes more pains with that of Ernst Gombrich, but rejects it all the same. The right account of style is to conceive of it as deeply analogous to Noam Chomsky's idea of transformational grammar, which operates on the basic lexicon—the 'deep grammar' as Chomsky termed it—to produce surface structures, the purposes of which can be thought of as close to ordinary sentences. If we read something like 'primordial content' for 'deep structure' and the 'the physical work of art' for 'sentence', we can get a rough idea of the analogy. This would explain the reaction—which Wollheim goes to some length to explain and justify—to a painting produced by a 'nonpainter', i.e. the one-off product by some person or animal that happens to be indistinguishable from the product of some master: One cannot rate it, one cannot say with any precision what it expresses. What is missing is a style, of a grammar under which it was produced, which requires a period of acquisition, of practice. This goes together with the claim that aesthetic judgement is never atomistic—not just this work— but holistic: the work in the context of the artist's style, which necessarily involves other works, normally by the same artist. Style turns out to be essentially psychological, not sociological. Readers of Wollheim's later work—such as the Three Lectures in Part I of this volume—will recognize that he back-pedalled on the analogy between syntax (grammar) and artistic expression, but this need not detract from the reasoning here on display. [Eds]

I

'Style Now'. The title of this lecture—or my choice of it—would seem to stand in need of explanation. That explanation I shall try to provide as we go along. For there are a number of reasons why, at this juncture, I should want to take up the problem of style. Some of these reasons are quite subjective, and stem from my present interests. Others are quite a bit more objective and relate either to current

Uncollected Writings. Richard Wollheim, Gary Kemp, and Elisabetta Toreno, Oxford University Press.

intellectual inquiry or to the condition of the visual arts today. Rather, therefore, than try to present these reasons at the outset, I shall introduce them into the discussion as and when they seem relevant. I should like to express my deep gratitude to the Power Institute for its invitation to deliver this lecture, and so for the opportunity to review these issues in a new and challenging environment.

II

Let me start with the last of the reasons that I suggested for my choice of topic: the condition of the visual arts today.

I do not have to remind you that there exists a whole band of writers and thinkers—more numerous perhaps than those who live by art—who live by telling us that art is in a state of crisis: nor shall I burden you with the various diagnoses and remedies that have been proposed for this crisis. Myself I am some way from being convinced on this score. But I must say this: that long before I became involved—or entangled—in the theoretical issues I want to take up in this lecture, it seemed to me very plausible to think that, if there is a crisis in the visual arts today, or, if you prefer, in so far as there is a crisis in the visual arts today, this comes from the particular difficulties that confront the contemporary painter in the formation of a style. These difficulties have ultimately their source in the market-place, in the alliance of dealer and client. For wide open to new influences, new forms, new ideas though this alliance may be, on one matter it is quite insistent, and that is that a painter with whom it involves itself should have learnt to impose upon his work an immediate and instantaneous look of its own. This, it seems to me, is the most powerful pressure under which the contemporary painter labours. He is forced, we might say, to seek recognition through the recognizability of his work. And recognizability is not merely not the same as, in some cases it is quite inimical to, the existence of a style.

This last point is, I am aware, not obvious. Indeed to some it may seem counter-intuitive. To establish for it a modicum of plausibility will involve determining some of the central characteristics of style. This is what I shall now try to do. Then at the very end of this lecture I shall return quite briefly to the issue I have raised, which was one but only one of the reasons I had for wanting to talk about style. And I hope that what I meanwhile will have found to say about style will have an interest of its own.

III

To determine the first characteristic of style as I see it, let me start with a rather simple fact: a fact about our attitude towards painting. For me it is an incontestable fact, and I am reasonably confident that it will seem so at least to some of you. If it does not seem so to you, I may say something that will alter your perception. Or if—which

I think more likely—you are initially inclined to take it as an incontestable fact, then shy away from it in fear of its implications, I hope I shall give you reason to see that its implications aren't that fearsome. The fact is this: that in so far as we are interested in paintings, what we are interested in is the paintings of painters. Or better, perhaps, in so far as we are interested in paintings as paintings, what we are interested in is the paintings of painters. Of course, on occasions, we are also interested in, or may also be interested in, the paintings of schizophrenics, of art school applicants, of chimpanzees, of world politicians, of our own children. But on any such occasion, I would wish to say, we are not interested in the painting as a painting. We look to the painting in order to diagnose sickness, to discover promise, to validate a theory, to elicit biographical information, or simply because it is by whom it is. And though I would be the first to agree—as against a mistaken but quite widespread 'purism' in criticism—that, when we are interested in a painting as a painting, we may quite legitimately draw on history, on biography, on evaluation, it seems to me quite inconsistent with this kind of interest—let us call it an aesthetic interest—that we should go to the painting just to get from it such information. So the fact that the paintings of non-painters should interest us in a large variety of ways, emotional, sentimental, doesn't go against the fact that I've taken as my starting-point—that it is only the paintings of painters that can interest us as paintings.

And this, let me emphasize, is both in itself and in the use to which I put it in the course of my argument, a fact specifically about painting, in that it does not rest for its acceptability upon some more general fact about the arts, which may, or may not, be so. In other words, what I have said about the limits of our aesthetic interest in painting does not oblige me to think that an aesthetic interest must be similarly confined to the poems of poets, to the novels of novelists, to the music of composers. In point of fact, my own view on this matter, for which I shall not be able to argue, is that the arts can be arranged on some kind of a spectrum, according to the degree to which habituation and aesthetic interest go together. At one end of this spectrum there lies painting, at the other the novel, and points in between are occupied by music, poetry, sculpture. But I am not, of course, asking you to accept any of this. I have brought it up only to show that what I claim to be a fact about painting I claim as a fact specifically about painting, and I am not just using painting to assert some more general thesis.

To the question—the next to arise—why it should be that the only paintings that interest us as paintings are the work of painters, the most obvious answer would be. Because they are much better. It takes a painter to turn out a good painting. However, l doubt if this is the right answer. Or if it is the right answer—and there may be a very broad way of taking it such that it is—I am quite sure that to put it this way conceals at least as much of the truth as it reveals.

For, in the first place, it seems not to be generally true, as the answer assumes, that we take an interest only in good paintings. Of course, life is short, art is voluminous, and there comes a point when we should be wasting our time looking at

the third—or even at the second-rate. But my feeling would be that, if someone looked exclusively at good paintings, found nothing of interest in anything else, we should fairly soon come to doubt whether he was really interested in painting at all. I leave that thought with you. Secondly, it isn't true—as once again the answer assumes—that the question whether a painting is good or not can be settled independently of whether it is or isn't by a painter. Consider a situation which we may well have found ourselves in: We are shown a painting, we think we recognize the artist, we then learn that it is our host's one and only shot. Our evaluation is bound to change. Of course, this might be due to snobbery, but it needn't be, for even if we are free from any such weakness, the opinion that we hold of the picture is almost bound to shift.

But understand this case, with which I stay for a moment, contrast what happens here with what happens in another kind of case to which it bears a marked superficial resemblance. And that is when we learn that a painting is not by one painter but by another. A painting, we learn, is not by Gris but is by one of those painters who turned Cubism into an academic discipline. For here too there is room for a shift of opinion, and the shift need not be, though of course it could be, due to snobbery. For what might happen is that, now knowing what we know about the painting's authorship, we are able to perceive demerits in it that were previously masked from us. On the basis of this change in our perception, our opinion legitimately shifts. We don't simply *say* that it is less good—that would be snobbery— we *see* that it less good.

But when we learn, not that the painting is by a painter other than whom we thought it by, but that it is not by a painter at all, the situation is in several respects different. One: the shift in opinion is now mandatory. Our old opinion just cannot, in such a case, survive the revelation—whereas in the other case we might, mightn't we, go on to think that for one splendid moment in his life Gleizes managed to paint as well as Gris. Two: our opinion, when it shifts, will, characteristically, not go either up or down. It will go more like sideways. In other words, we shall lose all willingness to pass judgement on the painting, and if, nevertheless, we are pressed to do so, we shall feel the unfairness of the pressure. And three: the shift in our opinion—the lateral move out of evaluation—will be based not on a change in our perceptions but, rather, on a loss of confidence in what we perceive. We shall no longer know what weight to attach to what shows up, on the canvas. We shall feel ourselves in no position to say how much of what is there is intentional, and how much is accidental. Or how much of what is accidental is just sheer accident, and how much was allowed and encouraged to happen as it did. Or how much of what is intentional came about because there seemed nothing letter to do, and how much came about because it seemed the thing to do or what had to be done.

If all this is roughly true, and I am at this stage aiming at no more than approximation to truth, we can see how misleading is to say that the work of someone who isn't a painter will fail to interest us because it is too bad. It looks rather as though

there is no way open to us of saying whether it is good or bad. And the reason for this lies not with something present in the painting that then spoils or mars it, but rather with something absent from the person who painted it. An omniscient critic confronted by the bad painting of a painter might be able to say how it could be rectified; confronted by the painting of a non-painter, he could only say how he or she might be rectified.

But what would he say? For what is it that the non-painter necessarily lacks, and that the painter may possess? The suggestion I shall make this evening will not, I am sure, surprise you. It is that the crucial difference between the painter and the nonpainter lies in the fact that the formation of a style is open to the one, but not to the other. Likewise it is the exercise of a formed style that is the precondition of our aesthetic interest in painting.

But to say this is to give little away until something further is said about what style is: until more of its characteristics, over and above this one, are collected. Two problems, considered and put together, may advance our understanding.

IV

In the domain of art-history the concept of style is widely used: so much so that it might seem to provide a natural starting-point for any inquiry into the nature of style. Yet I suggest that any sustained reading in the conventional literature of art history is likely to leave one with the feeling that, far from its being the case, as I've maintained, that style is somehow crucial to the question of aesthetic interest, the very notion of style is fit only to be scrapped. For the literature provides us, on a scale to which quotation could not do justice, with characterizations of one and the same style which arc demonstrably inconsistent. Sometimes the inconsistencies are overt: when one art-historian denies what another asserts. Sometimes the inconsistencies are covert: when the characterizations seem merely to be different, but each lays claim to completeness. Either way round, what are we to make of a notion which can give rise to such diversity of opinion on almost any occasion of its application? What claims can it lay to clarity or distinctness?

Recently a suggestion has been made which could account for the situation I have just described, and account for it not just in that it would explain how it came about, but also in that it would to some degree legitimize it. The author of the suggestion is a philosopher, Morris Weitz,[1] and Weitz argues that we are worried about the existing state of stylistic analysis only because our expectations are all

[1] Morris Weitz, 'Genre and Style' in *Contemporary Philosophic Thought: The International Philosophy Year Conferences at Brockport*, vol. 3: *Perspectives in Education, Religion, and the Arts* (Albany, NY: State University of New York Press, 1970), pp. 183–218; cf. James S. Ackerman, 'Western Art History', in James S. Ackerman and Rhys Carpenter, *Art and Archaeology* (Englewood Cliffs, NJ: Prentice Hall, 1963), pp. 164–86.

wrong. We look for a style-characterization that would catch the essence or true nature of a style and, when different characterizations of the same style conflict, we conclude that at least one must be wrong. But this is to miss the point of stylistic analysis, which is, in effect, a way that art-historians have of classifying pictures or features of pictures into groups that they happen to find convenient. And what is convenient for one art-historian may well not be convenient for another. For the two may differ in their point of view and, differing in point of view, will differ also in the respects in which they find it significant that paintings resemble, alternatively are unlike, one another. Once we understand this, we shall no longer be troubled by the seeming inconsistencies between style-characterizations. Indeed we shall come to recognize the phenomenon for what it is: a symptom of the continuing vitality of art-historical inquiry. It is evidence of the fact that art-historians are able to see their material in different perspectives, from new positions of vantage, and so preserve the freshness, the vivacity of the material itself. Stylistic concepts are not only, in Weitz's quasi-technical usage of the term, 'irreducibly vague'; they are also, he contends, 'beneficially vague'.[2] And, as we come to appreciate this, our interest will at the same time shift from the style-characterizations themselves to what lies behind them: to the different points of view occupied by arthistorians, and to the different 'style-giving reasons' which they correspondingly find adequate.

I have introduced Weitz's suggestion as a way of dealing with one charge that can be brought against conventional stylecharacterizations: that they are often mutually inconsistent. But it is worth pointing out that it simultaneously goes some way to meeting another charge that can be brought against them: that they are internally incoherent. So often they read like mere inventories of pictorial features that have been brought together in a haphazard way without unity or system. For to this objection Weitz would have the reply that style-characterizations have, if not an explicit, then an implicit, unity, a unity which derives from the point of view of the art-historian. If the features that compose them seem at first quite unconnected, what they have in common is that they are those features which simultaneously come into focus when viewed from a single, specific point.

Yet I find Weitz's suggestion ultimately untenable. The rescue operation it carries out in the interest of style is too costly, and, if I have spent time upon it, it is in order to understand what the concept of style cannot afford to give up even to gain philosophical respectability. For what Weitz's argument denies to style is the character of being generative. Style on such a view—and the view in one form or another is very common—has nothing to contribute to the making or construction of a painting. The view must deny this: for if one did think that style was something operative, how could one be satisfied with a characterization of style that was made

[2] Weitz, 'Genre and Style', 211.

exclusively from the art-historian's, or any other purely external, point of view? ('External' meaning in this context external to the painter himself.)

An analogy might be useful. Let us imagine some anthropologists who are attempting to survey over a fairly extensive territory a diverse array of utterances and inscriptions and to classify these according to the language they are in. Now, one way they might proceed would be to regard the classification as determined entirely by questions of convenience. In that case, since it is natural to assume that different anthropologists would have different senses of what was convenient, a likely outcome is that there would be disagreement about where one language began and another ended, and also, of course, disagreement about how any one language should be characterized—how, as we should say, its grammar should be constructed. And, as the case has been set out, all these disagreements would be acceptable if, but only if, they could be traced to disagreement on pragmatic issues or the method of classification. But suppose that the anthropologists came to think that the variety of the utterances and inscriptions they were attempting to survey could, in part at least, be explained by reference to the different languages they were in, or that the grammar of those languages had been operative in the production of the utterances and inscriptions; then, it seems, they would have to change the way in which they proceeded. No longer would it be possible for them to treat all outstanding issues between them as though they were mere matters of convenience. For these issues, or some of them, would have now to be recognized as being or as involving matters of fact, and both in distinguishing one language from another and in setting out the grammar of each, our anthropologists would have to respect this constraint: that their classification would have to correspond to the intuitions of the native speakers of the various languages.

That this second way of proceeding is the right way in respect of language classification and language analysis is, I take it, quite obvious, and my point (as against Weitz) would be that the same procedure is called for in the matter of pictorial style. For would claim that style is generative in the production of paintings in much the same way as grammar is generative in the production of utterances and inscriptions. And as direct confirmation of this, there is, interestingly enough, one significant context in which we admit this. And that is when we judge the work of a painter, either over a period of time or in a given painting, to be mixed or transitional in style: for in making such a judgment, we thereby impute an element of tension, or indecision to the work-tension or indecision which may be harmful or may be creative. But the tension or indecision is in the work such is the implication of what we say; whereas on a Weitz-like view of the matter, it need only be in us. On a view like his, our judgment would show either that we could not sort out our categories or that we could not make up our minds.

To sum up my position *vis-à-vis* that of Weitz, I should say that, though he is right to think that all style-characterizations include a point of view, he is wrong to think that the point of view should be the art-historian's rather than the artist's. And

he goes wrong because he fails to appreciate the generative role of style in art. But to say that style is generative—which I shall now assert as the second characteristic of style—is open to misunderstanding, and I want briefly to dissociate myself from two possible misunderstandings. In the first place, I have said nothing to suggest that the painter has explicit knowledge of, or could bring into consciousness, the operations that constitute his style. I am sure in fact that he could not; I am sure-to put it another way—that the artist could not anticipate the art-historian in a significant part of his work. Secondly, if the procedures that constitute a painter's style turn out to be complex and highly structured, it does not follow that the painter in each and every exercise of his competence runs through these procedures, either consciously or otherwise. There are many cases where a skill, like computing, depends upon the acquisition of elaborate operations, and in employing this skill we consequently draw upon these procedures, but not by means of an internal rehearsal of them.

I said that there were two problems which, when considered and put together, might advance our understanding of pictorial style. Let me now turn to the second problem: which starts at one remove back from our topic.

V

Ernst Gombrich is a thinker to whom not only I, but anyone seriously interested in the theory of the arts, must be deeply indebted. A problem to which Gombrich has returned on a number of occasions—most notably in the last chapter of *Art and Illusion* and in some of the essays that make up *Meditations on a Hobby Horse*[3]— is that of expression, and of the undoubted power of paintings to express human feelings, moods, or emotions. What Gombrich has found to say on this problem is complex and defies ready summary. But a contention that he has consistently advanced is that, in order to understand the expressive significance of a painting, we need to know the alternatives (that is, the equiprobable alternatives) that were open to the painter and between which the painting before us therefore represents a specific choice on the painter's part. That the painter did on the surface of his canvas he did in preference to certain other things he might equally well have done: and we must learn what those other things were before we can say what the painting expresses. The expressive meaning of the painting lies, we might say, not just in its being what it is—say A: it lies in its being what-it-is-rather-thananother-thing— say A-rather-than-B-or-C-or-D-or-E, where B to E are the kinds of thing that it was equally open to this painter to have done or made. In the following quotation

[3] E. H. Gombrich, *Art and Illusion: A Study of the Psychology of Pictorial Representation* (New York: Pantheon, 1960; 2nd edn, Princeton, NJ: Princeton University Press, 1972), and *Meditations on a Hobby Horse* (London: Phaidon, 1971).

Gombrich tries to clinch the point by making us see how one and the same feature of a work of art could, if drawn or selected from different sets of alternatives, have quite different significance:

> What strikes us as a dissonance in Haydn [he writes] might pass unnoticed in a post-Wagnerian context and even the *fortissimo* of a string quartet may have fewer decibels than the pianissimo of a large symphony orchestra. Our ability to interpret the emotional impact of one or the other depends on our understanding that this is the most dissonant or the loudest end of the scale within which the composer operated.[4]

Or again, Gombrich asks us to consider the very different impact that Mondrian's *Broadway Boogie Woogie* [URL22] might make on us if we were to learn that it was the work not of a painter given to severe geometrical designs but one to whom animation or turbulent forms came more naturally: say, Severini [URL 23].[5] Whatever we make of the detail of this example, indeed of either example, the point comes across: the expressive meaning lies in the choice in which the painting originates.

Gombrich's theory of expression gives rise to difficulties because, at any rate at times, he seems to suggest that, for us to grasp what a painting expresses, it is not only necessary to know the alternatives out of which the painting, or the various features of the painting, were selected; but that to know this is sufficient. When we know this, we thereby know what the painting expresses. In this lecture I shall pass over all difficulties that arise from this source,[6] and concentrate on one problem which exists not just for Gombrich but for anyone who thinks—as indeed I do—that the existence of alternatives is a corollary of expression. And the problem is this:

How are we, given some part of the output of a particular painter, to determine the range of alternatives out of which that which we have before us is a selection? How are we on the basis of his *oeuvre* to reconstruct his repertoire?

The first point to recognize is that this problem remains, however much (or however little) we have of the *oeuvre* under inspection. For, even if we have the whole of the *oeuvre* before us, it is always possible that we do not have the whole of the repertoire; for there might be some fraction of the repertoire that the painter never employed. This would happen, of course, if there were certain feelings or moods or emotions that the painter never had occasion to express. These mental states (to use a blanket term) never having called for expression, no use would have been found for the corresponding part of the repertoire.

[4] Ibid. 62.
[5] Ibid. 331–3.
[6] I have discussed these issues in Richard Wollheim, *Art and its Objects* (New York: Cambridge University Press, 1968), sections 18, 28, 2–9.

So it follows that, if we want to reconstruct the repertoire from a portion of the *oeuvre*—small, large, total—what we need to know as a preliminary is whether we have the whole or less than the whole of the repertoire before us. And initially this might seem easy enough. But reflection shows that, as Gombrich has laid out the issue, such knowledge is unobtainable. For the only way we could have of finding out whether the part of the painter's work that we have before us exhibits the whole of his repertoire is to determine whether he has expressed the full range of mental states open to him, or whether there were some he never had occasion to express. But to determine whether he expressed the full range of mental states, we need to determine what mental states he did express. And this, on Gombrich's view, we cannot determine until we know the repertoire—which is just what we want to find out. So we move round in an unbreakable circle.

I think that there is a way of breaking out of this circle, though it would require an alteration to Gombrich's account. But such an alteration is, I think, required on general grounds as well as to meet this particular problem. The alteration consists in substituting for the notion of the repertoire a more powerful notion. For the notion of the repertoire does not imply any linkage or significant interrelationship between the alternatives that constitute it. The repertoire collects its constituents like a shoppinglist. The alteration I propose would be that we substitute for this notion a stronger notion—let me call it for the moment that of the repertoire-plus—which further insists that the constituent alternatives fall together or form a unity. With such a notion the problem of our knowledge of the repertoire begins to admit of solution. For now the possibility is open that, from a fair sample of the painter's work, we should be able to reconstruct the full range of alternatives with which he operated. What opens up this possibility is, of course, the whole in which the alternatives are united. And in addition to resolving this problem, the introduction of the repertoire-plus has the advantage that it gives a more realistic picture of the structure within which the painter normally works. All I have now to do is to introduce for the new notion an old word which seems to express it better than the clumsy locution to which I have resorted. That word (need I say?) is 'style'.[7] But in simultaneously strengthening Gombrich's conception and introducing a new word for it, I have elicited a third characteristic of style: that style permits expression. Gombrich in his account of expression makes difficulties for himself by using a weaker conception of style than either his arguments or the facts of the case necessitate.

[7] In 'Style' in David L. Sills (ed.), *International Encyclopedia of the Social Sciences* (New York: Free Press, 1968), Gombrich explicitly connects the word 'style' and the preconditions of expression as he conceives them.

VI

I now want to pause and review the situation. I shall assume that the concept of style as I have identified it in these three contexts is one and the same concept: an assumption whose acceptability or otherwise must depend on its consequences. So far the following characteristics of pictorial style have emerged: First, style is the precondition of our aesthetic interest in a painting; it is only a painting in a formed style that can—though of course it may not—interest us as a painting. Secondly, style is generative; or, to put it somewhat differently, style is something that the painter internalizes. Thirdly, style permits expression.

Now, the first two characteristics clearly go together, in that the first suggests the second. For, if style were purely classificatory or assigned from an altogether external point of view, it is obscure how its possession could set the painter significantly apart from the non-painter; or, to put it more precisely: how style-possession could explain why the work of the one has an aesthetic interest denied to the work of the other. (Indeed, as we have seen, on the classificatory view, the assignment of a style to a painter would seem to be as much a fact about us, who make the classification, as about the painter, who is classified.)

However, if on one (the classificatory) view of style we don't see how its possession *could* account for aesthetic interest, there still remains the question how on the other (the generative) view it actually *does*. And here I must take up the third characteristic of style: that it permits expression. The point, which I put—rather obscurely, you may have felt—by saying that we don't know what weight to attach to what shows up on the canvas of the non-painter might now be rephrased as: We don't know how far we are entitled to find it expressive; we cannot say whether it speaks to us.

But that style permits expression is so far simply a view I have taken over from Gombrich. What reason is there to accept it? I shall not answer this question directly. For though I think that the Gombrich thesis is right in its central intention, I think that the account he proposes of how style permits expression is defective. So what I shall do is to adjust the account, and then hope that the revised picture we are offered of the relations between the two will have an intuitive acceptability. For, according to Gombrich, style permits expression in that style is a set of alternatives; and this suffices in that expression is a choice within a set of alternatives. Very roughly, I want to suggest that this reverses the order of things, which is that style gives rise to alternatives because it permits expression. But since this is rough, let me explain.

I think that style permits expression in two broadly distinct ways, both of which are present in the work of most painters, though to varying degrees. In the first place, since style consists in a systematic way of elaborating or operating on content, it has the consequence that different contents can receive clear and articulated formulation. In many cases the expressive significance of a work will reside

straightforwardly in the content. In the absence of style, content would not come through, it would not be preserved; and so style permits expression by allowing the painter to do just this. Secondly, style is linked to expression more immediately, and that is because the style itself may be expressive. Expressive significance now resides not just in the content but in what specifically happens to the content. It is no longer the *fact* of elaboration, it is the *manner* of elaboration, that leads to expression. In *Guernica* [URL24], it is the assurance with which Picasso constructs the painting that allows us to collect the content: and along the way we pick up more expression from the type, shape, and combination of the elements. It is worth observing that, though these two ways in which style permits expression are complementary, there is also, potentially at any rate, a tension between them—a tension that has left its mark, if obscurely, in many theoretical discussions of style. For the first way encourages the view that style is omnivorous, that it can absorb everything, or that in any given style anything can be stated. The second way, however, encourages a more selective or fastidious view of style: so that different styles are appropriate to different content, and in any given style not everything can be stated.

I think that an account such as I have given of the relations between style and expression not only gives us a better insight into expression in painting, it also fits in better with what we know already about style. For it might be said that intrinsic to Gombrich's unrevised thesis is a view of style that is essentially lexical a view, that is to say, that equates style with a set or list of items, if of a very diversified kind. A style is like a vocabulary. But the view of style implicit in the revision that I have provided of Gombrich's thesis presents style less as a set of items, more as something that determines that set. Style, in other words, turns up in my view more as something law-like or regulative. And this view of style fits in better, I think, with one characteristic of style that I have already reviewed—namely, that style is generative—and also with another characteristic which I have mentioned but not reviewed—that style has a unity. For that unity it is now possible to locate in something like a coherent set of rules, though how to define a coherent, as opposed to a merely consistent, set of rules remains a problem. (In point of fact, I doubt if the unity of a style, or indeed a style itself, can be fully characterized until we place an expressive interpretation on it.) And the view of style as law-like or regulative also fits in well with yet another, a fifth, characteristic of style which I shall mention now, but not again. And that is this: that in the internalization of pictorial style a crucial role is played by physical or psychomotor control. Style modifies the laws of bodily behaviour. To adapt a famous saying of the modern world: Style begins at the end of a hand.

We now need to ask, What is the nature or character of the rules in which style consists? The rest of this lecture will attempt, if obliquely, to answer this question. But first, let me now return—now that we have so many of the characteristics of style laid out before us—to a remark, made earlier, and which may have seemed

odd at the time. I said, you will remember, that we should not expect much illumination from the conventional literature of art-history. I meant that remark: that is, I intended a distinction within the literature. For I think that the characterization of style that I have been proposing fits in very significantly with what has been said, or suggested, within the other, the 'unconventional' literature of art-history. I refer to the work of such powerful thinkers as Wölfflin, Riegl, or Paul Frankl: to whom I owe a great debt.

VII

At this point, I want to change course in my argument. In doing so I shall give a fresh significance to the title, and I hope a further justification to the topic, of this lecture.

Of recent years, as you will know, some far better than I, important advances have been made in our understanding of language through the systematic development of theoretical linguistics. Of course, there has been much distinguished work in this field, but I am thinking particularly of the work associated with Noam Chomsky and his collaborators. Transformational grammar is only one strand in contemporary linguistics, but to many, including myself, it offers the most exciting and illuminating perspective on the subject. More recently, in the last six or seven years, scholars of literature have drawn on transformational grammar to explore what traditionally have been dark areas in critical theory. One of these areas is that of literary style; 'stylistics' is not a new word in critical terminology, but it would be fair to say that the subject has of late been opened up in a way that offers new promise.[8]

Let me try to explain how transformational grammar has been applied to the problem of literary style. According to generative grammar—a subject broader than transformational grammar—a grammar (that is, the grammar of a given language) is thought of as a device or mechanism for producing, or from which may be derived, all those sentences of that language which, independently, we think of as grammatical. What makes a grammar transformational is that it accounts for the derivation of grammatical sentences in two phases. Only the second phase is of concern to us. In this phase we start off with underlying strings of elements which aren't words but are more abstract than that. We operate on those strings or deep structures by means of rules called 'transformation rules', and we get what are recognizably sentences or surface structures. Now one feature of any such rule is that, relative to a given underlying string, it is either obligatory or optional. Obligatory, if we have to apply the rule in order to derive a sentence; optional, if there is a

[8] For the best general picture of this work see Donald Freeman (ed.), *Linguistics and Literary Style* (New York: Holt, Rinehart & Winston, 1970).

choice of rules, any one of which will get us a sentence. It is precisely at this point that the application of transformational grammar to literary style has occurred; for the argument has been that a writer's style can, in part at any rate, be understood in terms of the optional rules he characteristically employs. So, Richard Ohmann, in a highly suggestive essay entitled 'Generative Grammars and the Concept of Literary Style',[9] has attempted to account for the style of Faulkner, Hemingway, and D. H. Lawrence by exhibiting their consistent preference for certain optional transformations—for instance, the use in Faulkner of the relative clause transformation and the conjunctive transformation—and he provided a check on this hypothesis by taking passages from these writers and then systematically reversing these transformations or using other optional transformations, so that we could observe how, under such a simple procedure, most of the features which a sensitive reader would intuitively identify as characteristic of the style of the writer in question are obliterated. Of course, the style characterizations with which Ohmann's argument is concerned are still very broad, but he justifiably points out how far they take us, considering the minimal grammatical apparatus that they invoke.

The suggestion that I should like to make—and for the purposes of this lecture it will remain strictly on the level of a suggestion—is that it might well be possible and profitable to extend to the problem of pictorial style the techniques and procedures that appear to offer so much within literary inquiry. But where I say 'possible' and 'profitable', each of these words, it must be recognized, could serve as the heading for a lengthy discussion. For note at the outset a most obvious difference between applying a transformational analysis, on the one hand to literary, on the other hand to pictorial, style. And that is that in the first case, but not in the second, the proposed analysis occurs within a heavily prepared context. For it is against the background of thinking that language use in general can be explained in terms of transformational grammar that the attempt is undertaken to account for certain special and idiosyncratic uses of language by appeal to some fragment of such a grammar. But nothing analogous exists in the case of painting.

Let me first make certain that I have put this last point clearly. If a critic applies transformational grammar to the elucidation of literary style, he will do so on the basis of a pair of beliefs to which he subscribes: first, he will believe that there is a grammar of a transformational kind that fits the language concerned; but, secondly, he will also believe, more generally, that all grammars must be transformational in character. Or, to put the matter the other way round, he will judge the transformational grammar with which he works to be *descriptively* adequate, in its fit to the language it is about, and also *explanatorily* adequate, in its fit to the theory that is about it.[10] Now it may be that an account of painting that is going to fit the

<hr />

[9] Reprinted in ibid.
[10] Sec Noam Chomsky, *Current Issues in Linguistic Theory* (The Hague; Mouton, 1964); also his *Aspects of the Theory of Syntax* (Cambridge, MA: MIT Press, 1965), I, paras 4, 6.

facts will turn out to be transformational in character. And it may also turn out that any such account, or indeed any such account of any of the arts, must be transformational in character; that is, that we shall have a theory of art to show this. But as yet we know none of this, and we cannot assume it. More specifically, we cannot assume the first on the basis of the second. Indeed, I should tend to think that, if we ever do establish any general findings about what, say, painting must be like, it is at least as probable that we shall establish them through an understanding of what pictorial style is as that we shall be able to appeal to these general findings in our efforts to understand style.

And that is why the issues of *possibility* and *profitability* loom so large in considering a transformational approach to pictorial style. First, then, what are the preconditions of such an approach? Specific to the approach is the conviction that the terminal objects under inquiry—that is, the physical paintings—can be accounted for as the output of a two-stage process, the second stage of which consists in the operation upon an abstract base by means of transformation rules. And the most important single feature that a transformation rule exhibits is that it applies to an object *in virtue of its structure*. Sometimes the effect of applying a transformation rule is that structure changes as we move from base to terminal object, sometimes structure remains constant, but always the operation of the rule takes account only of structural aspects.[11] From this it follows that the two most general preconditions for a transformational approach are, first, that we should have adequate motivation for postulating in the domain of painting a distinction between base objects and surface objects, and, secondly, that we should have an acceptable method for picking out structure or applying structural descriptions at both levels.

In the case of language, the most powerful motive for distinguishing levels, deep and surface, is the issue of ambiguity.[12] For, though some ambiguities can be resolved straightforwardly on the surface by introducing brackets—for instance, the sentence: 'I saw the little girl's dress' can be disambiguated by (as it were) punctuating the sentence—other cases of ambiguity require us to postulate for the different interpretations different underlying sources or, as the phrase goes, different transformational histories. For instance, the now notorious 'Flying planes can be dangerous' can be disambiguated by referring either to a string containing the equivalent of 'planes which are flying' or to a different string containing the equivalent of 'someone flies planes'. And a related, and perhaps a more generalized, motivation is the desire to bring out the close connections that obviously exist between certain sentences, but where this closeness of connection cannot be

[11] Sec Noam Chomsky, *Syntactic Structures* (The Hague: Mouton, 1957), 5.5, and 'On the Notion "Rule of Grammar"', reprinted in Jerry A. Fodor and Jerrold Katz (eds), *The Structure of Language* (Englewood Cliffs, NJ: Prentice Hall, 1964).

[12] Noam Chomsky, 'Three Models for the Description of Language' (1956), reprinted in R. D. Luce, R. Bush, and E. Galenter (eds), *Readings in Mathematical Psychology*, vol. 2 (New York: John Wiley, 1965).

exhibited by a matching of surface structures e.g. (though this relates to an earlier formulation of the theory) the active and passive versions of a sentence. Now I suggest that a similar motivation holds good in the domain of pictures. Certainly I can think of cases where paintings, if they aren't identical, look very similar, and yet they are to be understood in very different ways. For instance, the colour experimental works of Josef Albers and the stark paintings of certain minimalists like Ad Reinhardt. And I am inclined to think that an explanation of the differences (or, more accurately, differences despite similarity) in terms of derivational history is quite promising. And perhaps the introduction of deep pictorial structures does justice to what certain earlier thinkers had in mind when they conceived of physical paintings as derived from 'mental' paintings or some such shadow entities.

On the very complex question, whether we can, in any kind of principled way, assign structural descriptions to paintings on surface and deep levels, the biggest issue is what categories we are to use within such descriptions. What, in other words, is to correspond in these pictorial descriptions to, say, 'Noun-phrase', 'Verb-phrase' in linguistic descriptions? Any categories that we use must satisfy various conditions. They must be free from arbitrariness: they must between them be capable of codifying all the necessary information for stylistic analysis: and they must strike the appropriate balance between the specific and the abstract. Each of these conditions can, of course, give rise itself to problems of interpretation. What does it mean, for instance, to say that the categories must not be arbitrary? An answer that I should propose is that they should be categories that also play a substantive role in any adequate account that we may give of our perceptual processes, or more particularly, of those perceptual processes involved in looking at pictures.

A preliminary list of possible categories might read something like this: Form; Ground; Colour; Depth; Edge; Point of view. And each of these categories might dominate, or have as subsidiary to it, more specific categories. And now note about my list one initially surprising feature: that it contains an ineliminable reference to representation—not, of course, to figurative representation but to representation more broadly conceived. For depth, for instance, enters into a painting only through the representation of depth.[13] Now is it right to have this reference to representation within the most general categories employed in structural description, or is this too constricting? Or, again, might not the right thing be to treat representation as standard, and then to account for the apparently rare cases of non-representation as coming about through the application of structure-dependent rules which operate upon underlying structures and eliminate, or all but eliminate, representation? I feel that these questions are not idle, and the issue that provokes us to raise them is therefore plausibly crucial to painting.

[13] Cf. Richard Wollheim, *On Drawing an Object* (London: University College London, 1965), reprinted in his *On Art and the Mind* (London: Allen Lane, 1973); also *Art and its Objects*, section 12.

So much for the possibility of a transformational approach to pictorial style: what of its profitability? Given the absence of what I have called a well-prepared context for it, why should we prefer this approach to others? (Of course, this is a slightly absurd way to put the question, for it suggests that there is a multiplicity of approaches open to us between which we can choose; whereas, as I see it, we are lucky even to have a straw at which to grab.)

The first advantage of a transformational approach that I can see is that it might permit us a sharper sense of the distinction between the stylistic and the non-stylistic aspects of a painting: say, content, or technique. Now this might strike you as disingenuous since I have already said that in selecting the correct categories that we are to use within structural descriptions we need to make sure that we have those by means of which all the information necessary for stylistic analysis can be codified. So doesn't this mean that the issue of what is and what isn't style or a stylistic aspect of a painting is settled at this point: and, moreover, settled there by a decision on our part? But, if my understanding of a transformational approach is right, its attraction is that it offers us a double check. For it is one thing to set up the appropriate categories, and another, though very closely related thing, to apply them. And the advantage of a transformational approach is that, within it, the question of how the categories that appear in structural descriptions are actually applied to paintings, or what features they are allowed to pick out, is settled beyond residual doubt only when we see what features of paintings can be operated on by structure-dependent rules. An example: I gave in my suggested list of pictorial categories Colour. That seems to imply that the colour in a painting is part of the style. Now, the sense in which this is so, and the sense in which this isn't, is brought out when we recognize how colour can be, and how it can't be, modified by transformation rules. So the application of such a rule might, for instance, have the effect of equalizing the tonality between colour expanses, or, again, of breaking down such expanses into their additive constituents, but an effect that such a rule couldn't have would be the reversal of colour between expanses quite arbitrarily picked out on the surface. For any rule that effected this would not be structure-dependent; for it wouldn't operate on the pictorial array in virtue of its structure. And that helps us to see how colour may be, and how it can't be, part of style.

And this leads on directly to a second advantage of a trans-formational approach, and that is its appeal to structure and structural considerations. For this seems to give us not only, as I've just said, a powerful way of discriminating between style and the rest, but a way that seems intuitively correct. It fits in with our natural conviction that style can be assessed only in the context of the whole painting: or, if style can sometimes be discerned in a detail, this is only because the detail is (as it were) structurefraught.[14]

[14] This point seems to have been appreciated by Wölfflin: see Heinrich Wölfflin, *Principles of Art History*, trans. M. D. Hottinger (New York: Holt, 1932), p. 6.

Thirdly, a transformation approach seems well calculated to bring out a, or perhaps the, kind of complexity typical of painting. And that is complexity that can be exhibited as a direct function of the length of the derivational history of the painting, where this history seems like something we have a natural power to discern. Indeed, I take it that, if we are not to be credited with some such power of discernment, a transformational approach would have no explanatory value.

Now, I hope that I can convey the kind of thing I have in mind through a couple of examples. In late Cezanne and much Matisse we encounter a kind of complexity which could be at least partly accounted for by the operation on an abstractly conceived figure-ground array of a certain rule—a rule that has the effect of successively retrieving the ground in such a way as to make it approximate to, or of equal weight with, the figure. Or in some of the finest works of Mark Rothko, do we not observe a complexity which can be attributed once again to the operation on a figure-ground array, though this time of a rule that suppresses or deletes, though not altogether without trace, the ground?

I leave this fragmentary discussion of a transformational approach to pictorial style on a question mark.

VIII

And now I should like, in conclusion, to return to the issue which was the first to engage me this evening: the condition of the visual arts today. That I connected with the topic—or, more specifically, with the title—of this lecture by saying that it was a conviction of mine of some standing that, if there is a crisis in the visual arts today, it comes about from the peculiar difficulties that confront the contemporary painter in the formation of a style. And these difficulties I in turn connected—you will remember—with the pressures under which the painter finds himself to give to his work an immediate and instantaneous look of its own: pressures which I suggested were ultimately economic in character, deriving from the position of art in the market-place of today.

Now, I hope that I have said enough to indicate why I think that anything that systematically forms an obstacle to the formation of style on the part of a painter could readily bring the visual arts into a critical condition. But that there should be—in the way in which my argument assumes—an antagonism or conflict between the demand for recognizability made of a painter's work and the formation of a style may still seem problematic. The antagonism is certainly not self-evident, but I hope that I have, in the course of this lecture, said something to make it too seem more plausible. For it is implicit in the conception of style that I have been advancing that whether different paintings in the same style will have the same look will depend on the content that is elaborated within the paintings. If that

differs, so may the look of the work. And this difference in look may very well just be what the young painter cannot afford.

But, it might be said, is this not to take too narrow a view of the matter? For does not style itself provide a ground of recognizability? Now it is certainly true that the paintings of a painter with a formed style are recognizable in virtue of their style; but only when, and by those by whom, the style itself has been recognized. And there is nothing in what I have said, and nothing in the facts of the case, to suggest that the recognition is any more simple or instantaneous a process than the formation of a style. From a certain point of view, by a certain time-scale, both processes are accomplished, I suppose, with a rapidity that says something interesting about the congruence of the art of painting and human nature. But that point of view, that time-scale, are not those of the *avant-garde* dealer or his clients greedy for profit or power. And if the style has not been recognized, then it is not necessarily true that paintings in one and the same style will look recognizably alike. Hence the constant danger that for style and its formation will be substituted what might be called the trademark and its imposition on the painter's wares.

With what tragic consequences for our society we can only glimpse. I have spoken of Picasso's *Guernica* [URL24]. It would be a hideous irony of history if in the very year when, to our total incredulity or indifference, over the rural areas of South-East Asia, a hundred Guernicas are perpetrated a day, the resources are wanting to project even one upon a pictorial surface.[15]

[15] These last words were written in June 1972, when the US bombing of North Vietnam and the NLF-controlled areas of South Vietnam had reached a new intensity.

3
Aesthetics, Anthropology and Style: Some Programmatic Remarks (1978)

It is sometimes overlooked that the production, perception, and assessment of works of art involve distinctive yet fundamentally related evaluative contexts. The nature of these activities depends on the complexities of historical conditions, hence the mutual contribution of aesthetics and anthropology. This interdisciplinary relation veers one way or the other depending on methodological requirements. A transparently evident case is the case of the 'transcultural object', i.e. a work of art from an 'anthropological culture' (one with an alien Artworld—one cannot help but characterizing such objects in light of Arthur Danto). Two further points deepen the inquiry. First, given that 'art […] is an essentially historical phenomenon', that it 'changes', we are addressing the past art of our own culture; and second, there is no genuine understanding of art without the imposition of style. Yet 'style-description', the sum of criteria used by art historians to situate artworks within specific periods and territories, produces only a 'taxonomic view'—a creation of critics or historians for their own purposes, which is hopeless: an artist need not be affected in any way by style in that sense. What is wanted is a 'generative' notion of style: a psychologically real, grammar-like method implicit in the working of an artist. This is one of Wollheim's foundational points, sketched here but introduced at more length in 'Style Now', included as Chapter 2 in this anthology, and discussed in Art and its Objects. *Thinking of style as generative produces a solution to taxonomic limitations, and indeed to the problem of transcultural objects, of the transcultural application of style-concepts: Wollheim avers that 'we do right to assume that an aesthetic concept is culturally universal until we have reason to think that it isn't'—indeed, he refers to Noam Chomsky. This explains why the fact that art cannot be genuinely understood without the imposition of a style does not represent a significant problem. Wollheim, at least on this matter, is a naturalist.* [Eds]

Uncollected Writings. Richard Wollheim, Gary Kemp, and Elisabetta Toreno, Oxford University Press.
© Bruno Wolheim 2025. DOI: 10.1093/9780191995767.003.0003

I

Aesthetics has much to learn from anthropology, and anthropology has much to learn from aesthetics. In this paper I cannot hope to do more than say something fairly general about these two processes and their interrelations, and then to illustrate what I have said by reference to a problem that is necessarily of great interest both to the philosophy and to the anthropology of art. The problem is that of style. In talking of art and of style shall have particularly in mind pictorial art and pictorial style.

II

Certain concepts—and these I shall call from now onwards, without prejudice 'aesthetic concepts'—find a significant employment in connection with art. This employment may be in the production, or in the perception, or in the assessment, of works of art. Of these concepts some may be employed only in connection with one or these activities, but there seems good general reason to believe that those concepts which can lay claim to centrality in our understanding or will occur in all three contexts

Of course, this belief needs to be carefully interpreted, and it is plausible only on the assumption that a given concept can be employed in a given context without there being given verbal expression. But this seems on independent grounds realistic. It seems realistic, for instance, to assume that a concept should be employed in the production of art, that it should occur there regulatively, and that this should not be linguistically manifest.

The relevance of this to the present topic is that the concept of style is a very strong candidate for being one of those central to our understanding of art.

III

Aesthetics may be said to begin when an aesthetic concept is subjected to analysis. To subject a concept to analysis is to set out its conditions of application. Ideally analysis would take the form of laying down the truth-conditions for all those assertions, or all those types of assertion, in which the concept characteristically is used. In practice analysis falls short of this ideal, but its success will be measured in terms of the understanding it offers us of the concept under analysis.

Very roughly, it may be said that a concept will be subjected to analysis in one or other of two very different circumstances. On the one hand, the application of the concept may be problematic: that is to say, there will be a considerable degree uncertainty whether something does or does not fall under the concept, and in

consequence the motivation for analysing the concept will be to resolve this uncertainty. The uncertainty, it will be felt, can be resolved by, but only by, making the conditions of application as explicit as philosophical ingenuity permits. On the other hand, the application of the concept may be quite unproblematic. There will be no more than a marginal degree of uncertainty whether things do or do not fall under the concept, and over at least the central range of cases all is clear. Nevertheless the analysis is motivated, for what lies behind it is the desire to have a better grasp of the concept and, more specifically, to grasp how it stands to related concepts. In such cases we know when to say that something falls under the concept, but we do not know, or we do not fully know, what we are saying when we say this: whereas in the other cases, though we don't know when to say that something falls under the concept, we probably have fuller knowledge of what we would be saying when we did say this though such knowledge is thus far merely implicit.

IV

This distinction between the two very different circumstances in which an aesthetic concept may be subjected to analysis suggests an amplification of my opening remark. For it suggests one way in which it might be determined whether aesthetics has something to learn from anthropology, or whether anthropology has something to learn from aesthetics. And the suggestion would be that when the application of the relevant concept is unproblematic, then aesthetics will learn from anthropology, but when the application is problematic, then the lesson will go in the reverse direction.

The rationale to this way effecting the division would go thus: It is to aesthetics, not to anthropology, that, naturally enough, the task of producing the analysis falls. However, there are situations in which aesthetics might look to anthropology for evidence on which to base its analysis. Now, when the application of the concept is unproblematic, then anthropology might be expected to supply aesthetics with many many clear instances where the concept applies and many many clear instances where the concept does not apply, and a consideration of these cases and of what also holds true of them is precisely what should aid aesthetics in making explicit the conditions of application for the concept. By contrast, when the application of the concept is problematic, then anthropology will have nothing to offer aesthetics in the way of clear instances of the concept's applying or not applying, and so aesthetics in formulating the conditions of application of the concept will have to rely on its own resources: it will have, that is, to rely on linguistic intuitions and on comparative material—where comparative material would be material drawn from other and well confirmed conceptual analyses. It is, however, a correlate of this that, when the application of the concept is unproblematic, anthropology has no identifiable advantages to look forward to from the making explicit

of its conditions of application: but that there are clear advantages for anthropology to anticipate—in the way, that is, of determining in many cases whether the concept does or does not apply—when its application has been hitherto problematic.

Such, I have said, is one natural way of thinking that it is determined whether anthropology has something to learn from aesthetics or whether aesthetics has something to learn from anthropology. Reflection, however, might further suggest that, convincing though it is as far as it goes, it is also superficial. There are two complications that it overlooks.

The first complication is this: that whenever anthropology has something to learn from aesthetics, or whenever aesthetics has something to learn from anthropology, the chances are that there is also a lesson to be learnt the other way round. The point is, once considered, reasonably obvious, and perhaps the only implication that needs to be emphasized here is that the question that we should pose is when it is that anthropology has *more* to learn from aesthetics, or when it is that aesthetics has *more* to learn from anthropology.

The second complication, however, is more significant and makes itself felt at just this point. For so far I have talked as though, when an aesthetic concept comes up for analysis. There are two and just two possibilities. Either the application of the concept is unproblematic or the application of the concept is problematic; and in the first case anthropology will be able to provide aesthetics with clear instances of its use, and in the second case aesthetics will not have clear instances of its use to go on. But not merely does this not exhaust the possibilities that theoretically are open, but it does not touch upon one possibility that, in the nature of the subject-matter, is highly likely to obtain when it is an aesthetic concept whose analysis is at issue.

This possibility, stated at its most abstract, is that the application or the concept will be unproblematic over one domain but problematic over another. And what it is in the nature of the subject-matter that makes this a likelihood is that art—the topic of aesthetics—is an essentially historical phenomenon[1]. Essentially art changes, and these essential changes find expression in, amongst other localities, the conceptual structure that surrounds art. So, to spell out the possibility, the application of a certain aesthetic concept may be unproblematic in connection with one historic manifestation of art and problematic in connection with another. And, given the way in which, understandably, aesthetics has developed, it is only a short step from this to think that a situation highly likely to arise is one where aesthetics will have to provide an analysis of a concept whose application is unproblematic over the art of 'our' culture and problematic over the art of an anthropological culture.

[1] Richard Wollheim, *Art and its Objects* (Harmondsworth: Penguin, 1970).

V

But, it might be argued, what does this situation do to alter, as opposed to refine, the original suggestion about when it is that aesthetics has more to learn from anthropology and when the converse holds? For the situation is, surely, just one where anthropology has more to learn from aesthetics and for the reason that the original suggestion canvasses: that is, that prior to the analysis anthropology has little, or no, evidence to offer aesthetics, and yet, once the analysis has been produced, anthropology can make good use of it.

But to argue thus is—or so one might put it—to find the notion of the application a concept being problematic itself insufficiently problematic. It is to assume that, when the application of a concept is problematic, there is either simple ignorance what the conditions of application are or simple ignorance whether these have been satisfied. But ignorance on both these scores can be complex, and the significance of the new situation under review is that it brings out the degree to which this complexity can go.

VI

An aesthetic concept, let us suppose, is unproblematic over 'our' society but problematic over an anthropological society.

The first reason why the concept may be problematic over the anthropological society is that we do not know how to pick out for this society conditions that are equivalent to the conditions that determine its application in our society. The answer may ultimately be that there are no such conditions, and that the concept is therefore limited in its transcultural application. If, however, the concept is not limited in this way—and my own feeling would be that we do right to assume that an aesthetic concept is culturally universal until we have reason to think that it isn't—and we nevertheless have difficulty in extending the class of its conditions of application, the reason may well be that we are looking for the equivalence on too unabstract a level. Or—to put the matter the other way round—it may be that, when we initially identified the conditions of application for the concept in our society, we included too much of the concrete setting that is peculiar to that society, and it is this that proves recalcitrant to generalisation.

But there is another factor, again in the nature of the subject matter, that may further add to the difficulties of determining the conditions or application for an aesthetic concept transculturally. For if it is true, as I claimed earlier on—though I produced no arguments in support of this claim—that, for at least the central aesthetic concepts, if they are to be used in the perception or assessment of works of art, then they must have been used in the production of those works. The implications for the present problem are serious. It follows that in picking

out the conditions that would justify us in applying a given concept to the art or some anthropological society, we must satisfy ourselves that these conditions are also evidence for our thinking that that concept was employed in the production of that art. In using it of a society we need assurance that it was used in the society.

Now this factor clearly complicates the problem of determining transculturally the conditions of application for an aesthetic concept. But this does not exhaust its consequences.

For the second reason why an aesthetic concept may be problematic over an anthropological society is that, even when we have picked out its conditions of application, we may be systematically uncertain whether these are satisfied. And the more complex these conditions, the more likely this is to be the case. This is where the factor that I have just been considering is likely to make itself felt again. For, if amongst the conditions of application for an aesthetic concept over an anthropological society are evidence of the use of that concept in that society, the problem when the concept does and when it does not apply is bound to increase in difficulty. Both the logic and the epistemology of aesthetic concepts in their transcultural use exhibit a fairly radical complexity.

<div align="center">

VII

</div>

This incursion into just how it is that the application of an aesthetic concept over an anthropological society is problematic was undertaken with a purpose. It was undertaken in order to dispute the suggestion that, when this is so, aesthetics has nothing, or nothing sizeable, to learn from anthropology. For this would be so, I claimed, only if the ignorance that prevents anthropology from applying it unproblematically—whether this was ignorance of its conditions of application or ignorance whether these conditions were satisfied—was simple. I have tried to show that it is more likely to be complex. And in this state of complex ignorance anthropology can already have found out or worked out matter of inestimable use to aesthetics when it comes to provide an analysis of the concept. To give two examples that come straight out of what I have been saying: Given a particular concept, any indication of what would he the suitable level of abstraction on which we should look for the conditions of its application transculturally, or, again, any suggestion of what we should take as adequate evidence (linguistic or non-linguistic, it will be remembered) for the regulative employment of that concept this or that culture—these are just the things that would be of inestimable value for aesthetics and also likely to derive from anthropology. If so far anthropology has not taught aesthetics a great deal along these lines, this may be only because aesthetics has been slow to indicate to anthropology what it is that it needs to learn.

VIII

So much for methodology. I now wish to turn to the substantive problem of style, where by 'style' I mean individual style, not general style. And the significance of this problem in the present context is twofold.

In the first place, it is widely conceded that the application or the concept of (individual) style to a work of art or culture is a precondition of its aesthetic interest.[2] (Related to this fact, it would seem, is another, almost as widely conceded: namely that— again, within 'our' culture—the satisfaction of the concept of style is a precondition of a work of art's expressiveness.[3]) Now if this is so it must be a matter of serious moment whether this concept can be applied transculturally. For if it cannot, then either works of art produced outside our culture lack aesthetic interest or aesthetic interest adheres to them along a different route. Many philosophers and anthropologists of art who accept the premiss of this argument would appear to deny the conclusion quite light-heartedly and without explanation.

Second, if the concept of style can be applied transculturally, the methodology of its application is an interesting variant of that which I have just sketched. However, to appreciate this second point, as well as to be in a good position to try to adjudicate upon the first, it is necessary settle one issue which is often left unsatisfactorily vague: and that is whether, in talking or thinking or (individual) style, we are talking and thinking of something that is, or of something that is not, endowed with psychological reality. Or—to put it another way—whether we are taking what may be distinguished—following the practice of linguistic theory[4]—as a taxonomic, alternatively a generative, view of style.

IX

To explain this last point let us start a few moves back. A historian of art considers the work of an artist who is generally agreed to have had and used a formed style. The historian formulates a characterisation of this style, which I shall call a style-description. (We might conveniently contrast a style-description, which characterises the style of the artist, with stylistic descriptions which characterise the artist's individual works but from the point of view of their style, and are therefore dominated by some style-description.) However, when he has produced his style-description, it would be natural for him to ask of it, Is it adequate? But if he is

[2] See Richard Wollheim, 'Style Now', in Bernard Smith (ed.), *Concerning Contemporary Art* (Oxford: Oxford University Press, 1974), pp. 133–53; (and in this volume, pp. 65–83.

[3] E.g. Ernst Gombrich, *Meditations on a Hobby Horse* (London: Phaidon, 1963); 'Style' in David L. Williams (ed.), *International Encyclopedia of the Social Sciences* (New York: Random House, 1968), pp. 352–61.

[4] Noam Chomsky, *Aspects of the Theory of Syntax* (Cambridge, MA: MIT Press, 1965).

to answer this question, he must have—either explicitly or implicitly—a criterion of adequacy for style-descriptions. Now the distinction have in mind between the two views of style might be conveniently brought out by considering two passible criteria of adequacy, both of which enjoy some measure of support and which can be paired off with these two different views.

The first criterion of adequacy would be this: A style description is adequate if and only if

1. it picks out all the interesting, significant, distinctive, features of the artist's work; and
2. it groups them conveniently.

where the key words, 'interesting', 'significant', 'distinctive', 'convenient' are all un-disguisedly intended to make reference to a point of view from which the features show up as interesting, significant, distinctive, and their grouping is found convenient. That point of view is the historian's.

The second criterion of adequacy would be this: A style-description is adequate if and only if

1. it picks out those elements or the artist's work which are dependent upon certain processes or operations characteristic of the artist's activity; and
2. it groups these elements into stylistic features accordingly, i.e. according to the processes on which they are dependent.

To invoke the first criterion of adequacy is to take a taxonomic view of style, and to invoke the second criterion of adequacy is to take a generative view of style. And to take a generative view of style is to imply that style has psychological reality.

X

There are, I think, powerful reasons for taking a generative view of style;[5] though it is worth recording that the consensus of orthodox art-historical opinion seems still committed to the taxonomic view[6] in which they are reinforced by anti-theoretically minded philosophers or art[7]. Here I shall cite only one reason, and

[5] Wollheim, 'Style Now'; Geoffrey Hellman, 'Symbol Systems and Artistic Styles', *Journal of Aesthetics and Art Criticism*, 35.3 (1977), pp. 279–92.

[6] E.g. James S. Ackerman, 'Western Art History', in James S. Ackerman and Rhys Carpenter (eds), *Art and Archaeology* (Englewood Cliffs, NJ: Prentice Hall, 1963), pp. 123–231.

[7] E.g. Morris Weitz, 'Genre and Style', in Howard E. Kiefer and Milton K. Munitz (eds), *Contemporary Philosophical Thought: The International Philosophy Year Conference at Brockport*, vol. 3: *Perspectives in Education, Religion and the Arts* (New York: Albany State University of New York Press, 1970), pp. 183–218.

that is not so much a reason for the generative view or style as (more modestly) a reason against the taxonomic view of style. It is that if we take the taxonomic view of style, we are totally unable to account for the fact about style that I claimed was widely conceded namely, that style is a precondition of aesthetic interest. Indeed, if we take the taxonomic view, we cannot appeal to style—that is, to the artist's possession of an individual style—as a precondition of anything. For on this view, just as it is not a fact about the artist that he has the style that the style-description assigns to him, so it can not a fact about him that he has a style. For from a different point of view, he might have a different style assigned to him, or no style at all. Indeed, relativised in this way neither the style that an artist has nor his having a style can any longer be said to be 'facts' in any straightforward way, and therefore are unsuitable to be introduced in order to explain further aspects of the artist and his work.[8]

XI

However, someone convinced in general of the correctness of a generative view of style might very plausibly find difficulty in understanding how to interpret this view. A central problem (and one that, as we shall sec in a minute, links up with the problem of applying the concept of style trans-culturally) is what is meant here by a process and how processes are to be individuated—for they must be individuated, if pictorial elements are to be grouped into stylistic features by reference to them.

On the relevant notion of process I shall say this: that a stylistic process involves as a minimum a conceptualisation or schematisation of the pictorial elements, and then the application of these schemata or concepts to the pictorial area. Examples may bring out what I intend, and I offer two drawn from the classical art of modern Europe. We might think that we have different stylistic processes when we observe that one artist, for example Raphael, conceptualises contour and shading together, under a single schema, so that they make an undifferentiated contribution to his work, whereas another, Leonardo, conceptualises them separately, under different schemata, so that each makes its own contribution to his work. It is to noted that the schemata and concepts that in this way are regulative of stylistic processes could be much more abstract than this. They could determine just very general invariances.

It follows from this that any adequate style-description must reflect or pick up on the conceptual equipment of the artist. If it fails to do this, then, on the generative view of style, it misrepresents his style.

[8] Cf. Jerry A. Fodor, *Psychological Explanation* (New York: Random House, 1968).

XII

It is now time for us to look at what I have called the methodological variant that appears in the application, transculturally, of the concept of style. For the concept of style shares with other aesthetic concepts the requirement that the conditions for its application to other cultures include something of the conceptual habits of those cultures. But with the normal run of aesthetic concepts, the relevant condition is that the concept itself should have been employed in the production of that to which it is applied. But with the concept of style the condition is less direct. It is that some concept, or set of concepts, capable of regulating a stylistic process should have been employed in the production of that to which the concept of style is applied. The transcultural application of the concept of style requires the previous regulative employment not of that very concept but of a concept dominated by it.

This is the variant.

But, of course, before we can comply with it we need to know in some general kind of way how to identify at least approximately the concepts that are dominated by the concept of style or that could regulate stylistic processes. What, we might ask, borrowing a term from literary analysis, are the primes of style?

Now, in asking this question, we might be tempted to think that we cannot begin applying the concept of style transculturally until we have answered it. But would not this precisely be an example of the simple-minded way of finding the application of an aesthetic concept to another culture problematic? It would be tantamount to saying that, since the application of the concept to an anthropological society is problematic, anthropology must wait on aesthetics and meanwhile aesthetics has nothing to learn from anthropology. And that we have seen is error.[9]

I shall conclude by saying that I am fairly confident that it is worth redefining this error in the context of the concept of style. For insight into the primes of style, and how they can be transculturally re-identified, is precisely the kind of thing that philosophers of art should clamour for from anthropologists of art.

Postscript

At the time that I was writing this essay it struck me that the points that I was trying to make would be immeasurably clearer and more vivid if I could find a way of illustrating them visually. However, whenever I came close to looking for suitable material, an objection restrained me. For surely if my points were sound, did it not follow that there was no way of illustrating them —at any rate, of illustrating them out of anthropological material?

[9] Either Wollheim is following his penchant for unusual turns of phrase, or he meant to write either 'in' or 'an' before 'error'. [Eds]

Fig. 3.1 Ears and hands of Botticelli, according to Morelli.

Take for instance, the notion of a 'stylistic feature', about which the reader might well feel some uncertainty. But suppose what I say about it in this essay is true, then two conditions would have to be satisfied before any piece of anthropological material could be regarded as an adequate illustration of it. The first is this: that it would have to be the case that the material illustrated was indeed the outcome of a formed style, and to be certain of this one would have to be assured that the relevant concept i.e. individual style, did apply over anthropological art. The second condition is this: that for the material to illustrate a stylistic feature one would have to be able to isolate that feature from the rest of the material, and to be able to do this one would need to know on what level or abstraction to look for the feature. But in my essay I argue that whether the concept of individual style can be applied beyond our culture and how levels of abstraction for stylistic features are to be identified are two questions on which it is hard to make much progress before anthropological material has been carefully gathered, sifted, and analysed. So, in trying to illustrate the notion of stylistic feature I would simply jump over what I have been arguing for in the text.

However, it has since occurred to me that by relaxing somewhat the requirements, it might yet be possible to use visual material to make my points. So: We might relax the requirement that it is an actual stylistic feature, as opposed to something that could be a stylistic feature, that is illustrated. We might relax the requirement that the illustration isolates the feature and only insist that it somehow contains it. And we might abandon the requirement that the material illustrated is anthropological: it could be the more familiar material processed by art-historians.

Consider the schedules employed by Giovanni Morelli, the founder of scientific connoisseurship,[10] to establish not (as it turns out) individual style but something related though weaker, what might be called 'fingerprint' [Fig. 3.1].

Let us assume that this schedule represents not only one fingerprint but also the style of the relevant artist, Botticelli. Then the question would be legitimately raised, how many stylistic features are illustrated here? There would of course be

[10] I've dealt with this at greater length elsewhere [in *On Art and the Mind*, London: Allen Lane, 1973].

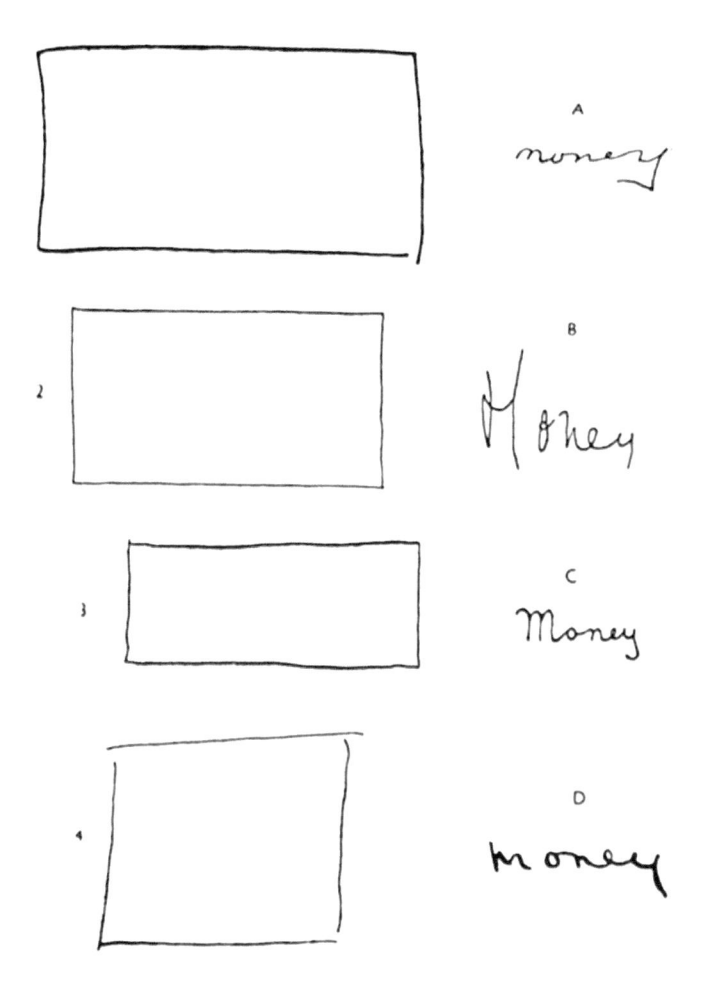

Fig. 3.2 Graphology

only one correct answer to this question, depending on the correct style-description for Botticelli. In ignorance of the correct answer, we might imagine the answer to be one, two three, four ... With each thought experiment we would imagine the schedules to contain—though of course, never to isolate—stylistic features differently individuated. And with each different individuation of stylistic feature[s], we could associate the notion of a different level of abstraction. If we imagine the answer to be one it follows that that feature exists on the highest level of abstraction.

Or consider the following quiz taken from a book on graphology [Fig. 3.2]:[11]

[11] Eric Singer, *A Manual of Graphology* (London: Duckworth, 1969).

Each of the four rectangles has been drawn by one of each of the four writers of the word 'money'. The task is to pair off writer and rectangle.

Suppose we tried to solve this quiz by stylistic analysis. We should be justified in doing this only if we thought that drawing rectangles/writing the word is an activity controlled in the appropriate way by stylistic process. Nothing in the material before us can settle this for us, but if the activity is stylistic, then we have before us material illustrative of four styles. Suppose that we start on the handwriting. Then we have two questions that cannot be answered independently.

On what level of abstraction should we, for each style, look for its stylistic features? What are the stylistic features constitutive of the different styles? (Theoretically it might be possible to specify levels of abstraction without giving examples of features that exist on them, but I don't see how.) Then, if we had answers to these questions, we could then turn to the rectangles and try to see where these stylistic features recur. But of course rectangles and pieces of handwriting might be in the same style and not share stylistic features—they might come out of different parts at the style. Or, when we turned to the rectangles we might see that we had given faulty style descriptions, i.e. we had identified the stylistic features inappropriately

The official answer to the quiz is this:

No. 1 has been drawn by writer D, easily recognisable by the strong pressure of the stroke and the slight slant to the left of the vertical stroke.

No. 2 has been drawn by writer C. Both are very regular and completely upright.

No. 3 has been drawn by writer B. Both are upright. In both the stroke is extended at the top.

No. 4 is drawn by writer A. Both are done a bit haphazardly. Both are slightly inclined to the right.

Has the official answer been arrived at by stylistic analysis?

4

Style in Painting (1995)

Wollheim mentions in his introduction that this, originally in the 1995 volume of essays The Question of Style in Philosophy and the Arts, *is a revisitation of a view expressed in 1972 and 1979. And it came on the heels of an essay on the same topic in his 1994 collection 'Pictorial Style: Two Views'; the present piece considers the subject yet further. Indeed the subject is important to him. He describes his generative, psychologically real notion of individual style: one realized in the artist's 'practical capacities', one that is 'encapsulated in the artist's body […] the hand, the arms', that 'puts within reach of a painter the fulfilment of his intentions'. He distinguishes this notion from the merely taxonomic, categorizing notion of general, historical, or universal style, which is not of genuine use in explanation (he drops, however, the earlier reference to Noam Chomsky's claim that 'Universal Grammar' is psychologically real, but not intrinsically available to consciousness). Painting must be understood as the mode of intentional action that it is. Wollheim stresses the importance of his distinction between 'style-description' and 'stylistic description', an important difference which the taxonomic notion of style cannot capture. He concludes by observing that there are times of deviance from the normal 'one style, one artist' pattern: a painter may lose or depart from their individual style. Indeed, although style needn't normally be consciously represented, the 'time may arise in an artist's life when he starts to represent his style internally [… if] this is a time of deep crisis, we have to be prepared for the possibility that these representations will be misrepresentations.' The potential of introjection, crisis of identity, and other maladies explored in depth psychology thus inevitably makes its appearance.* [Eds]

I

In this chapter I want to re-present and to reconsider a thesis about style—specifically, pictorial style—which I advanced in an essay written in 1977 entitled 'Pictorial Style: Two Views', to be found in Berel Lang's 1979 collection, *The*

Uncollected Writings. Richard Wollheim, Gary Kemp, and Elisabetta Toreno, Oxford University Press.
© Bruno Wolheim 2025. DOI: 10.1093/9780191995767.003.0004

Concept of Style.[1] Pictorial style is a long-standing interest of mine, and I believe style to be a fundamental, indeed a foundational element in the art of painting, and anyone interested in the very little progress that I have made with this element over the years—which may show something about *me,* but which also, I think, shows something about *it*—may compare this essay with an earlier and more complex version of the thesis which I gave in 1972 as the Power Lecture in Sydney and other Australian cities under the title 'Style Now',[2] as well as with the more up-to-date summary of the thesis which I included in my 1984 Mellon Lectures at the Washington National Gallery of Art: now published as *Painting as an Art.*

II

One way of looking at 'Pictorial Style: Two Views' would be to see it as offering a whole catalogue of distinctions.

The essay opens with a broad distinction between *general style* and *individual style.* General style is subdivided into *universal style, historical* or *period style,* and *school style:* and individual style, which is the contrast to general *style,* and which is the real topic of the essay, and for that matter of this chapter, is in turn opposed to *signature.* To grasp what is special to individual style, the contrast between a *merely taxonomic* and a *generative conception* of style is invoked, and the better to understand a generative conception of style, the notion of a *style-process* is invoked, and a style-process in turn breaks down into a *schema* or *universal,* a *rule* or *instruction,* and a *disposition:* the disposition being the internalisation of a rule operating upon what falls under a schema. To refute the taxonomic conception of style I suggested two arguments, each of which is directed against an alleged consequence of this conception: these two consequences I associated with what I called the *description thesis* and the *relativisation thesis.* At this stage it struck me that in order, not just to refute the merely taxonomic conception of style, but (a further matter) to establish the generative conception, what was required was not argument but evidence: and this evidence could only be the fruit of research that presupposed the generative conception. In 1977 I suggested that this search lay in the future. It still does. This means that, now as then, my advocacy of *one* view of style, in so far as it aims at more than *a priori* or intuitive appeal, remains promissory. Another way of putting this last point would be that, now as then, it is the intuitive, the *a priori,* appeal of the thesis I advanced in my essay—in other words, that aspect of it which rests on the distinctions I proposed—that should get the lion's share of attention, and the attention it needs is a matter of showing that these distinctions do not compose a

[1] Reprinted in Richard Wollheim, *The Mind and its Depths* (Cambridge, MA: Harvard University Press, 1993).
[2] See Chapter 2 in this volume. [Eds]

mere catalogue. It has to be shown that they furnish the most natural way of ordering the material of style.

<h1 style="text-align:center">III</h1>

Perhaps I should make it clear that the view of pictorial style that I advocate cannot be expected to find favour, or even to possess intelligibility, outside a broader framework within which the art of painting may be set. This framework is essentially an interpretative framework, and it presupposes that, in trying to understand a painting, in trying to grasp its meaning, we should always see it as (what after all it is) the product of a human mind: the mind of its painter. I say its painter in the singular: though I do not see any fundamental difficulty in extending the framework to cover paintings whose authorship is plural. There should be no greater difficulty in using this framework to understand a work made by more artists than one than the artists themselves would have had in co-operating on the work: which was probably not negligible.

Such a framework might be called a psychological framework. Arguably it might also be called an intentionalist framework, the open question being whether the project of understanding works of pictorial art as products of painters' intentions is or is not narrower than that of understanding them as products of painters' minds. Since I at any rate take a very broad view of what an intention—that is, of what a painter's intention—is, equating it with more or less any psychological factor that motivates him to paint one way rather than another. I shall assume there to be no crucial difference between the two projects. It is in *Painting as an Art* that I put the real case, as I saw it then, as I see it now, for understanding pictorial works of art in psychological, indeed in intentionalist, terms. My argument was this: that, in the case of human artefacts, intentionalist understanding prevails except in those cases where *for a special reason* it doesn't. It is, as is said nowadays, the default mode of understanding. And those cases where intentionalist understanding does not prevail, or where it meets principled opposition, amount to three in number. In two of these cases, understanding of an artefact does not appeal in any way to the artefact's history of production. Let us look at these two cases first. One is where the artefact essentially figures as part of a rulegoverned system that assigns meaning to every item, to every simple or complex, according to the position it, the item, occupies within that system as a whole. As example would be a sentence or a wellformed string of words—not a speech-act, or the utterance of that sentence— as a part of a natural language. The second case where any appeal to history of production is superfluous is where the artefact essentially has a purpose or function, and this purpose is specific enough to determine what the artefact is like to a very minute degree. An example here would be a law or an article in the constitution of a sovereign state. Now the third case where intentionalist understanding is out of place is where the history of production *is* relevant, but in each case, this history is

so totally choreographed—it might, for instance, exemplify a Markov chain where each link in the chain is absolutely conditioned by the immediately preceding link—that what goes on in the head of the artificer, or in the heads of the artificers, can be completely discounted. An example here would be a ritual.

Now it is my claim that a pictorial work of art falls under none of these three headings: hence it requires psychological or intentionalist understanding. (A point about this claim. There may very well be some parts of pictures, there may even be some pictures in their totality, that are bound by meaning-rules, or that are teleologically conditioned, or whose production is exhaustively choreographed, but these instances would do nothing to overthrow a claim about how pictures as a whole, alternatively pictures *in general,* are to be interpreted. So if you are impressed by these seeming counterexamples—*if,* I stress—then take my claim as requisitely qualified.)[3]

I am fully aware that our age bristles with anti-intentionalist, antipsychologistic, claims about the understanding of art. It bristles with semiotic claims and teleological claims: that is, claims that, from the point of view of explanation, art can be assumed to have the structure of a language or can be equated with the output of a social or economic system. So let me make clear that, if any of these claims were justified, my particular view of style would fall to the ground. Having made this point, I now move on to my view of style, armed with the conviction, which you may not all share, that none of the arguments for these claims have the power to detain us.

IV

The starting-point of my consideration of pictorial style calls for the deployment of two of the distinctions I have reviewed: that between individual style and general style, and that between a generative conception of style and a merely taxonomic conception of style. (The word 'merely' here is all important.)

I start thus: We can and do talk of the style of Rembrandt. At the same time we can and do talk of the style of the school of Amsterdam (or the school of Leyden): of the style of northern baroque: and, finally, of the baroque itself as a style. Here we have individual style, school style, historical or period style, and universal style. And the first point I want to make is that, when we make these distinctions, it is at least open to us to make one more distinction than the surface structure of our talk makes apparent, for it is a distinction buried in what we say: furthermore we often take advantage of this opportunity. The opportunity arises because in the world individual style differs from school style, period style, and universal style not just in that an individual is a different, or different kind of thing from a school, from a period, or from the world of art at large—that is, *the things that have the style* are

[3] Wollheim left out the closing bracket; it seems obvious if not certain that he meant to put it here. [Eds]

different—but in that *style itself*, or *the thing had*, is a different, or different kind of, thing when had by an individual from what it is in the other three cases. We don't of course always recognise this: but when we *do*, though our talk continues not to, our thought does. For, in giving expression to this recognition, we employ, when we refer to individual style, the generative conception of style, as opposed to a merely taxonomic conception, which is what we use in talking of school style, period style, universal style. However, employing a generative conception of style is not simply a way of recording that there is something special about individual style. It does that, but it does more than that. It registers what *is* special about it. In other words, unpack the generative conception, and you will discover what is different about individual style. Unearth what is different about individual style, and you will have the materials for reconstructing the generative conception of style.

<div align="center">

V

</div>

So let us consider what it is that *is* different about individual style. What are the characteristics that single out individual style? I suggest the following:

(a) Individual style has *reality*. That is, there is a fact of the matter to a painter's having a style: having a style makes a difference to the painter.

(b) Individual style has *psychological* reality. That a painter has a style is a fact of psychological matter: the difference that having a style makes is a difference in the mind of the painter.

(c) Individual style is something that the painter *acquires*. A painter's style is not a matter of natural endowment. Nor does a painter have a style solely in virtue of being a painter. It is easy to confuse the truism that, if X, a painter, has a style, then it is X's style that he has with the further claim that, if X is a painter, then there is a style, X's style, that he has. The latter claim is not truistic, it is false. A painter may have no style: though, if he has one, it would be his and it would be named after him. In my earlier essay I made it true, stipulatively true, that every *artist* has an individual style. That impresses on us a particular way of understanding the term artist.

(d) An individual style is acquired through being *formed*. It is formed, not learnt: though an artist may learn how to form a style. He may learn it through being taught, from example, or by trial and error. Or he may just form a style without having first learnt how to do so.

(e) Before forming a style, the artist produces his *pre-stylistic work*. The style once formed accounts for the artist's *stylistic work,* so long, that is, as the style endures. However, the style may, for one reason or another, decay or disintegrate, and then, if the artist continues to work, his work will be *post-stylistic*. And finally the style may persist yet a possibility opens up which conventional art history often

overlooks and which a realist understanding of style singularly equips us to recognise: that is, the artist may engage in some undertaking that his style cannot encompass, and in this case his work will be *extra-stylistic*. Extra-stylistic work presents special problems for the student of style or (as he is called) the connoisseur. He may be misled by it in one or other of two ways. If he is trying to build up a description of the artist's style, he may be misled by extrastylistic work and build up an unduly broad description of the artist's style: however, if he has already built up a true description of the artist's style and is now trying to use this description to construct a corpus of the artist's work, he may be misled by extra-stylistic work into constructing an excessively narrow corpus.

(f) The style that the artist forms subdivides itself into two capacities or skills. The first consists in segmenting or conceptualising the elements of a painting in a certain preferred way: this gives what I call the 'schemata' of that artist's style. The second consists in evolving rules or principles for operating with these schemata: that is to say, giving shape to them and placing them on the support in relation to one another. Two points need to be stressed about both these capacities. In the first place, they are practical, not theoretical, capacities. They are exercised by the artist in making his picture and they evince themselves in an intellectual form only if it is in the nature of the particular artist to reflect upon his way of making a picture. Secondly, both capacities resist propositional or (for that matter) imagistic formulation. This point does not merely recapitulate the previous point: it also tries to do justice to the high degree of context-dependence to which these capacities are submissive. In different contexts the same style might find outlet in two very different-looking outputs.

(g) Individual style is highly internalised: not just in that it does not require reflective consciousness, but further in that it is encapsulated in the artist's body. Individual style involves a modification of the movements of the fingers, the hands, the arms, indeed the whole body: more specifically, it involves modification of those movements through the monitoring role of the eye. Style is a particular fine-tuning of what Merleau-Ponty called the 'hand-eye'.

(h) And finally style can be partially grasped through its consequences. Specifically style puts within reach of a painter the fulfillment of his intentions. An artist can *fulfil* his intentions: the painter who is not an artist can merely make work that is *suggestive of*, or *evidential for*, his intentions. A further point, or perhaps the same point, and I find it hard to decide which, the formation of a style permits expression.

VI

A point that cannot be too heavily or too frequently emphasised is that this view of style is not a *formalist* view of style. The schemata that are the bricks out of

which individual styles are formed are not to be understood as limited to formal or formally defined elements. (The problem here, as elsewhere in arguing against formalism, is to make the target, formalism itself, a coherent view.) Formalism, if it is to merit its appellation, ought to think of schemata as narrowly configurational items which a careful scrutiny of the support will reveal inscribed on it. Schemata should be confined to such things as lines, squares, spatterings, absence of black, expanses of white or red, and film of blue over apricot. Few formalists are as consistent as this, so my strategy will be to give a capacious list of items that I believe a viable account of pictorial style *must* be ready to admit as possible schemata in an artist's style, and I am confident that, at *some point* in the course of this list, any self-styled formalist will object.

In the first place, then, room must be found in the list of schemata for *material elements* of the painting: that is, elements that depend upon the artist's materials not only for their realisation (all plausible candidates, including configurational items, must do this) but also for their identification. Examples would be: cross-hatching, contour, (in medieval panels) punch mark, (in later art) impasto, patches of lapis lazuli, priming, weave of the canvas. Secondly, room must be found for *represented elements* in the painting: that is, elements whose claim to be part of the content of their paintings rests on the fact that they can be, and correctly are, seen *in* the surface of the painting. Examples would be: sphere (as opposed to circle, which *is* configurational), middle ground (as opposed, say, to half way up the surface, which also is configurational), in movement or fast-moving, foreshortening. A sure sign of a represented element is when its identification requires attention not just to the two dimensions of the surface, but to a third dimension. For that third dimension is a represented dimension. Finally (and by now at any rate the formalist is left behind) there must in the list of schemata occur *figurative elements*: that is, elements that not only require for their detection seeing-in but are then identified through concepts of which geometry, even in the most extended sense, has no ken. Examples would be: body, foliage, drapery, valley, battlefield, shadow, reflection in the water, skin, eyebrow.

Incidentally the last four examples of figurative elements that might turn up as schemata within a particular artist's individual style have not been chosen at random. They are taken from interpretative views of my own about the style of two major artists: Monet and Titian. I have recently argued that shadows, particularly shadows that run at six o'clock from the represented object straight down towards the bottom edge of the painting, play a crucial role in Monet's strategy of incorporating the spectator. They account for his marked preference for back-lighting or the *contre-jour* effect. Indeed it was only when Monet fully appreciated that reflections in the water are not like shadows but *invariably* run straight towards the spectator, no matter where the source of illumination is, that he shifted from back-lighting to direct or frontal illumination. (The *Poplar* series is the turning-point.) Again, I have argued—and the argument is too detailed to

recapitulate here—that in the style of Titian, the segmentation of, and emphasis upon, skin, human skin, and the eyebrow, envisaged as the arch that frames the organ of sight and shows off the delicacy, the fragility of skin, are crucial factors in the systematic fulfilment of his intentions.

In decrying a formalist understanding of pictorial style, I ally myself, as I see it, with two highly original thinkers in the field, whose contributions to the theory of style are momentous but whose work has been in several regards gravely distorted: Heinrich Wolfflin and Giovanni Morelli. Morelli's anti-formalist stance is surely attested to as strongly as one could wish by the schedules that he offered for the recognition—I should say for the stylistic recognition, the recognition via style—of the work of the great, and the less great, masters: for these schedules try to establish how the artist in question depicted the ear, the ball of the thumb, the forefinger, the toe. What has allowed Morelli to be erroneously recruited to the formalist camp is the suggestion, made (I believe) too much of, that these depictions always preserved a constancy of configuration: that they were completely inelastic to the pressures of context. The case of Wölfflin is more complex. Addressing himself primarily to the issues of general style, he gave the impression that, when the issue of individual style came to be broached, the schemata out of which the different individual styles were made up could be identified in the same way, in the same terms, as those in which he *purported* to describe general style: that is, in overtly configurational terms, such as open versus closed forms, painterly versus linear etc. But when we examine Wölfflin's account of an individual style—say his account of Raphael's style in the Stanze, in *Classic Art*—it is represented elements, indeed figurative elements, that are invoked and do the work.

VII

Reference to Wölfflin and to Wölfflin's preoccupations might seem to provide just the right pretext for switching from individual style and the generative conception of style and the merely taxonomic conception that suffices for its characterisation. But I shall delay making the transition until I have made a methodological point about the study of individual style. It is a point that requires the introduction of a new distinction, and once the point is made, the contrast between individual and general style should be starker.

I start then with the distinction. The distinction is between a *styledescription* and a *stylistic description*. A style-description, as I use the phrase, is a description of an artist's individual style: it describes the schemata and the rules, and it might, for good measure, throw in some indication of where and why it was that the artist took on tasks to which his style could not be turned so that the work he

did was extra-stylistic. In contrast to a style-description, a stylistic description is a description not of an artist's style but of a painting by an artist in his style, and, in describing it, it concentrates on the picture's stylistic features: it concentrates on those features which the painting owes to the artist's style and shows how this is so.

I hope that I have said enough about individual style to put it beyond doubt that in my view the project of producing either kind of description is a fantastic idealisation of conceivable art-historical practice. But this does not mean that to reflect upon these idealisations is without value. Quite the contrary, I should say.

The first thing that such reflection reveals is that there *is* a distinction to be drawn between the stylistic and the non-stylistic features of a painting. For not everything that manifests itself on the surface of an artist's work is the direct output of that productive system which is his style: though it might be hard to find features that were untouched by style. Secondly, what are the stylistic features of a picture in an individual style depends on the content—that is to say, the schemata and the rules—of the style that it is in, and there is no way, independent of the style itself or in advance of the style description, to predict how the features of a painting will divide themselves between the stylistic and the non-stylistic. And the third thing that reflection on the distinction between styledescription and stylistic description brings to light is the ineliminable gap that divides the two. In other words, there is no delimitable body of information that will allow us to infer from any stylistic description of a work by an artist or any set of stylistic descriptions of works by the same artist to the relevant style-description. This results from amongst other things, the fact that, in any given work or in any given body of work of an artist, his style may not be employed in its entirety. Conversely, there is no delimitable body of information that will allow us to infer from the style-description for a given artist to the stylistic descriptions that paintings of his will satisfy. This results from, amongst other things, the vast complexity of ways, which is not in principle reducible, in which the different rules constitutive of the style interact with one another.

VIII

And now is the moment, as I see it, to turn from individual style to general style in all its varieties, or to turn from the generative conception of style to a merely taxonomic conception. For once we make the transition, then it will turn out to be a feature of the new terrain in which we find ourselves that here there is no gap to open up between style description and stylistic description.

Let us look at this.

In so far as it is plausible to think of a style that belongs to a school, or of a style that belongs to a period, or of a style that is in principle universally available, it is clear that we are not entitled to claim that in each case there is a productive system

that could account for the style. That being so, in what does the unity of a general style consist? And the answer must be that it consists in some conjunction, or some disjunction, or (likeliest) some conjunction of disjunctions, of features or properties that are identified by their appearance, and what makes it plausible to colligate such features is that clusters of otherwise related works of pictorial art satisfy just such colligations. We scan, say, the paintings of students of some artist and find that they share certain features to define a certain school style. Or we scan the paintings produced by various painters living in some temporal and probably spatial propinquity and find that they share certain features and then we use these features to define a certain period style. And the same kind of thing goes for universal style. And that general styles are, all of them defined in this way, by invoking solely manifest properties that are observed to be co-instantiated, reveals conclusively that general style involves a merely taxonomic conception of style.

And now we should be able to see why, in the domain of general style, there is no gap between style-description and stylistic description. The only discrepancy that could occur would be of a trivial kind. It would be when a painting in a general style does not satisfy *all* the properties definitive of that style, for then there would be an underlap of stylistic description and style-description. Not the whole of the style-description would be taken up in, or find its way into, the stylistic descriptions of work in that style. But this offers no difficulty of principle. In the case of a general style, particular stylistic descriptions stand to the appropriate style-description like different texts in the same language do to a lexicon of that language. However in the case of individual style, particular stylistic descriptions stand to the appropriate style-description more like different texts in the same language do to a grammar of that language.

What characterises general style may now be formulated. I suggest the following:

(a) General style, unlike individual style, lacks reality. There is no fact of the matter to it. From this it follows that

(b) general style, unlike individual style, has no explanatory value. It cannot explain why paintings in a given general style look as they do. On the contrary, they are in whatever general style they are in because of how they look. And another consequence to follow from the fact that general style lacks reality is that

(c) art historians may reconstruct or redefine general styles as they find helpful. They may tamper with the identities of styles by amalgamating, subdividing, or gerrymandering them, and they may tamper with the contents of styles by altering the properties that define them. They may do so for a number of reasons, but the reason can never be that they thereby do better justice to the styles themselves. By contrast all justified rewritings of styledescriptions of individual styles will, if justified, be justified in this way.

IX

I have mentioned, as have other contributors to this volume, *signature.*[4] Signature is not, strictly speaking, a form of style at all. It is however a sibling of style, and, in so far as we look at it in this way, it is the merely taxonomic conception of style that we employ. Signature is a set of features that we use, and are justified in using, to establish authorship. They are drawn from stylistic and non-stylistic features of the work indifferently, but, in so far as they include stylistic features these features do not have to be identified stylistically, i.e. as the outcome of certain stylistic processes. They can be identified in any way that best serves the purpose for which signature is invoked: that is, making true and secure attributions of painting to painter. Signature itself is of great importance to art history, but I do not believe that the conception of signature is of much interest to the theory of art.

X

I have talked of individual style as psychological. I wish it to be recognised that, on my understanding of the matter, it is psychological only in a minimal sense. It is psychological only in the way in which vision or language-competence is psychological. It interacts with other psychological phenomena at any rate at some level. There has been no suggestion on my part that the artist has direct access to the processes of style, or even that he is in a particularly good position to retrieve them after the fact: indeed there is no reason to think that he has any mental representation of his individual style, either in an overall way or in its detail or structure. This last fact is connected with the well-attested way in which artists never fail to resent the fact that they have a style. (Which is not to say that they wouldn't also resent the allegation that they *didn't* have one.)

However, times of crisis may arise in an artist's life when he starts to represent his style internally. And at the same time he represents to himself the style of others. If this time is a time of *deep* crisis, we have to be prepared for the possibility that these representations will be misrepresentations, and in line with what depth psychology teaches us is pervasively the case, they will be misrepresentations in *corporeal* terms. The artist's own style and those around it will be conceptualised as bits or parts or products of the body, and by this stage the scene is set for any one of the great dramas of projection, introjection, projective identification, that deep crisis precipitates. The style of another becomes an introject, and it is I think in this way, in these terms, that we should attempt to understand the otherwise

[4] C. Van Ecky, J. McAllister, and Vander Vall (eds), *The Question of Style in Philosophy and the Arts* (Cambridge: Cambridge University Press, 1995). [Eds]

puzzling phases in the lives of great artists when their individual style drifts into grave trouble. I am thinking, for instance, of the extraordinary momentary submission of Titian to the muscular style of Michelangelo or Pordenone: or the momentary submission of Renoir to the hard-edged style of Ingres: or the clamorous inner dramas of Picasso's stylistic evolution.

I mention this subject not to develop it, but just to show what must be developed if we are to stick to the maxim that I claimed in 1977 is fundamental to stylistic studies: one artist, one style. Only in cases of real breakdown should this maxim be abandoned. After all, a style can retain its identity, can be the very style it is, *and* undergo change. Indeed nothing can undergo change unless it remains what it is, or retains its identity. It is not change that contrasts to identity: what contrasts to identity is diversity. I am sorry to end this chapter on a truism, but regrettably the state of the subject makes it appropriate.

THE THEORY OF PICTORIAL REPRESENTATION

<center>

5

On Pictorial Representation (1998)

</center>

This lecture was originally delivered as the Gareth Evans Memorial Lecture at the University of Oxford, 26 November 1996. In it, Wollheim delivers his well-known theory of pictorial representation, and defends it briefly against both the Semiotic and the Resemblance views of Malcolm Budd and Chris Peacocke (for more detailed criticism of the Semiotic view, see Lecture III of Pictorial Organization, Chapter 5 in this volume; for Wollheim's criticism of a later Resemblance view, see 'What Makes Representational Painting Truly Visual?' (Chapter 6 in this volume). His criticisms of semiotic approaches—here understood as 'the grasp of representational meaning is fundamentally an interpretative, not a perceptual, activity'—are here handled at a very general level: Wollheim finds this in violation of the 'fundamental requirement' that 'pictorial representation is a perceptual, more narrowly a visual, phenomenon'. Resemblance Theory, on the other hand, passes the 'minimal requirement', but does not pass the 'amplified requirement', that representational seeing 'will be, or include, a visual awareness of the thing represented'. For the right-hand term in 'x is experienced as resembling y', though a 'possible visual field', is not itself a matter of visual awareness. According to Wollheim, his theory—founded on childlike experiences of seeing animals in clouds and the like—straightforwardly passes the test, and he defends the theory against the frequent criticism that his use of seeing-in is phenomenologically too thin. He avers that on matters of further detail the verdict must go with his theory (on the famous c.1535–40 painting: 'Parmigianino (1503–1540)'s Madonna is not represented as having a long neck', for example). He takes pains to stress the advantages of a central phenomenological feature of seeing-in, which is its 'permeability to thought, whether the thought is directly caused by the marked surface or is partly prompted by another', notes that it is one two-faceted experience, not two simultaneous experiences,[1] and closes with his finding 'place for imagination in my account of representational meaning, but it is a place that is ancillary to seeing-in and is

[1] This is a change from his earlier (1980) view in 'Seeing-As, Seeing-In, and Pictorial Representation' that seeing-in involves two experiences at once: Richard Wollheim, *Art and its Objects*, 2nd edn (Cambridge: Cambridge University Press, 1980), supplementary essay 5, p. 224. [Eds]

Uncollected Writings. Richard Wollheim, Gary Kemp, and Elisabetta Toreno, Oxford University Press.
© Bruno Wolheim 2025. DOI: 10.1093/9780191995767.003.0005

relevant only to certain paintings', namely the infrequent but important role of the 'internal spectator' (see 'Imagination and the Pictorial Understanding', Chapter 11 in this volume). [Eds]

I

Philosophical theories of representation abound.

This tells us something; in fact, it tells us two things, two philosophical things, about representation. The first thing is that, when we set out to ascertain the extension of the concept representation, armed with the resources we should expect to be adequate—that is, such intuitions as we have, plus the careful consideration of examples—we encounter many hard cases. Are maps representations? Are traffic signs representations? The second thing is that these hard cases are totally resistant to stipulation. No-one (I find) will take it on trust from me that, say, trompe l'oeil paintings [see Fig. I.2] are not representations, but that most abstract paintings are. The centrality of representation within the pictorial arts means that any answer that is not supported by a theory, moreover a theory that meshes at once with a general account of perception and with broad cultural practices, will not do.

Hence the abundance of theories of representation.

II

However many such theories fall short of a certain minimal requirement, which has as its aim to safeguard our strongest intuition about representation, this time about, not its extension, but its nature. And that is that pictorial representation is a perceptual, more narrowly a visual, phenomenon. Imperil the visual status of representation, and the visual status of the pictorial arts is in jeopardy. And for the duration of this lecture, I shall take what is nowadays called the 'opticality' of pictorial art as given.

But how is the minimal requirement upon a theory of pictorial representation to be framed? I start with the following: (One) if a picture represents something, then there will be a visual experience of that picture that determines that it does so. This experience I call the 'appropriate experience' of the picture, and (two), if a suitable spectator looks at the picture, he will, other things being equal, have the appropriate experience.

Some explanations:

A suitable spectator is a spectator who is suitably sensitive, suitably informed, and, if necessary, suitably prompted. The sensibility and information must include a recognitional skill for what is represented, and 'other things being equal' means that, in addition to viewing conditions being good enough, the spectator must

recruit all these qualifications to the task to hand. As to 'suitably prompted,' that is intended to forestall a possible oversight and to neutralize an all too common prejudice. What may be overlooked is that sometimes, even if a spectator has the relevant recognitional skills, he may not be suitably informed unless he is told, thing by thing, what the picture before him represents. Without this information, he will not have the appropriate experience. And the prejudice is to assume that, if, without this information, the spectator is unable to experience the picture appropriately, then, with this information, he will still not be able to. The information may affect what he says, but how could it affect what he sees?

Elsewhere I have argued that to dispel this prejudice we should recall those childhood days when we were given a line-drawing and asked to say what was in the foliage, and we said nothing, because, turn it this way, turn it that way, we saw nothing, and then we were prompted, we were shown the key, and we said 'Boy', 'Camel', 'Fish', 'Rabbit', 'Deer', and what had changed was not just what we said. What had also changed was what we saw. Hence prompting, and the need for reference to it in even so skeletal a version of the minimal requirement.

What makes this version skeletal is that, though it insists that, for each representational picture, there *is* an appropriate experience, it says nothing about what this experience is like. Later we shall have to make good this deficiency. Meanwhile, are there any theories that fail the minimal requirement even in this version?

III

Suspicion falls first on the theory, or rather family of theories, that I have called Semiotic, which have in common that they ground representation in a system of rules or conventions that link the pictorial surface, or parts of it, with things in the world.

If, in our day, the most vociferous of these theories are those which model the rules of representation upon the rules of language, they are also the most vulnerable since, true to the analogy that inspires them, they hold that representational meaning depends upon pictorial structure. But, in the relevant, or combinatory, sense, pictures lack structure. There is no nontrivial way of segmenting pictures without remainder into parts than can be categorized functionally, or according to the contribution they make to the meaning of the whole.

Accordingly, what is specifically wrong with linguistically oriented Semiotic theories of representation can come to obscure what is essentially wrong with Semiotic theory. To bring this out I propose (one) to concentrate on the most plausible version of the Semiotic theory, which is one that not merely drops the commitment to pictorial structure, but insists that the rules of representation cannot be applied, either by artist or spectator, without recognitional skills for the things represented, and (two) to consider whether such a theory meets the minimal requirement by

seeing what it makes of the process by which representational meaning is assigned to pictures by a spectator. Of course, on the face of it, there is no smooth transition from what representational meaning is to how representational meaning is assigned, or vice versa. No theory of representation should neglect the fact that one of the best ways of finding out what a picture represents is by looking at the label. However, for any theory of representation, there is a way of assigning meaning to pictures that tracks how that theory says that pictures come by their meaning, and my current strategy is to see whether the way associated with the most plausible kind of Semiotic theory allows sufficient room for perception. Does it allow room for an appropriate experience?

The answer will turn out to be No. No, in that, though the most plausible Semiotic theory lets perception in at two distinct points in the process of assigning representational meaning to pictures, at a third, and what is the crucial, point it excludes perception.

Any Semiotic theory, linguistically oriented or plausible, lets perception in at point one: the spectator must be visually aware of the surface to which he then applies the rules of representation. Any plausible, as opposed to linguistically oriented, Semiotic theory lets perception in at point two: for the spectator must have the relevant recognitional skills if he is to apply the rules of representation. However, Semiotic theory of all kinds is debarred from finding any further need for perception. And that is because, from this point onwards, all the spectator has to do is to apply the rules to the surface, and the rules will take him, without any help from perception, to the thought of what is represented, which is his destination.

A way of putting the point is to say that, on any Semiotic theory, the grasp of representational meaning is fundamentally an interpretative, not a perceptual, activity. In consequence no appropriate experience is postulated, and it is thus that the Semiotic theory fails the minimal requirement.

IV

If it shows how wide of the mark Semiotic theory is that it fails the minimal requirement even in this skeletal version, this also suggests that, if further theories of representation are to be tested, the minimal requirement needs to be amplified. It will have to say, for every representation, what the appropriate experience is like.

At this point help comes from another strong intuition that we have, again about the nature of representation. For, if, before an otherwise suitable spectator, looking at a representation, can have the appropriate experience, he must have the relevant recognitional skills, the corollary is that, if he lacks these skills, he can, through looking at the representation and being suitably prompted, acquire them. Other things being equal, he will simultaneously have the appropriate experience and

acquire the recognitional skill. It is thus that children acquire a very large number of their recognitional skills from looking at illustrated books. My daughter, on seeing her first elephant at age two, exclaimed, 'Babar.'

This being so, if we want to know what the appropriate experience is like, we have only to ask, Through what kind of experience do we gain a recognitional skill? and the answer to that question is surely this: We gain a recognitional skill through an experience in which we are visually aware of the thing, or the kind of thing, that we are thereby able to recognize. Arguably there could be degenerate cases in which we learn to recognize one thing on the basis of being shown something very like it and then getting ourselves to see the look-alike as the thing in question. But this method could as readily leave us with a merely inferential, as with a truly recognitional, skill. If all this is so, then we can fold this conclusion into our minimal requirement as clause three so that the whole thing now runs as follows: (One) if a picture represents something, there will be an experience of it, called the appropriate experience, that determines that it does so; (two) if a suitable spectator looks at the picture, he will, other things being equal, have this experience; and (three) this experience will be, or include, a visual awareness of the thing represented. I call this the amplified, as opposed to the skeletal, version of the minimal requirement.

Thus re-armed, I turn to the next theory on which suspicion falls, though it is also that on which common wisdom settles: that is, the Resemblance theory. It too is a family of theories, members of which may be divided up two ways.

The first way of dividing up such theories is between those which do not, versus those which do, insist that the resemblance, which holds, of course, between something pictorial and something extra-pictorial, is experienced. However, what these latter theories insist upon is not that there is a resemblance between two such things, and that this resemblance is experienced. All that they ask for is that the two things are experienced as resembling, which is compatible with a very wide range of actual resemblance or actual dissimilarity. Clearly it is only the latter kind of Resemblance theory that will satisfy the minimal requirement, indeed, that will satisfy it even in its skeletal version. For it is only it that finds room for an appropriate experience.

Secondly, Resemblance theories may be divided up according to the terms between which the resemblance relation holds. (And, since, from now onwards, I shall confine myself to theories of experienced resemblance, and since experienced resemblance, unlike resemblance itself, is nonsymmetrical, I shall be able to talk about the right-hand, or resembled, term and the left-hand, or resembling, term.) Now, disagreements about the resembled term are, in effect, disagreements about the scope of representation, and I shall return to that topic later. As to disagreements about the resembling term, the crucial issue is whether it is, at any rate in the first instance, something on the pictorial surface or some part of the spectator's experience on looking at the pictorial surface.

Finally, and still on the issue of the resembling term, let us be on our guard against those versions of the Resemblance theory which rely upon generalizing remarks of a sort that we indisputably make in front of representational pictures, and which are of the form 'That looks like a Saint Bernard', 'That looks like Henry VIII.' For note that, when we make such remarks, the demonstrative picks out, not some part of the pictorial surface, not some part of the spectator's experience, but the represented thing: the very breed of dog, the very royal person, that the picture represents. In other words, in each such remark, the resembling term is an artifact of, or has been brought into existence by, representation. In consequence, any generalization of such remarks will not be a theory that explains representation by reference to resemblance. It will be a theory within, not of, representation, Which it presupposes.

It was received opinion that the Resemblance theory was dead, and then in the last few years two singularly subtle versions of it have appeared, raising second thoughts: one advanced categorically by Christopher Peacocke,[2] but renouncing the label, the other, coming from Malcolm Budd,[3] accepting the label, indeed, expressly looking to see the best that can be done under it, and hence advanced only hypothetically.

Both theories are theories of experienced resemblance, and both introduce the visual field of a spectator so as to obtain the left-hand or resembling term. However, the two theories conceive of the visual field somewhat differently. Peacocke conceives of it as having both representational and sensational properties—but only the sensational properties provide the resembling term in the case of pictorial representation. For Budd the visual field has only representational properties, and therefore these provide the resembling term. Indeed, for Budd my visual field is nothing but how the world, as I look out on it, is represented by vision, *with one proviso*: that we have abstracted away all properties involving distance, or outwardness. (Whether such an abstraction is possible, or whether the most that we can do in this direction is to conceive of the different things we see as represented to us as all equidistant from us, is an important matter, but not to be pursued here.) It follows from there being these differing conceptions of the visual field that, for Budd, when something in the visual field is experienced as resembling something else, something nonpictorial, so too is the corresponding part of the pictorial surface. But not so for Peacocke, who introduces another relation holding between the picture and what it represents, and this relation goes through, and is defined partly in terms of, experienced resemblance.

And just a word on what both theories take to be the resembled term. It is another visual field, a possible visual field: more precisely, it is that visual field which

[2] Christopher Peacocke, 'Depiction', *The Philosophical Review*, 96 (1987), pp. 383–410.
[3] Malcolm Budd, 'How Pictures Look', in Dudley Knowles and John Skorupski (eds), *Virtue and Taste* (Oxford: Basil Blackwell, 1993), pp. 154–75.

the spectator of the representation would have, were he, instead of looking at it, to look at what it represents. But, for any represented thing, there is a myriad of ways in which it can be seen, and to each of these ways there corresponds a different possible visual field. Accordingly, the second visual field, or the resembled term, fixes, not only what is represented, but how it is represented: that is to say, what properties it is represented as having. Take two of Monet's *Grainstacks* that represent the same two stacks. Evidently they represent them differently, or as having different properties, but how are we to account for these differences? On the present theory we are to do so by first taking the visual fields to which looking at these two pictures gives rise, and then asking of each, Which of the myriad visual fields to which looking at two grainstacks in nature gives rise would a suitable spectator experience it as resembling? So, if one of these pictures represents a large grainstack, and it represents this as in full sunlight, it does so because the visual field generated by looking at it pairs itself off with the visual field that would arise when looking at a large grainstack and seeing it as in full sunlight.

The further details of both theories are more complex than I have need to take account of, but let me, at this stage, express a preference between the two theories. Peacocke's theory specifies that the experienced resemblance between the two visual fields is specifically in respect of shape. In doing so, it gratuitously comes down on one side rather than the other of Heinrich Wölfflin's famous distinction between the linear and the painterly modes of representation, between the art of stressed, and the art of unstressed, edges.[4] Peacocke's theory aligns itself with the linear mode. Budd professes to avoid this partiality by substituting experienced resemblance in structure for experienced resemblance in shape. If—and I repeat 'if'—there is a real difference that correlates with this distinction, then Budd surely improves on Peacocke in substantive adequacy.

So now to the question whether the Resemblance theory thus refined can meet the minimal requirement. So long as the minimal requirement remains skeletal, the answer is Yes. The Resemblance theory clearly insists on an appropriate experience. What each picture represents is determined by some experienced resemblance. But amplify the minimal requirement along the lines suggested, and the answer is, just as surely, No. And that is because the experienced resemblance, which is between two visual fields, does not include a visual awareness of the second field, let alone of what the second field is of, or what the picture represents.[5] True: in order to experience the resemblance, we must have dispositionally

[4] Heinrich Wölfflin, *The Principles of Art History*, trans. M. D. Hottinger (New York: Holt, 1932).

[5] Peacocke expressly makes this point when he contends that, in the case of the representation of e.g. a castle, his theory demands that the concept castle enter the content of the appropriate experience in a more embedded fashion than it would if that experience were an experience as of something falling under that concept. He also says that, if the appropriate experience were an experience as of a castle, that would favor an illusionistic account of representation. 'Depiction', p. 403. My thesis of twofoldness is intended to block that line of reasoning.

a recognitional skill for what the second field is of, or what the picture represents. But it is no more required by the Resemblance theory than it is by the Semiotic theory that this skill is manifested in an actual or nondispositional awareness of the represented thing. And that, if I am right in characterizing the appropriate experience, is what is called for.

At the beginning of *Philosophical Investigations* II, xi,[6] pages which cast alternating beams of light and darkness on the topic of this lecture, Wittgenstein distinguishes between two situations in which I can experience or observe a resemblance. The first is this: Two faces confront me, and I observe a resemblance between them. The second is this: One face confronts me, and I observe its resemblance to another face, which is absent. Now, it is only if representations give rise to experienced resemblance of the first sort that a Resemblance theory could be constructed that satisfied the minimal requirement for a theory of representation. But it is only the second sort of experienced resemblance that it is plausible to think of in connection with representation.

At this point it might be objected that the amplification I have laid upon the minimal requirement, or that there must be a visual awareness of what is represented, is excessive, and that I have done this by reading too much into the conditions in which a recognitional skill is acquired.

I shall not follow this line of reasoning. Instead I shall turn to the theory of representation that I have long advocated, for this theory appears to meet the amplified requirement, and the question that I shall address is whether it does so at a cost in cogency or (some would add) intelligibility.

<div align="center">

V

</div>

Central to this theory is a special perceptual skill, called 'seeing-in,' which we, and perhaps the members of some other species, possess.[7] Seeing-in is prior, both logically and historically, to representation. Logically, in that we can see things in surfaces that neither are nor are taken by us to be representations, say, a torso in a cloud [URL25], or a boy carrying a mysterious box in a stained, urban wall [Fig. 1.2]. And historically, in that doubtless our remote ancestors did such things before they thought of decorating the caves they lived in with images of the animals they hunted. However, once representation appears on the scene, it is seeing-in that furnishes, for each representation, its appropriate

[6] Ludwig Wittgenstein, *Philosophical Investigations*, ed. G. E. M. Anscombe (Oxford: Basil Blackwell, 1953).

[7] See Wollheim, 'Seeing-As, Seeing-In, and Pictorial Representation'; *Painting as an Art* (Princeton, NJ: Princeton University Press, 1987), lecture II.

experience. For that is the experience of seeing in the pictorial surface that which the picture is of.

What is distinctive of seeing-in, and thus of my theory of representation, is the phenomenology of the experiences in which it manifests it self. Looking at a suitably marked surface, we are visually aware at once of the marked surface and of something in front of or behind something else. I call this feature of the phenomenology 'twofoldness.' Originally concerned to define my position in opposition to Gombrich's account,[8] which postulates two alternating perceptions, Now canvas, Now nature, conceived of on the misleading analogy of Now duck, Now rabbit, I identified twofoldness with two simultaneous perceptions: one of the pictorial surface, the other of what it represents.

More recently I have reconceived twofoldness, and now I understand it in terms of a single experience with two aspects, which I call configurational and recognitional. Of these two aspects I have claimed that they are phenomenologically incommensurate with the experiences or perceptions—that is, of the surface, or of nature—from which they derive, and what I had in mind was something of this order: Sometimes we experience a pain in the knee. This is a complex experience, but it is not to be understood by seeing how one part of it compares with having a pain, but nowhere in particular, and how the other part compares with being aware of one's knee and where it is. What I never wanted to deny was that each aspect of seeing-in might be, through its phenomenology, functionally equivalent to the experience from which it derives. The fact that we can acquire recognitional skills through looking at representations, a point on whose theoretical significance I have always insisted, conclusively proves this to be so.

Criticism of my theory of representation has largely taken the form of asking for more: specifically, more about the phenomenology of seeing-in.[9]

On this request, some methodological remarks:

> First, we must not respond to such a request as though there were a canonical mode of describing phenomenology so that we could, taking some experience, and proceeding region by region, finish up with a tolerably comprehensive account of what it is overall like.

> Secondly, we must not expect from ourselves, or allow anyone else to do so, a description from which someone who had never had the experience could learn what it would be like to do so. In fact, the demand for such a description is implicitly a denial that the experience exists. For it implies that no-one will have had such an experience.

[8] E. H. Gombrich, *Art and Illusion* (London: Phaidon, 1960).
[9] E.g. Malcolm Budd, 'On Looking at a Picture' and Kendall L. Walton, 'Seeing-In and Seeing Fictionally', both in Jim Hopkins and Anthony Savile (eds), *Psychoanalysis, Mind and Art: Perspectives on Richard Wollheim* (Oxford: Basil Blackwell, 1992).

Thirdly, we must never lose sight of the philosophical point of phenomeno-
logical description. It is not to teach us the range of human experience. It
is for us to see how some particular experience can, in virtue of what it is
like, do what it does. It pursues phenomenology only to the point where
function follows from it. In the case of seeing-in, we need to know how it
can provide an appropriate experience for each and every representation,
or how (the same thing) the scope of seeing-in can coincide with that of
representation.

I shall pursue this last line of inquiry, but first I want to consider a proposal
which many might find plausible. This is that, granted that seeing-in grounds rep-
resentation, experienced resemblance grounds seeing-in. In other words, when-
ever we see something in a surface, this is in part because of a resemblance that we
experience between it and the something else.

There are, I believe, three considerations that militate against such a view.

<div align="center">

VI

</div>

The first consideration is this: The surface of any picture can contain elements
that, though individually visible, make no contribution to what the picture repre-
sents. In Budd's phrase, they lack 'pictorial significance.' Consider, for instance, the
punchmarks in a Gothic painting, or the dabs of complementary color, red, say, in
a field of green, that Monet used to enhance vivacity.

Now, if seeing-in rested on experienced resemblance, we would need an ante-
cedent way of filtering out such elements, otherwise we shall think of a picture
as representing anything and everything that we can experience these elements
as resembling. We shall think that Duccio represents the Madonna's halo as em-
broidered [Fig. 5.1], or that Monet has scattered tiny scarlet blossoms through
the reeds.

If, however, we retain seeing-in as prior, then we shall be encouraged to look at
the picture, to see in it whatever we are inclined to, and it is only if we have reason
to suspect what we have seen that we shall start to check the surface for elements
that might have led us astray. However, since elements that are indubitably insig-
nificant need not lead us astray, there is, so long as the priority of seeing-in is main-
tained, no necessity for an antecedent principle of exclusion. And this, as I see it, is
fortunate, since none seems available.

The second consideration is this: If experienced resemblance is basic, then what
we must be expected to do is to attend to each pictorially significant element that
we can identify and be visually aware of it at least to this degree: that we experience
it as resembling something or other. Perhaps additionally we need to experience it
as having that property in respect of which the resemblance strikes us. And this is

Fig. 5.1 Duccio di Buoninsegna (Italian, active by 1279–1318), *Madonna and Child*, *c*.1290–1300. Tempera and gold on wood, 27.9 × 21 cm (with engaged frame). Photo © The Metropolitan Museum of Art, New York (2004.442).

because, since, on this view, the only way in which anything can be represented in the picture is through some part of the picture being experienced as resembling it, neglect one pictorially significant element, and we shall lose some part of what the picture represents.

At this point the question arises whether a theory of experienced resemblance, like a linguistically oriented Semiotic theory, requires that pictures be capable of systematic segmentation. If the answer is No, which seems, on general grounds, more plausible, and pictorial elements can in principle swell so as to engulf both small groups of marks *and* the circumambient surface between them, a danger lurks. Consider, by way of example, 'the small black circle' of which Roger Fry[10] made so much in his formalist onslaught upon Breughel's great *Procession to Calvary* [Fig. 1.1]—how are we to say for certain that we experience such elements as resembling something in the world that the picture represents, rather than as resembling a representation of those things? In other words, can we prevent the theory of experienced resemblance from declining into what I have called a theory within, as opposed to a theory of, representation?

By contrast, when seeing-in is given priority, all that is required is that we are visually aware of the surface, and how detailed this awareness must be is an open matter. And this is because there is no perceptible feature of the surface corresponding to every feature of what is represented. The representational content of a painting by Gainsborough or Turner is not constrained by what I have called 'localization.'

The third consideration against the priority of experienced resemblance is this: That this view requires us not only to be aware of what properties the pictorially significant elements have, but to infer from these properties how the corresponding object is represented, or (the same thing) what properties it is represented as having. But such inferences can be wild. Parmigianino's Madonna [URL26] is not represented as having a long neck, nor did Ingres, who despised anatomy, show his odalisques that is, the women themselves—with, as contemporary critics maintained, one vertebra too many [URL 27].

A final observation: Those who find a place for experienced resemblance in an account of representation think it in their favor that such an account readily yields a criterion of naturalism in representation. If it does, I, on the contrary, see that as a mark against their account. For, once we start to survey the very different kinds of representation that we think of as naturalistic, it seems crude to believe that there is a single, let alone a simple, criterion, least of all one in which experienced resemblance plays a primary role, of naturalism, ahistorically conceived.

[10] Roger Fry, *Transformations: Critical and Speculative Essays on Art* (London: Chatto and Windus, 1926), pp. 15–16. For a discussion of this passage, and of formalist criticism, see Richard Wollheim, *On Formalism and its Kinds* (Barcelona: Fundacio Antoni Tapies, 1995). [And see Chapter 1 in this volume, Lecture I.—Eds]

VII

I return to the question how the scope of seeing-in and the scope of representation can be identical, and I start by asking, What is the scope of representation?

The answer falls into two parts. The first part is ontological, and it gives us the various kinds of things that can be represented, or what I call the varieties of representation. The second part consists in an overarching constraint, and this is imposed by the limits of visibility. As Alberti put it, 'The painter is concerned solely with representing what can be seen.'

The varieties of representation are given by a cross-classification. Along one axis, we have representations of objects *versus* representations of events. Women (objects) can be represented, and so can battles (events). Along the other axis we have representations of particular objects or events *versus* representations of objects or events merely of a particular kind. So we can have a representation of Madame Moitessier (particular object), or a representation of a young woman behind a bar, perhaps a young woman of some specificity—but no particular young woman (object merely of a particular kind). Alternatively we can have a representation of the Battle of San Romano (particular event [URL28]), or a representation of a cavalry skirmish—one fought at dusk, on level terrain, between sides evenly matched, muskets reinforcing sabers—but no particular skirmish (event merely of a particular kind). Representations that are of things merely of some particular kind, whether objects or events, are, I believe, best identified through their intrinsic failure to sustain answers to the question, Which object? Which event? or, Which woman? Which battle?

Nelson Goodman[11] has pointed to another variety of representation: that is, a representation of all things of a certain kind. These are to be found in dictionaries or manuals, but seldom in pictorial art.

However, in considering the scope of representation, I believe that the better starting-point is with the second part of the account: the *constraint* upon representation, or visibility. It gives us more immediate insight into how the scope of representation and the scope of seeing-in coincide. And that is because of what this constraint asks for. Representation does not have to limit itself to what can be seen face-to-face: what it has to limit itself to is what can be seen in a marked surface.

But what is the difference? For is there anything that can be seen in a surface that cannot be seen face-to-face?

The answer is Yes, and we already know at least part of the reason. For we can see in pictures things merely of a particular kind, and these we cannot see face-to-face. We cannot see face-to face women and battles of which we may not ask, Which woman? Which battle?

[11] Nelson Goodman, *The Languages of Art* (Indianapolis: Hackett, 1969), ch. 1.

But some might insist that, though we can see in pictures kinds of things that we cannot see face-to-face, we cannot see them as having *properties* that we cannot see, or cannot see things as having, face-to-face. It was in elaboration of this doctrine that Lessing famously denied that pictures can represent events unfolding in time; that is, that they can represent events *as* unfolding in time.

It is arguable that where Lessing was really at fault was in the limits he attributed to what can be seen face-to-face rather than in the limits that he consequentially imposed upon what can be represented. Without opening up this issue, let me simply point out that pictures can represent things as having properties that lie extremely close to the limits of face-to-face visibility, and leave it open on which side they actually lie. So pictures can represent a man as singing and a woman as listening to him; they can represent kings as seeing things that are not given to the human eye; they can represent a man as renouncing all earthly goods but one, and why; and they can represent a woman as hearing news the greatness, the terribleness, of which she struggles to take in.

VIII

If we now ask, How is this so? we are asking for a general account of what it is for something to be visible in a surface.

Consider the following experiment: I look at a picture that includes a classical landscape with ruins. And now imagine the following dialogue: 'Can you see the columns?' 'Yes.' 'Can you see the columns as coming from a temple?' 'Yes.' 'Can you see the columns that come from the temple as having been thrown down?' 'Yes.' 'Can you see them as having been thrown down some hundreds of years ago?' 'Yes.' 'Can you see them as having been thrown down some hundreds of years ago by barbarians?' 'Yes.' 'Can you see them as having been thrown down some hundreds of years ago by barbarians wearing the skins of wild asses?' (Pause.) 'No.'

At each exchange, what 'Yes' means is that the prompt has made a difference to what has been seen in the scene, just as the 'No' signifies that, for *at least this spectator here and now,* the limits of visibility in this surface have been reached. Now, let us assume that this spectator is the suitable spectator for this picture. In that case we can understand the 'No' as a refusal on his part to be forced beyond the appropriate experience, hence a refusal to force upon the picture something that it does not represent.

What this thought-experiment primarily shows is the central phenomenological feature of seeing-in, which is its permeability to thought, whether the thought is directly caused by the marked surface or is partly prompted by another. And it is this feature that in turn accounts for the wide scope of seeing-in, wider, as we have seen, than that of seeing face-to-face. It is the permeability of seeing-in to thought

that accounts for the wide range of things that can be represented and for the wide range of properties they can be represented as having.

However, two observations are called for.

The first is this: Just because it is true that, on looking at a picture, we can recruit a thought to our perception so that what we see in the picture changes, it does not follow from this that we have any way of indicating where the change occurs, or what it amounts to—apart, of course, from repeating the thought that has brought about the change. Secondly, in insisting that thought, conceptual thought, can bring about changes in what we see in a surface, I am not taking sides on the issue whether the experience of seeing-in has a conceptual or nonconceptual content. Tasting soup has a nonconceptual content, but, if we are prompted conceptually about what is in the soup, the soup can taste different.

IX

Another psychological phenomenon that is highly permeable by thought is imagination, and it is tempting to think that imagination, specifically in its more perceptual mode, or visualizing, grounds seeing-in.

A simple version of this proposal is that, when I see a face in a picture, I am led, by the marks on the surface, to imagine seeing a face. However, imagining seeing a face, which is now assigned the role of the appropriate experience, floats free of the representation. Though it determines what the picture represents, it and the seeing of the pictorial surface are only externally related.

A more complex, and a far superior, version of this proposal, which has been championed by Kendall Walton,[12] is this: I see the pictorial surface, I imagine seeing a face, and of my seeing the surface I imagine it to be an experience of seeing a face. Furthermore, the veridical experience of the surface and the imaginary experience of the face, both perceptual, form, in Walton's phrase, 'a single experience': twofoldness again.

My difficulty with this second proposal is how to understand the core project, or imagining one perceptual experience to be another. For, if we succeed, in what way does the original experience retain its content? For, what is left of the experience of seeing the surface when I successfully imagine it to be some other experience? However, if I do continue to see the surface, or this experience retains its content, how have I succeeded in imagining it, the experience, to be an experience of seeing a face? And note two things: First, that imagining one experience to be another is something more experiential than simply imagining that one experience is the other. And, secondly, note that this problem arises exclusively where (one) what

[12] Kendall L. Walton, *Mimesis as Make-Believe* (Cambridge, MA: Harvard University Press, 1990).

we imagine to be something different from what it is is something perceptual *and* (two) what we imagine it to be is also something perceptual. There is clearly no fundamental difficulty in my moving my hands and arms in a jerky and irregular fashion and imagining of it that I am conducting some great orchestra, nor, for that matter, in my looking hard at an old enemy and imagining of it that I am burning him up with my gaze. In the first case neither experience is perceptual: in the second case, only one is perceptual.

X

I too find a place for imagination in my account of representational meaning, but it is a place that is ancillary to seeing-in and is relevant only to certain paintings.[13] These are paintings in which the suitable spectator is offered a distinctive form of access through the presence in the represented space—though not in that part of it which is represented—of a figure, whom I call the Spectator in the Picture. The Spectator in the Picture has, amongst other things, a psychological repertoire: a repertoire of beliefs, desires, attitudes, responses. What then happens is that the suitable spectator, the suitable *external* spectator we might say, starts to identify with the internal spectator: that is, to imagine him, the internal spectator, centrally, or from the inside, interacting with the represented scene as the repertoire assigned to him allows or constrains him to. The net result will be that the external spectator will find himself in a residual state analogous to that of the internal spectator, and this state will in turn influence what he sees in the picture when he reverts from imagination to perception.

Take as examples of representations that contain a Spectator in the Picture some of Manet's single-figure compositions: say, *The Woman with a Parrot* [Fig. 5.2] or *The Street-Singer* [URL29]. When I look at either of these paintings, I see in its surface a woman momentarily but intensely preoccupied. She is distracted by a secret. Then I recognize from a variety of cues the existence of a second figure, male perhaps or perhaps indeterminate as to sex, who stands in the represented space somewhere just this side of the picture plane. I then start centrally imagining this figure trying, trying hard, trying in vain, to make contact with the represented figure. The tedium, the frustration, the despair that I come to imagine, to imagine from the inside, the Spectator in the Picture's experiencing will trickle back into me and reinforce how I see the woman.

I recapitulate this account of the Spectator in the Picture, taken from *Painting as an Art*—though omitting all discussion of what evidence we might have, in the case of any given picture, for there being such an intervention—in order to emphasize

[13] Richard Wollheim, *Painting as an Art* (Princeton NJ: Princeton University Press, 1987), lecture III.

Fig. 5.2 Édouard Manet (French, 1832–1883), *Young Lady in 1866*, 1866. Oil on canvas, 185.1 × 128.6 cm. Photo © The Metropolitan Museum of Art, New York (89.21.3).

the difference in role, and the division of labor, as I see it, between perception and imagination in our interaction with representational paintings. But, note, none of this is intelligible unless we acknowledge the existence of a form of imagination that contemporary philosophy has, implicitly at any rate, rejected. And that is centrally imagining someone other than oneself. Currently, imagination from the inside is treated as though it must be *de se*. If I imagine anyone from the inside it can only be myself, and, if I *seem to* imagine another, what I really imagine is either myself in another's shoes, which falls short of the project I am assuming, or myself being another, which is incoherent. Much recent discussion of the role of imagination, or (as it is currently called) simulation, in grounding our knowledge of other minds is vitiated by this failure to recognize the scope of imagination.

XI

Let me, even at this late date, point to a surprising omission in this lecture: surprising, since the phenomenon not only figures large in many accounts of representation, but it is the keystone of my own account. There has been no mention of artist's intention: 'intention' being the word that has come to mean those psychological factors in the artist which cause him to work as he does.

The most schematic way of fitting the artist's intention into the account that I have given is this: With any representational picture there is likely to be more than one thing that can be seen in it: there is more than one experience of seeing-in that it can cause. However, the experience of seeing-in that determines what it represents, or the appropriate experience, is the experience that tallies with the artist's intention. With omission of the artist's intention from the argument, I have had to put the point more obliquely in terms of the suitable spectator, who is identified as the spectator with suitable sensitivity and suitable information and suitably prompted. But it is the same point, for consider what 'suitable' here means. It means the sensitivity, the information, the prompting, that are required if the spectator is to see the picture as the artist desires him to. However, there has also been an advantage in putting the matter as I have had to: that is, in terms of what the suitable spectator sees rather than of the artist's intentions. For it has made it clear why, for some representations, there will be no appropriate experience. Such an experience will elude even the suitable spectator, and that is because the artist failed to make a work that can be experienced in a way that tallies with the intentions that he undoubtedly had. In such cases the work, we must conclude, represents nothing—though, of course, to put it like this obscures the fact that failure, failure to realize intention, is always a matter of degree. Balzac's Frenhofer apart, can it ever be total? Representational meaning, indeed pictorial meaning in general, is, on my view, dependent, not on intention as such, but on fulfilled intention. And intention is fulfilled when the picture can cause, in a suitable spectator, an

experience that tallies with the intention. And note that the spectator's knowledge of the artist's intention, however acquired, can legitimately mold what he sees in the picture. However, what this, or indeed any other, knowledge cannot legitimately do is to substitute itself for perception. If all the suitable spectator can do is to pick up on the artist's intention, and interpret the work accordingly, and there is no register of this in his experience of the picture, the conditions of representation have not been satisfied.

Representation is perceptual.

6

What Makes Representational Painting Truly Visual? (2003)

The piece is a response to Robert Hopkins, in a Session on pictorial representation and published in the Proceedings of the Aristotelian Society *of 2003. Hopkins—author of* Picture, Image and Experience *(Cambridge: Cambridge University Press, 1998)—defends a sophisticated variant of the view that Wollheim's 'seeing-in' can be cashed out as 'experienced resemblance.' Partly Wollheim reacts as he did largely to previous variants of this view—those of Christopher Peacocke and Malcolm Budd (see the previous entry): they have a predilection for linear as opposed to painterly styles. In addition, to have the appropriate experience, Hopkins's view wrongly entails that 'it is not necessary to have any kind of experience' of the represented object. Moreover, his view suggests that each represented component can be 'localized'; but not all can be, as when a picture, for example, depicts the aftermath of a storm. Wollheim also identifies various other problems of detail in Hopkins's argument—including again but with more care the difficulty in describing the long-necked Madonna (c.1535–1540) of Parmigianino or the portrait known as* The Green Stripe *(1905), painted by Henry Matisse (1869–1954), the title of which describes the green stripe that bisects the face of the female subject). He closes with some fresh remarks in connection with Kendall Walton's 'Make-Believe' theory of depiction. In looking at these problems from various points of view, one gains confidence, if not in Wollheim's view exactly, then in appreciating the force of those problems.* [Eds]

Any experiential view of pictorial meaning will assign to each painting an *appropriate experience* through which its meaning can be recovered. When the meaning is representational, what is the nature of the appropriate experience? If there is agreement that the experience is to be described as *seeing-in*, disagreement breaks out about how seeing-in is to be understood. This paper challenges two recent interpretations: one in terms of perceived resemblance, the other in terms of imagining seeing. Neither view gives a correct account of how the spectator distributes his attention between the marked surface and the represented object.

Uncollected Writings. Richard Wollheim, Gary Kemp, and Elisabetta Toreno, Oxford University Press.
© Bruno Wolheim 2025. DOI: 10.1093/9780191995767.003.0006

I

I start with the claim, which I have elsewhere defended, that, if pictorial representation is to be truly visual, what is required is that, for every representational painting, there should be a visual experience of the picture, in terms of which its representational properties are to be explained. I call this *an appropriate experience.* And, for the experience to be appropriate, it must satisfy the following conditions: it must not only be of the picture, but it must be had in front of the picture, and it must come about as a result of looking at the picture; it must be available to any spectator who is adequately sensitive and adequately informed; it must match, or tally with, the intentions of the artist in so far as these have been fulfilled; and the nature of the experience will be that of seeing something in the surface of the picture. A picture will fail to give rise to an appropriate experience in two somewhat different sets of circumstances. One is when the intentions of the artist are such that none of the experiences that a suitably sensitive, suitably informed, spectator could have on looking at the work that the artist produces could be said to tally with those intentions. In such circumstances the fault lies with the intentions: the intentions are too confused, too complex, too abstract. The other set of circumstances is when the work is such that none of the experiences that would undoubtedly tally with the artist's intentions could ever be had in front of the work as it stands, no matter how sensitive, how well-informed the spectator may be. Now the fault lies with the work: it is too inept, too insensitive, too over-worked. And, when either set of circumstances comes about, there are two things that can be said. One is that the artist's intentions have not been fulfilled, either because the intentions were unfulfillable or because the work failed to fulfil them. The other is that the work lacks meaning, or is not to be understood. In real life both these things are thought to admit of degree: an artist's intentions are generally thought to be more or less unfulfilled, and works of art can be indicted for falling this or that amount short of being fully comprehensible.

In claiming that the representational properties of a painting are to be explained in terms of the experience appropriate to it, I am in effect compressing two claims: one structural, one substantive. First, there is the broad structural claim that the way to understand pictorial representation is through what we see, or, more precisely, what we correctly see, when we look at representations: this holding both on a more general level, and on a more particular level. It holds on a more general level in that what it is for a picture to represent something is to be explained by reference to the general nature of the experience to be had in front of it, and it holds on a more particular level in that what a given picture actually represents is to be explained by reference to the specific content of the experience to which it gives rise. This structural claim may be put by saying that pictorial representation is essentially experiential, hence, in standard cases, essentially visual.

Secondly, there is the narrower substantive claim about the general nature of the experience to be had in front of a representation, or what such an experience is like. Is it falling for an illusion, is it noticing a resemblance in some respect between some part of the picture and what it is thereby of, is it exercising the imagination in some special way, is it using some particular mode of perception that, though also called for in certain other contexts, is peculiarly associated with representation? And the substantive claim that I make is a version of the last kind of view, a version that I have tried to identify through use of the notion of *seeing-in*. When a picture represents, say, a horse, the appropriate experience to be had in front of it is to see a horse in its painted surface, and what is most distinctive of the phenomenology of such an experience is what I call twofoldness, or that, within a single experience, but as separate aspects of it, I am aware of the surface and of a horse.

For most philosophers of art, perhaps because they are more concerned with philosophy than they are with art, my substantive claim, or the account that I have offered of the mode of perception involved in looking at representational paintings, has proved to be the more interesting part of my claim about the visuality of pictorial representation. Furthermore my account has achieved widespread acceptance. But widespread acceptance of the account has not equalled general agreement on the topic. Quite the contrary: for the key notion in the account—that of seeing-in—not carrying, as indeed I recognized at the time, its meaning on its face, philosophers have reinterpreted it so as to get the theory of representation that they favour. They have smuggled into the appropriate experience modes of perception, hence into aesthetics theories of representation, that I had hoped talking about seeing-in would block. Specifically I want to consider two ways in which seeing-in has become for philosophers of art a Trojan Horse to secure victory for their favoured theory of representation. One account to benefit in this way is that which grounds representation in *resemblance*, and the other is an account that derives representation from a certain exercise of the imagination for which the notion of *make-believe* has been used, and my argument will be that neither adventure succeeds.

II

I start with Resemblance theory, and shall take as the best, and best worked out, attempt to reformulate this theory within at least the terminology of seeing-in that of my fellow symposiast, in his book, *Picture, Image and Experience.*[1]

[1] Robert Hopkins, *Picture, Image and Experience* (Cambridge: Cambridge University Press, 1998). But see also Christopher Peacocke, 'Depiction', *Philosophical Review*, 96.3 (1987), pp. 383–410; Crispin Sartwell, 'Natural Generativity and Imitation', *British Journal of Aesthetics*, 31.1 (1991), pp. 58–67, and 'Representation', in David Cooper (ed.), *A Companion to Aesthetics* (Oxford: Basil Blackwell, 1992); and Malcolm Budd, 'On Looking at a Picture', in J. Hopkins and Anthony Savile (eds), *Psychoanalysis,*

At the outset, it must be noted that there are three different ways in which it might be proposed that resemblance is involved in the explanation of representation. All three can be formulated within at least the terminology of seeing-in.

The first proposes that a condition of seeing x in y is that there is a resemblance between x and y, hence between y and x.

The second proposes that a condition of seeing x in y is that there is a perceived resemblance between y and x

(Note that, as we move from the first to the second proposal, a fact, overlooked by many earlier resemblance-theorists to the detriment of their version of the theory, forces itself upon our attention: that is that, whereas resemblance is symmetrical, perceived resemblance is non-symmetrical.)

The third proposes that there is an identity between seeing x in y and perceiving y as resembling x.

So long as we hold to the view that representation is essentially experiential, it is only the third proposal that has an *immediate* claim on our attention. For it is only it that, telling us something about what seeing-in is like, thereby tells us something about what representation is. The other two proposals, with nothing to say about the phenomenology of the appropriate experience, have nothing directly to say about the nature of representation. I say 'directly': for, not only has the claim that seeing x in y is seeing y as resembling x (the third proposal) no appeal unless one also believes that there is a perceived resemblance between y and x (the second proposal), but this second proposal is likely to be a matter of continuing interest even if the third proposal is abandoned, or it is no longer held that resemblance enters into the appropriate experience.

I am aware that, in regretting, as I do, the revival of Resemblance theory, which only a few years ago had been given up for dead, I am personally on shaky ground, and that is because what has motivated the revival is largely the sense that, given an experiential approach to the nature of representation, more must be said about what the appropriate experience is like than is to be found in any accounts thus far offered of seeing-in. This being so, it has been thought that an appeal to resemblance, or more specifically perceived resemblance, can fill the gap, and in a way that accords with age-old intuitions.[2] I too think that something must be said about what it is like to see something in a picture, and, the more that can be truly said, the better. But to think that enough needs to be said so that someone who didn't believe that there are such experiences is convinced of their existence is to succumb to unrealistic standards. On the question where to begin, Professor Hopkins and

Mind and Art (Oxford: Blackwell, 1992). Budd, unlike the other writers, presents the Resemblance theory in a conditional form.

[2] Of the writers cited in the previous footnote, Peacocke and Hopkins explicitly state their views as an attempt to put flesh on the bones of a seeing-in theory, something which I am thought to have failed to do.

I are nominally in agreement, for we both seem to think that we should begin with the appropriate experience as a whole, or what I call its *twofoldness*.[3] If we are lured into beginning with one fold aware of or the other, so that we start either from considering what it is like when we are a marked surface without seeing anything in it, or from what it is like when we see something face-to-face, and then try to work our way forwards towards the totality of seeing-in by adding some phenomenological feature here, subtracting some feature there, the attempt is doomed to failure.[4]

However, I concede that, in trying to say what is wrong with this flawed project by calling its starting-point and its destination 'incommensurate', I hoped for too much from what was a phrase of the moment.

III

So on to the question: What, if anything, is wrong, or misleading, with understanding the appropriate experience in front of a representational picture as seeing one thing (the marked surface) as looking like another thing (the represented thing, whether object or event)?

I shall present two objections,[5] and I believe that both are sufficiently general that I am not required—as I would be if I were arguing, not against, but in favour of, a perceived resemblance account—to introduce the respect or respects in which, according to the account, we are supposed to see the resemblance as holding. Hopkins's own proposal on this score, that the respect is 'outline shape', or that we experience the solid angle subtended at our eye by the configuration on the surface as equal to that subtended by the represented thing, is interesting, but I have two reservations. One is: Are solid angles subtended by objects at the eye things that can be the content of our perceptions? The other is: Does not such a view of the respect in which similarity holds unduly favour, in Wölfflin's terminology, 'linear' over other more 'painterly' forms of representation?

So to my two objections to neo-Resemblance theory.

Both objections stem from the way in which such a theory has, or so I contend, to understand the appropriate experience. The first objection is that doing so excludes a certain kind of representational picture. The second objection is that

[3] I say 'nominally' in agreement, because in fact Hopkins's strategy is to start from considering what it is like when we see a marked surface without seeing anything in it, and then he moves forward to considering what it is like when we see such a surface as resembling something else; as far as I can see, he never considers the total experience.

[4] Compare trying to describe what it is like to hear a tune in the head by starting from hearing a tune in a concert-hall, and then taking away certain aspects of the experience, and perhaps adding others from elsewhere.

[5] A third objection, which I developed in Richard Wollheim, *Art and its Objects*, 2nd edn (Cambridge: Cambridge University Press, 1980), I shall omit here, though I still believe that it is formidable. Its argument is to the effect that the only thing that I could see a part of a marked surface as is an individual as opposed to an event, which unduly limits the scope of representation.

doing so misconceives the very nature of the appropriate experience. Both objections start from the same broad feature of the theory: that of necessity it construes the appropriate experience as a case of *seeing-as*. And now let me point out that it is because of this starting-point, and the generality of the argument that follows, that I believe that, in criticizing the Resemblance theory, we do not need to take into account the respect in which we are supposed to perceive resemblance to hold.

The first objection claims that, if a picture represents what it does because of the fact that we see it, or some part of it, as resembling what it represents, then it must be that we have, in each and every case, a way of identifying the representing element. To see y as resembling x, we must be able to demarcate y. And this unduly restricts the scope of representation. For, if there are representational pictures where we can identify the part of the surface in which something is represented, there are other pictures—pictures that pre-theoretically we would think of as representational—where we can't. When Turner depicts a Slave Ship labouring in the aftermath of a prolonged storm, we can point to where the ship is represented, but we cannot point to where the aftermath of the prolonged storm is represented [URL30]. Yet it is. And note that the resemblance theory requires that the representing element is demarcated even in cases where, seen face-to-face, the represented element would not be demarcated. In other words, the theory commits representation to an otherwise unmotivated requirement of *localization*.[6]

The second objection is deeper, in that, instead of identifying one kind of representational picture that the theory leaves out, it claims that, for every kind of representational picture, the account of the appropriate experience that the theory favours distorts the role played within that experience by, first, the represented object, and then the representing surface. More specifically, the account *plays down* the role of the represented object, and *plays up* the role of the representing surface.

First, how is it that the theory that explains seeing x in y in terms of seeing y as looking like x plays *down* the role of x in that experience?

It is surely a ground-level observation about the difference between pictorial and linguistic representation that, though, if we are to understand a linguistic representation of x, it suffices for us to have a thought of x, we must, if we are to understand a pictorial representation of x, have an experience of x. One clear advantage of the account of the appropriate experience in terms of seeing-in is that it brings this out into the open by equating the required experience of x with what is in effect a mode of seeing x. However it is not necessary to insist on such a strong construal of how x enters into the pictorial experience to see that the account of that experience provided by the resemblance theory leaves something out. For, in order to have what that theory identifies as the appropriate experience, it is not necessary to have *any* kind of experience of x. As Hopkins himself concedes, what suffices for

[6] Wollheim, *Art and its Objects*, Supplementary Essay V.

someone to see y as looking like x is (1) an experience of y, (2) the thought of x, and (3) some kind of knowledge of the appearance of x recruited to the experience of y. No room has been found, let alone thought necessary, for an experience of x: the represented object goes unexperienced.[7]

What Hopkins concedes, Wittgenstein asserts. Wittgenstein opens the famous Section II xi of the *Philosophical Investigations*[8] with a contrast between two different kinds of situation in which we might be struck by the resemblance between two faces. There are two distinct kinds of case that we might think of as cases of perceived resemblance. One is when both faces are present to us, and we are struck by the match between them; the other is when only one face is present, and it puts us in mind of the other. Now the point that Wittgenstein wishes to make is that it is only in the first case that we have an experience of the second face. Now add in the fact that, if we want to equate the appropriate experience in front of a picture with an experience of perceived resemblance, then, since representation is invariably representation of the absent, it is only the second case of perceived resemblance that can be relevant. In other words, what might naturally seem most central to representation, or an experience of the represented object, turns out, on the perceived resemblance theory of representation with, to be gratuitous. The role of x in seeing x in y is seriously played down within any such theory.

Secondly, how is it that an account that explains seeing x in y in terms of seeing y as looking like x plays *up* the role of y in that experience?

In the past, in arguing against illusionistic, or quasi-illusionistic, accounts of the appropriate experience, I have emphasized that, when we see x in y, not only have we, as I have just been insisting, an experience of x, but we are aware of y. Awareness of the marked surface is foundational to my idea of twofoldness, but I believe it to be an exaggeration to identify that awareness with seeing the marked surface as something or other.

There is, it is true, a completely bland sense of 'seeing-as', in which, when we report ourselves as seeing y as x, we do no more than register the fact, which is arguably universal, that we have recruited to our perception a thought, or that we perceive what we do under a certain description, where this thought, this description, is something that we may be able to retrieve with some measure of success.[9]

However, it is not this bland sense of the term, but a stronger sense, nowadays widely identified with aspect-perception, that is invoked when seeing-as is looked to as providing the key to the way in which perception of the marked surface of a representational picture can deliver up its representational content, and it is this that I challenge. For, when I see y as x in this strong sense, I in effect use x as a kind of lens through which to see y. In any such case, y is the focus of my awareness,

[7] Ibid. 78–81, where I take 'being involved in an experience' to fall short of being experienced.
[8] Ludwig Wittgenstein, *Philosophical Investigations* (Oxford: Basil Blackwell, 1953), II.xi.
[9] This account of seeing-as is phrased as it is to leave open the question of nonconceptual content.

and a way of capturing the central cases is to say that I am carried forward by my curiosity about y, however involuntary it might be, and however fanciful a form it might take.

But none of this seems to match the true phenomenology of looking at a representation when, out of my attention to the surface y, there emerges an experience of something else, x. For, though my attention to the surface persists, it would surely be deeply implausible to say that the surface remains the focus of my awareness, or that, in seeing something in it, I am indulging my curiosity about it.

This is not, of course, to deny that, once we have come to see x in y, we may very well develop curiosity about just what it is about y, or about how it is marked, that induces us to see something, specifically to see x, in it. But such curiosity is stimulated by, it follows upon, seeing x in y: it is not what inspires the appropriate experience.

IV

A quasi-positivistic strand that runs through Hopkins's book is to the effect that we need to distinguish between the philosophical task of saying what it is to see x in y, and the psychological task of discovering when, or in what circumstances, we may expect to see x in y. Not merely am I disinclined to take this distinction very rigidly, but I believe that, at this stage, fairness to Resemblance theory requires us to ignore it, and to take up the question, If it is true that perceived resemblance does not enter into the appropriate experience, might there not be a place for it as a condition, or concomitant, of representation? In other words, we should give resemblance a second chance by substituting for Resemblance theory proper an account that asserts a purely contingent connexion between resemblance and representation.

However, this second option requires us to ask (1) What are the terms between which the resemblance holds? and (2) In what respect does it hold?

As to the terms to the resemblance relation, it must be observed that, if the relation is to be a condition of representation, neither term to the relation can presuppose representation: it must not be something that we can identify only through invoking representation.

And what gives teeth to this observation is that, as I have pointed out elsewhere, one consideration widely held to justify the connexion between representation and resemblance, whether as necessary or as contingent, very evidently transgresses this principle, at least as far as the first term is concerned. The consideration I have in mind is grounded in the fact that we readily say in front of representational pictures things like, 'That looks like Napoleon,' or 'That resembles a Deptford pink.'

However, if such remarks are to come out true, the demonstrative, the 'that', must be understood in not the obvious way. In 'That looks like Napoleon,' 'That looks like a Deptford pink,' the 'that' must be taken to refer, not, as we might initially

suppose, and as a Resemblance theorist would want, to some part of the marked surface, but to the historical figure himself, to the very endangered plant. And, if we take the 'that' in that way, we are presupposing representation. For it is only representation that brings the reference of 'that', the man, the flower, into existence.

(Incidentally, if we do take the 'that' in that way, the next thing to note about 'That looks like Napoleon' and 'That looks like a Deptford pink' is that they turn out not to use the notion of resemblance at all. For, if both the first term and the second term now refer to what the picture represents, there are no longer two terms between which resemblance could hold. In consequence 'That looks like ...' in 'That looks like Napoleon' means something equivalent to 'Judging from appearances, I should say that what I am looking at is ...' It is, in other words, the same 'looks like' that we use when Mary approaches us from far away, and we say 'That looks like Mary.')

However, it might seem that, whatever difficulties there might be with establishing the first term to the resemblance relation, the second term, the resembled term, is unproblematic. It is surely what the picture represents, or some part of it.

Let us bracket this conclusion while we briefly turn to the respect in which the resemblance may be expected to hold. It seems reasonable to think that, at this stage, we can be lax with ourselves, and say that the respect in which we expect the resemblance to hold is whatever respect in which it does hold. If the resemblance relation were being used to explain representation, which it now is not, this would be intolerably circular. But circularity doesn't matter when we are only looking to see if any version of resemblance underpins representation.

Nevertheless disappointment awaits us. And this is because, no matter how easy-going we are about the respect in which we look for the relation to hold, we shall not find, for every representation, a resemblance holding between its surface and what is represented.

To be convinced of this, let us momentarily adopt the point of view, not of the spectator of a representation, but of the artist. Imagine an artist who is asked to depict, say Napoleon, or the Deptford pink. His basic task, though clearly not all that is expected of him, is so to mark the surface that a suitably sensitive, suitably informed, spectator will see in it the emperor or the plant. What reason do we have for thinking that such an artist will, in carrying out his basic task, be constrained to do so through getting the surface to resemble in some respect or other what he wishes to represent?

At this point Hopkins re-enters the argument with an explanation why we might fail to find the underlying resemblance, although it is invariably there, and his explanation is that, having taken such trouble to get the resembling term to the relation right, we rushed into error about the resembled term. For, when y represents x, the perceived resemblance holds, not between y and x, or, as he

puts it, *x*-as-it-is, as we have been assuming, but between *y* and (something new) *x*-as-it-is-represented.

If the suggestion appears to save the day, not so much for Resemblance theory proper, which we may conclude is beyond salvation, but for the contingent account, two questions remain.

The first is: How are we to understand the phrase '*x*-as-represented'? Is there a systematic way of picking out, for any *y*, where this is a representation of *x*, a corresponding *x*-as-represented-in-*y*?

The second is: What would the interest, or significance, of such a perceived resemblance be within a general account of representation?

Hopkins seems to think that he has a systematic way of answering the first question, which, starting from any representation *y* of *x*, will get him to an *x*-as-represented-in-*y*. For this latter entity he understands as something (1) that exists external to *y*, and (2) whose every property is identical with some property of the marked surface.

Let us take as an example Matisse's famous portrait of Madame Matisse, painted in 1905, and often called *The Green Line* because Matisse has run a line of green paint down the middle of the face of the sitter [URL31]. Now, of Madame Matisse-as-represented-in-*The Green Line*, which contrasts with another entity to be called 'Madame Matisse-as-represented-in-*Le Chapeau Vert*' [URL32], which is to be arrived at by starting from another portrait of Madame Matisse of the same year, we can say (1) she exists external to *The Green Line*, and (2) she has a long face, arched eyebrows, a puzzled expression, and a green line running down her forehead and nose and terminating on her mouth.

I have to say that, if this is a promising start, how we go on is less clear. For instance, out of what resources supplied to us by the marked surface, do we endow Madame-Matisse-as-represented-in-The *Green Line* with three-dimensionality? Hopkins struggles with this issue in what are surely the least persuasive pages of his book.[10]

But suppose the task could be solved, I think that the next question—What interest attaches to any perceived resemblance between *y*, the representation, and *x*-as-represented-in-*y*?—brings us up short. For surely it is only if *x*-as-represented-in-*y* is what *y* represents that a perceived resemblance between *y* and this new entity should impress us. But it isn't. What *y* represents is *x*, and this is confirmed by the fact that the artist chose to represent *x* as he did—or, as Hopkins would put it, that he conjured into existence *x*-as-represented-in-*y*-because he thought that that way of representing *x* did some special justice to *x*.

However that should not be the end of the matter. For I hope that enough has been said to establish that the notion of *x*-asrepresented-in-*y* raises some

[10] Hopkins, *Picture, Image, and Experience*, 114–17.

significant questions, not to be passed over, about what may broadly be called, the 'what' and the 'how' of representation.

There are three different contexts in which we may think of the how of representation. Two of these relate back to the what of representation, and how it is represented: the third relates to the representing surface, and how it is marked. I call these respectively the Representational how, the Presentational how, and the Material how. They call for elucidation.

Of the Material how, nothing particular needs to be said in this paper, except that it is through it that the other two hows are realized, and these differ from one another in that the Representational how corresponds to a property of the what of representation, possessed either permanently or transiently, whereas the Presentational how does not qualify the what at all. It may reflect a range of things from the expressive vision of the artist, through the artistic pressures of the day, to the artist's technical limitations.

Let me give examples: so (and this is the Representational how) when Titian painted the Emperor Charles V on horseback [URL33], he represented someone whose office required him to be a horseman, which he was. When Degas painted the Duke and Duchesse de Morbilli in an estranged pose [URL34], he represented an estranged couple, which is what he probably thought all couples to be. By contrast (and this is the Presentational how), when West Arnhem Land aborigines painted stick figures, they were not representing humans who were as thin as sticks. When Parmigianino painted the Madonna with a long neck, the Madonna whom he represented is not, despite the title given to his picture, a longnecked Madonna. When Matisse painted a stroke of green down his wife's face, he was not representing a woman who had a green line down her face. Sometimes it is an interesting issue whether we are up against the Representational or the Presentational how. When, in *The Execution of the Emperor Maximilian* [URL35], Manet painted the rebel firing squad in French kepis, was he illustrating rumours he had heard that the Mexican rebels depended both for weapons and for uniforms on what they captured from the French, which would be the Representational how, or was he— the Presentational how—making the point that it was the French who, through putting Maximilian on the Mexican throne, were ultimately his executioners?

Where does all this leave the notion of what is to be seen in the picture? To answer this question, we must bear in mind is that, though seeing-in is, in the first instance, a visual capacity open to all, it then, within the orbit of representational painting, is honed into a skill, upon which the sensibility and the knowledge of the right kind of spectator, who is attuned to the intentions of the artist, leave their mark. What this means is that the spectator learns how to let certain parts of the Material how affect what he sees in the picture, and other parts affect only how he sees it. What is to be seen in a picture embraces the Representational how, but the Presentational how is initially excluded, and then let in only to modify how the what is seen. The long neck of Parmigianino's Madonna can be seen in his picture,

but it cannot be correctly seen in it, and so it should be allowed only to bring about how the Madonna is perceived.

V

My discussion of Resemblance theory concludes with some remarks on the place of seeing-as within the theory of representation.

In insisting that seeing-in, as opposed to seeing-as, is central to the appropriate experience, I do not exclude seeing-as from an overall account of representation. On the contrary: seeing-as occurs twice over within any such account, but how it does so is important.

In the first place, seeing-as is a precondition of the appropriate experience. For me to be able to see anything in a representational painting, I must see it as a representational painting.

Secondly, seeing-as has a role within the appropriate experience, but a secondary role. For, when I look at a representational painting, and see something in it, I all but invariably bring bear upon it a perceptual skill, and this is either *a recognitional skill*, which is what allows me to see things of a particular kind, or *an identificatory skill*, which is what allows me to see particular things. This means that, when I see something in a painting, I see it either as a thing merely of a particular kind (say, as an endangered plant), or as a particular thing (say, as the man Napoleon). Seeing x in y is standardly seeing x as if in y. Seeingas helps to account for the content of a representational picture, but it does nothing to explain its nature or its existence.

VI

In conclusion, I turn briefly to another attempt to appropriate the notion of seeing-in in support of a theory of representation that I believe to be in conflict with what might be hoped for from introducing that notion. This time the attempt is in the interest of the Make-Believe theory, as developed by Kendall Walton,[11] and whereas Hopkins's theory, if I am right, distorts the nature of the visual experience appropriate before a representation, Walton's makes it hard for me to see how that experience is visual. Walton so little agrees with me on this point that he claims that his theory establishes 'the fundamentally perceptual nature of pictorial representation'.[12]

[11] Kendall Walton, *Mimesis as Make-Believe* (Cambridge, MA: Harvard University Press, 1990), and most recently 'Depiction, Perception, and Imagination: Responses to Richard Wollheim', *Journal of Aesthetics and Art Criticism*, 60.1 (2002), pp. 27–35.

[12] Ibid. 34, n. 37.

To settle this claim, we may start with Walton's broad characterization of the appropriate experience as (1) a composite experience, partly perceptual, partly imaginative, with (2) the components linked in just the way that I have called twofoldness.

The first thing to note is that if, for Walton, the appropriate experience is overall perceptual, this cannot be in virtue of its expressly perceptual component. For that is no more than the spectator's looking at the marked surface in front of him. All that that can establish is that representation is a visible phenomenon, or that as, say, with handwriting, we have to look and see what is there before we can understand it. It is a further matter to establish that representation is a visual phenomenon, or that we understand a representation through looking at it correctly.

So, secondly, can the imaginative component in the account, which Walton characterizes as the spectator's imagining his looking at the marked surface of the picture to be his looking at what the representation represents, do the trick? An initial lead is that Walton thinks it important that he talks of *imagining one thing to be another* rather than *imagining that one thing is another*, and I am sure it is. But its importance is not what we might hope for. What the preferred locution secures is, not perceptuality for the whole, but what I call twofoldness: it locks the two components together. So we still need to know, Does someone's imagining his looking at Matisse's canvas to be his looking at Madame Matisse herself provide him with a perceptual experience of Madame Matisse?

One way in which this might be argued for would be if it could be shown that this complex, or second-order, imaginative project included, or otherwise necessitated, what is a, perhaps the, form of imagining that is clearly perceptual: that is, visualizing. I see no reason to believe that it can be. Nor does Walton argue that it does, rather the contrary. And, as he was the first to see, if it did, it looks as though it would be at the cost of twofoldness. How could looking at the marked surface and visualizing what it represents be locked together?

So, thirdly, is there some other form of imagining that (1) could be described, as Walton wants it to be, as imagining one perceptual experience to be another, (2) could be thought to ensure overall perceptuality, and (3) could fill the role of an experience appropriate to pictorial representations? Walton thinks, Yes, and, in a recent article, offers some examples.

Of these examples, there is one that I understand clearly, but unfortunately it fails to satisfy the first or the third criterion. I do not see how it has the structure that Walton claims for it, and, not only does it relate to another art, but I do not see how it can be adapted to the experience of looking at pictorial representations.

The example goes thus: I attend a performance of *Die Zauberflöte*, sounds come to me from the flute in the orchestra pit, and I imagine my listening to these sounds to be my listening to Papageno's crude instrument. Now I believe that what happens in such a situation, which reconfigures it somewhat from Walton's description, is that (1) I imagine the sounds that I hear when I listen to the flautist to be

sounds coming from Papageno, and (2) on this basis, I hear the sounds coming from the flautist as sounds coming from Papageno. But, if this redescription is correct, there is nothing here that is analogous to the experience appropriate to pictorial representation. For, as we have seen, when we look at representations, we do not imagine an identity between marked surface and represented object, there is no seeing-as that enjoys centrality within the experience, and the represented object, unlike the sounds emanating from Papageno's flute, is actually perceived.

In other words, I believe that the experience that Walton brings before our attention is indeed one of make-believe, and, if it surprises him that I so readily think of seeing the play or listening to the opera in this way, I see no compulsion to extend this kind of experience to that which we have in front of representational paintings.

If a last-minute consideration is needed to support this claim, let me recall that, when I introduced the notion of twofoldness as characteristic of looking at pictures, I thought that one of its merits was that it could explain how we are able to admire the great masterpieces of representational art: for, by insisting that we are simultaneously aware of the marked surface and the rep resented object, twofoldness allows us also to be aware of the fineness of the match between the two that the great painters effected. But neither a great actress nor a great opera singer stands to the character she plays like brush-strokes or chiaroscuro stand to what we see in them. They are not the Material how of their art, nor do we have need for a theory that exhibits them as such.

7

In Defense of Seeing-In (2003)

This is a good recommendation for introducing students to Wollheim's theory of pictorial representation. He concisely explains: seeing-in; that the capacity for seeing-in plausibly pre-dates representation; its relation to two-foldness; and the role of the artist's intention in fixing what can correctly be seen in a picture, as opposed to the mere seeing of things in a stained wall etc. He rather soft-pedals the appeal to what elsewhere he terms 'prompting,' but takes pains to fix the limits to the role of cognition; a picture cannot pictorially represent what cannot be seen in it. All of this is done briefly but in an unfussy way with examples. But some material will interest the more experienced. At the end of section 3 is a sharp way of handling the distinction between representing individuals and representing kinds; in 4 and 5 he describes problems with thinking of 'this represents that' in terms of grasping two separably conceivable acts of mind, one of this and one of that. In the closing section, he observes that attempts to explain depiction in terms of objective properties of surfaces, and types of thing run up against the sheer diversity of representation, as exemplified by the 'ways in which a woman's face can be represented or the vast diversity of painted surfaces in which a woman's face can be seen;' he may have been aiming at the work of John Hyman, whose well-received book was in the future but Wollheim surely saw the article 'Pictorial Art and Visual Experience,' 2000.[1] [Eds.]

I

When we look at a picture, by which I mean a representational picture, we see something in it. That is my starting point. So when we look at Édouard Manet's *Émilie Ambre* [Fig. 7.1], we see a woman in it. In saying that we see a woman in it, I refer to a certain feature of our perception of pictures, and this feature has important theoretical consequences. Because of this feature what two well-known groups of theorists find to say about pictorial perception is false. It is not the case that the representational content of Manet's painting, or the fact that it represents Madame Brunet [URL36],[2] is something that we infer from our experience

[1] John Hyman, 'Pictorial art and visual experience,' *British Journal of Aesthetics* 40.1 (2000), pp, 21–45. Hyman (in conversation) agrees, that Wollheim must have read it but that it cannot be established with certainty. [Eds]

[2] Wollheim slips between two pictures here—irrelevant to the point he is making. [Eds]

Uncollected Writings. Richard Wollheim, Gary Kemp, and Elisabetta Toreno, Oxford University Press.
© Bruno Wolheim 2025. DOI: 10.1093/9780191995767.003.0007

Fig. 7.1 Édouard Manet (French, 1832–83), *Portrait of Émilie Ambre as Carmen*, 1880. Oil on canvas, 92.4 × 73.5cm (unframed). Photo © Philadelphia Museum of Art (1964-114-1).

of the marked surface: for we also have an experience, a visual experience, of her. Furthermore it is not the case that the visual experience we have of Madame Brunet is such that, in the absence of information to the contrary, we would believe that we were seeing her face to face. When we look at the painting, we see Madame Brunet, but the way we see her, or the mode of perception, is such that we say that we see her in the picture. So, representational content is experiential, but it is not the product of illusion.

Is there something that we can say directly about that feature of picture perception, or seeing something in a picture, which carries with it this double load of theoretical consequence?

I believe that we can, and, to pick out this phenomenological feature, I have, for a number of years, used the term 'twofoldness.' When I look at the Manet, my perception is twofold in that I simultaneously am visually aware of the marked surface and experience something in front of, or behind, something else—in this case, a woman in a hat standing in front of a clump of trees. These are two aspects of a single experience. They are not two experiences: they are not two simultaneous experiences, as I used to believe, nor are they two alternating experiences, as Ernst Gombrich has claimed in *Art and Illusion* (1956).[3]

It should not be hard to see how twofoldness refutes the two theories of representational content that I have referred to. That, in looking at Manet's Madame Brunet, I experience a woman in a hat falsifies the inferential view, and that I am visually aware of the marked surface refutes the illusion view.

If we use the term 'seeing-in' to identify the appropriate perceptual mode to adopt toward representational pictures when we view them as representational pictures—as opposed to some other way, such as regarding them exclusively as paint samples or exclusively as props in some game of memories—then my further claim is that twofoldness is an essential feature of seeing-in. (In contrasting viewing pictures as representations and viewing them some other way, I am leaving open the question whether, once we have succeeded in seeing something that was intended to be a representation as a representation, we are able to view it any other way. I have serious doubts on this score.)

II

If we think of twofoldness as built into seeing-in, then we can use the notion of seeing-in in two different ways.

In the first place, we can use the notion of seeing-in to provide a definition of a representational picture. A representational picture is a picture that requires, or calls for, seeing-in. What frees this definition from triviality is that although representation can be explained through representation, we do not need representation in order to identify seeing-in. On the contrary, seeing-in precedes representation both logically and historically. We can see things in objects that were neither intended to be, nor are believed by us to be, representations. Looking at a stained wall in *Chicago 1948*, we can see in the wall a boy carrying a mysterious box [Fig. 1.2].

[3] Ernst Gombrich, *Art and Illusion* (London: Phaidon, 1956).

And I am sure that our ancestors engaged in such diversions before they thought of decorating the caves they lived in with images of the animals they hunted.

Understood in this way, or through the perceptual skill of seeing-in, the category of representational picture includes both figurative and abstract pictures. It does not however include all figurative and abstract pictures, for there are two comparatively restricted groups of pictures, one figurative and one abstract, that do not, for what are complementary reasons, call for twofoldness, and hence are not representational. On the figurative side, there are trompe-l'oeil pictures [Fig. I.2] for they do not call for awareness of the marked surface; and, on the abstract side, there are those pictures which aim at flatness [URL37], for they do not call for us to experience one thing in front of the other.

Second, we can use the notion of seeing-in to identify the representational content of a picture. A painting represents whatever can be correctly seen in it.

The point of 'correctly' is to indicate that, whereas with nature, there is no impropriety in anything that we may happen to see in, say, a stained wall, and with a Rorschach test the only impropriety is to insist on seeing nothing rather than something in the fabricated inkblots put in front of us, there is, once representation arrives on the scene, one thing, just one thing that we do right to see in its surface. We do wrong—though the wrong may be committed in play or jest, and not in error—if we see anything else in its surface. When Marcel Proust went to the Louvre and saw his friends from the Faubourg in the paintings of the old masters—for instance, the Marquis du Lau in a remarkable double portrait by Domenico Ghirlandaio [Fig. 1.2]—he was playing a game, and the game was to see what he was not supposed to see. Once seeing-in is transposed from nature to art, or at least to artifactuality, it gains a standard of correctness.

I would make a further claim to the effect that this standard is set by the fulfilled intentions of the artist. And the intentions of the artist are fulfilled when, working under the causal influence of certain psychological factors, which have come to be called in this particular theoretical context 'intentions,' he has so marked the surface of his painting that it is possible for a properly sensitive, properly informed, spectator to have an experience that tallies with those factors. 'Tally' here is a broad term, and its specific application depends on the type of psychological factor, or intention, that is seeking fulfillment. When the artist has a representational intent, which is our current concern, this intention is fulfilled when it is possible for a properly sensitive, properly informed, spectator to see in the surface that the artist has marked the object that he intends to represent. Likewise the artist's representational intentions are unfulfilled when it is impossible for an appropriate spectator to see that object in the picture. What makes what an appropriate spectator can or cannot see in a picture relevant to fulfillment of the artist's representational intention is that experiences of seeing-in 'tally with' representational intentions.

III

Within the account that I have offered of how we identify a painting's representational content, there is a point that needs elaboration. I have equated a painting's representational content with what can be correctly seen in it, and I have equated what can be correctly seen in a painting with an experience that conforms with the artist's intentions. In other words, the artist's control over the content of the picture that he is making is limited in this respect: that it is out of the things that can be seen in his picture that his intention determines what the picture represents. If something cannot be seen in a painting, it forfeits all chance of being part of its content.

So the question arises, How can we determine, for a given picture, whether something can be seen in that picture? What are the limits of visibility in a picture?

The question is clearly ambiguous between an extensional and a nonextensional reading. Since there is little doubt but that when we ask whether something can be seen in a picture, the 'something' is clearly to be understood in a nonextensional way, we should reformulate the question thus: How do we determine, for a given picture, the range of things that something that can be seen in that picture can be seen as?

One proposal for answering that question is this: In a given picture, we pick out a certain object that can be seen in it. Let us imagine that we merely pick it out as 'that thing.' Then people in turn propose various concepts that apply to the thing in question, and what we have to decide for each such concept is whether it affects how we see the object or whether it merely affects what we say about it. If for a given concept, and the concept could be one that had independently occurred to us, the answer is positive, then we can see the object as falling under that concept. If the concept is f, then we can see the object as f, and fs are visible in that picture.

In an article of recent years,[4] I applied this test for visibility in a picture in the following way: We look at a painting showing a figure seated amongst classical ruins [Fig. 1.18], and someone starts to ask questions of us, to which we must answer, Yes, or No. So, for example, Can you see those columns as having been thrown down? Yes. Can you see those columns as having been thrown down hundreds of years ago? Yes. Can you see those columns as having been thrown down hundreds of years ago by barbarians? (with some difficulty) Yes. Can you see them as having been thrown down hundreds of years ago by barbarians wearing wild asses' skins? (with little difficulty) No. Though we are perfectly ready to believe that the barbarians whose handiwork our eyes are prepared to acknowledge in this picture did indeed wear wild asses' skins, there is no way in which this belief, or the concept that figures in it, can help us to structure our perception of the painting, or can affect

[4] 'On Pictorial Representation' (1998); and in this volume, Chapter 5.

how we see the columns. So, of the range of concepts put to us in this test, it is the only one that is not instantiated by something visible in the picture.

Those who are impressed by the modularity of the faculties are likely to resist this test and what it is supposed to show, but to them all I can say is that, whatever credence we might give to the role of modularity in perception in general, there is obviously a level of complexity above which it doesn't apply, and there is reason to think that picture perception lies outside its scope. The reason can be brought out by our considering pictures of women. Now, of some of these pictures, such as Manet's *Émilie Ambre*, when we further ask, What woman is it of? there is an answer to this question, whereas with the rest, such as Manet's *La Prune* [Fig. 7.2], there is no answer to this question. To generalize, some pictures are of particular things or events, and others are of things or events merely of some particular kind.

The explanation for why we classify the two paintings in different ways is not that there is in reality such a person as Madame Brunet and that Manet painted his painting by painting her, whereas there is no particular person whom *La Prune* represents, though all this is in fact true. For, in the first place, I believe (contra Nelson Goodman) that we should put Jean-Auguste-Dominique Ingres's *Jupiter and Thetis* [URL38] in the same category as Madame Brunet even though Jupiter and Thetis are not real persons. Second, to invoke this kind of explanation at this stage would be to go into reverse about how a representational picture comes by its content. Accordingly, if we really do think that there is a division within paintings of the kind I propose, according to which *Émilie Ambre* and *Jupiter and Thetis* lie on one side of the line and *La Prune* lies on the other, this must be because there is a difference, a perceptual difference, between an experience of a painting that we would naturally report by saying 'I see a particular woman in that picture' and an experience of a painting that we would more naturally report by saying 'I see merely a woman in that picture.' And, if this is so, then one experience must be laden with referential thought and the other laden with nonreferential thought, and this would in turn show that, in the domain of picture perception, perception exemplifies a rather remarkable degree of permeability by thought.

IV

I return to the claim that when I look at a picture appropriately, the twofoldness that qualifies my perception is not a matter of my having two experiences, each one of a familiar kind, which can also be had outside the aegis of seeing-in. Rather I have one experience with two aspects, and this is distinctive of, if not unique to, seeing-in.

I have said that some philosophers deny or have denied this idea outright. But other philosophers, and also (or so it seems to me) some perceptual psychologists with interests in this area, in effect assume its falsity. Whether this is so or not, let

Fig. 7.2 Édouard Manet (French, 1832–83), *Plum Brandy* (*La Prune*), *c.*1877. Oil on canvas, 73.6 × 50.2 cm. Photo © National Gallery of Art, Washington (1971.85.1).

me set up a straw man who does assume two separate experiences, and I want to consider how this assumption can grossly distort something that he might be inclined to think of as 'the problem of picture perception.'

If someone holds that looking at a picture is not characterized by twofoldness but is constituted of two paired experiences, each of a kind familiar to us from outside the perception of pictures, one of which presents the viewer with something two-dimensional, the other with something three-dimensional, then the person is likely to think that the problem of picture perception is how to explain the occurrence of a problematic experience, that is, the experience of something three-dimensional when confronted solely by a two-dimensional surface. That being so, the natural next step is to look for the explanation of this experience within the experience paired with it: namely, the experience of looking at the marked surface, and seeing it as such.

<div align="center">

V

</div>

Our straw man goes wrong in locating the explicandum of his inquiry where he does. For, when we look at, say, *Émilie Ambre*, it is not the case that we have an experience of the sort that would, in the absence of ancillary evidence to the contrary, lead us to believe that we were seeing *Émilie Ambre* face to face. But might our straw man not yet be right in what he takes to be the explicans? He might be. It might be the case that, whenever we saw something in a marked surface, we were led to do so by a prior experience of the surface for the duration of which we inhibited ourselves from seeing something in it. But I am skeptical that this is so: I cannot readily believe that every occasion on which we see something in a marked surface is preceded by our seeing that surface without seeing anything in it. So the latter kind of experience cannot furnish an explanation of the former kind.

A different kind of explanation of why we see something in a marked surface, though the two can get confused, is an appeal not to some way in which we see the surface but to some way in which the surface is. The way the surface is, in such cases, is not necessarily something of which we are aware, but, unless it were as it is, we would not see in it what we do.

It is sometimes argued that, in any account of what we see in a surface, there is no room for any feature of the surface to play a role unless this feature is itself visible. But this betrays a confusion between two kinds of account. For it is certainly the case that in an *analysis* of what it is to see something in a marked surface, a feature of the surface of which there is no awareness is out of place. This is because an experience can only be analyzed in terms of constituent experiences. But when it comes to an *explanation* of what it is to see something in a surface, the situation is different. For we can explain an experience in terms of other experiences, but also in terms of features of the environment to which the experience is sensitive, even

though the person might have no awareness of them as such. In the second case, the explanation does not double as an analysis.

VI

If we do think that it is possible in principle to explain how we see a woman's head in a painting by citing objective features of the painted surface, it is important to recognize that because of the vast diversity of ways in which a woman's face can be represented or the vast diversity of painted surfaces in which a woman's face can be seen, the explicandum in such cases will be not something of the generality of the representation of a woman's face but something of the particularity of Raphael's depiction of a woman's face, or Guercino's depiction of a woman's face, or Picasso's depiction of a woman's face, or Willem de Kooning's depiction of a woman's face. Some might feel that this would leave the central question of representation, why these are all representations of the same thing, unanswered. But anyone sensitive to what a painter is doing when he paints a woman's face might prefer not to raise this question.

WOLLHEIM ON OTHERS

8

Forms, Elements and Modernity

Reply to Michael Podro (1966)

Michael Podro was a British art historian and aesthetician (of special note for Wollheim studies is his book Depiction *(1998); the present piece is a response to 'Formal Elements and Theories of Modern Art', published in 1966 in* The British Journal of Aesthetics*). We include this not because of the positive views coming from Podro, but because of the germs detectable of what would become Wollheim's view of pictorial organization, which is the focus of the three lectures which appear as Part I in this book: it is not possible generally and insightfully to conceive pictures according to compositional rules operating on elements or constituents—such schemes work at best only locally. Rather, the significance of an item sometimes depends quite drastically on what it represents.* [Eds]

I

It is clear what is the object of Dr. Podro's attack. He is against a certain style of art and a certain form of art-education, both of which have acquired classical status in the mid-1960's. The art-education is that which goes on under the name of Basic Design, and the art is the heterogeneous body of painting and sculpture, executed in many different countries by artists of widely varying ages, which bears most heavily upon it the influence of Bauhaus teaching, particularly as this has filtered through the work of Josef Albers. More accurately, Podro is not against any particular kind of art or any particular kind of art-education, but only against a specific theory or dogma upon which both are usually based: however, the inaccuracy is not so important in that it is dubious whether either would survive in its actual form, let alone retain its validity, if the theory which is invoked in support of it were subverted. The theory is that which asserts the existence of simple or basic constituents of pictorial design.

Let us start with Kandinsky's case of the square canvas with a dot placed at its centre, against which there is then set another square canvas this time with the dot placed off-centre. From this juxtaposition Kandinsky (according to Podro) tries to demonstrate the existence of basic constituents, more particularly that the dot is

Uncollected Writings. Richard Wollheim, Gary Kemp, and Elisabetta Toreno, Oxford University Press.
© Bruno Wolheim 2025. DOI: 10.1093/9780191995767.003.0008

such a constituent; and it is a large part of Podro's case that such a demonstration is invalid.

I shall follow Podro in considering in turn various features of the example that might be thought to provide evidence for the existence of simple constituents:

1. That the dot and its position are different, in that in each case the dot retains its character as a feature or thing whereas its position changes. But if this proves anything, it proves too much. For if it proves that the dot is a basic constituent, it also proves that the position of the dot is a basic constituent. For just as the dot can be now here, now there, so the position can be now occupied, now unoccupied. In both cases we can distinguish the enduring subject from its transient properties. But surely no-one would think of a mere position on the canvas as a pictorial constituent.

2. That as the dot changes its position, so the configuration looks different. But such an effect could be achieved without its being recognized that the configuration is the same but for the position of the dot: either because the dot was not observed to have changed position or because the dot was not observed to have retained its identity in those different positions. And in neither case would it be plausible to think of the dot as a constituent of the different pictorial compositions.

 So far, then, it seems that neither of the two obvious features about Kandinsky's example go any way to demonstrating that the dot which is placed centrally on one canvas and off-centre on the other is a basic constituent of composition.

 Podro then considers a third feature of the example: one which differs from the other in this respect, that if it is a feature of the example, it is a contingent not a necessary consequence of the juxtaposition.

3. That when we look at one canvas after looking at the other, we have a propensity to see one as if it were the other: more specifically when we look at the canvas with the dot offset after looking at the canvas with the centralized dot, we tend to move the dot over to the centre in our vision and then have to readjust. In other words, Podro is prepared to assume here, for the sake of the argument, the operation of a conventional pragnanz-effect.

Now unlike the other features of the juxtaposition, this one does (Podro allows) show something that is relevant to the theory under discussion. If we do have a propensity, or at any rate a preparedness, to see the dot elsewhere than its actual position, then we can regard the dot as a constituent of the composition. In other words, our disposition to vary [the] perceptual set can be regarded as a criterion for a pictorial constituent. But two points need to be observed.

In the first place any judgement that a particular element is a constituent is not a generalization about elements of that kind or type. It is a judgement that is strictly

relative to a particular composition or a particular kind of composition. And this is brought out inadvertently by Kandinsky's own example. For by our criterion the dot may well be a constituent of the composition where it is off-centre, but conceivably might not be a constituent of the composition where it is centralized: for our tendency to see things symmetrically might be an iron law which we could not break even for the benefit of a thought-experiment.

Secondly, though we may now have a criterion of what it is for a discernible element to be a constituent of a composition, this has nothing to do with simple constituents. For this mark of being visualizable otherwise than it is can clearly apply to elements that are not at all simple: and Podro cites the example of what he calls 'a highly complicated piece of representation' namely the goddess-figure in Rubens's *Judgement of Paris* [URL39], which we can think of as turning on an axis and thus forming successively the embodiment of Hera, of Athene and of Aphrodite.

However, it is now open to someone to suggest that Podro could go on to give us a criterion of what it is for something to be a simple constituent by conjoining the criterion that he has got with a criterion of simplicity. Podro does not directly meet such a suggestion, but I think it is possible to reconstruct what his attitude to it would be. It looks as though he would reject such a suggestion on the grounds that the distinction within constituents between simple constituents and complex constituents is utterly peripheral and possesses no aesthetic interest. It is possible that he might go beyond this and even challenge the concept of simplicity itself: although if he did, it is worth pointing out that the validity of the concept is implicitly asserted in the way in which we have seen that he characterizes the goddess-figure in the Rubens.

II

However, there is a reason over and above that of mere consistency why Podro would be ill-advised at this stage to reject the simplicity/complexity polarity, rough and tendentious though it may often be. For it would prevent, or at any rate inhibit, the elaboration of his theory in a way which would allow it a wider application. In this second section of my paper I want to suggest what that could be.

It is a view, as old as Aristotle,[1] that it is the mark of a good work of art that all its elements are so arranged that we could not imagine the smallest dislocation or transposition without the value of the work itself being impaired. When, however,

[1] Aristotle, *Poetics*, VIII, 9: cf. ibid. VII, 8–10. For two interesting contemporary discussions, see E. H. Gombrich, *Raphael's Madonna della Sedia* (Oxford: Oxford University Press, 1956) and Meyer Schapiro, 'On Perfection, Coherence and Unity of Form and Content' in Sidney Hook (ed.), *Art and Philosophy* (New York: New York University Press, 1966).

we consider the high degree of differentiation that characterizes many paintings or sculptures, whether this is calculated in terms of representational units like bodies or trees or in terms of technical units like brush-strokes or facets, the view seems ridiculously exaggerated. Surely it isn't true that not one square centimetre of Titian's *Bacchus and Ariadne* or the Würzburg ceiling could be different without detriment to the whole?

In critical practice it is generally conceded that this theory has only a limited application. Elements in a picture are implicitly divided into those which could not suffer change without aesthetic loss and those which could, and enlightened analysis takes the form of elucidating the picture by reference to the former rather than to the latter.

Now it would be tempting but wrong to equate the inviolable elements of the picture with the larger or complex elements, and the violable with the smaller or simple elements. As we shall see later, there is some congruence between these two groups but the overlap is by no means perfect. A striking example of a complex element which it would be wrong to think of as inviolable would be the bunches of fruit or flowers that make up the swags in Squarcionesque paintings. Whatever we feel about this particular motif, whether we are or are not inclined to think of it as put to better use in one painting than another, it is clearly inappropriate for us to wonder whether, say, the gradation between the different bunches on a single swag might not have been more fittingly or beautifully organized. Considerations of technique or handling aside, we take the swag as a unit not because we think its organization could not be altered without disrupting the picture but because we treat its internal differentiation as a matter of comparative indifference.

Having said this much, I now wish to equate constituents as defined by Podro with what I have called the inviolable elements of a picture. For it is only those elements which, within the terms of the particular composition, we can visualize as being otherwise than they are that we can appropriately think of as being as they should be. For the rest we are not called upon to make the act of perceptual imagination, and so any judgement of perfection passed upon them would be mere idle piety or ingratiation.

It is just because in the case of the Rubens we can so readily see the composition as constituted of one element gyrating, that we take into account the disposition of the three goddesses in forming our judgement of the whole. How the element is in fact disposed becomes a proper matter of judgement just because of the perceptual freedom we have in respect of it. Conversely in the case of the Squarcionesque painting where we are not asked to see the swags as admitting of other perceptual possibilities it is futile to think of their particular internal formation as a virtue of the picture.

We can now see why it would be misguided for Podro to reject the simplicity/ complexity polarity altogether. For it is not merely a fact, it is an interesting one

that just as there are constituents that are not simple elements, there are also complex elements that are not constituents.

But yet the situation cannot be left just like this, even though this may be the truth. For the distinction between the violable and inviolable elements of the picture, between constituents and non-constituents, has a very arbitrary look. In the third and final section of this paper I shall try and indicate a historical background to this problem.

III

In *Art and Anarchy*[2] Edgar Wind suggested that Morellian criticism could be regarded not merely as a typical product of the modern understanding but, more profoundly, as a revealing symptom of our modem sensibility. For, he argued, modern art—by which he meant, as I shall, the art of roughly the last hundred years—is in origin and by design that which all art becomes when subjected to Morellian analysis: that is, an art of fragments, an art in which detail is made paramount. In reviewing *Art and Anarchy*[3] I suggested that what was true in Wind's thesis could be better expressed by saying that in modem art detail has been progressively eliminated. Let me explain.

The subjects that constitute the traditional repertoire of art have almost invariably committed the artist to the depiction of a mass of heterogeneous material, under which he was in constant danger of being swamped. Accordingly one of the major problems has been how to organize this material in an aesthetically acceptable fashion, and the solution has lain in subsuming minor elements into complexes of a more embracing character. These complexes are then further ordered so as to produce a unity which is the picture. The history of style, or at any rate of pictorial composition in so far as this is a narrower topic, is the history of these different solutions, and it is the inter-relations between the complexes characteristic of each solution that form the subject-matter of most aesthetic judgements.

To describe these solutions as ways in which elements are subsumed into complexes may give rise to a misunderstanding. For it might be thought to imply that compositional techniques always consist in inserting smaller elements into larger elements, so that the whole composition resembles a series of Chinese boxes. But if this is meant in any sense which goes beyond the tautological observation that a complex is always larger than the elements that constitute it, it runs the risk of parodying the methods of the old masters. For a great deal of the excitement of their pictorial solutions comes from the way in which comparatively small elements are sometimes allowed to remain outside all complex structures and enter into

[2] Edgar Wind, *Art and Anarchy* (London: Duckworth, 1963), pp. 35–51.
[3] *New York Review of Books*, 30 April 1964, pp. 7–8.

the composition of the whole independently, as sovereign elements. An example of such an effect would be the sheaf of corn in the foreground of the *Portinari Altarpiece* [URL40]: another would be the tiny figures that make up, but are not totally submerged in, the distant circle round the crosses in Breughel's *Road to Calvary* [Fig. 1.1]. But sometimes such daring strokes will appear without any obvious iconographical or dramatic warrant: I am thinking for instance of the small fluttering pieces of drapery or hands that are distributed across the surface in many of Lotto's portraits. Equally, there will be cases where comparatively large and distinct elements will be deliberately put together and contained in yet larger and more complex structures: this is, for instance, the widespread practice in Poussin's earlier dramatic compositions, like the *Plague at Asdod* [Fig. 8.1].

Another misunderstanding which it would be wise at this stage to guard against is that the internal structure of these complexes is a matter of aesthetic indifference. On the contrary, the old masters were always prepared for that switch of attention from, on the one hand, the picture as a whole, when we examine the relations between the complexes, to, on the other hand, the complexes themselves, when we examine the inter-relations between *their* constituent elements. Moreover the two forms of attention are linked in this way: that in cases where the internal structure

Fig. 8.1 Nicolas Poussin (French, 1594–1665), *The Plague of Ashdod*, 1630–31. Oil on canvas, 148 × 187 cm, (unframed). Photo © Musée du Louvre, Paris (INV 7276; MR 2312).

of the complexes is really defective this can interfere with our seeing them as complexes, *i.e.* as terms to the higher order relations in which the composition consists.

With these two points firmly in mind we can now, I suggest, identify the complexes of traditional composition with the constituents discussed in the earlier parts of this paper, *i.e.* those elements which we feel free to visualize as being placed other than they are but which, in a well-ordered picture, we consider to be placed exactly as they should be.

My historical observation is that from the Impressionists onwards there has, for a variety of reasons, been a sustained attempt to discontinue the traditional methods of composition and to allow even the smallest element in a picture the right to figure as an independent constituent of the whole. Factors as diverse as the suspension of history-painting or the desire that the paint should be handled in a consistent fashion across the whole canvas have contributed to this tendency. I am not claiming, of course, that in modern painting there has been a rejection of order: for that would be utterly false. I am saying that there has been a movement away from a certain kind of order: roughly, the ordering of a picture in the interests of what might be called visual economy. Although even to this thesis there are striking exceptions: like the *Ateliers* of Braque or the compositions of Rauschenberg.

The theory that lies behind Kandinsky's experiment with the two canvases can now be seen as an extreme programmatic extension of this 'modern' tendency. It is indeed only against such a historical background that the theory can be understood or evaluated. I do not think that any of this goes against what Dr. Podro has said: though it may suggest a somewhat larger context than he allows.

I am aware that throughout this paper I have said nothing about the way in which a painting determines for us what we are to regard as its constituents or what elements we are encouraged to visualize otherwise than as they are. That (as they say) could be the subject of another paper: alternatively it may be something which, though intrinsic to any experienced vision of art, is incapable of characterization in any general way.

9

A Critic of Our Time (1959)

As is more than evident from the extensive introduction to his works, which Wollheim wrote (see 'The Image in Form', Chapter 10 in this volume), Adrian Stokes wholeheartedly adopted the psychoanalytic method—influenced by the pioneering theories of Melanie Klein (1882–1960), who was also his therapist—in order to probe the origins of artistic activity. Here the more narrow focus is Greek Culture and the Ego, which Stokes published in 1958. Wollheim's lucid explanation of Klein's theory helps understand Stokes's parallel between the phases of making art and the infant's complex apprehension or construction of a world of objects. The practice of art is akin to the infant's emotional reconciliation with primordial destructive impulses. Ancient Greek statuary and Greek culture altogether, the book contends and Wollheim brilliantly explains, mirror the steps of the infant's successional phases. Wollheim welcomes the novelty of the Kleinian angle but raises two objections and one technical criticism: Stokes's seeming conflation of the process of creation with the created object; the tendency to posit an isomorphism of the ego, the work of art, and cultural entities generally, whereby cultures are not sufficiently exposed to the external and often happenstance conditions of history; finally, a writing style that could be more friendly towards the reader. [Eds]

Adrian Stokes' writings on art, some of the most distinguished of our age, fall into two phases. In the first phase he wrote as aesthete, with an aestheticism that was mannered yet also stringent and literal, rather close to Pater. In the second and present phase, the dominant influence is that of psycho-analysis, and in a number of books and articles Stokes has attempted a consistent and fairly comprehensive interpretation of various aspects of art in terms of Kleinian theory. He therefore deserves to be one of the most influential critics alive: a man who combines an eye trained by scrupulous attention to the actual surfaces of works of art with such understanding and knowledge of the deepest origins of artistic activity as modern science has to offer—is this not the ideal specification of the modern critic?

Mr. Stokes makes no attempt to conceal the fact that in order to understand his books one must understand the theory of which they are applications: and this, as

Uncollected Writings. Richard Wollheim, Gary Kemp, and Elisabetta Toreno, Oxford University Press.
© Bruno Wolheim 2025. DOI: 10.1093/9780191995767.003.0009

I have indicated, is not orthodox Freudianism but the development or extension of it associated with Melanie Klein. On the validity of Kleinian theory I have no competence to pronounce, but it seems to me that (if true) it has greater potentialities as a tool in the understanding of Art than orthodox theory. But before elaborating this point, which is vital to our assessment of Stokes's criticism, I shall sketch in a background that may yet be unfamiliar to many.

The starting-point of Melanie Klein's work is the problem of anxiety in small children: by pursuing this theme she was led to a number of fresh insights into the primitive mind. In the first part, she came to a revised conception of the id or reservoir of instinctual energy. For to Freud the id was predominantly identified with the libido or sexual impulse. From 1920 onwards (it is true) he suggested that alongside the libido was the death-instinct, and that man was the battle-ground of an 'eternal struggle' between two groups of instinct, Eros and Thanatos. But this dualism remained with him an essentially speculative idea, and it was left to Klein to retrieve it from the realm of abstraction and to show in detail the role of the aggressive, as well as the sexual, urges in the life of the emotions.

Closely connected with the more complex view of the id, goes an increased attention paid to the ego and its mechanisms for dealing with instinct and anxiety. Freud had compared the relation of the ego to the id to that of a rider to a horse, and went on to specify a number of different ways in which one controls the other. The simplest and intuitively most obvious of these devices is that of repression: and Freud's most widely known work is undoubtedly that concerned with the fate or activity of repressed wishes and instinct. But he also considered other methods of dealing with stress and conflict. He refers occasionally, and ambiguously, to sublimation: in connection with melancholia and the development of the super-ego, he discusses introjection: paranoia is the result of projection. Some of these mechanisms are, however, incompletely specified, and it is a feature of Klein's work that she concentrates on a larger range of defences (e.g., manic defence, idealisation), and also endeavours to specify in greater detail the role of each in the development of the psyche.

For Klein, like Freud, is essentially dynamic. She believes, that is, that from the beginning the infant is propelled along a course of development: new problems arise for it not simply out of old problems or from the environment, but in accordance with a trend or sequence of events—a trend which may be inhibited or arrested but which in itself provides the norm of development from which all deviations deviate. Klein's contribution to our knowledge of this trend is twofold. In the first place, she managed (by the evolution of special techniques of analysis) to trace it right back to birth itself, and indeed to find in events of the first few months experiences vital to later conflict and anxiety. Secondly, she isolated and defined the most important single psychological mechanism on which the infant's development depends: the rhythmic process of introjection-and-projection which sets up a kind of oscillation in all early object-relations. At first, the infant is attracted by objects that excite it or impinge on it: it descends on them, makes them part of

itself, 'incorporates' them in its own 'inner world' of phantasy. But once having the objects inside it, it then wants to expel them, to reascribe them to the world. In doing so, though, it projects not just the objects as such but also the feelings with which it has invested them, and so peoples the world with persecutors (the painful objects) or benign forces (the pleasurable objects). And then the infant is ready for re-introjection. By means of this primordial process—which is not merely analogous to, but clearly influenced by, the primary physical processes of feeding and excretion—experience begins.

On a more descriptive level Klein distinguished two phases or 'positions' in early development. In the first (the 'paranoid-schizoid' position, so-called from its resemblance to a psychotic condition of later life), the infant lies at the mercy of objects (most particularly the mother's breasts) which alternately gratify and frustrate it and so arouse in it now pleasurable, now painful sensations. Lacking any conception of 'whole' objects, the infant assigns differing sensations to different causes, and so arrives at a fragmented picture of the world, exaggerated by the ceaseless introjection-projection process. He feels himself surrounded by a multiplicity of objects, of which some are benign but most malevolent. In face of so much hostility he falls prey to persecutory anxiety, from which he seeks relief in a process of 'splitting' the good from the bad and denying the bad.

Gradually, however (at the age of four or five months), through the operation of a reality-principle, the infant begins to realise that the objects of his hate and love are merely different aspects or moments of the same 'whole-object,' that the good or gratifying breast is one with the bad or frustrating breast, and accordingly that revenge wreaked upon what he hates is really destruction of what he loves. Faced with this terrible revelation, overburdened by concern for what he has done or wanted to do, he falls into a kind of depressive anxiety which is the prototype of much of what is later known as guilt. Depressive anxiety differs from persecutory anxiety in that it is not fear for the self and what might be done to it, but fear of the self and what it might do. To allay it the infant resorts straightway to the manic defence: to a denial, that is, of any aggressive designs upon the object of his love and equally of any concern or guilt, and a strenuous insistence upon bliss and exhilaration. Or worse still he may regress to the primitive splitting mechanisms of the 'paranoid-schizoid' position. But ultimately none of this works: for denial and regression only increase fear, and fear increases anxiety. If the infant is to find any serene issue out of his anxiety, he must admit to himself the damage he has caused and recognise that the cause of it lies in himself, in his ambivalence, in the terrible but fundamental conjunction of love and hate, and then he must trust to his capacity to make reparation to the object that he has hurt. To do so he must recognise that the object is something whole and united, and yet independent of, and other than, him and his emotions. This is the crucial test for the ego's well-being and advancement: if it passes this test, it emerges integrated. Moreover, in the capacity to tolerate depression, to admit ambivalence, to offer reparation, is to be found the

origin of most of what we value most in life: of unselfishness, of morality, of love, of art. Of Art—for in the creation of Form, which is one of the essential elements of Art, we have man's most sublime effort to amend, by the construction of whole objects, for his elemental destructiveness.

In his latest work, *Greek Culture and the Ego*,[1] Mr. Stokes weaves a few more subtle and complex strands between Art and the successful transcendence of the depressive position. A work of art, I have said, can plausibly be regarded as a typical product of the integrated ego: but equally it can be regarded as a more or less adequate symbol of the integrated ego—and it is the symbolic, or mirroring, aspect of Art that provides the subject-matter of this book. Stokes argues that the Greek aesthetic canon with its emphasis on symmetry and proportion, on the one hand, and the all-importance of the human body, on the other, gave rise to a form of art in which this symbolical element achieves its consummation. For the insistence on proportion led to works of art in which the harmony, the integration, of the integrated ego found a direct physical correlate: and again, the concentration upon the human body as the supreme aesthetic motif, does justice to the fact that the integrated ego is essentially a 'corporeal form,' by which expression I take Stokes to mean that the ego is essentially bound up with a sense of physical identity and uniqueness. Now, the historical thesis of the book is that this supreme capacity of Greek art to mirror the integrated ego is not a mere coincidence, but is connected with the most general values and ideals of Greek culture. For if we examine not merely Greek art but Greek religion, Greek politics, Greek science, we find that the dominant attitudes asserted in these various spheres are just those which in Kleinian theory are connected with the successful 'working through' of the depressive position: an appreciation of the variety and independence of phenomena, an acceptance of death and loss, a rejection of the transcendental, the shunning of everything exalted and immoderate. In a culture devoted as none before and perhaps none since to the maintenance of ego-values, it is not surprising that the art of the age should have celebrated the integration of the ego to a degree that has made it 'the model and indeed the despair of many civilisations.'

After this brief 'placing' of Stokes's criticism, I want to return to the problem of method and the question whether a Kleinian approach to art—an approach, that is, formed by Kleinian interests as much as by Kleinian theory—is likely to make a valuable contribution to art-criticism. For whatever we may think of this or that element in Stokes's work, it undeniably represents an attempt to interpret works of human creativity in a quite new and original way. What are we to think of this attempt, and how does it compare with criticism inspired by orthodox theory?

In the first place, Kleinian criticism does not demand material about the artist's mind and experience on the same extravagant and impossible scale as Freudian

[1] Adrian Stokes, *Greek Culture and the Ego* (London: Tavistock, 1958).

criticism. For Freudian criticism is essentially interpretation in terms of instinctual impulse: after a few cursory references to sublimation, the Freudian critic settles down to discover the 'latent content' of the work before him, and in order to discover the latent content of a work of art, as of a dream (and Freudian art-criticism is closely modelled on Freudian dream-interpretation), one needs to know a great deal about the associations and circumstances of its creator. Kleinian criticism, on the other hand, by relating the work of art not to the variable impulses of the artist's id but to the invariable processes of the artist's ego, can dispense with voluminous biographical material. In other words, the change from a predominantly id- to a predominantly ego-interpretation has obvious economic advantages.

Secondly, by concentrating upon the content of the work of art, Freudian criticism laid itself open to the objection, often urged against it, that it ignored the specifically aesthetic aspect of art; for if products of identical content are treated identically, how do we distinguish between, say, a Leonardo and a day-dream or a child's game with the same motivation? Kleinian criticism has deliberately set itself to redress the balance. A work of art is defined in terms of the possession of certain formal characteristics and those characteristics are then analysed as the natural correlates or products of certain ego-processes. (At this stage, however, a word of warning. Any recognition that the analysis of a work of art is not exhausted by analysis of its content is welcome, but Mr. Stokes can perhaps be accused of extending the concept of form as freely as certain Freudians did that of content.)

On the other side of the balance sheet there are two objections, with which Mr. Stokes can probably deal, but I don't think he meets them in this book. In the first place, like other thinkers with a psychological theory about the nature of Art, he does not always distinguish between Art as creation and Art as object. That is to say, when he attributes a purpose or role to Art, is he talking about what the artist puts into the work of art or about what the spectator gets out of it? Perhaps Stokes doesn't feel it necessary to make the distinction because he thinks that the two are always or nearly always the same. But if he thinks this, then he must (like others before him) hold some hypothesis to the effect that the spectator when confronted with the work of art 're-lives' or 're-enacts' the creative process. But such a hypothesis, if held, should be stated. That the perception of Art is vicarious experience is not the sort of fact about human nature that we can afford to take for granted.

Secondly—and this relates specifically to *Greek Culture and the Ego*—I am immensely distrustful of anything that seems like 'cultural psycho-analysis.' 'Culture mirrors contrasting ego-states,' Mr. Stokes writes, and I wonder exactly how much he means. If he is merely saying that there is an identity of structure, an isomorphism, between certain kinds of ego and certain cultural manifestations, and that the ego often perceives the isomorphism where it exists, and uses it as a source of comfort or 'life-enhancement,' and that in certain cultures certain structures are particularly in evidence and so certain kinds of ego flourish there, I have no objection. But in any context in which this fact is relevant, it must also be relevant that the

ego can sometimes perceive an isomorphism where no such isomorphism exists—as a result, for instance, of projection—and, to collect these cases we need to move out of 'cultural analysis' and back to the study of particular histories. If, however, as I suspect, Mr. Stokes wants to claim that where there is an isomorphism between a work of art and a kind of ego, not merely does the ego thrive on the work of art but the work of art can, without further question, be causally attributed to the ego, then I feel that it is time for scepticism to assert itself. Art, science, religion, any branch of culture is an institution, and as such has a history of its own. This history is influenced by climate, by disease, by discovery, by death, by money, by coincidence, by a thousand factors that cannot be ultimately reduced to the elements of the psyche. And not only does the 'institutional' aspect of culture defy psycho-analytical explanation, but it also determines the areas in which any such explanation is relevant. For the only features of culture that can be of significance to the analyst are those which can be regarded as 'optional,' those where, society imposing nothing, the individual is free to express himself, either in the unlimited sense that anything is possible or in the limited sense that choice can be made between socially determined alternatives. It is not always clear in Mr. Stokes's account of Greek art where he draws the line between the 'expressive' and the 'institutional' aspects of art, or whether he believes (*quia absurdum*) that the institutional aspect is itself susceptible to deep analysis.

Mr. Stokes is a difficult writer: his sentences are highly condensed; he has a disturbing habit of inserting into his text quotations from psycho-analytical literature whose relevance to what he is saying is far from evident; and he carries indifference to the reader's self-confidence to the extent of using expressions like 'I should say,' 'I take it that ...,' and 'I think I am already discussing....' Worst of all, he presupposes throughout some direct acquaintance with psycho-analytical theory. But it would be sheer laziness and stupidity for anyone seriously interested in the visual arts to use these as excuses for not reading Mr. Stokes. Anyhow, why should we think the secret of Art is to be revealed to those who lack patience and knowledge?

For those who cannot accept the main theme of the book, there are many fascinating and suggestive asides: for instance, a thoughtful treatment of the question which an eminent art-historian once said to me he thought should be the starting-point of all aesthetics, why there is no art either of smell or of taste.

10

The Image in Form

Introduction (1972)

In 1972, Richard Wollheim edited a volume of writings of Adrian Stokes, with whom he had a lifelong intellectual engagement. The importance to Wollheim of Stokes's critical method was such that he dedicated his seminal Art and its Objects *(1968) to the British art critic. Stokes's position in art history is these days largely ignored. This volume and its introduction are useful reminders of the artistic and intellectual sensitivity of Stoke's often difficult but nonetheless inspiring studies. Wollheim refers to no fewer than eleven books authored by Stokes; they are bounded, according to Wollheim, by a commitment to articulate, in Stokes's inimitable style, what it is about art that makes it figure so profoundly in our lives. Stokes's discovery of Freud's psychoanalysis, and then the contributions of Melanie Klein (see Chapter 10 in this volume), allowed him to make explicit what had up to that point perhaps been only implicit in the views of one who took as his starting point his 'love of stone'. The connection of psychoanalysis to the question of the value of art is a constant in Wollheim's work, and Stokes was a seminal influence.* [Eds]

Adrian Stokes was born in 1902. He was brought up in a London that has now largely vanished, and he has lived, for years at a time, in Italy, in Cornwall, on the North Downs, and, since 1956, in Hampstead in an eighteenth-century house, where he paints and writes. His life and his work have always been intimately entwined, and he has cultivated privacy in both. He has been unconcerned with reputation, and the sources of his inspiration have lain in the progress of his own ideas and in the physical environment. In 1925 he first came to live in Venice, and he has described to me how he immediately fell under the influence of the city and its lagoons and of d'Annunzio's passionate novel *Il Fuoco*, in which the poet not only recounts his affair with the Duse but also makes many references to the Renaissance and to Pisanello. The months that ensued, absorbed in a city and its architecture, in buildings and the life they house, in painters of the past, in what another man had made of these things and how he had invested them with feeling,

Uncollected Writings. Richard Wollheim, Gary Kemp, and Elisabetta Toreno, Oxford University Press.

above all in his own shy intense reactions, epitomize, if in a heightened form, the interplay of reflection, art, and place so characteristic of Stokes's work.

This volume deals only with Stokes's critical writing and with what is necessary for the understanding of that. Though the body of this writing, which now amounts to some eighteen volumes, is not familiar to a wide circle of readers, its influence, direct and indirect, has been considerable. There are certain painters, sculptors, poets, philosophers, critics and historians of art who are profoundly indebted to him. And, increasingly, some of the earlier volumes, with their thick paper and their velvety old-fashioned photographs, have become eagerly sought after.

Of those aspects of his childhood which concern us in that they have contributed directly to his work, Stokes has given us a description, included in this volume, in which he retains throughout the child's perspective. In the fantasies of the young boy, exercised daily in a London park under a succession of governesses, we discover much that is later to assert itself either in the motivation or the content of his writing—two things never far apart in the work of an original artist. Fear, concern, the sense of loss, a feeling for order, the desire to restore and to put everything right—first experienced most poignantly in relation to the objects and events of the childhood round, to the drained bed of the Serpentine, the rough boys who infested the Park, the Magazine by the lakeside in which dangerous explosives were stored, the red-coated soldiers, the big horse-chestnuts in candle, and the myth of the Park returned to an eighteenth-century grandeur—to which must be added a powerful capacity to find in the outer world intimations of the inner: these things later manifest themselves as the motive force behind Stokes's work, but they are also what he is eventually to write, more eloquently, more directly than any other writer I know of, as the perennial subject-matter of art. In the autobiographical pages, mostly to be found in *Inside Out* and *Smooth and Rough*, we find representations, unexcelled in our literature, of the artist and the aesthete in the making.[1] We see the child hungry for experience, and hungry also for the understanding of experience. These passages recall the best of *Praeterita*, and they are the equal of Pater's strange confessional fragment, 'The Child in the House'.[2] But, if in sensibility Stokes has much in common with Ruskin or Pater, in intellectual culture or the degree of self-consciousness there is the difference of a century.

The love of art was of slow formation in Stokes's life, and in its development the first visit to Italy, where he arrived on New Year's Eve 1921–2, was a crucial event. From then onwards, the craving for sensuous experience, which had so stirred the young boy on his daily walks, gradually turned towards painting, sculpture, above all architecture: for with Stokes the experience of art has always proved most

[1] Adrian Stokes, *Inside Out* (London: Faber & Faber, 1947); *Smooth and Rough* (London: Faber & Faber, 1951). [Eds]

[2] John Ruskin, *Praeterita* (London: Everyman, 2005); Walter Pater, 'The Child in the House', in *The Collected Works of Walter Pater*, vol. 3 (Oxford: Oxford University Press, 2019). [Eds]

profound, most satisfying, when art finds expression in a corporeal form of in a form sufficiently approximate to the body for us in make the assimilation. Hence, it was only a natural step when, under the influence of the great Diaghilev seasons, Stokes extended the range of his aesthetic interest to take in the dance, and he later came to write some of the best accounts of traditional ballet in the language. More generally, the connection between art and the body, the corporeal nature of art as we might think of it, has always figured centrally in the subject-matter of Stokes's criticism, though, as this criticism evolves, the connection receives at different times a different elaboration and a different explanation.

But to talk of the evolution of Stokes's criticism inevitably brings us to the second major theme of his writing. For at much the same time as the love of art asserted itself, he began to sense the fascination of psychoanalysis. It was early in the 1920s that Stokes read *The Interpretation of Dreams* and *The Psychopathology of Everyday Life*.[3] From the very beginning he experienced the attraction of the new ideas, and they slowly began to exert their influence over his thinking. The crucial event in this process was still several years off, as we shall see, and even then it was some time before the two themes of art and psychoanalysis were explicitly brought together in the critical writings. Nevertheless, if Stokes's early work can be read much as though it belonged to the tradition of nineteenth-century aestheticism, it is to be observed that, throughout, there is a place reserved for psychoanalytic theory, at which it can be introduced when the moment is right. For from the beginning the notion finds acceptance that art is a form of externalization, of making concrete the inner world, and the evolution of Stokes's criticism can largely he accounted for by the increasingly richer view that is taken of the inner world and of how and by what means it works its way out.

Stokes's first book, *The Quattro Cento*, appeared in 1932, though an article on Rimini and the Tempio Malatestiano, which was to be the subject of his second book, had already been published in T. S. Eliot's *Criterion* some two years earlier.[4] In point of fact, *The Quattro Cento* and its successor *Stones of Rimini*, the repositories of much intense observation and reflection, represent the work of several years.[5] Throughout the 1920s Stokes revisited Italy on a number of occasions, sometimes making his home there, sometimes travelling extensively. Often he was by himself, and in some of his most memorable descriptions we seem to discern the reveries of the young man, as he stands alone, absorbed in the temple facade, or wandering through the courtyard of a Renaissance palace, or the crowded piazza of a small country town. At other times he was in company—for instance, with the Sitwells, met by chance in Italy, who were (he has said) 'the first to open my eyes',

[3] Sigmund Freud, *The Interpretation of Dreams* (Ware: Wordsworth Press, 1997); and *The Psychopathology of Everyday Life* (New York: Norton, 1971). [Eds]

[4] Adrian Stokes, 'The Sculptor Agostino di Duccio', *Criterion*, 9.34 (1929), pp. 44–60. [Eds]

[5] Adrian Stokes, *The Stones of Rimini* (London: Faber & Faber, 1934). [Eds]



though their aesthetic interests and his were and remained very different. A closer affinity of taste was established with Ezra Pound, whom Stokes first met as a tennis partner in Rapallo in the autumn of 1926: for the two men soon discovered that they shared not only a common admiration for the Tempio Malatestiano and the sculpture that adorned it, which Pound had already written about in the Cantos, but also a community, or perhaps a complementarity, of response.[6]

From the beginning, indeed from the opening words—the first chapter is entitled 'Jesi', and it starts: 'No sign of Frederick Hohenstaufen in the railway station at least'—*The Quattro Cento* exhibits an idiosyncrasy of manner, later to become characteristic, that sets it apart from normal critical or art-historical writing. There is an obliquity of approach, long elaborate descriptions suddenly shot through with darting phrases, or an accumulation of detail, closer perhaps to lore than to learning: there is an independence, bordering eccentricity, of judgement, and a heady freshness of observation: and there is the constant proximity of humour and depth.

In conception *The Quattro Cento* is, it is true, the most conventional of Stokes's books. For it has been endowed with an elaborate architectonic which, if it might have done something to illuminate the place of the book in some rather larger literary scheme which was ultimately abandoned, tends to obscure the thesis that it presents. The architectonic of the book is strictly geographical, divided according to the city-states of Renaissance Italy, with the central section devoted to Florence and Verona. The thesis, however, cuts across geographical distinctions and will even divide some part of the work of a given artist from the rest. For the central aim of the book is to identify and to define a mode of art, which, though it produced some of its finest manifestations in Italy in the fifteenth century, cannot be equated in any straightforward way with Quattrocento art nor even with any specific school or tradition within Quattrocento art. For this mode of art Stokes devised the label, 'Quattro Cento', from which in turn the book derives its title.

Quattro Cento art is identified through a number of characteristics varying greatly in generality and in concreteness. In *The Quattro Cento* they are allowed

[6] Of recent years the literary relations between Stokes and Ezra Pound have been the subject of speculation by a number of literary critics. In Donald Davie, *Ezra Pound: Poet as Sculptor* (London: Oxford University Press, 1964), much is made of the connection, and *Stones of Rimini* is talked of as a commentary on, or an elaboration of, Cantos 17 and 20. The truth would seem to be that Stokes and Pound became independently interested in Rimini, and that it was this common interest that they discovered at a chance meeting. There seems little reason to think of Pound as an influence on Stokes's visual aesthetic; though Stokes profited greatly from his encouragement. Pound was the first to read in the late 1920s the article, which was subsequently to appear in the *Criterion*, about Agostino and 'stone-and-water'. In a projected volume Stokes intended to explore the purely historical background of the Tempio, and there he would have made explicit reference to the Malatesta Cantos. The volume, however, was never written, partly because, as we shall see, Stokes's visits to Italy were, at this period, abbreviated, and partly because, as he worked on the testimony, his view of Sigismondo's personality became more uncertain and, in particular, his disagreement with Pound's estimate became more marked. And, meanwhile, *Colour and Form* crystallized. Pound was perhaps disappointed by the non-appearance of the second volume on Rimini, and the relations between the two men loosened.

to emerge in course of description, and, in consequence, though I have tried to do justice to them in the excerpts I have chosen, I cannot be certain I have succeeded. Associated with the various characteristics are certain distinctive merits or virtues, but Stokes is careful not to claim for Quattro Cento art supremacy, even within the art of the Renaissance. It is one mode amongst others—though for him at least invested with an inexhaustible poignancy and beauty.

The first characteristic is a passionate attachment to the medium, to stone: 'the love of stone'. But what Stokes means here—and the point is important to emphasize and it is one to which he constantly reverts, elaborating and elucidating it each time he does so—is the love of stone *as a medium:* the stone, that is, is treasured for its potentialities, for what can be coaxed out of it. And if, elsewhere, apropos of Agostino di Duccio or Michelangelo, Stokes talks, seemingly, of the unqualified love of the stone, the love of the block or the slab, this, it must be understood, is a derivative love. That in the first place the stone is loved as a medium is brought out, indirectly, by a kind of compliance that Stokes presupposes between artist and done. On the artist's side, there is the outward thrust of fantasy, the projection of this on to stone, and parallel to this, there is (as an observed effect, I take it) the way in which the stone, in the hands of such an artist, pushes itself forward on to the surface. The stone blooms, there is 'encrustation', or 'exuberance'. The art of the Quattro Cento is, in one favoured phrase, the art of 'stone-blossom'. And if we are uncertain what are the visual conditions on which these descriptions rest, or in what precisely the effect consists, it is best to turn to the various detailed accounts that Stokes provides of what are for him dear examples of the Quattro Cento: the courtyard at Urbino by Luciano Laurana, or certain works of Verrocchio. in such passages, where we can set the description against the object, the terms begin to explain themselves.

The second characteristic is mass, where this is contrasted variously, with massiveness, typical of Roman architecture and the Baroque, and with a rhythmic or linear treatment of space, such as we find in the work of Brunelleschi. The third characteristic is immediacy. And it is by design that I group these two characteristics together, because the former is best understood through the latter. For 'mass-effect' can be thought of as that awareness of space which arises (or can arise) instantaneously, or from 'the quickness of the perceiving eye'. It does not require a process of synthesis, taking place over time, in which successive impressions are first accumulated and then pieced together, but it is an immediate response to the tension, or inner ferment, expressed on the surface of the wall. Conversely, the kind of architectural space that engenders this kind of awareness is not cumulative, nor does it appear to be built up out of discrete spatial units. (Stokes, it is true, introduces the notion of mass-effect rather differently, though, I think, nothing I have said is inconsistent with his intentions. For the definition of mass-effect he invoked the theory, still current at the time, according to which our awareness of space is ultimately derived from the sense of touch and there is

no more than an analogue to this awareness in the visual field. This theory, which was first systematically laid out by Berkeley, died hard in aesthetics: witness the vogue enjoyed, around the turn of the century and then later, by Berenson's notion of 'tactile values' as a vital component of the Florentine achievement. It was then in keeping with this tradition that Stokes defined mass-effect as that awareness of space which is peculiarly connected with the sense of sight and hence is to be contrasted with the 'normal' awareness of space. However, nothing that Stoke says commits the notion of mass-effect to the Berkeleyan theory irrevocably, and, indeed, freed from its theoretical trappings, the idea of a treatment of space distinctive in its appeal to the eye or to visual cues can only gain in plausibility or clarity.)

The fourth characteristic is the most difficult to pin down. Quattro Cento art is, we are told, 'emblematic', it has 'the power of emblem'. The concept of the emblematic, which disappears from Stokes's later writings, though not without a trace, falls into two parts, which are evidently if elusively related. The first is that the signs or symbols recurrent in the art render up their meaning readily: they are transparent to the eye, or at least translucent, and are what a whole school of aesthetic philosophers have called 'iconic'. The second is that the process of making the signs or symbols becomes itself symbolic or meaningful—perhaps, indeed, it is the only source of meaning in the arts, and the signs or symbols in which it issues acquire their meaning derivatively from it. And, if this initially seems obscure, we might consider for a moment human expression, or the expression that finds an outlet through the body. For there too it is the very making of the expression, or the gesture, that is in the first instance meaningful, so that the expression itself gains its meaning from the way in which it is made. If this parallel is valid, then it would suggest that at any rate part of what is intended by talking of Quattro Cento art as emblematic is (once again) a claim about the relation in which the artist stands to the medium. He is related to the stone with much the same intimacy as he is to his own body.

To these, the chief characteristic of the Quattro Cento as a mode of art, Stokes next adds perspective, which he regards as an 'indispensable' constituent. And if this strikes us as incongruous, falling clearly on the side of the content, or how the subject-matter is represented, while the other characteristics are uncompromisingly formal, this only brings up in a clear, because in a concrete, form a general difficulty that underlies the whole characterization of the Quattro Cento: and that is the difficulty of seeing where the unity of the Quattro Cento lies, or how, for instance, the various characteristics are supposed to fit together. *The Quattro Cento* contains many fine insights and many beautiful discriminations, yet there is a real problem in knowing in what sense it deals with a single mode of art. For the resolution of this we have to turn to Stokes's next two books on the visual arts, which can conveniently be grouped together: *Stones of Rimini* (1934), and *Colour and Form* (1937). In the interval Stokes had clarified and integrated his aesthetic

categories in a way that was to be of the greatest importance for his later writing. Let us look at this.

In *The Quattro Cento* there is at various points an uncertainty that arises. An observation has been made about this or that work of art, and then the doubt may be experienced how the observation is to be understood or interpreted. Does the observation, we find ourselves asking ourselves, belong to the side of the artist and does it accordingly refer to a way in which he has worked? Or does the observation relate to the spectator, and is its aim to pick out what he can or perhaps should discern? It was in the course of removing this uncertainty that Stokes was ultimately able to resolve the more general difficulty that, as we have just seen, attached to the notion of the Quattro Cento as a unitary mode of art.

The first step was to adopt a consistent point of view. In *Stones* of *Rimini* the standpoint of the artist, rather than of the spectator, is consistently maintained. And this is achieved through the device of first putting in the forefront of attention a single artistic achievement, the reliefs in the Tempio Malatestiano,[7] and then considering—empathically, we might say—how it could have come to be executed. In *Colour and Form*, once again, a consistency of standpoint is retained, though now it is the more shadowy or generalized figure of 'the painter' who is the protagonist and through whose eyes we are led to reconsider many of the central issues of art and several of the greatest works of art.

In pointing out that the clarification of Stokes's earliest aesthetic is effected through the adoption of a single standpoint, I am not claiming that any viable aesthetic must be written exclusively from the point of view of the artist, alternatively, exclusively from the point of view of the spectator. On the contrary, I would think that any aesthetic written in this one-sided way would be seriously misleading. My point is only that what has first to be done is to collect together those observations which belong to one side or the other and allocate them correctly. For it is only when each standpoint has been fully articulated that the two can be collated: though it is only when they have been collated that an adequate aesthetic is likely to emerge.

However, it is not merely a shift of standpoint, or rather a shift towards consistency of standpoint, that occurs between *The Quattro Cento* and its successors; there is also an important conceptual innovation, and one *permits* the other. In the first book, in the course of trying to identify Quattro Cento art and to distinguish it from other contemporary trends, Stokes had written:

[7] Throughout *Stones* of *Rimini* the master of the Tempio reliefs is unequivocally identified with Agostino dc Duccio. This is now a matter of dispute: see, for example, John Pope-Hennessy, *Italian Renaissance Sculpture* (London: Phaidon, 1958); Charles Seymour, Jr, *Sculpture in Italy, 1400–1500* (London: Penguin, 1966).

The distinction I am making is laborious. I might have simplified it into a distinction between carving and modelling, between the use of stone and of bronze, were it not for the fact that the bronze can well convey an emotion primarily imputed to the stone, while, on the other hand, stone can be carved, as it was by Lombard sculptors, to perpetuate a conception not only founded upon the model but inspired by modelling technique. (*The Quattro Cento,* p. 28)[8]

In this passage the concepts of carving and modelling are, of course being used literally—in such a way, that is, that they are tied unequivocally to specific techniques or physical processes. And as such the concepts are, he finds, restrictive, or positively misleading. However, once the aesthetic theory comes to be restated from the standpoint of the artist, it seems plausible to reconsider using these concepts and possible to consider using them in an extended or metaphorical sense. Carving and modelling are now thought of as the two most general attitudes that the artist might adopt to his medium—altitudes derived from, but not confined to, the techniques or processes after which they are named. So adjusted, the two concepts move into the centre of Stokes's aesthetic. More specifically, the notion of the Quattro Cento gives way to that of carving: the Quattro Cento artist is recognized as *par excellence* the carver.

The dichotomy of carving and modelling has a longish history not only in artistic practice but also in aesthetic theory. However, in deciding to employ the terminology that he had rejected in *The Quattro Cento*, Stokes would seem to have been influenced less by intellectual precedent than by the painters and sculptors whom he was seeing in England at this time: notably Ben Nicholson and Barbara Hepworth. For in the work of these artists and their associates the sense of direct engagement with the material was a highly self-conscious element, and in this respect they thought of themselves as in deliberate reaction against both the academic and the 'fine art' or Rodinesque traditions, in which the making of models which were then sent to Italy to be cast by fine craftsmen still played a significant role. Writing around this period, Henry Moore, who was much involved with this new aesthetic, referred to Donatello the modeller as 'the beginning of the end'.[9]

It would, however, be wrong to think of the prominence now afforded to the notions of carving and modelling as simply a conceptual innovation; or—perhaps a better way of putting the matter—it would be wrong to think of the conceptual innovation involved as simply a change of vocabulary. On the contrary: the introduction of concepts that applied, in the first place, to actual techniques, and then, by extension, to generalized ways in which the artist might regard his relation to the medium, coupled, as we have seen, with the adoption of the artist's viewpoint

[8] Adrian Stokes, *The Quattro Cento: A Different Conception Of The Italian Renaissance: Part One Florence & Verona* (London: Faber and Faber, 1932).

[9] Quoted in John Russell, *Henry Moore* (London: Allen Lane, 1968), p. 19.

as that from which aesthetic description or analysis is formulated, allowed Stokes to present a clearer and more far-reaching view of the kind of art with which he was still centrally concerned. I shall, by and large, leave Stokes to speak for himself on this point. For, by including most of the central section of *Stones of Rimini*, with its description of the Tempio reliefs, I have, I hope, allowed the reader to see for himself how much the aesthetic gained in lucidity, in depth, and in subtlety through the changes that had occurred since *The Quattro Cento*. There are, however, one or two observations worth making.

In the first place, it is to be observed how the characteristic that Stokes had spoken of in *The Quattro Cento* as 'the love of stone' is clarified within the new conceptual context, and how, in particular, the point to which I drew attention—that it is love of stone *as a medium* that Stokes is talking about—comes out very sharply. The point is now made by resolving this characteristic into two components. There is, on the one hand, the artist's resolve to project his fantasies and emotions on to the stone, while yet preserving the integrity of the stone. Accordingly, the surface of the stone acquires differentiation, and yet the various layers or facets into which it is resolved contrive to be related without abrupt transitions or emphasis. And it is at this significance of perspective, which had proved a recalcitrant of heterogeneous element in the original stylistic characterization of the Quattro Cento, is integrated into the new account; for the value of perspective is that it allows the externalization of the artist's fantasy (or what in the broadest sense might be called 'representation') in a way that does not involve any undue or assertive attack upon the stone of the kind we get with other more frankly 'illusionistic' devices for securing depth, such as undercutting or high relief. The stone remains inviolate. Or, more accurately, it has a chance of remaining inviolate: for Stokes distinguishes between the use of perspective within the carving tradition—the 'love of perspective', as he calls it, in writing of Piero, the artist in whom it is exemplified supremely—and the mere exploitation of perspective in chillier ways, which he regards as a characteristic abuse in fifteenth-century Florentine painting. And, on the other hand, there is the artist's attention to the stone itself, to the varied intimations and suggestions it exhales, to what we might think of, or what at any rate the true carver might think of, as the fantasies that in some metaphorical sense it contains. There are many factors—its geological history, its cultural associations, the particular way it responds to manipulation, as well as its appearance to the eye—which determine the precise contribution that a type of stone makes to the art of those who love it. In many passages, limpid, persuasive, moving also below the level of consciousness, Stokes suggests the most intimate connections between marble, low relief, and fantasies of water. However, for Stokes the favoured way of bringing out this connection has always been by invocation of what he sees as its most powerful exemplification: 'the largest, the oldest, the most varied aesthetic object that has survived today', Venice, 'the city of Venice among intrusive waters'. It is for this reason, and not for the mere

enrichment of the text, that the description of Venice is such a constant point of return in Stokes's writing.

Again, it is to be observed how the adoption of the new concepts helped to free Stokes's aesthetic theory from any residual chronological reference. For it was hard not to associate the Quattro Cento with the Quattrocento. But under the heading of 'the carving tradition' Stokes felt himself able to talk in one breath of the great sculptors and architects of ancient Athens, Alberti, Piero della Francesca, Giorgione and the Venetians, Michelangelo, Vermeer, and Cezanne and his true descendants. And if this list of names suggests a much wider frame of aesthetic reference than anything we had so far been prepared for, we have at this stage to conjoin *Stones* of *Rimini* with *Colour and Form*. For in this later book Stokes explicitly set himself to establish correspondences within the domain of painting for the various characteristics and virtues by reference to which he had identified the carving tradition in sculpture and architecture. Colour takes the place of stone as the loved medium, and the love of colour is then said to find expression in a number of characteristic ways. Stokes enumerates: the depiction objects as self-lit; the exploitation of near-complementaries, and of the phenomenon of simultaneous contrast; the application of any particular colour to the surface in such a way as to reveal its constituents. And for one pervasive colour-effect typical of the carving painter, Stokes borrowed a term from a philosopher whose influence he had felt as an undergraduate and to whom he owed (he told me once) one of the few intellectual debts he had contracted at Oxford: the philosopher is F. H. Bradley, and the phrase is 'identity-in-difference'.

That colour—or perhaps more precisely colour-form—should be the major concern, or the prime love, of the carving tradition in painting is based upon the consideration, for which Stokes thought that there was adequate scientific support, that our awareness of something being external to us, or of 'outwardness', is most powerfully given to us not simply by vision but by chromatic vision. It is in virtue of colour—'surface' colour, that is—that we have the sense of otherness, which in turn is vital to such notions as projection and externalization. Once the centrality of colour is given, then the ways in which the love of colour expresses itself follow very closely the pattern that Stokes had laid down for the love of stone. There is, on the one hand, the projection of the painter's inner stales on to the colour surface, while yet retaining the integrity of that surface. And, on the other hand, there is the painter's attention to the potential life, or the 'vitality', of the canvas as the bearer of colour.

So far I have spoken of the concept of carving, how it takes over from that of the Quattro Cento, and how this allowed the tradition picked out by this latter notion to be clarified and generalized—its aims to be more sharply formulated, and its presence in history more widely recognized. But no less important, though less evidently so for the reader of *Stones of Rimini*, is the introduction of the contrasted or antithetic concept of modelling. In *The Quattro Cento* we read of values

alternate to those of the preferred tradition: there are references to massiveness, plasticity, the scenic, the pictorial, emphasis, 'finish'—sometimes involving the subtlest uses of these terms. (As, for instance, in the description of Ghiberti included in this volume). Nevertheless, the nature of these values is not always defined: and apart from the seemingly accidental fact that they, or groups of them, happen to have been brought together within the great historical styles, it is left unspecified whether they have any principle of unity. With the introduction of the concept of modelling this changes. Subsumed under a single concept, which in turn associates them with a specific attitude or relation of artist to medium, these various values no longer seem to be merely deviant, but interlock to form a countertradition. And if the immediate sequel to the conceptual innovation effected in *Stones of Rimini* happens to be that the carving tradition is upgraded and is now given—as it was not in *The Quattro Cento*—supreme status, in the long run this is not how things are to remain. The characteristics of modelling—once it is recognized that they too constitute a tradition—are to be reconsidered, and in Stokes's later writing they are acknowledged not simply as something of which art will never be free, nor as something which forms an inevitable substrate of carving, but as possessing their own significance and value, as 'a vital and irreplaceable constituent' of art itself. But to understand this reassessment and to see how it comes about, we must take a broader view.

I have talked of the two large themes that go to the making of Stokes's criticism—art and psychoanalysis—and I have already said that, if the second of these themes remains latent throughout the earlier writings, there is, as it were, a place reserved for it, which it can, when the moment is ready, come forward and occupy. In this connection I referred to the idea, present from the beginning, of art as a form of externalization or projection. In a moment we shall see that there is more to it than this: that there are other ways in which the later criticism is anticipated in the earlier. Meanwhile we might discern, even in the earliest writings, but markedly in *Stones of Rimini*, both a reference to and a reliance upon such connections or associations in the mind as psychoanalysis would assume to be not merely present but operative. Assumptions are made about the mind of the artist and about the mind of the reader, how one is to be described and the other addressed, of a kind that would seem natural to anyone exposed to Freudian theory. But for the explicit appearance of psychoanalysis we have to wait.

The significant date in all this is, we might imagine, the beginning of Stokes's analysis with Melanie Klein, which itself ran on through the 1930s; and it is this that I have referred to as the crucial event in the process in which the psychoanalytic colouring to Stokes's criticism becomes more saturated. In point of fact, the immediate consequence of the analysis was the interruption of those leisurely, protracted visits to Italy upon which the first books depended. Life, we must assume, changed. And it should be observed that the earliest attempts to draw upon the findings of psychoanalysis or to bring these findings into connection with the

experience of art occur in the autobiographical volumes, where they are carried out on a purely subjective or personal level: as though Stokes felt, in keeping with the tenor of psychoanalysis, that it was only when lie had worked out these links or connections for himself, that it was only when he had tested them against his own experience and found them compelling, that he was prepared to generalize them, or assert them as part of a critical theory. It is the greater pity that the very complexity, that the intricate workmanship of *Inside Out* (1947) and *Smooth and Rough* (1951), make them comparatively unsuitable for excerption. I have included what I can.

For Stokes psychoanalysis has much of the imaginative richness and vitality of art itself. He has experienced its charms, and he is deeply immersed in its literature. However, that part of psychoanalytic theory which he has taken up and deployed in his criticism and which is therefore relevant to its understanding is restricted, and it falls within the extension effected to Freud's theory by Mrs Klein. More specifically, we can identify it with her account of the two 'positions' which she postulated in trying to characterize the early history of the individual.

The starting point for Mrs Klein's work was Freud's account of infantile development. For Freud infantile development could be reckoned in terms of comparatively distinct phases, or, as he was later to call them, 'organizations'. Each phase is dominated by a particular part of the body, which currently enjoys primacy in the sexual constitution of the infant, and from which the phase takes its name. By primacy Freud meant more than that for the infant, during any given phase, the dominant part of the body is the infant's sexual organ, and pleasure derived from that part of the body is the infant's sexual activity. He also meant something to the effect that the whole, or a great deal, of the infant's emotions and relations to objects outside itself are coloured by thoughts of, or feelings about, that part of the body. The parts of the body that enjoy or can enjoy primacy are the mouth, the anus, the penis or its counterpart, the clitoris, and, more generally, the genitals. Primacy passes from one part of the body to another, in accordance with a sequence that is by and large biologically determined, though it can be upset or modified by environmental circumstances or the infant's perception of them. In normal circumstances, the infant passes from the oral, through the anal, and the phallic, to the genital phase, and this cycle is completed within the first five or six years of life.

Each of these phases marks, in the first instance, a stage in the infant's sexual development. Or, to put it the other way round, the infant's development is initially calculated in terms of sexuality and its transformations. Freud, however, never thought of this as the whole story, and he was keen that it should not be thought of as such. For him any totally adequate account of infantile development should correlate the sequence of libidinally distinguished phases with phases in the emergence of the ego. Instinct and that which controls, moderates, or deflects instinct evolve concurrently and not without interaction. In Freud's thought, an overall or integrated account of infantile development, in which the course of the two

evolutionary currents would be traced, remained something of an ideal; though, for a number of specific infantile situations, such as those from which paranoia or melancholia derive, he provided vignettes, worked to some considerable degree of detail, of the total psychological structure and condition.

It was to fill out Freud's account of infantile development that Mrs Klein postulated her two positions which the infant is said to adopt. The very term 'position' discloses this, for by 'position' Mrs Klein meant something considerably more complex than a stage in libidinal or sexual development. She expressly meant it to include, for instance, the mechanisms of defence to which the infant, while it adopts a particular position, characteristically resorts in dealing with anything painful in the outer or the inner world. Mrs Klein called her two positions the paranoid-schizoid position and the depressive position. These names, however, are not to be taken as indicating that the positions are in themselves psychotic. On the contrary, they are part of normal development, though they are related (like the phases of sexual development that Freud identified) in several significant ways to the disturbances of adult life.

There are, it might be said, three distinct ways in which Mrs Klein's account supplements what Freud found to say about infantile development. In the first place, it is to be noted of both positions that they are initially adopted, by the infant at an earlier period than any in which Freud took a close interest: in and just after the oral phase. In this way, Mrs Klein's account contributes to the prehistory of that part of the infantile development which Freud laid bare. Secondly, though we can date the first appearance of the two positions, or their original adoption by the infant, they are not confined to this or to any other of the phases identified in Freud's chronology of the libido. Indeed, the temporal relations between the two positions themselves are not secure, for the movement backwards and forwards between them is superimposed on all infantile development. The transition from the paranoid-schizoid position to the depressive position and the overcoming of the latter—crucial moments, according to this account—are never achieved completely, beyond all danger of regression. In this way, Mrs Klein's account furnishes a counterpoint to Freud's account. Thirdly, the two positions are identified primarily by reference to the ego and its structure, and only secondarily by reference to the libido. Indeed, in so far as reference is made to the libido in defining the two positions, it is impure or oblique, in so far as what is referred to is the libido as channelled or directed by the ego: in other words, to the kinds of relation that the ego establishes with objects or elements in the external world. In the paranoid-schizoid position, the ego lacks integration, the objects to which it is related, both outer and inner, are part-objects, and the characteristic defences to which it resorts are splitting and denial. In the depressive position, the ego has achieved a measure of integration, even if this is not securely established: the objects to which it is related are conceived of in their integrity, which means, significantly, as both good and bad; and instead of the unrelenting attempts to distort

the world, typical of the earlier position, it allows itself to experience guilt, regret, and longing.

Against this background it is now possible to formulate the basic project of Stokes's later writings: *Michelangelo* (1955), *Greek Culture and the Ego* (1958), *Three Essays on the Painting of Our Time* (1961), *Painting and the Inner World* (1963), *The Invitation in Art* (1965), and *Reflections on the Nude* (1967). Very roughly—and for anything even approximating to the subtlety and ingenuity of Stokes's criticism there is no alternative to a return to the writings themselves—what Stokes has endeavoured to do is to associate the two modes of art that he had identified, the carving and modelling traditions, with the two positions that Mrs Klein has postulated. Of course, the associations are both multiple and complex, and in many cases they are mediated by a number of intervening factors or run through chains. The overall point to be made is that in each case, the mode or tradition of art is held to reflect or to celebrate the kind of relation to the outer world that is typical of the corresponding position.

The connection between the carving tradition and the depressive position is the more readily grasped. The carver, we are to imagine, in respecting the integrity and the separateness of the stone, celebrates at once the whole object with which he characteristically enters into relation and also the integrated ego that he projects. In a single sentence in *Greek Culture and the Ego*, Stokes brings the two aspects together: 'The work of art is esteemed for its otherness, as a self-sufficient object, no less than as an ego-figure.' (*Greek Culture*, p. 50.) In talking of self-sufficiency, of aesthetic detachment, of the rejection of taste and smell as constituents of the work of art, Stokes is drawing together characteristics that have often been insisted on in the drier or more academic forms of aesthetics as essential to or as definitive of art itself; he then connects these characteristics with others, more immediately linked to observation, which he had described and analysed in his earlier writings: and he is then able to offer this new amalgam as equivalent, for him, to one, but only one, of the great traditions in art.

For perhaps the most intriguing element in Stokes's later writing is what he makes of the modelling tradition. What up till then had been comparatively neglected, at times indeed despised, is systematically reconstructed, and then in its reconstructed form is brought into association with the earlier of the two positions. What underlies this is the realization that, in the last analysis, the 'modelled' work of art can be thought of as the mirror-image of the 'carved' work of art. Examine the characteristics of each, and we see that they are those of the other in reverse. So, in the 'carved' work of art there is a lack of any sharp internal differentiation: the individual forms are un-emphatic, and the transitions between them are gradual: there is, to borrow the phrase in which Stokes described Piero's figures, a certain 'brotherliness' in the composition. And the reward for this is that the work of art as a whole asserts its distinctness or otherness from the spectator. By contrast, in the 'modelled' work of art, there are sharp transitions and considerable internal

differentiation: the forms are distinct and individuated, they billow out from, or burrow their way into, the background, and in the overall composition, either the parts remain quite separate and their effect is cumulative, or else they are somewhat intemperately or arbitrarily brought together by means of some overriding device. And the price that is paid for this is that the work of art as a whole tends to merge with or envelop the spectator. Just as a lack of sharp internal distinctions produces separateness from the spectator, or self-sufficiency, so an insistence upon internal distinctions produces a loss of separateness, or a dependence upon the spectator. In this loss of separateness, which is also called the 'incantatory' element in art or art's 'invitation', we can see how the tradition to which this effect typically belongs enables its objects to epitomize both the part-objects of early relations and the still inchoate ego which enters into such relations. With the expressive value of the once depreciated modelling tradition securely established, it is no surprise that the tradition should be recognized as a rightful partner in the development of art. Earlier reservations fall away. 'For many years now,' Stokes wrote in 1961, in an essay not included in this volume, 'I have no longer regarded an enveloping relationship to be foreign to the intention of art; on the contrary I have thought of it as a fundamental attribute when associated with the opposite relationship to an independent object' (*Three Essays on the Painting of Our Time*, p. 28).

It would be vain, in this introduction, to take further the summary of Stokes's views as these are to be found in the later books. All I should like to do is to point out one feature, already present in the earlier criticism and to which I have made implicit reference, upon which so much of these developments depends.

In discussing the transition from *The Quattro Cento* to *Stones of Rimini* I said something about the way in which perspective, which seemed a discrepant element in the earlier volume, falls into place in the later book. The discrepancy arose, I suggested, because the mention of perspective seemed to introduce a characteristic that belonged to content amongst so many characteristics that were purely formal, and the discrepancy was resolved by a shift to a unitary, and hence an internal, point of view. In this resolution we may now see the presage of much that is to come. For if we consider the bulk of criticism that has been written under the influence of psychoanalysis, we can see that it deliberately models itself upon those parts of psychoanalysis which are concerned with the discovery of a hidden or latent content inside a public or manifest content: and the parts of psychoanalysis I have in mind are, of course, the analysis of symptoms, the theory of parapraxes (errors, etc.), and, supremely, the interpretation of dreams. And in pursuing this particular course, psychoanalytically oriented criticism has only been following the lead (or so it has assured itself) set by Freud in his famous essays on Leonardo and the Michelangelo *Moses*. By now the methodological inadequacies of this kind of approach have been fully exposed. Most substantially, the point has been made that art criticism framed in this way is likely to leave out of account the 'art' aspect of the work art. From the beginning Stokes's criticism, even as it began to feel

the influence of psychoanalysis, has struggled to avoid these dangers, and to do full justice to that aspect of art for which we esteem it. In part, this has involved bringing certain formal aspects of the work of art under interpretation. But in part, and more significantly, it has meant dismantling somewhat the rigid distinction between form and content on which much traditional art criticism and art theory has indolently rested. It is the first steps in this process that we observe in *Stones of Rimini*, in the discussion of perspective, or in much of what is written in the early books about art and the body; and it moves forward at such a pace that, by the time we reach the later writings, it becomes for the reader the most natural thing in the world—in the world of art, at any rate—to assimilate a shape to a feeling, or to equate the use of a specific material with a fantasy. In these works we catch the unmistakable voice of psychoanalytic culture.

If this last observation does not already take us there, it is time to turn to another aspect of Stokes's writing: the style. I have referred; explicitly and implicitly, to a number of transformations that take place in the criticism over the years. As a concomitant, or perhaps a consequence, of these transformations, there goes a no less remarkable transformation of style.

Affected somewhat by Ruskin, Stokes's early style was formed upon that of Pater, a writer whose influence, once experienced, is never totally shaken off. Stokes read Pater when he first began to visit Italy, and he was, he has told me, 'bowled over'. Stokes's prose exhibits a number of characteristics that we find in Pater: many of the same phrases, the same use of inversion, and some of the same cadences. Above all, Stokes derived from Pater a certain precision in the use of language which no one earlier had attempted in the same fashion. For the precision I have in mind does not consist in the exact setting down of observable features: it is a precision not of description, but rather of presentation, as though the critic's task was to offer up, along with the object, those associations and sentiments which determine its place in our understanding or appreciation. To many of Pater's characteristics—Stokes has not the sureness of ear of Pater, and he is happily free of his whimsicality—Stokes adds things of his own: a certain strength, and a wry oblique humour which is certainly not to be found in the older writer.

But with the increasing influence of psychoanalysis upon the content of the criticism, the style is modified. The old sensibility to associations is retained, but something has to be done to accommodate the intellectually more complex framework within which the consideration of individual works of art or individual artists comes to be set. The style becomes more aphoristic. And the ultimate critical task is now felt to have been incompletely realized unless all the related thoughts, all the relevant sentiments, have been gathered in—as they might be in a psychoanalytic interpretation. One result can be, perhaps, a certain lack of focus, and sometimes it is not easy for the reader to determine which is the central idea, and which are the reservations or the qualifying thoughts. But then this too can be a form of precision: the finding of a precise equivalent to the ambiguities, to the fluctuations of

feeling and perception, which are inherent in art. Delicately, abstrusely, magically I would say, the struggles of the artist for unity, for some kind of unity, his triumphs and reverses, are recreated for us by someone who knows. *'Poeta che mi guidi'*: I can think of no better words, the words of Dante about Virgil, to describe Stokes as a critic of the arts.

Some seven or eight years ago in contributing a Preface to *The Invitation in Art* I argued that it was wrong to think of Stokes as narrowly an aesthete, to the exclusion of being a social critic. Indeed, I argued that there is a natural connection between these two roles, and that it is the cases in which they do not coincide, in which the aesthete is indifferent to the conditions of his society, that require explanation. I shall not repeat what I said then, but I should like, in conclusion, to add an observation.

In the intervening years, much has been written about the gap between art and life, and how it might be bridged. Most of what has been written has been absurd. And in part the fault lies in a confusion or uncertainty in the minds of those who have pontificated. For they have failed to distinguish between a conceptual issue and a purely practical issue. That is to say, they have identified the gap sometimes with the essential difference between art and what is not art, and sometimes with the many different devices, generally oppressively or enviously conceived, by which art has been segregated from those for whom it was made and turned into a preserve of the rich and the arrogant. In decrying the latter, they have fallen into denying the former, and accordingly they have railed against both indiscriminately. In objecting to the ways in which art has been exploited and degraded, they have come to assert that there is no such thing as art, that there is only life, lo read Stokes's writings on these issues is to be recalled to a fresh sense of their significance and their urgency. For his work has been a sustained attempt to defend, to justify, if need be to sharpen, the conceptual distinction, and also to narrow, perhaps to close, the cultural divide.

11

Imagination and Pictorial Understanding (1986)

Wollheim's view of painting is often thought of as being highly rar-efied and 'intellectual'; but here he goes to some lengths to tie pictorial meaning down to what can be experienced before the picture. This is in reply to Anthony Savile, in the Joint Session of the Mind Association and the Aristotelian Society of 1986. Contrary to some theorists—Kendall Walton is the main figure in philosophy—'we have a perfectly good ex-planation of how we perceive representations without invoking imagin-ation.' For by 1986, Wollheim's famous view of pictorial representation had firmly taken shape: it involves a unitary 'two-folded' experience comprising the 'configurational' fold—seeing the arrangement of brush-strokes and the like—and the 'recognitional' fold—for example, seeing the figurative content. That the experience is perceptual rather than im-aginative does not minimize the role of the viewer's 'cognitive stock'— that what 'he sees in the marked surface [is] determined partly [. . .] by how the surface is, but partly [it is] determined by the concepts and be-liefs that the spectator has and mobilizes.' But even if 'perception of rep-resentations is not necessarily imaginative, does it necessarily become imaginative when concepts and beliefs in excess of a certain limit are brought to bear upon it?' Savile's answer—at least as understood within Wollheim's framework—is that it does not, but that 'in advancing his pictorial understanding of a representation', a spectator 'may gainfully draw upon a background belief but without getting its constituent con-cepts to provide fresh descriptions under which he is then able to see what it represents. The upshot is that [. . .] [w]e merely redescribe.' This is 'manifestly false'. Wollheim's alternative distinguishes the internal spectator from the external spectator:[1] whereas the external spectator is the normal gallery-goer, the internal spectator is an imagined figure who is indeterminate in various respects but will possess 'a repertoire

[1] The foundational distinction between 'centrally' imagining and 'acentrally' imagining is one of the philosophy of mind; originally set out in *On Art and the Mind* (London: Allen Lane, 1974), pp. 58–9; *The Thread of Life* (New Haven, CT: Yale University Press, 1984), pp. 71–84; it is reiterated in *Painting as an Art* (Princeton, NJ: Princeton University Press, 1986), pp. 103–4. [Eds]

Uncollected Writings. Richard Wollheim, Gary Kemp, and Elisabetta Toreno, Oxford University Press.
© Bruno Wolheim 2025. DOI: 10.1093/9780191995767.003.0011

*of attitudes and responses to the represented scene' and—crucially—'is
normally placed so that his field of vision is coincident with what can
be seen in the picture'; this point of view is 'inserted into the represented
space', and to apprehend the resulting content one must identify with the
figure (the variety of imagination thus is 'central' rather than 'acentral',
to invoke the nomenclature of* The Thread of Life*). The result may be
fed back into one's pictorial understanding of the picture, adding to one's
visual apprehension of its representational content. A final question is
why imagination from the outside—'imagination that is from no-one's
point of view'—is not 'a feasible resource for the artist to exploit'. Again,
Wollheim insists that only visual experience can figure in pictorial con-
tent; since, first, 'the imagining is done from no-one's point of view, the
imagined visual experiences are disembodied'; second, 'the visual ex-
periences upon which imagination from the outside will concentrate
will surely be experiences that are simply discrepant with the experience
that the spectator of the picture has from looking at the picture. They will
be in a different perspective.'* [Eds]

I

Mr Savile, I am sure, did not choose the title of our symposium in the belief that
there is just one single question concerning imagination and pictorial under-
standing, and that to this question there is a determinate answer. The notorious
looseness of the first of these terms—I think that Savile would say of both—rules
this out. But there are a number of interesting issues in which both imagination
and pictorial understanding figure and where the consequences of vagueness can
be avoided, and Savile in his contribution has identified some of them.

Savile, it will be noted, has identified these issues in the context of represen-
tational, indeed, much more narrowly, of figurative, painting, and, in discussing
these issues, I shall follow this constraint—if, that is, it *is* constrictive. I do not be-
lieve that he and I see these issues all that differently, but there are differences, and
I shall concentrate on them. Not all our differences are disagreements.

At the outset let me say how much more congenial I find it to debate the aes-
thetics of the visual arts under the aegis of Gotthold Lessing than to do so in the
more familiar shadow of Immanuel Kant.

II

I begin with the issue of how we look at representational pictures or how through
the use of the eyes we gain an understanding of what they represent. (I say 'of

what they represent' rather than 'of their representational content' because, as will emerge later, I use the second phrase in a significantly broader sense than the first. Pictures can have as their representational content things that they don't represent.) The question now is, Does imagination necessarily enter into the way we look at representational pictures?, and I agree with Savile, that, if we exclude the vapid sense of imagination in which it means no more than the opposite of narrowmindedness or equates with the recognition that in most situations there are likely to be more possibilities than we at first think of, imagination has no necessary part to play in the perception of what is represented. Imagination may put us in the right frame of mind for such perception, but it does not have to be a constituent of the perception itself.

My principal reason for holding this view, and furthermore for holding it in advance of any subtle disambiguation of imagination, is that we have a perfectly good explanation of how we perceive representations without invoking imagination. Indeed invoking imagination would only erode the explanation by casting its adequacy in doubt. The explanation is one in terms of a very specific visual capacity which we humans have—innately, there is reason to believe—and which is distinguished by the special phenomenology which the visual experiences that manifest it display. I call the visual capacity 'seeing-in', and I call the phenomenological feature distinctive of experiences of seeing-in 'twofoldness', and by 'twofoldness' I mean this: When I look at, say, the representation of a woman, it is to be expected that my visual experience will have two aspects to it: on the one hand, I recognize or identify a woman, and, on the other hand, I am aware of the marked surface, and both the recognition or identification and the awareness are visual. When my experience satisfies this description, I may be said to see a woman in the marked surface or in the picture. However I must point out that, though I have found it convenient to illustrate seeing-in and twofoldness via a case of looking at a representation, this is an inessential feature of the example. For I can see things in objects that are not, and are not taken by me to be, representations: I can see things in clouds, and stained walls, and frosted panes of glass, and Rorschach test cards. Seeing-in does not presuppose representation. On the contrary, seeing-in precedes representation, and this is why seeing-in can be used to elucidate representation. Very roughly, P represents X if X can be correctly seen in P, where the standard of correctness is set for P by the fulfilled intentions of the artist of P.

But this last point is to leap ahead, and I return to twofoldness to emphasize that my account of what it is to see representations specifically distinguishes itself from accounts that posit not one experience with two aspects but two experiences. Such an account would posit in the example I gave an experience of a woman *and* an experience of the surface, and particular accounts would then go on to differ amongst themselves on whether these two experiences are simultaneous or successive. A general feature of these accounts is that they dispense with an appeal to a specific visual capacity. At their core illusion is installed. In the case of looking at

the representation of a woman, such an account would say that the experience of the woman is illusory, and the rest of the account would explain how this illusion is partial, or oscillatory, or blocked, or in some other way compensated for. I cite these other accounts, and the feature of them that is to my mind fatal for them, or the postulation of illusion, in order to bring the account that I favour into sharper focus. When it is in sharp focus, then it becomes manifest that it is explanatorily adequate without the invocation of imagination in any substantive role.

<div align="center">

III

</div>

On the account of seeing-in that I favour, seeing-in—the experience, of course, not the capacity—has two aspects to it. I dub them the recognitional aspect and the configurational aspect, and it is my belief that no systematic account can be given of how the two aspects correlate or how the marked surface has to be or to seem for a given thing or event to be perceived in it.

Any attempted account of the correlation is almost certain to invoke in a more, or a less, sophisticated fashion, the notion of resemblance: though it must also be pointed out that there are other points at which accounts of representation may introduce resemblance. The truth is that there is no single compact account of representation in terms of resemblance. Resemblance can occur variously in such accounts: resemblance can, for instance, be held to hold between pairs of objects (the representation, what is represented) and it can be held to hold between pairs of experiences (looking at the representation, looking at what is represented).

The experience of seeing-in has then a recognitional and a configurational aspect. But in one important respect these aspects of one single experience behave as though they were what it is crucial to remember they are not: that is, separate experiences. For both aspects are conditioned by the cognitive stock that the spectator holds and brings to bear upon the representation that he confronts. Both how he sees the marked surface and how he sees what he sees in the marked surface are determined partly, of course, by how the surface is, but partly they are determined by the concepts and beliefs that the spectator has and mobilizes. 'Has *and* mobilizes': for these are, of course, two separate conditions, and the second must be fulfilled as well as the first in respect of any part of the cognitive stock if it is to impinge upon the spectator's perception.

Having observed that this permeability of perception by cognition applies to both aspects of the experience of seeing-in, I shall from now onwards consider it only in the context of the recognitional aspect, and I do so in order to raise a second issue about imagination and pictorial understanding, which is whether there is a certain level of subsidy from the cognitive stock at which the perception of representations becomes more than mere perception and begins to involve

imagination. In other words, even if the perception of representations is not necessarily imaginative, does it necessarily become imaginative when concepts and beliefs in excess of a certain limit are brought to bear upon it?

A necessary preliminary is a slightly closer look at the way in which cognitive stock impinges upon the perception of representations. There are two reasonably distinct points at which this occurs and to see this it will be useful to have the cognitive stock divided up along the lines I have indicated: that is to say, into concepts on the one hand, and beliefs on the other. For when a spectator looks at a representation he will call upon some part of his cognitive stock—and this will consist of concepts—to provide the descriptions under which he perceives what he sees in the picture. And at the same time he will make use of some other part of his cognitive stock—and this part will consist of beliefs—to justify his perceiving what he sees in the picture under the concepts that he does. As the spectator perceives what the picture represents, some part of his cognitive stock will be foregrounded and some other part backgrounded. Whether either part of the cognitive stock is employed correctly depends upon whether the ensuing perception concurs or doesn't with the fulfilled intentions of the artist: but that is not a part of the account that I shall pursue here.

An example: A spectator looks at Manet's *Execution of Maximilian* [URL35], and at first he sees in it three figures facing a group of men holding objects parallel to the ground. As his understanding of the represented scene increases, he will perceive it, or parts of it, under such concepts as 'rifleman', 'firing squad', 'Emperor and his two generals', 'sombrero', 'képi', and so on. These concepts are foregrounded. However, what justifies the spectator, in subsuming the represented scene under these concepts, is a body of beliefs which he has about such matters as the Mexican expedition, the involvement of Napoleon III, the Juarist uprising and its outcome, the sympathies of liberal Parisians at the time, the uniforms of the two sides, the conventions of military executions, and so on. These beliefs are backgrounded. Periodically, as the spectator attempts to deepen his understanding of the picture, further concepts will be plucked out of his background beliefs and foregrounded: each time this happens, how he sees the picture shifts somewhat. His perception expands.

So I return to the question, Is there a point at which the mobilization of cognitive stock to the perception of representations brings about the dilution of perception by imagination?

To this question Wittgenstein gave the answer, Yes. He thought that, though the perception of representation does not inherently require imagination, a point can be reached at which it does. He writes

It is possible to take the duck-rabbit simply for the picture of a rabbit, the double cross simply for the picture of a black cross, 'but not to take the bare triangular

figure for the picture of an object that has fallen over. To see this aspect of the triangle demands *imagination. (Philosophical Investigations,* II, xi, p. 207.)[2]

However Savile dissents from this. He thinks that the answer to the question is, No, in that in the expansion of our perception of a representation, imagination is not required. He writes, and the sense of his words is clear even if it is not clear what he means by image, 'What must surely be contentious is that the filling out of the image that is achieved as the work comes to be more repletely understood really operates through imagination (p. 24).'

Now I too think that the expansion of our perception of representations does not involve imagination. I think, in other words, that the answer to our question is, No. But these Yes's and No's don't really give the state of opinion, because everything depends on how the issue is conceived. My conception is a natural projection of how I conceived the first issue. It is this: Imagination can in good faith be denied a role in the expansion of our perception of representations just in case each step in the expansion receives the same explanation, and this reiterated explanation is in terms of a visual capacity, specifically seeing-in. It is because I see no reason why the process I outlined above, in which background information gets recruited to seeing-in, should ever come to a halt—or why, at any rate, it should come to a halt before the notional point is reached at which everything that the picture represents has been perceived by the spectator—that I find no place here for imagination.

Wittgenstein senses a discontinuity in our expanded perception of representation, and so, on my view of the matter, it is not surprising that he should have room for imagination. But the discontinuity that he senses arises because, it seems to me, he misunderstands from the very beginning what it is to perceive a representation. He garbles the capacity of seeing-in, and it happens in the following way: It is certainly the case, and should be common ground to all, that, when I see x in y, there is invariably some f such that I see x (in y) as f. But this embedment of seeing-as within seeing-in is erroneously taken by Wittgenstein as licensing him to understand seeing-in in terms of seeing-as, so that he comes to think that, when I see x in y, what I in effect do is to see (some part of) y as x. When, for instance, I first set eyes on the *Execution of Maximilian, I* see some part of Manet's canvas as a rifle, some other part of it as a man, and so on. This, it seems to me, gets the perception of representation started on the wrong track, and Wittgenstein, quite rightly, thinks that we cannot go very far—if, that is, we can go any distance—Unable to get himself to see the marked surface differently, he starts to treat it differently. So, for instance,

[2] Wittgenstein's reference to the double-cross is not strictly relevant to my discussion since he goes on to make it clear that for him this is not a case of representation. We do not see the black or the white cross on, in the sense of 'in front of', the white or the black ground as the case may be. 'A black cross on a white ground is not essentially a cross with a white surface in the background.' Again the two ways of seeing the cross 'are not connected with the possibility of illusion'. If Wittgenstein is right about this example, it is not a case of seeing-in but merely a case of seeing-as.

(I quote), 'We regard *(betrachten)* the photograph, the picture on our wall, as the object itself (*op. cit.*, p. 205). It is this line of thinking that has been projected by Gombrich in his meditation on a hobby horse and by some interesting articles by Kendall Walton, in which the original starting-point is scarcely recognizable.

With Savile the position is rather different. He finds no discontinuity in our expansion of the perception of representations, the explanation is the same at all stages, but since the explanation he gives of what occurs is not in terms of a visual capacity, *a fortiori* not of seeing-in, it is unclear that he has a right to exclude imagination. There is a lacuna in his account, at least as I read it, which something has to occupy. It may turn out to be imagination.

Savile's account seems to be this: As we expand our perception of a representation, what we do essentially is we re-describe it. These redescriptions may correspond to successive shifts in the way we see what we see in the picture, but they may not. I give another quotation which takes up (indeed only two sentences later) on the previous one: 'We do not fill out the image at all: we rather come to amplify the description we are able to give of what is initially manifest to us, and do that by reason of knowledge about the subject that we bring to the picture from elsewhere (p. 24).' Cast into my terminology, this means that a spectator, in advancing his pictorial understanding of a representation, may gainfully draw upon a background belief but without getting its constituent concepts to provide fresh descriptions under which he is then able to see what it represents.

Savile's account can, I believe though I am not sure of this, be followed a stage further. It isn't just that sometimes we redescribe and reperceive what we see in the picture but at other times we merely redescribe it. There comes a point at which we can only redescribe. In other words, there is, in Savile's thinking too, a discontinuity, though it is an underlying discontinuity, underlying the smooth recruitment of descriptions to what is represented, and in this last quotation Savile reveals where it occurs. The point at which redescription is necessarily unaccompanied by reperception is reached when the descriptions already given have captured everything that the picture *manifestly* represents. All that further descriptions can do is to capture what the picture *implicitly* represents and this *ex hypothesi*—I am trying to reproduce Savile's argument—is something that we cannot see in the picture.

Let me say that I find the distinction between what a picture manifestly and what it implicitly represents less than persuasive, particularly when it is prized apart, as it is by Savile, from the distinction between what a picture represents and what it merely appears to represent but in fact doesn't (e.g. the eyes in the Rembrandt portrait), which is indeed a very useful distinction to have before us. Nor do I find the examples helpful. Savile suggests that the van Eyck angel is only implicitly represented because its body is not visible. Does this mean that something is not manifestly represented if some part of it is not itself represented? Or Savile suggests that Laocoon is only implicitly represented as being about to scream because the screams still lie in the future. But does this mean that something is not manifestly

represented as doing this or that if the proper description of what he is represented as doing makes reference to something that is not itself represented?

I think that Savile's commitment to this distinction within representation is misguided, but, so long as he holds to it, the agreement between him and me on the present issue of imagination is at once notional and tenuous. The position can be summarised like this: Savile's commitment requires him to hold, like Wittgenstein, that shifts in perception do not regularly account for what goes on when we redescribe what we see in a picture. Now, unlike Wittgenstein, he doesn't turn to imagination to give an alternative account of what goes on. The upshot is that he says that nothing goes on. We merely redescribe. But this is manifestly false, and the result is that Savile, having foresworn perception, might have to turn back to imagination.

IV

I now turn to a third issue about imagination and pictorial understanding, which again is an issue that Savile also raises, and it breaks fresh ground in that it concerns itself with a form of imagination that is, while we engage in it, exclusive of perception, and he asks whether there is not a place for it in our understanding of representations. In other words, might we not, at any rate with certain pictures, be required at some moment to stop looking at them and to start imagining something about their content so that then, at a later point, our perception of what we see in them will be enriched, deepened, and made more secure, by what we have imagined? Savile answers this question, Yes, so do I, but again our view of the matter is not exactly the same, so I shall say how I see it.

But first a point of agreement between us. We can be required to come to understanding of a picture along some such route only if following this route concurs with the fulfilled intentions of the artist. Indeed in this case, as we shall see, it is worth going further and making the point that the intentions of the artist must themselves have been appropriately formed: not every incitement of the imagination is legitimate. Savile however is right to insist that the concurrence of the spectator's imaginative project with the artist's intention does not require that the spectator should in every detail imagine just what the artist had in every detail intended him to imagine. The artist could establish certain broad limits within which the spectator may imagine whatever he reasonably wants: that too would be concurrence.

Now to how I see the issue.

There are, I believe, representational, and specifically figurative, paintings in which the artist offers the spectator a form of access to what the picture represents which is over and above the standard route. The standard route is, of course, seeing-in, and the spectator is offered imaginative access, and the offer is put to

him in the following way: There is inserted into the represented space, though not into the represented part of it, a figure. This figure has an identity of his own, subject to the same taxonomy as that of the figures who are represented: that is, he may be a particular figure, or he may be merely a figure of a particular kind, and, if he is merely a figure of a particular kind, the kind may be more, but it may also be less, specific, so that at the least specific, which is the likeliest, he is just—whoever. Such a figure has, in addition to an identity, a repertoire of attitudes and responses to the represented scene, and he is normally placed so that his field of vision is coincident with what can be seen in the picture. I call this figure the spectator in the picture or the internal spectator, in contrast to the spectator of the picture or the external spectator, and though the picture doesn't represent the spectator in the picture—he can't be seen in the picture—I think it is correct to think of him as part of the picture's representational content. Now the endowment of the picture with an internal spectator offers distinctive access to the content of the picture in that the external spectator can—and must if he is to reach full pictorial understanding of the picture—imagine this figure from the inside. He must identify with him. He must, and will if he follows the intimations of the picture, centrally imagine this figure interacting with the represented scene as his repertoire allows or constrains him to, and then the outcome will be that the spectator of the picture will find himself in the same residual state as the spectator in the picture might be expected to be on doing whatever he is imagined to have done. This residual condition will then colour the way in which the spectator of the picture perceives the picture, and specifically the way in which he perceives what he sees in the picture, when, as he is next required to do, he reverts from imagination to perception.

Let me emphasise that I believe this account to hold true only for certain paintings, and it is a hard matter to see which.[3] Only certain paintings offer this access.

An example: I look at Manet's *Woman with a Parrot* [Fig. 5.2], and I see in its surface a woman momentarily but powerfully preoccupied, who cossets a secret. Then I imagine from the inside a figure who I find reason to believe stands in the represented space just this side of the picture plane. I start to centrally imagine this unrepresented figure trying, trying hard, trying in vain, to make contact with the represented woman. The tedium, the frustration, the despair that I come to imagine the figure with whom I identify experiencing trickles back into me and it reinforces and intensifies how I see the represented woman.

A distinctive feature of my account must be the duplication of spectators: the spectator of, the spectator in, the picture. Why? This feature is, I believe, crucial to solve a problem that arises for any account of pictures that exploit not just imagination, but specifically imagination from the inside, or centrally imagining, in

[3] Cases of which I am certain are most of the single-figure paintings of Manet, the nature-pictures of Caspar David Friedrich, the group portraits of Hals and probably Rembrandt, and, amongst non-figurative paintings, the all over paintings of Jackson Pollock.

disclosing their meaning. The problem is one that Savile raises, though I think he underestimates it, and I start with his statement of the problem.

Savile formulates the problem in the context of his looking at Velasquez's *Las Meninas* [URL41]. (In passing, let me say that to my mind this painting is not one that contains an internal spectator. Of recent years this view has gained prestige through a powerful misinterpretation of the painting by Michel Foucault: it is not, as I see the painting, pictorially warranted.) Savile states the problem thus: Suppose that he, Anthony Savile, is standing in the Prado, looking at *Las Meninas*. Then, to avail himself of the imaginative access to its content that the picture offers him, he must think some such thought as, 'Here am I, Anthony Savile, watching Velasquez make what he can of my Hapsburgian features.' Thinking such a thought demonstrates his arrival, his imagined arrival, on the represented scene. But (the problem is) such a thought cannot concur with Velasquez's fulfilled intentions. For clearly Velasquez did not anticipate Anthony Savile looking at his picture and therefore he could not have intended that this thought, with its ineliminable self-reference to Anthony Savile, should be thought in front of it. But to this objection Savile has a reply. He contends that the thought of his that imaginative entry into the represented world of the picture requires him to think must, if it is legitimately to afford pictorial understanding, have been anticipated, indeed have been intended, by Velasquez, but only to this extent: that it instantiates a certain schema, and that Velasquez intended that every spectator who wished to understand his picture should think his own self-referential instance of the schema.

Savile's retort meets the problem as he formulates it, but the question remains whether his formulation catches the real difficulty. I think not. If it is true that, in gaining imaginative access to the content of the picture, Savile has to think thoughts of the kind that he manages to show are unproblematic, he has also, in thinking them, to do something else. He has to do what thinking these thoughts presupposes, and this, I suggest, remains problematic. He has to imagine himself, the thinker of these thoughts, on the represented scene: and by this I mean not just that he has to imagine himself in the room where in point of fact Velasquez painted the royal couple, but that he has to imagine himself in that room as Velasquez represented it. He has to imagine himself as part of the representational content of the picture. Now if this is what Savile has to do, the same goes for every spectator of the picture. And this is where I think the real difficulty, the difficulty beyond Savile's difficulty, lies. For it now seems that, in order to arrive at a full understanding of the picture, every spectator is required to imagine the content of the picture differently—that is, with himself in it—hence, presumably, falsely. And 'required' here, let me remind you, means 'required by the artist'. Now it is one thing to hold that the artist requires that every spectator should entertain his own self-referential thoughts in order to arrive at the content of the picture: but it is quite another thing to hold that the artist requires that every spectator should entertain his own self-referential conception of what the content of the picture is.

Is this a fatal flaw in any account of pictures that offer understanding of themselves through imagination from the inside, a flaw which might be thought to communicate itself from the account of the pictures to the pictures themselves? Or is there a way out? It is here that the duplication of spectators comes to the rescue: What caused Savile such difficulties in front of *Las Meninas*—difficulties deeper, I claim, than Savile himself recognized—is that he insisted on centrally imagining himself in the room where Velasquez was painting the royal couple. Trouble came not from the fact that he invoked imagination from the inside but from the fact that he invoked it to imagine himself from the inside. However, on my account of how pictures may offer imaginative access, it is not himself who the spectator of the picture, in availing himself of the offer, has to imagine from the inside, it is the spectator in the picture. And the spectator in the picture, having been established there by the artist, is constant across all spectators of the picture. Centrally imagining him does not, even hypothetically, disturb the content of the picture.[4]

This particular feature, and its rationale, to one side, I now turn to the general nature of pictures that offer imaginative access to their content, and suggest that this can be grasped through two sets of conditions. The first set, which I shall not consider, consist of conditions that must be satisfied if we are to think of the artist's intention to incorporate a spectator into the picture as fulfilled. The second set are conditions upon the artist's intention, and they must be satisfied if what the artist intends is to be conducive to pictorial understanding. I have already specified one such condition, and in its very strongest form. It is that the spectator in the picture should normally be so located in the represented space that his field of vision coincides with what the spectator of the picture can see in the picture.

The idea behind this condition, and the idea that must therefore be renegotiated if the condition is to be relaxed, as I suspect it should be, is that the internal spectator must be so located that the fruits of imagining him from the inside that come the way of the external spectator can then, in Savile's phrase, 'feed back into the response to the scene that is actually represented' (p. 34). I would add, 'as it is represented'.

But why does this idea even seem to require that the internal spectator should be placed at what might summarily be called the point of origin?

A simple way of precipitating an answer would be this: Many pictures contain unrepresented spectators who are not at the point of origin. Far from it: they are located—this shows the kind of picture I am thinking of—in the wings of the represented scene, either to left or right but in each case out of sight, or else they

[4] I recognize that this will be found no solution to the problem to which self-referentiality gives rise by those who hold that, say, for A to imagine B from the inside, A must imagine himself being B doing or experiencing the things that B would. I do not believe that this account survives reflection, and I have argued against it in my *The Thread of Life*, Chapter III.

are located behind obstacles that are themselves represented. I shall call unrepresented spectators with these very different lines of vision wayward spectators. Now let us suppose that such a spectator were to be wished on the external spectator, by the artist, as the figure with whom he is required to identify. It seems intuitively clear that the fruits of such an imaginative project could not be fed back into understanding of the representation as we have it. For what any such imaginative project surely will do is this: it will furnish the spectator of the picture with information (let us call it that) which is better calculated to advance his understanding either of the scene which the picture happens to represent or of some other hypothetical picture which, if it existed, would represent the scene in the perspective of this wayward spectator than it is to advance understanding of the picture at stake. This being the case, it seems to me that this imaginative project can only retard understanding of the picture at stake. The analogy is far-fetched, but it is a little as though, in trying to get someone to understand Titian's portrait of Charles V [URL33], we encouraged him to look hard at the baron Gros's representation of the Emperor [URL42].

It is however one thing to say that the spectator in the picture must not have a perspective on to the represented scene that is totally skewed from that of the picture itself, and quite another to insist that he cannot deviate from the point of origin. Could not a more relaxed attitude be adopted as to the precise location between, say, a range of points in the unrepresented part of the space all just this side of the picture plane?

At this stage it must be that another consideration is brought into play. If, to eliminate wayward spectators in the picture, it is enough to argue that identification with them could not enhance understanding of the picture at stake, elimination of spectators in the picture who approximate to the point of origin must introduce deeper issues. It must be grounded in some conception of what pictorial understanding is, which is generally left implicit. This conception would be that our understanding of a picture must be global. It cannot be piecemeal, or built up out of our understanding of parts of the picture taken in isolation. And this conception must in turn rest on a deeper view: that is, that in so far as we seek to gain pictorial understanding in this piecemeal fashion, we of necessity look at the part of the picture that we have isolated as though it were a distinct picture, a picture in its own right. Reflection upon films that try to capture paintings by ranging over their surface and giving us a sequence of shots of detail can only lend weight to such a view of the matter.

Nevertheless it seems to me that this view of the matter is gratuitously despairing and that there are precautions that we can take which would restore legitimacy to the piecemeal understanding of a picture in those cases where this is what is asked of us: specifically that this could happen when it is laid down by the artist that pictorial understanding is to come about partly through vicarious imaginative entry. An example: In *The Dutch Group-Portrait*, an extremely difficult and

obscure work, which nevertheless remains the major discussion of pictorial works that offer this kind of understanding, Alois Riegl says, à propos of Frans Hals' 1616 Banquet portrait of the officers of the St George Militia Company [URL43], that we do not grasp the complex structure of this work until we experience a certain passivity in front of it. To do so we must identify with, for instance, an internal spectator to whom the first seated figure from the right is extending a hand which is initially hard to make out. Obviously we do not do this if the internal spectator with whom we identify is out of arm's reach, as he would be if he were stationed at the point of origin. He must be closer in and to the right. It seems to me that in this case it would be gratuitously dogmatic to say that the fruits of centrally imagining such a spectator resist being fed back into the pictorial understanding of Hals' picture considered as a unit. I consider therefore that some flexibility about the location of the internal spectator is legitimate, but it is crucial to retain a sense of what can and what cannot legitimate it.

We have not done with this third issue until we consider a question to which I have so far assumed an answer. If imaginative access to the content of a picture is made available by the artist, why must it be offered solely through imagination from the inside? Why is not imagination from the outside, or imagination that is from no-one's point of view, a feasible resource for the artist to exploit?

Of course, acentrally imagining the represented scene can be a useful preparation or training for looking at the picture and seeing what there is to be seen in it. That, I take it, is not the question, and what we must consider is whether it could ever be legitimate that we should, in concurrence with the artist's intentions, cease looking at the picture, engage in some imaginative project that involves acentrally imagining, and then return to a perception of the picture into which is then fed the fruits of this project which we have taken time off to engage in.

I think that the answer to this question is, No, but it depends upon yet deeper considerations, or on being able to show that acentrally imagining a represented scene can only subvert, it cannot supplement, the perception of the representation. Two considerations here need to be exploited. The first is that acentrally imagining a represented scene is, unlike centrally imagining it, likely to be purely visual. It will have no affective aspect. This is because, since the imagining is done from no-one's point of view, the imagined visual experiences are disembodied. And this is novel, because in the case which we have so far been considering where imaginative access occurs through centrally imagining some figure, the contribution that such imagining makes to the understanding of the picture comes almost exclusively from what this figure is imagined to feel—in response, of course, to what he is imagined to see. But this is not all there is to it. It is not only that the fruits of acentrally imagining are purely visual: it is unclear how they are visually relevant to the understanding of the picture. This takes us to the second consideration, which is that the visual experiences upon which imagination from the outside will concentrate will surely be experiences that are simply discrepant with the experience

that the spectator of the picture has from looking at the picture. They will be in a different perspective, and they will not be experiences of seeing-in: they will lack twofoldness. In so far as such experiences can be thought to have a contribution to make to the understanding of a painting, does this not simply constitute a reflection upon the adequacy of painting?

12

A Note on *Mimesis as Make-Believe* (1991)

This article reviews the book Mimesis as Make-Believe *(1990) by American philosopher Kendall Walton. In* Meditations on a Hobby Horse *(1963), as elsewhere though less prominently, Ernst Gombrich famously discussed the parallel between art and toys in what later Walton called 'props' for make-believe games.[1] In his discussion on Seurat's La Grande Jatte (1884), Walton explains how such fictional truth works: the very dabs of the brush highlight the material quality of the painting without preventing us from imagining the couple strolling in the park. In other words, the textures, colours—that is, the material qualities of paintings—act as props to create illusionary reality or, 'fictional truths'.[2] Wollheim praises the book: '[I]t is important, it is interesting, and it is ambitious.'[3] But here he wants to discuss his almost two-decade disagreement with Walton on the nature of pictorial representation—disagreement that is nevertheless spawned by a shared belief that paintings fundamentally have representational contents or meaning.[4] According to Wollheim, for Walton a picture 'represents what occurs or is fictional in those games of make-believe or coordinated imagination which it is the function of the picture to prescribe'. Wollheim finds fault with this, partly for relatively complex internal reasons—it perhaps implausibly implies that seeing and imagining morph into one phenomenological experience—but chiefly because his own view is simpler and plainly intuitive by comparison: '[T]hat painting is a visual art, demands that the experience is a visual one, and my account of representation locks in this claim by insisting that the experience exemplifies a very specific perceptual capacity that we possess [...] which I call "seeing-in".'[5] The view is naturalistically and historically plausible: 'Seeing-in exists prior to representation,' he says, 'which*

[1] Kendall Walton, *Mimesis as Make-Believe: On the Foundation of the Representational Arts* (Cambridge, MA: Harvard University Press, 1990); Ernst Gombrich, *Meditations on a Hobby Horse* (London: Phaidon, 1963). [Eds]

[2] Walton, *Mimesis as Make-Believe*, pp. 21 and 38. [Eds]

[3] Ibid. 401. [Eds]

[4] Ibid. 402. [Eds]

[5] Wollheim here says 'it was, I believe, first postulated by Einstein'! It is also of some scholarly interest that he says that it was 'urged on me by Michael Podro, that made me change my view of the seeing-in experience from thinking of it as a conjunction of two experiences [in 'Seeing-As, Seeing-In'] to thinking of it as one experience with two aspects': Richard Wollheim, *Painting as an Art* (London: Thames and Hudson, 1987), p. 360n. [Eds]

Uncollected Writings. Richard Wollheim, Gary Kemp, and Elisabetta Toreno, Oxford University Press.
© Bruno Wolheim 2025. DOI: 10.1093/9780191995767.003.0012

exploits it, and it is it that allows us to see figures in clouds, in stained walls, in the embers of fires, and in empty teacups.' [Eds]

The appearance of *Mimesis as Make-Believe is a* major event not only for all those interested in philosophical aesthetics but for anyone with a philosophical concern for issues of symbolism, expression, and communication. The focus of the book is the problem of representation. But the light it throws illuminates a much larger area.

Walton's book has three qualities to a very high degree: it is important, it is interesting, and it is ambitious. It is important because it presents a powerful, timely critique of the various linguistic, semi-linguistic, quasi-linguistic models of artistic content or meaning that are so much in favour today, all across the spectrum from Nelson Goodman to Jacques Derrida. It is interesting because of its breadth of reference, philosophical and cultural, and because of the many fine observations, the sharp aperçus, that its author provides us with. And the book is ambitious in that it offers a comprehensive theory which, based on a few convincing intuitions, themselves much worked over in argument, aims at explaining the phenomenon of representation in its full diversity: that is, as it turns up in painting, drama, the novel, music, cinema, sculpture, the graphic arts.

For the purpose of this note I shall more or less ignore the third quality: I shall overlook the book's theoretical ambitions. I have a reason for doing so. I agree with a lot of what *Mimesis as Make-Believe* has to say. There are a number of points on which it has opened my eyes. But there are also points of disagreement between Walton and myself, which some will think minor, others major, and it is on them that I wish to concentrate. Our disagreements concern the precise nature of pictorial representation, and, if our discussions on this topic, now for nearly two decades, which, I am glad to see, Walton remembers as agreeable as I do, have achieved anything, they have at least established that we do not see eye-to-eye. We may be on the same side, but we do not occupy the same position. However, in taking up our disagreements, I propose doing so as if Walton had no comprehensive theory for which they had implications.

Common ground between Walton and myself is that pictures (or almost all of them) have representational content or meaning. For much of the time Walton talks of representational meaning in terms of what propositions a given picture makes fictional, and, though I have reservations about both the key terms here—'fiction' I personally would keep for mythological pictures or pictures illustrative of novels or epic poems, and I am doubtful (for reasons recently stressed by Christopher Peacocke) whether pictorial meaning is *fundamentally* propositional—I find it easy to go along with this way of putting things. Both Walton and I would agree that it is part of the representational content of Seurat's *La Grande Jatte* [URL44] that a couple strolls in a park by the river, and it is part of the representational content of

Malevich's *Suprematist Painting* [URL45] that a yellow rectangle lies over a horizontal green line.

The choice of these two examples shows further common ground between Walton and myself, for we both think that abstract as well as figurative paintings can have representational content.[6] Walton, it is true, distances himself from my position in that he claims that, though what Seurat represents as strolling in a park, i.e. a couple, is not part of the picture itself, what Malevich represents as lying across a green line, i.e. a yellow rectangle, *is* part of the picture itself—as is, for that matter, the green line. I find this way of distinguishing between figurative and abstract representation implausible. Surely it is more intuitive to believe that what Malevich represents as lying across a green line is not a particular patch of canvas but is something, some shape, two- or three-dimensional, that that patch of canvas represents. Of course, it is possible for a patch of canvas to represent itself. But this, I am reasonably sure, is not what underlies Walton's view of abstract representation: in abstract paintings, it is, according to him, not represented patches of canvas but brute or material patches of canvas that are represented to be this way or that way. If I am right on this point, then Walton's view of abstract paintings must be that their representational content—unlike that of figurative paintings—is built up in two stages. First, certain things are picked out, which will then be represented as being a certain way: these things are invariably parts of the picture, and they are not picked out through representation. Secondly, these picked-out things, or parts of the picture, are then represented as being some certain way, which is generally, perhaps invariably, some way they are not. But this two-stage view, which by Walton's own high standards is strangely under-motivated, strikes me as a return, a partial return (it is true), to the very account of representation that he had criticized in Goodman or John G. Bennett. More particularly, does it not in trying to attribute to pictures a division of labour between the referential and the predicative functions reinvoke the linguistic model?

To turn now to the substantive source of disagreement between Walton and myself. If we both agree that paintings represent, how do they come to represent what they do? To this question, my answer would be that a picture represents that which it has the power to cause a suitably sensitive, suitably informed spectator to see in its surface *and* which the artist marked the surface so that the spectator should see in it. Walton's answer is that the picture represents what occurs or is fictional in those games of make-believe or coordinated imagination which it is the function of the picture to prescribe: more specifically, a picture depicts that which a spectator is supposed to imagine himself seeing at the same time as, and in a way that is inseparable from, his perceiving the picture itself.

[6] Wollheim's original had the following sentence as '(Walton, …', but without a closing parenthesis. [Eds.]

There are two respects in which our answers appear to diverge: The first is the contribution or non-contribution of the artist's intention to fixing what is represented. The second turns on the character or the phenomenology of that experience of the surface had by the spectator, which, if it matches (following Wollheim) the artist's intention or (following Walton) the function of the picture, seals the issue of what is represented.

I have little to say about intention, particularly in light of Walton's rather fluid attitude to the relationship between intention and function. (In a later essay, Walton writes that the 'artist's intentions have a less essential role in my theory than they do in Wollheim's,' which puts the matter pretty concisely.) My basic argument for intentionalist criticism, or 'criticism as retrieval', is that in the case of human artefacts, appeal to intention is the default way of understanding them. Where the artefact is embedded in a symbol system, or where it is correlated with a clear social function, or where it results from a fully choreographed productive process, *and these factors can account for as much detail of the artefact as we are interested in*, intention may be ignored. In *Painting as an Art* I contend that none of these special cases holds for painting.

A more serious issue is that of the relevant experience to be had by the spectator which fixes the representational content. The status of painting, or that painting is a visual art, demands that the experience is a visual one, and my account of representation locks in this claim by insisting that the experience exemplifies a very specific perceptual capacity that we possess—it was, I believe, first postulated by Einstein—which I call 'seeing-in.' Seeing-in exists prior to representation, which exploits it, and it is it that allows us to see figures in clouds, in stained walls, in the embers of fires, and in empty teacups. Any particular experience of seeing-in has—such is its special phenomenology—two distinct aspects to it: we perceive a surface, and in this surface we see something in front of or behind something else.

Walton says that I do not 'fully explain what seeing-in amounts to'. Nor, he adds, do I claim to. Walton is right on both counts, and my thinking was that seeing something in a surface, as the exercise of a specific perceptual capacity, is such an everyday experience that it would only be necessary for me to gesture towards it for a reader to understand what I had in mind. Of course, to establish that an experience of this kind has a natural place in any perspicuous account of representation *is* a further step, but my claim would be that this is something that I have attempted. By contrast, it seems to me that the kind of experience that Walton regards as foundational for representation is so elusive, so unfamiliar, that even the comparatively explicit description he gives of it reminds me of nothing familiar and provides me with no reason to think that it could fill the role he assigns to it.

In chapter 8 of *Mimesis as Make-Believe* Walton gives the fullest—and, though I don't have the earlier versions before me, what I believe to be the most convincing—account of the experience that the spectator appropriately has before a representational painting. The spectator sees something: he imagines

something; and the seeing and the imagining are 'integrated into a single complex phenomenological whole.' Read quickly, this sounds (at any rate to me) somewhat like my view, but let us take it slowly, and see what happens to the constituents.

The spectator sees a canvas entitled *Water Mill with the Great Red Roof* [Fig. 12.1]. As he does so, he starts to imagine—what? Scattered through Walton's text are various suggestions. He starts to imagine that his perception of (some part of) the canvas is a perception of a mill. He starts to imagine that he is perceiving a mill. He starts to imagine, to imagine visually, a mill: he sees a mill in the mind's eye. Of these suggestions it is evident that only the third goes far enough in the direction of visuality to secure the distinctive character of representation. However it may be asked whether seeing in the mind's *eye* or visualizing has the appropriate kind of visuality to sustain representation at any rate on Walton's understanding of the matter. For Walton insists, it will be remembered, that the seeing (of the picture) and the imagining (of what is represented) must amalgamate. (It was a consideration of this kind, urged on me by Michael Podro, that made me change my view of the seeing-in experience from thinking of it as a conjunction of two experiences to thinking of it as one experience with two aspects.) But, when the imagining of what is represented is equated with visualizing, how is this amalgamation possible? There seems to be no feasible point

Fig. 12.1 Meindert Hobbema (Dutch, 1638–1709), *The Watermill with the Great Red Roof*, 1662–65. Oil on canvas, 81.3 × 110 cm. Photo © Art Institute, Chicago (1894.1031).

of union between the two experiences. They operate in different, uncoordinated spaces.

Now, in conclusion, let us suppose all these difficulties—the difficulties about imagining and about the relationship of imagining and seeing in the head of the spectator—resolved. What is the overall character of the account of pictorial representation that Walton leaves us with? More particularly, how does this final account tie in with the intuitions from which it starts out: intuitions about games of make-believe involving props?

Games of this sort depend upon stipulations or conventions. So, within a certain *game, it* is stipulated that anyone who sees a stump in the middle of a path should imagine that he sees, or that there is, a bear in the middle of the road. Stipulations may be linked in some perspicuous fashion, so that, in this same game, someone who sees two, three, four . . . stumps in the middle of a path, should imagine that he sees, or that there are, two, three, four . . . bears in the middle of the road. When later stipulations are held to follow from the original stipulation, we have what I call 'transfer', and games of any sophistication, or, for that matter learnability, require transfer. There is no incompatibility between transfer as such and the overall conventional character of a game that involves it.

Now let us leap forward to pictorial representation. How much, if any, of the structure of make-believe underlies it? To my mind very little; more particularly too little to justify the project of explaining pictorial representation in terms of make-believe. (My impression is that what helps to make the project seem plausible is our taking *as* our starting-point games of make-believe that—prematurely, we might think, from the point of view of conceptual priority—make use of representation: for instancing, playing with dolls.)

With representation the range or extent of transfer has become indefinitely large, and in a way that the purely formal notion of repleteness does not, cannot, capture. Someone who can recognize a representation of a water-mill can, if he has the power to recognize the real-life things themselves, recognize the representation of a stream, a roof, a decaying tree—or of a zebra, of a submarine, of a noise-filled room, of a ripe lemon. Furthermore, if the person lacks the real-life recognitional powers, he can acquire them from the representation. Transfer on this scale is not, as far as I can see, to be explained by stipulation or convention, however internalized. I believe that the only factor that can explain it is an autonomous perceptual skill, which is just what I take seeing-in to be. From seeing figures in stained walls there is a smooth transition to seeing a water-mill in Hobbema's canvas [URL46]. I take *games* of make-believe to be a different starting-point, from which there is no easy ride to the Golden Age of Dutch Painting.

13

Danto's Gallery of Indiscernibles (1993)

Originally in 'The Artworld' of 1964, then in more detail in his book The Transfiguration of the Commonplace *of 1983, Arthur Danto famously founded his wide-ranging and paradigm-busting theory of art substantially on the conclusions drawn from thought-experiments. They involved various pairs of apparently indiscernible objects which differ either in artistic meaning, or in that one is a work of art and the other is not. Wollheim—in a contribution to a volume of essays about Danto—is not unimpressed with Danto generally but he is not impressed with this move. The thought-experiments have a fault they often have in philosophy, namely that of extrapolating from a few cases considered in abstract to the general case. '[I]t may very well be possible for the concept to be applied, even though for some reason one or more of the assumptions does not hold', Wollheim says, where 'the assumptions' are the presuppositions underlying the practice of using the concept. In this instance, 'it is generally the case that objects that have been made with the broad intention of being works of art will [...] stand out from objects that have not been made with such an intention; and [...] that it is generally the case that works of art that have been made with different specific intentions will stand out from one another.' The use of indiscernibility connects with the question of whether perception can be cognitively penetrated. Danto—naming support from Jerry Fodor (1935–2017) and others in philosophy of mind—thinks that it cannot be. Wollheim points out that the relevant issue is not whether basic perception is cognitively penetrable, but whether one's experience of a work of art—far downstream from the modularity-suggesting type of perception studied in cognitive science and psychology—can be affected by beliefs. Wollheim, needless to say, thinks that it can be, and often rightly so. Danto was inspired by the art and art-movements in post-war New York [but the argument based on indiscernibility reaches back to the* enfant terrible *of the plastic arts, Marcel Duchamp (1887–1968)]. Of this age, Wollheim says that it 'cannot be set straight without an excess of footnotes over text'; the 'scene is too overcrowded with figures who tried to get into the history without contributing to the art.'* [Eds]

Uncollected Writings. Richard Wollheim, Gary Kemp, and Elisabetta Toreno, Oxford University Press.
© Bruno Wolheim 2025. DOI: 10.1093/9780191995767.003.0013

What is distinctive of Arthur Danto's philosophy of art, what gives it distinction, is the way it embodies a remarkable group of characteristics that unmistakably belong to its author: the love of intricate argument, an acute visual sensibility, no small degree of intellectual ambition, a highly individual sense of tradition and of the weight of history, equanimity in the face of innovation, and an irrepressible comic energy. Freddie Ayer once said that it was clear to all, except perhaps to a few psychologists, what the criterion of cleverness is: it is the ability to make a good joke. I should expect Danto to be of much the same mind, he certainly scores well by this measure, and it is a matter of absolutely no surprise that an important dialectical role within his aesthetic should be played by a number of thought-experiments of considerable ingenuity and real subversive wit.

Each of these thought-experiments asks us to imagine a particular set of indiscernible objects, or objects that the eye cannot tell apart, and each set is made up of at least one object that is not a work of art and one or more other objects that are. The look that is hypothesized as common to all the objects involved in any one thought-experiment is described in as much detail as it permits and in a way that gently satirizes art-historical description.

In this essay I want to consider these experiments, what their content is, how they are conducted, what is claimed on their behalf, and what it is that they actually show us. Each time I read *The Transfiguration of the Commonplace*,[1] which is where they are largely to be found, I am impressed afresh by the complexity and the richness of the issues involved, and I shall try, but without hope of total success, to examine the matter without getting involved in the larger purposes of Danto's philosophy of art which he believes are ultimately, or at several removes, to be supported by the various thought-experiments.

Specifically there are two theses of Danto's developed aesthetic that I shall ignore in trying to understand his use of these thought-experiments. The first thesis is that, in the last resort, the work of art is not identical with, and so is to be distinguished from, the supporting physical object, whether this be canvas, piece of metal, lump of stone, which is then said to be its vehicle.[2] The second thesis is that, when an object is said to be a work of art, this is not a straightforward predication: it is more in the nature of an interpretation, or an identification, and an analogy to which Danto is drawn is with saying in front of a representational painting, 'This is Icarus', 'There is a horse', 'Here is a cube'.[3] I am prepared to disregard these two theses because it seems to me that they in no way contribute to what Danto thinks that the thought-experiments have to teach us: what they do is take the sting out of certain further consequences that someone might want to draw from these lessons.

[1] Arthur Danto, *The Transfiguration of the Commonplace: A Philosophy of Art* (Cambridge, MA: Harvard University Press), 1981.
[2] Ibid. 101–5, 125–35.
[3] Ibid. 95, 99, 125–35.

Let me run over some of the different objects, the different indiscernible objects, that Danto asks us to conjure up. They are:

1. Nine exactly resembling rectangular canvases, all painted unbroken red, which are: (a) *The Israelites Crossing the Red Sea*, showing, as Kierkegaard had suggested, the sea after the Israelites had crossed over and the Egyptians were being drowned; (b) *Kierkegaard's Mood*, revealing, we must presume, the very mood that Kierkegaard was in when he made this suggestion; (c) *Red Square*, which Danto thinks of as a clever bit of Moscow landscape; (d) *Red Square*, a minimalist work; (e) Nirvana, an illustration of Indian metaphysics; (f) *Red Table Square*, a still life executed by an embittered disciple of Matisse; (g) a red canvas, not a work of art, but primed by an artist, no less than Giorgione; (h) another red canvas, which has no claim to have anything to do with either art or art history, which happens to have been painted red by we know not who, and, finally; (i) *Untitled*, an expanse of red-painted canvas by an artist of egalitarian views, called J, who, irritated by the inferior status that has been accorded—unaccountably, he thinks—to the previous work, eventually feels that there is nothing for it but for him to take the situation into his own hands and declare his painting a work of art, and in this we are to imagine him successful.[4]
2. Two beds, which are: (a) J's bed, which he, once again, has decided to exhibit as a work of art, and with the same outcome; and (b) a bed, which there is no reason to think of as a work of art, but made to precisely the same specifications by the very same carpenter.[5]
3. Two metal objects, consisting of: (a) the first can opener ever invented; and (b) *La condition humaine*, which is its exact double, produced at the precise same time, by an artist, and well received.[6]
4. Two very complex canvases, which are: (a) *The Polish Rider*, considered until recently by most, and still by many, to be one of Rembrandt's deepest paintings; and (b) the result of someone's puffing a mass of paint in a centrifuge, which, then being spun, deposits the paint in what miraculously turns out to be a precisely matching distribution over the canvas.[7]
5. Three ties, which are: (a) a work said to be entitled *Le cravat*—or, more plausibly, *La cravate*—which is a tie once worn by Picasso, and painted by him a smooth unbroken bright blue, without a trace of the brushwork showing, a gesture that is in some part to be understood as an explicit repudiation of the New York emphasis upon, or cult of, the painted mark;

[4] Ibid. 1–3, 5.
[5] Ibid. 11–13.
[6] Ibid. 29–31.
[7] Ibid. 1–2, 3, 42, 48.

(b) the work of a child, who, having got hold of a tie of his father's, painted it bright blue and gave it that same smooth surface that exactly reproduces Picasso's; and (c) a cunning forgery of Picasso's work, which was then in error signed by Picasso.[8]

6. Two piles of hemp, which are: (a) a pile of the sort exhibited by Robert Morris; and (b) a pile that belonged to the stock of a ship's chandler in Antwerp in the seventeenth century.[9]

7. Two snow shovels, which are: (a) that selected by Marcel Duchamp to be exhibited as a readymade; and (b) any old snow shovel.[10]

In addition, Danto makes great play with various related sets of oddities, but which differ in some crucial respect, perhaps in several, from those he selected to be the material for the thought-experiments proper. So, in some cases, the members of these sets are all works of art, or they aren't totally indiscernible. Examples of these imperfect sets, all of which Danto discusses, are: (8) the two *Don Quixotes*, one by Cervantes, the other by Borges' hero, Pierre Menard, which faithfully transcribes some part of Cervantes' text, both of which are said by Borges to be a distinct work of art;[11] (9) the Erle Loran diagram of Cezanne's portrait of his wife, which is not a work of art, and Roy Lichtenstein's *Portrait of Madame Cézanne*, which is a work of art, but based only on the Loran diagram;[12] (10) the illustrations of Newton's first law and third law of motion, submitted by K and J respectively for the decoration of a library, which are identical;[13] and, finally, (11) Truman Capote's non-fiction novel *In Cold Blood*, and, on the one hand, a report prepared in a district attorney's office and, on the other hand, a piece of investigative journalism, both of which have the same content as, but differ greatly in literary manner from, Capote's book.[14]

I turn now from the material of the thought-experiments to how they are conducted.

Whatever else a thought-experiment is, it is, surely, an *experiment*. That being so, a natural requirement is that there should be a gap between what the experimenter is asked to do, and the result of the experiment, or what the experiment establishes. In all cases it should be that there are two possible outcomes to the experiment. The experiment can turn out positive, or it can turn out negative: in other words, the state of affairs that the experimenter is asked to envisage may be shown to be possible, or it may be shown to be impossible.

[8] Ibid. 40–48.
[9] Ibid. 45.
[10] Ibid.
[11] Ibid. 33–9, 41.
[12] Ibid. 142–4, 147–8, 165, 168, 172, 193–4.
[13] Ibid. 120–24, 129, 130.
[14] Ibid. 144–7.

Under the influence of linguistic philosophy, this constraint was overlooked. It was overlooked because of a particular view, characteristic of the time, of what it is for a state of affairs to be possible or impossible. For once this is equated, as it was by linguistic philosophy, with the question whether the *description* of that state of affairs is consistent or self-contradictory, then there will be a tendency for the thought-experiment to be over before it begins. With only the minimal logical acumen, the experimenter should, on this view of the matter, be able to infer from what he is asked to envisage whether it is a possibility or not. The design of the experiment, adequately understood, gives its result, and in this way the experiment itself drops out of the picture.

Danto himself obviously is not of this methodological persuasion. He is no linguistic philosopher. Yet, in this regard, he argues much as if he were. So, having, at the beginning of chapter 1 of *The Transfiguration of the Commonplace*, introduced us to the nine identical red canvases, of which seven are works of art, furthermore all different works of art, and the remaining two are not works of art at all, and having described, in rather greater detail than I have managed, what they are like and their histories, and then having asked us to imagine them, he says, at the beginning of chapter 2, without appeal or reference to the detail of our imaginative project, that 'that there should be indiscernible artworks—indiscernible at least with respect to anything the eye or ear can determine—has been evident from the array of red squares with which we began this discussion.'[15] Ten pages on, and the indiscernibilia that we were asked to imagine have become 'actual instances.'[16] And another hundred pages on, and we are told that the possibility of there being such things is something that we 'have known from the beginning.'[17] In other words, for Danto too, asking the experimenter to imagine that something is the case is—obvious contradictions in what he is asked to imagine apart—proof enough that this something is possible. There is no actual experiment that the experimenter must carry out in his mind before he is warranted in coming out with a result. The displacement of mental energy that might have been expected of him as he grappled with the question whether, if one object was a work of art, another one, indistinguishable from it, could also be a work of art, or could not be a work of art, or had to be a work of art, now seems of absolutely no moment.

What am I claiming? Am I claiming that Danto is wrong to conclude that, for instance, the nine red canvases could possibly be what he asks us to imagine them to be: that is, seven works of art and two 'mere things'?

No.

[15] Ibid. 33.
[16] Ibid. 43
[17] Ibid. 143.

Am I claiming that Danto was not entitled to draw this conclusion without paying rather more attention than he did to the detail of the experiment that led him to do so?

Yes, I am claiming that. Indeed, it is hard to see how Danto, in concluding that the experiment was positive, could have paid less attention to what went on in the mind of the experimenter.

But I am also claiming more than that. My claim is that, even if Danto is not wrong in the result that he thinks that the experiment gives, he is wrong, and profoundly so, in that he supposes that the experiment gives a more conclusive result than, in the nature of things, it ever could.

To justify this claim I need a distinction within thought-experiments. The distinction is not often given its due. Thought-experiments may be divided according to the kind of concept that they test. Concepts may, for these purposes, be divided into two broad groups.

So, on the one hand, there are thought-experiments that test concepts whose conditions of application are determinate. Examples of such concepts are perceptual concepts, such as *red* or *sweet*, or concepts with a clear intellectual content, such as *triangle* or *straight line*. Such thought-experiments generally admit of conclusive results. They are of this pattern: they posit a certain background condition, and then they ask us whether, given this supposition, some other concept out of this group could also be instantiated, and we should anticipate being able to say conclusively either Yes or No. So, given that a particular surface is green all over, we are asked, could it also be red all over? Given that the taste of a particular fruit is sweet, we are asked, could it also be astringent at the same time? Given that a certain plane figure has three angles, we are asked, could it also have four sides? In all such cases, what we are asked to imagine is whether, in the given circumstances, the conditions of application for the concept that is being tested can, alternatively cannot, be satisfied. And it is reasonable to assume that what goes on in our heads, as we set ourselves to imagine what we have been asked to imagine, permits, one way round or the other, of a resounding answer, which we can take as totally definitive.

On the other hand, there are thought-experiments that test concepts that do not have determinate conditions of application: or do not have conditions of application of an informative kind. In such cases there is a more complicated situation. For, it follows that there are no conditions that, on any given occasion, have to be met if the concept is properly to be applied there and then. However, what do exist are broad assumptions that must in general hold if the concept is to be applicable at all: instead of conditions of application for a concept, there will be assumptions of applicability upon which the concept rests. And assumptions of applicability differ from conditions of application in that, in a given case, it may very well be possible for the concept to be applied, even though for some reason one or more of the assumptions does not hold. The explanation for this anomaly may lie partially in the

fact that assumptions of applicability give the point rather than the meaning of the concept.

The implications of what I have just been saying for the dialectical value of thought-experiments are considerable. For, if we conduct a thought-experiment, endeavoring to see whether a certain concept can be instantiated in a certain kind of situation, and the result turns out positive, we might be gravely misled. For we might conclude that background condition presented no obstacle to the application of the concept. But what might be the case, for all that the thought-experiment has shown, is that, though the failure of the background condition is not a condition of application for the concept—it, the failure of the background condition, is an assumption of its applicability. If that is actually so, then we find that we have been misled to the extent that we find ourselves thinking of a certain concept that it could be instantiated when some condition holds quite universally, when all that is true is that the concept may be instantiated in a one-off situation of that kind. It looks as though, as we move away from the kind of concept represented by perceptual concepts or concepts with a clear intellectual content, we need, if this is to remain a valuable form of experiment, a different kind of thought-experiment. We need a kind that asks us to imagine some concept instantiated when a certain situation is pervasive, or recurrent, or standardly the case. I shall return to this suggestion.

All this, as I see the matter, has a great deal to do with art. It has a considerable bearing on Danto's philosophy of art.

It seems beyond dispute that neither *art* nor *work of art* is a perceptual concept,[18] nor does either concept have a clear intellectual content. Neither *art* nor *work of art* is like *green*, or like *astringent*, or like *triangle*. In consequence, there are no determinate conditions for the application of either concept. But what we may expect to find are certain broad truths that must hold wherever there is art or works of art. There are surely assumptions of applicability for these concepts.

Dialectically what this comes to is that, if we try to run a thought-experiment asking 'Could there be an object that satisfies such-and-such a determinate condition and is a work of art?' it is more than likely—indeed, let us say, if only for the sake of argument, it is invariable—that we shall find that this is something that we can imagine: that is, the experiment turns out positive. In some cases, this may be a conclusion that we reach only reluctantly. And, if so, this is significant. I see it as of a piece with Danto's general indifference to what goes on in the head of the experimenter that he attaches no particular weight to the degree of conviction with which the result is attained.

[18] When Danto says that art and work of art are not perceptual concepts, as he does in *Transfiguration* 44, 61, he appears to use this claim to cover both that these concepts do not have perceptual conditions of application or are not dependent upon a recognitional skill, and that there being works of art has nothing necessarily to do with how they look. I agree with the first and disagree with the second.

However, my point is that, if the result is positive, we must be very careful what we conclude. It may be that the result cannot be generalized: that is, it may be that there could not be an indefinite number of objects that satisfied this condition and were works of art. For, to suppose otherwise could very well be to negate the assumptions of applicability for the concept *work of art.*

What follows is a suggestion how this might work out in practice. For it seems to me very plausible to maintain that the existence of works of art depends upon two conditions: first, that it is generally the case that objects that have been made with the broad intention of being works of art will, as a result, stand out from objects that have not been made with such an intention; and, second, that it is generally the case that works of art that have been made with different specific intentions will stand out from one another. This is very rough, and we may expect refinements to be added. For instance, it also seems necessary that the objects in question must have been made by someone experienced in doing so, and that the materials out of which the objects have been made fall within agreed limits.

Once these refinements have been achieved, we shall have, though still only in an approximate form, the assumptions of applicability for the concepts *art* and *work of art.* In a world where none of this held, there could not be art. But, being assumptions, they can be expressed only approximately, and they hold only generally. They can be expressed only approximately: in that further refinements and qualifications can always be added. And they can be expressed only generally: in that they are not exceptionless. And that they are not exceptionless is overdetermined. For it does not come only from the fact that they are assumptions of applicability, not conditions of application. Nor does it come only from that fact plus the further fact that they are stated roughly. Additionally it comes from the perennial self-consciousness of art, or the way in which over the generations artists reflect upon the assumptions of their art and, through confronting them, try to reanimate them.

If it is the case that the assumptions upon which the concepts *art* and *work of art* depend can be transgressed, we can carry out thought-experiments in which we in effect have them transgressed. Witness the various thought-experiments that Danto proposes. But it is quite a different matter to think that these assumptions need not hold even in general, or to find nothing implausible in the idea that art or works of art might exist in a world in which the hand and the mind regularly left no distinctive trace on the objects that they formed. Just that is what the unrestricted hypothesis of indiscernibilia is asking us to believe, and to believe it on the basis of the thought-experiment's turning out positive.

Thought-experiments of the kind that Danto is so gifted at designing show us very effectively that a certain assumption can be transgressed in a particular case. They do so, because they get us to envisage in a peepshow-like fashion the actual transgression. However, by the same token, or in virtue of their stubbornly perceptual character, they have no power to show us the other side of the matter. They

have no power to show us that the assumption cannot be universally transgressed, in the very respect in which the thought-experiment shows that it can be transgressed in a one-off way. It is for this reason that I said that Danto thinks that his thought-experiments are more conclusive than they possibly could be.

But this takes us to the suggestion, made earlier, that what we need is a different kind of thought-experiment. We need a kind more general in scope, which characteristically would ask us to imagine the concept *art* or *work of art* applied in a world that is identified by the total failure of some background assumption of art—for instance, if I am right, in a world where objects made even by the most experienced persons are completely impermeable to intention. But I have no suggestions to offer about how a thought-experiment expressly intended to test such a possibility would be designed. For the imagination, so focused on the particular, seems ill equipped to determine whether general situations are within the bounds of possibility. It may be that here we are beyond the resources of the thought-experiment: maybe at this stage only abstract thought, generally held to be the main resource of philosophy, must come to the rescue.

An interim postscript: one way of thinking about Marcel Duchamp's readymades, which have exercised an influence over contemporary aesthetics that seems to me quite out of proportion to their interest or significance, is that they occur in an interval or space that this discussion opens up. This is the interval that lies between the possibility of the singular transgression of any of the assumptions upon which art rests and the impossibility of the universal transgression of any such assumption. In this respect, as in others, Duchamp has been sadly misunderstood by those who thought of him and what he did and what he refrained from doing as examples to follow.

I return to Danto's thought-experiments, and their content, or what they ask us to imagine.

In each case Danto puts it by saying that we are to imagine some number of 'indiscernible' objects. But there is, I believe, an ambiguity in these instructions. For there are two things Danto might mean. Has he in mind objects that we initially, or after no more than a cursory examination, find ourselves unable to tell apart, or, does he have in mind objects that we cannot tell apart, no matter how much we learn about, and look at, them? Is it, or is it not, a requirement of indiscernibility that two objects should continue to look the same even after we have found out that, say, one is a work of art and the other isn't, or both are works of art but they were made by very different artists, at very different times, with very different intentions?

The question is crucial. For, as I see the matter, it is perfectly compatible with the assumptions of art that there should be, not just in what I have called a one-off way, but regularly or in general, pairs that are made up either of two works of art or of a work of art and some object that isn't a work of art and that are initially, or to someone who hasn't looked at or thought about them very hard,

indistinguishable. What seems to me impossible, except in a one-off way, is that there should be pairs of this sort that, ultimately, or when all the information is in, cannot be told apart. That, I claim, would transgress the assumptions of art: in particular, it would transgress the assumption that an object made by an artist out of some set of appropriate materials will bear the imprint of his intention.

So how does Danto wish us to understand indiscernibility? Should we understand it as initial indiscernibility or as ultimate indiscernibility? The answer to this question is far from obvious, not least because the question is premised on an assumption that it is not clear that Danto accepts it. The assumption is that the growth of belief or information in a subject's mind can, in certain circumstances, lead him to see a difference between two objects that, to begin with, he couldn't tell apart. The question assumes that belief or information can penetrate perception. Indeed it assumes, not just that belief or information can penetrate perception, but that specifically the belief that a certain object is a work of art, or the information that two works of art differ in the intentions from which they derive, is the kind of belief, the kind of information, that could affect how an observer would see these objects. In so far, then, as Danto does not accept this assumption, it is only to be expected that the ambiguity that I see in his general thesis is not something that he will feel called upon to resolve, and that for him initial, or as he calls it 'retinal,' indiscernibility is all that exists: in other words, what is initially indiscernible will, initial carelessness apart, remain ultimately indiscernible.

Danto at various places, not only in *The Transfiguration of the Commonplace*, but also, more recently, in an article entitled 'Description and the Phenomenology of Perception,' discusses the issue whether 'theory,' which in his vocabulary is the most general word for belief or information, can or cannot infiltrate perception. The view that it can he calls 'internalism,' the view that it cannot 'externalism.' However, as I have already suggested, what is relevant to the disambiguation of indiscernibles is not this broad issue but the narrower issue whether specific fragments of theory, such as whether a certain object is or is not a work of art, or what the intentions were with which the object was made, can or cannot infiltrate perception. Accordingly, I shall concentrate, not so much on fixing Danto's exact position in so far as his text allows us to, but on reconstructing why he might doubt, which I think he might, that a proper understanding of a work of art might infiltrate our perception of it, and thereby make, at least in principle, the indiscernible discernible.

There are, I believe, three considerations that push Danto in this direction, though not ineluctably so. In the first place, there is the evidence that Danto thinks that the thought-experiments themselves provide. And in this context he seems to find that of Picasso's *La cravate* and its indiscernibles especially cogent: for in this case how could the 'interesting differences' between these objects possibly be a matter of subtle differences open only to careful scrutiny?

For there are no subtle differences between these objects.[19] But this use of a thought-experiment is vulnerable to the very argument I have been deploying. For, however persuasive we may find the particular example—and I am far from sure that I find it persuasive at all—there is no reason to believe that the result could be universalized.

Second, there is the un-argued-for conviction that interpretation, which is involved both in thinking of an object that it is a work of art and in assigning to a work of art a meaning, is completely independent of, and radically distinct from, perception. We can, in other words, interpret two objects differently without conceding any visible difference. But here there may be the effects of confusion. For it is one thing to think that whether an object is a work of art, or what specific meaning a work of art has, may not be perceptual matters in that such things may very well require a great deal more than perception in order to establish them; but it is quite another thing to think that, having once been established, these are matters that do not, let alone cannot, affect how we see the objects in question. At this stage Danto appears to recruit to his defense a very narrow view of perception. According to this view, it is only what we see, as opposed to how we see it, that is truly perceptual.[20]

Third, Danto, especially in 'Description and the Phenomenology of Perception', is influenced by the, in many ways powerful, hypothesis of the modularity of the mind, or the view, recently revived by some cognitive scientists, that a number of the capacities or skills that we have—specifically those which we think of as faculties—are, in some measure, encapsulated one from another.[21] In particular, perception is held to be encapsulated from cognition. But it is open to question whether, even if we accept this hypothesis, we should expect it to be relevant at the point at which Danto tentatively invokes it.[22] Two aspects of the modularity thesis call this in doubt. First, the hypothesis applies best to comparatively rudimentary cases of perception: the illusions, or the constancies, being cases in point. Second, it has not been suggested that the hypothesis holds the full length of the perceptual process: on the contrary, it is solely in connection with the analysis of input that it has been found convincing, which leaves room for the penetration of perception by belief to occur at a later stage in the process. That being so, it seems premature to think that we have in the modularity hypothesis a theoretical reason to oppose the evidence from phenomenology: evidence that seems overwhelmingly to support

[19] Ibid. 44.

[20] Ibid. 115–35.

[21] See, for example, Jerry A. Fodor, *The Modularity of Mind* (Cambridge, MA: MIT Press, 1983).

[22] Arthur Danto, 'Description and the Phenomenology of Perception', in Norman Bryson, Michael Ann Holly, and Keith Moxey (eds), *Visual Theory: Painting and Interpretation* (London: Polity Press, 1991), pp. 201–15.

the idea that our perception of works of art is modified by beliefs that we have about what they are or what they mean.

It is a common accusation against academic aesthetics that it suffers from a disfiguring rootlessness. It tries, or so it is said, to pontificate upon the phenomena of art from no time, no place.

Whatever force this has as a form of criticism, it has no application to the philosophy of Arthur Danto. His aesthetic could scarcely be more clearly rooted. It derives from a place and a time. Watered by the mainstream of European art as this flowed through Renaissance and seicento Italy and nineteenth-century France, Danto's philosophy of art grows out of the soil of mid-twentieth-century New York painting and sculpture. And a physical metaphor of this sort is highly appropriate. No one can read Danto's text without recapturing the smells, and the sights, and the tireless, circumambient excitement, of the Village, and the uptown galleries, and the grimy, restless streets of Soho.

It is a great and enviable achievement to have imported so much actualité into Anglo-Saxon philosophical prose. At the same time, a hostage is given to fortune, for quite how far the general tendency of the argument will carry the reader along with it can never be completely divorced from how sympathetic the reader already finds himself to the art that substantiates the aesthetic. This might have been otherwise, for another, a less bold, a lesser critic might have rested content with recreating in the reader a sense of the grandeur of the local art, and have allowed its more anxious or disquieting undertones to go unremarked. Danto brings us up, time and time again, against what it was that made the American experimentation of the past 50 years such a bold undertaking.

I am myself an admirer, but certainly not a devotee, of the art to which Danto gives voice. I do not believe that history will treat New York as the Venice, or the Paris, or the Florence, of the second half of the twentieth century. It will always admire the genius of de Kooning and Rothko, it will respect the achievements of Hans Hofmann and David Smith, it will never cease to wonder at the rich inventiveness of Pollock and Cornell and Johns, it will increasingly appreciate the integrity of artists like Diebenkorn and Fairfield Porter and Louise Bourgeois and Thiebaud, and I am sure that it will look with favour on the merits of many minor artists: but I suspect that it will not forgive an age whose record cannot be set straight without an excess of footnotes over text. The scene is too overcrowded with figures who tried to get into the history without contributing to the art.

I can imagine the moment arriving, a thousand years from now, when an art historian, an Americanist, rediscovers in an old trunk a copy of Danto's long-lost philosophy of art. It is handed round, and read avidly. The thought-experiments are studied carefully, and there are many learned debates about which record actual cases and which may be presumed not to. The philosophers admire the philosophy, but to the art historians Danto is the Pliny of New York. And then at last the freshly discovered texts reach the curators, and their reaction is simple. How

they wish that they could simply disencumber their galleries of some of the enormous machines that they have inherited, which keep them awake at night with their continuous need of restoration, and instead pin up on the vacant walls some elegant sheets, made of the finest Italian acid-free paper, with printed on them in Centaur roman, a few of Danto's wonderfully ethereal, conservation-free, thought-experiments.

14

Walter Pater

From Philosophy to Art (1995)

Walter Pater (1839–1894) is popularly known, along with his famous sup-porter Oscar Wilde (1854–1900), as a card-carrying Aesthete, as one for whom Beauty is paramount, for whom the main thing in life is to 'burn always with this hard, gem-like flame, to maintain this ecstasy'.[1] This must be a caricature; and Wollheim assembles an extensive case for a quite different diagnosis. Pater's verdict on critical theory and philosophy—in particular the systems of metaphysics from Plato to Hegel—is that it is in general too speculative to win belief. What it shows, in one who does go in for it, is rather the person's subjective temperament. This goes as well for the philosophical thesis of Aestheticism. And as for the cult of beauty, Wollheim argues that 'beauty' in the Pater's case means 'expression'— which, for a person who did not live to see the art of the twentieth century, was a plausible line to take (and connects him firmly with the imminent critical movement known as Formalism, as in Roger Fry and Clive Bell). Pater's literary output was substantial, and Wollheim quotes from a wide range of it to marshal his case. Wollheim had written earlier (1974) on the same topic; little of the treatments of Hegel and Watteau survives here, but it has much more in the way of scholarly and philosophical detail. [Eds]

I

Walter Pater, the English critic and aesthete, spent the greater part of his adult life teaching philosophy at Brasenose College Oxford. Wallace Stevens, the American poet and aesthete, spent the greater part of his adult life selling life-insurance in Hartford, Connecticut. Stevens was a highly conscientious businessman, he rose to become the vice-president of his company, he went on working for four years beyond the statutory age of retirement, and, even at an advanced age, he found it too upsetting to the equilibrium of his life to absent himself from his office for the time required to deliver the Charles Eliot Norton Lectures at Harvard. No one,

[1] Walter Pater, *Studies in the History of the Renaissance*, ed. Matthew Beaumont (Oxford: Oxford University Press, 2010).

however, would suggest that Stevens's poetry, let alone his aestheticism, are best approached through his attitude to life-insurance, and the suggestion that Pater's criticism, and even more his aestheticism, are well approached through his attitude to philosophy is widely treated as no more plausible. I, on the contrary, think that this suggestion is compelling, and in this essay I shall be concerned—not for the first time[2]—to make out such a case. If the theme has been heard before, I hope some of the variations are new. I hold the disputed view that in criticism truth is more important, truth is much more important, than novelty.

II

Walter Pater was a highly conscientious teacher of philosophy. It follows from what I have just said about Wallace Stevens that this fact alone doesn't make my case, but it is an important element in it, and the facts are worth restating briefly.

Pater was elected to a non-clerical or lay fellowship at Brasenose College in 1864. In 1867 he became a college tutor, he took his first pupil in the Lent Term of 1868, and he started to lecture to the College around this time. In 1870, as part of the system whereby university teaching became more systematic—more Germanic, one might say—combined or University lectures were introduced on top of the College lectures, and the lists of such lectures were published in the *University Gazette*: as they are to this day. The more progressive, the more dedicated, teachers took part in the new system. Pater's name first appears in the University lists in the Hilary Term of 1872—two years after the system was initiated. From then onwards until 1883— when Pater partially withdrew from Oxford to London in order to lead a more intensely literary life, though he kept the terms in College—Pater's name was one of the most constant on the lists. No one lectured more often, and he lectured more often than most. In this period, except for one year, he lectured in two terms out of three. He generally chose either a book of Plato's *Republic* or the *Nicomachaean Ethics* in whole or in part. He also lectured on the *Phaedrus* and on the *Protagoras,* and two courses of lectures departed from the normal pattern of exegesis and comment and went under the titles *Mental Philosophy* and *Philosophical Questions.* We must wonder what the content of these courses was. *Plato and Platonism,* which appeared in 1893 and was the book that Pater told his future biographer, A. C. Benson,[3] was the likeliest to survive, affords us the best insight we have into the care, patience, and love of the text that must have been characteristic of Pater's style as a philosophical teacher. In the published correspondence we find more than one example of Pater crying off a meeting because

[2] See Richard Wollheim, 'Walter Pater as a Critic of the Arts', in *On Art and the Mind: Essays and Lectures* (London: Allen Lane, 1973). [Eds]

[3] A. C. Benson, *Walter Pater* (London: Macmillan, 1906), p. 162.

he had to spend time in preparing his teaching. Humphrey Ward wrote of his lectures as 'crammed with thought and work.' In 1888 the young Berenson, fresh from Harvard, arrived to spend a term in Oxford. Vernon Lee and others have described for us the *arrivisme* that already marked this young Cortez. He wanted, of course, to meet Pater but he also wanted to attend Pater's lectures. In a note Pater regretted that he could not give permission because, as he explains, the current course, which was anyhow about to come to an end, was not 'of a public character, or, in the full sense, lectures at all'. These lectures must have been College lectures, but the exchange not only reveals that Pater continued to give them during his London period but it also suggests that, by this time a famous writer, he had gained something of a second reputation through his University lectures.

<div style="text-align:center">

III

</div>

This however is only incidental to my case that Pater's work is best approached through his attitude to philosophy, and I would like to present the case in this way:

Criticism, which is what Pater's work was, has a suspended existence. It stands between theory on the one hand and art on the other hand. It is Janus-faced, and it looks towards both and strives to do each justice. The work of any particular critic can be thought of as a series of confrontations, effected in the critic's head, between the critical theory to which he chances to subscribe and the works of art that he is called upon to understand. His criticism has to fall within the general limits set by the critical theory he believes in, and it also has to bring out the salient character of the art works he criticizes. Failure on either count is failure, though of course there are times or places when the tendency is to look more indulgently on one form of failure than the other.

The more we reflect upon criticism—at any rate when we are in a certain mood— the more arbitrary, the more contrived, it can seem to be. In consequence we can come to feel that, if we are really to understand how a critic found what he was doing worthwhile, we need answers to two questions. We need to know, of course, what critical theory he espoused and what works of art he inquired into. But, more fundamentally, we need to know, if we can, what he thought critical theory is, and we need to know what he thought works of art are. Big questions, and too big for us just to assume that every critic will necessarily have an answer to them.

With Walter Pater the situation is favourable. Timid and inconclusive though he was in many ways, he did not shun big questions, and he responded to them with suitably large answers. So not merely did he have a view about what the theory of criticism is and a view about what works of art are but, in each case, the view that he had was part of a wider view. His view of critical theory derives directly from a more general view about the nature of speculative theory: his view of art works derives, just as immediately, from a more general view about the nature of cultural objects. So once we can grasp what Pater thought about speculative theory, once

we can grasp what he thought about cultural objects, we shall then be able to penetrate to the essence of his criticism. But can we do this?

I think that we can, and I think we can do this through looking carefully at his attitude to philosophy.

The single most important influence upon Walter Pater—it is evident throughout his work from broad tendencies of thought to many, many turns of phrase—is Hegel. And one lesson amongst many that Pater learnt from Hegel was that the character of philosophy is obscured unless we see philosophy as simultaneously an expression of speculative thought and a manifestation of human culture. Philosophy then is a rare thing in that it is an example of both the two phenomena on which we wish to find Pater's views. Accordingly, once we have grasped what Pater did think about philosophy, and what kind of thing it is, we shall have in our hands the raw materials with which to answer the questions that we need to answer if we are to penetrate to the essence of his criticism.

The strategy, then, is this: see how Pater saw philosophy. Generalize this vision in one direction, and you have how Pater saw the theory of criticism: for critical theory is like philosophy in being an example of speculative thought. Then generalize the vision in another direction, and you have how Pater saw works of art: for works of art resemble philosophy in being objects of human culture. Of course the problem that we shall have to face is how to divide up Pater's account of philosophy into those two components: how to decide which part of the account is trying to do justice to the speculative aspect of philosophy, and which part is trying to do justice to the cultural aspect of philosophy.

<div align="center">

IV

</div>

Pater's starting-point in philosophy was scepticism, and scepticism of the most thoroughgoing kind. Metaphysical systems put themselves forward as candidates for belief; they ask us to accept them as literally true: but belief is just what they are never entitled to receive. They are not entitled to receive it because they are so hyperbolic. It is in their essential nature to exceed what we could ever have good reason to accept.

As an undergraduate Pater fell under the influence of what he was later to call 'the wholesome scepticism of Hume or Mill'.[4] In one of the first articles he wrote, which was on Coleridge, he identified himself as a defender of 'relative' as against the 'absolute' spirit.[5] In *The Renaissance*, talking of the question of what beauty is or what its exact relation is to truth and experience he says that they are `metaphysical

[4] *Plato and Platonism*, p. 31. Unless otherwise indicated, all references are to the New Library Edition of the Works of Walter Pater (London: Macmillan, 1910).

[5] See 'Coleridge as a Theologian', in Walter Pater, *Sketches and Reviews* (New York: Boni and Liveright, 1919). This essay consists of those parts of Pater's review in the *Westminster Review*, January 1866, which Pater omitted from 'Coleridge' in *Appreciations*.

questions as unprofitable as metaphysical questions elsewhere'.[6] And there is every reason to think that this attitude of his persisted. In *Marius* the hero reflects upon the `weariness of systems which had so far, outrun positive knowledge'.[7] In *Gaston de Latour* Pater's intellectual sympathy lies undoubtedly with the scepticism of Montaigne, particularly of the First Book of the *Essays*. And in *Plato and Platonism* Pater sides with that criticism of Plato which charges him with giving 'an illusive air of reality or substance to the mere nonentities of metaphysic hypothesis'.[8]

However, as strong an element in Pater's attitude towards philosophy as this scepticism was his recognition of the fascination of philosophy. People would never give it up, nor could he. And it is crucial to see that this didn't establish a conflict in Pater's mind. He went through no crisis of faith in his attitude towards philosophy like that which so many of his more earnest contemporaries did in their attitude to religion. And that is because it would seem never to have occurred to Pater to account for the charms of metaphysics in terms of the claims that it laid to truth, of the news that it brought. The recognition that metaphysical speculation had no, or little, cognitive content was not a disillusioning experience for Pater, for it freed him to look for the inherent interest of such speculation, elsewhere, where—as he saw it—it would be more natural to look for it.

Where was that?

The fascination of metaphysical systems, freed from any cognitive claims, had, according to Pater, two distinct sources. It lay, on the one hand, in what such systems arise out of; on the other hand, it lay in what they lead on to. Metaphysical systems arise out of or have their sources in, human instincts, feelings, emotions. More precisely, they arise out of typical or characteristic constellations of such mental dispositions: out of temperaments or what Pater called—and the phrase will recur—'types of mind'. And metaphysical systems lead on to, or have as their all but invariable consequences, inclinations or habits of behaviour and perhaps more profoundly ways of conceiving or perceiving the world: in the broadest sense, what Pater calls the ethical. They rise, then, from the inner being of man, and they precipitate him into life in this or that specific direction.

We might put all this by saying that Pater combined an expressive account of the *causes* of metaphysics with a pragmatic view of the *effects* of metaphysics. Quotations support this. Here we have Pater on the genesis of metaphysics. 'What seems hopelessly perverse as a metaphysic for the understanding is found to be realizable enough as one of many phases of our so flexible understanding'[9]—where 'realizable' means of course 'conceivable' or 'capable of being grasped by the mind'. On the consequences of metaphysics he writes in *Marius*:

[6] *Studies in the History of the Renaissance*, ix.
[7] *Marius*, I, 140–41.
[8] *Plato and Platonism*, 143.
[9] Ibid. 48.

It has been sometimes seen, in the history of the human mind that when... translated into terms of sentiment—of sentiment, as lying already half-way towards practice—the abstract ideas of metaphysics for the first time reveal their true significance. The metaphysical principle, in itself, as it were, without hands or feet, becomes impressive, fascinating, of effect, when translated into a precept as to how it were best to feel and act.[10]

More aphoristically Pater writes—and this again is from *Plato and Platonism*—'Metaphysical formulae have always their practical equivalents.'[11]

These two sources of metaphysical appeal are brought together in a passage in the last completed chapter of *Gaston de Latour*, which Pater entitled 'The Lower Pantheism', where he pays tribute to the speculative system of Giordano Bruno. For he can find no better way of expressing his admiration than by pointing out the transparency with which Bruno's system at once looks backward to the mind from which it sprang, and also looks forward to the world which it seeks to modify. It combines the two sides of metaphysics in a pure form. Pater writes 'It is not always, or often, that man's abstract ideas penetrate the temperament, touch the animal spirits, affect conduct. It was what they did with Bruno.'[12]

Let us now observe some of this in—if the word is not too inappropriate—action. Pater's major contribution to literature was the creation of a genre: the Imaginary Portrait. And the significance of this genre for Pater was that it allowed him to catch that constellation of feelings, instincts, and emotions which he called a type of mind. In *Sebastian van Storck,* he set out to catch the type of mind that associates itself with one of the great, perennial metaphysical systems. The story itself is quickly told. It is set in mid-seventeenth-century Holland, and the central character is a charming and serious young man, a product of the *haute bourgeoisie*, given to melancholy, who turns away from the bustling cultivated life of his family and immerses himself in philosophy. The philosophy that comes to engross him is the monism of Spinoza. He writes a cruel letter of denunciation, or so the good people of the town found it, to the simple healthy girl he is engaged to, and he abandons her. He goes off to live in a lonely house on the shore and dedicate himself to abstract thought. A sudden rising of the wind causes the sea to flood, and Sebastian is drowned while saving the life of a young child. The narrative is told with great sympathy and with much calculated suppression of feeling.

Below the anecdotal surface, the work moves on two levels. On one level, it is expository. It tells of the match between a certain type of mind and a body of philosophy with which it has a natural affinity. On another level, it is cautionary. For characteristic of Sebastian, and symptomatic of a certain mental derangement, is

[10] *Marius*, I, 135.
[11] *Plato and Platonism*, 48.
[12] *Gaston de Latour*, 152.

his failure to grasp what a metaphysical system is. Sebastian's error, we might say, is that he takes the metaphysical system to which he is drawn literally. He ignores its origin in temperament, he is contemptuous of its consequences for life, and he looks upon it as what it could not conceivably be: the bearer of literal truth.

Pater spells out the diagnosis unmistakably. In the first place, Sebastian failed to see the origins of metaphysics in himself.

> Looking backward for the generative source of that creative power of thought in him, from his own mysterious intellectual being to its first cause, he still reflected, as one can but do, the enlarged pattern of himself into the vague region of hypothesis. In this way some, at all events, would have explained his mental process. To him that process was nothing less than the apprehension, the revelation, of the greatest and most real of ideas—the true substance of all things.[13]

Secondly, Sebastian failed to recognize how a metaphysical system, despite its abstract formulation, has the power to return one to life with an enhanced perception of reality. Of the central doctrine of Spinoza's system, which Pater expresses as 'The one alone is', he writes,

> There have been dispositions in which that abstract theorem has only induced a renewed value for the finite interests around and within us. Centre of heat and light, truly nothing has seemed to lie beyond the touch of its perpetual summer. It has allied itself to the poetical, or artistic sympathy, which feels challenged to acquaint itself with and explore the various forms of finite existence all the more intimately, just because of that sense of one lively spirit circulating through all things—a tiny particle of the one soul, in the sunbeam, or the leaf.[14]

But, Pater tells us, not so Sebastian van Storck. For him the practical equivalent of his metaphysical system was a cold stultifying immersion in the system itself: 'absolute selfishness', 'unkindly melancholy' are Pater's phrases. He goes on,

> And at length this dark fanaticism, losing the support of his pride in the mere novelty of a reasoning so hard and dry, turned round upon him, as our fanaticism will, in black melancholy. The theoretic or imaginative desire to urge Time's creeping footsteps, was felt now as the physical fatigue which leaves the book or the letter unfinished, or finishes eagerly out of hand, for mere finishing's sake, unimportant business.[15]

[13] *Imaginary Portraits*, 106.
[14] Ibid. 107–8.
[15] Ibid. iii.

In the essay of Amiel, which appeared in March 1886, the same year and month as *Sebastian van Storck*, Pater actually goes so far as to use the term 'intellectual inconsistency'[16] to describe the situation of someone who has a strong commitment to a metaphysical system—once again monism— yet forms no 'plan of action or production', of the kind, Pater suggests, that religion, to its credit, offers through its moral training and its shared institutions.

V

To this account of philosophy Pater adds two points of detail, both introducing small loops into the path that metaphysics pursues as it emerges from the type of mind it expresses into a set of propositions. There is, first, the influence of language, both in its general forms and in the peculiarities of the natural language in which the philosophy is formulated. Idioms, turns of phrase, pregnant metaphors collude with thought and extend lines of reasoning beyond their proper terminus. Secondly, there is the influence of the age, of the social environment, to which Pater pays deference though (it must be said) more in principle than in practice. *Plato and Platonism* contains two affirmations of the historical method. The first occurs in the first lecture, 'Plato and the Doctrine of Motion', when the historical method is considered along with the dogmatic method and the eclectic method and elevated above them. The second occurs at the beginning of the sixth lecture, 'The Genius of Plato'. But, by the time we get to the second passage, it is quite clear that Pater is asking us to look to the historical environment only so as to be able to distinguish the personal, which is for him the interesting topic, from what merely belongs to the period, which falls away. The ultimate aim is to rescue the portrait of a person from the character of an age. By now the Hegelian idea of the interpenetration of person and age has been lost sight of.

VI

Though ultimately intending to talk about Pater and art, I have so far talked only about Pater and philosophy. My strategy has been this: to grasp the essence of Pater's criticism we have to understand what he thought critical theory was and what he thought works of art were. Critical theory, because criticism has to conform to it; works of art, because criticism is about them. I then suggested that Pater's view of critical theory comes out of his view of speculative thought, and that his view of works of art is just a case of what he thought of objects of human

[16] *Essays from the Guardian*, 34.

culture. And then philosophy proposed itself as a way into the topic just because philosophy is at once an example of speculative thought and an example of a cultural object. So, if we know what Pater thought about philosophy, we might be in a position to grasp the essence of his criticism.

But now, having Pater's account of philosophy before us, how are we to use it?

My suggestion is this: that we should cut Pater's account of philosophy neatly down the middle, and then refer away one half of it to get Pater's view of critical theory and the other to get his view of works of art. Works of art resemble a philosophical system in the matter of their expressive character: the proper way to respond to a work of art is to take it as manifesting a temperament, a type of mind. By contrast, critical theories resemble a philosophical system in the matter of their pragmatic role: the proper way to respond to a critical theory is to take it as encouraging us to perceive or react to a work of art in a certain way. Though it must also be conceded that Pater was not indifferent to the expressive character of critical theory, nor did he think that works of art were without pragmatic role.

Having made this proposal, I now want to defend it against a powerful misunderstanding. For, it might be said, if it is really Pater's view that we should look to works of art for what they reveal to us about a type of mind, or to critical theories for how they lead us to regard works of art, someone might retort that, if this is so, then Pater wasn't really interested, in works of art, he wasn't really interested in critical theories. He wasn't, that is, interested in these things in *themselves*: he was only interested in them for what they showed about something outside themselves.

This response is based on a common confusion, which I shall illustrate from works of art. We can be interested in what a work of art says or means or reveals or expresses, and we can, we *can*, be so without any interest in *how* it does those things. We can ignore the connection between what the work says, means, reveals, expresses, and how it looks. In such a case we show no interest in the work itself. But, when we are interested in the work itself, there are ways and ways, not just one way, of being so, and some of these different ways will include an interest in what the work says, means, reveals, expresses, provided that we connect these various things it does with how it looks, sounds, or reads. Once we get confused about these issues, then we find ourselves committed to thinking that there is only one way in which we can take an interest in the work of art in itself, and that is by concentrating on how it appears to the total exclusion of all else. We can then go on to think that to show an interest in what the work, let us say, expresses, is to be interested in it solely for what it shows about something else, such as the psychology of the artist.

Walter Pater was, I think, clear-eyed on this issue, and, if we have doubts on this score, once again his attitude to philosophy comes to the rescue. He believed, we have seen, that *in part* the appeal of a metaphysical system derived from the type of mind that it expressed. Now nothing suggests that, in ascribing expressive value to a metaphysical system, Pater felt that he was draining interest out of it. He

never thought that, if he came across another metaphysical system that expressed the same type of mind as Plato's, the two would become interchangeable from his point of view. And even less inclined was he to think that the expressiveness of Plato's system was only accidentally related to its philosophical detail, or that it could, as a philosophical system, be grasped except through identifying the premisses and following the trains of reasoning.

This point comes out well, and rather more concretely, in the essay entitled 'The Beginnings of Greek Sculpture' which was published in the posthumous *Greek Studies*. The context is a discussion of Hegel's thesis that the specific role of Greek art was the expression of thought or abstract conception. Pater does not dispute this description, but he insists that a concern with the fact that works of art express thought goes nowhere without an accompanying concern for their sensuous properties: for it is only through their sensuous properties that they express thought. Without an independent interest in the use of material, in the elaboration of design, the Greek artist, Pater tells us, could never have accomplished depth of expression, and the student of Greek art is called upon to display a similar breadth of attention. It was for this reason that Pater encouraged an approach to Greek[..] art of the finest period through its origins in the Heroic age, when the traditions of craft and skill were valued in themselves. One quotation must do for many:

> A perfect, many-sided development of tectonic crafts, a state such as the art of some nations has ended in, becomes for the Greeks a mere opportunity, a mere starting-ground for their imaginative presentment of man, moral and inspired. A world of material splendour, moulded clay, beaten gold, polished stone;—the informing, reasonable soul entering into that, reclaiming the metal and stone and clay, till they are as full of living breath as the real warm body itself; the presence of those two elements is continuous throughout the fortunes of Greek art after the heroic age, and the constant right estimate of their action and reaction, from period to period, its true philosophy.[17]

This concludes what I have to say against the view that, in so far as Pater thought of art as expressive, he denied its intrinsic interest.

VII

I have arrived at what Pater thought works of art were and what he thought critical theory was by what may seem a rather high-handed procedure. I took Pater's account of philosophy and what he thought it is, carved it up, and distributed it

[17] *Greek Studies*, 223.

between art and theory. From Pater's view that philosophy is expressive in so far as it is a cultural object, and pragmatic in so far as it is a piece of theory, I concluded that for him culture, or art, is essentially expressive, and theory is essentially pragmatic. Would this view have recommended itself if I had adopted a more direct approach? I think so.

An expressive view of art is just what Pater comes out with whenever he commits to himself to a general statement about art. It also, as we shall see, conforms with his critical practice, such as it is. In *Plato and Platonism*, Pater writes 'The essence of all artistic beauty is expression, which cannot be where there's really nothing to be expressed: the line, the colour, the word following obediently, and with minute scruple, the conscious motions of a convinced intelligible soul.'[18] But, in the early essay on Luca della Robbia, which appeared in *The Renaissance*, he had already used the idea of art as expression, to arrive at the notion of an art of great rarity which comes about through expressiveness to some exceptional degree. 'They' (the Tuscan sculptors of the Quattrocento), he writes,

> bear the impress of a personal quality, a profound expressiveness, what the French call *intimitec* by which is meant some subtler sense of originality — the seal on a man's work of what is most inward and peculiar in his moods, and manner of apprehension: it is what we call *expression*, carried to its highest intensity of degree.[19]

And what went along with this conception of art as expression was a corresponding displacement of a rival conception of art. In Pater's thinking the notion of art gets detached from the notion of beauty. Art may, of course, exhibit beauty: but beauty is not an essential, or even characteristic, property of art.

This is not the orthodox view of Pater. It is evidently opposed to the view of Pater as the supreme aesthete, and, when I made, at the beginning of this essay, a promise that my approach to Pater's criticism would best explain his aestheticism, it may now seem that what I must have meant by that was that his aestheticism would be explained away.

But it may be thought that I have been refuted out of my own mouth. For in the sentence I quoted just now as evidence for Pater's conception of art as expressive, expression and beauty were linked. 'The essence of all aesthetic *beauty* is expression.' However a more careful reading is necessary.

In this passage Pater, under the influence of an expressive view of art, does indeed dissociate art from beauty *on the common understanding of that word*, and, if the word 'beauty' survives, it does so with a new sense. It survives with the sense bestowed on it by an equivalence that Pater asserts. It means `truth', or that precise

[18] *Plato and Platonism*, 120.
[19] *Studies in the History of the Renaissance*, 71.

consonance of the medium with the inner state that it expresses: *la vraie vérité*, as Pater loved to call it, or what he also calls *"fineness"* of truth'. In the essay entitled 'Style' Pater writes 'Well! All language involves translation from inward to outward. In literature as in all forms of art there are the absolute and the merely relative or accessory beauties: and precisely in that exact proportion of the term to its purpose is the absolute beauty of style, prose or verse.'[20] From now onwards, beauty as *traditionally conceived* is relegated to accessory beauty, and the term `beauty' itself is reserved for truth. What is presupposed in all this is what Pater, earlier in the same essay, talks of as `the idea of a natural economy, of some preexistent adaptation, between a relative, somewhere in the world of thought, and its correlative, somewhere in the world of language'.[21]

So what of Pater's much rehearsed aestheticism, which is in the eyes of most of those who think about Pater the most famous fact about him? Are there not a number of passages in which he clearly subscribes to the view that works of art should be prized for the sensuous pleasure that they can give, and is not the best-known passage from Pater, the Conclusion to *The Renaissance*, unambiguous assertion of just such a theory of criticism—extended indeed so that it becomes a theory of the whole of experience? I quote from the text of the first edition:

> While all melts under our feet, we may well grasp at any exquisite passion, of any contribution to knowledge that seems by a lifted horizon to set the spirit free for a moment, or any stirring of the senses, strange dyes, strange colours, and curious odours, or work of the artist's hands, or the face of one's friend. Not to discriminate every moment some passionate attitude in those about us, and in the very brilliance of their gifts some tragic dividing of forces on their ways, is, on this short day of frost and sun, to sleep before evening. With this sense of the splendour of our experience and of its awful brevity, gathering all we are into one desperate effort to see and touch, we shall hardly have time to make theories about the things we see and touch.[22]

But, before we become dogmatic about what this passage is telling us, let us remind ourselves of the view of critical theory that I have attributed to Pater. For, if I am right about this, then to talk of Pater's subscription to, or assertion of, a particular theory is never totally appropriate. For Pater a critical theory will derive its appeal from considerations not of truth but of utility. Its acceptability is a matter not of what it tells the critic, but of what it does for him. It is a matter of whether it leads him to see the work of art as it should be: that is to say, in its

[20] *Appreciations*, 34.
[21] Ibid. 30.
[22] Walter Pater, *Studies in the History of the Renaissance* (London: Macmillan, 1873), p. 211.

original expressive light. Indeed, in sentences that follow on those I have quoted, Pater goes on to say just this.

Theories, religious or philosophical ideas, as points of view, instruments of criticism, may help us to gather up what might otherwise pass unregarded by us. *La philosophie, c'est la microscope de la pensée.* The theory, or idea, or system which requires of us the sacrifice of any part of this experience, in consideration of some interest into which we cannot enter, or some abstract morality we have not identified with ourselves, or what is only conventional, has no real claim upon us.[23]

What then is the point of the Conclusion to *The Renaissance*? The answer is complex. In so far as it concerns itself with critical theory, it is an attempt to bring out as vividly as possible the consequences of one particular critical theory: aestheticism. It is concerned to show what aestheticism can do for us or how it can shake us up. However, the Conclusion to *The Renaissance* is not solely to do with critical theory, it is also about the metaphysical system in which the theory of aestheticism is generally embedded: that is, sensationalism, or the view that all there is is a succession of fleeting, unsupported, and independent sensations. In bringing out the reverberatory appeal of sensationalism, Pater shows how it might chime with a certain kind of temperament. And, if, in doing this, he is peculiarly successful, it is because he deliberately mobilizes all the linguistic‐ resources, all the resources of image or metaphor, upon which sensationalism can draw. The Conclusion to *The Renaissance* is, amongst other things, a brilliant piece of metaphysical mimicry, in which all the charms of one system are paraded in front of us.

Even if it were not an interpretative mistake to think of the Conclusion to *The Renaissance* as an affirmation of belief, it would not have been in character for Pater to have favoured aestheticism over all other critical theories. In the light of his commitment to expressiveness, a correct critical theory would have to be one that encouraged the critic to perceive in works of art the lineaments of human temperament. Admittedly, Pater's view of how works of art come by expressiveness—that is, through their sensuous properties—would have made him sympathetic to the idea that the critic should expose himself to the surface qualities of a work of art. But any such theory could only be preliminary. Indeed, in a yet profounder sense, all critical theory could only be preliminary. A theory has no greater claim upon us than the criticism it leads to.

VIII

With all this in mind, I now turn to Pater's famous essay on Botticelli. This essay first appeared in the *Fortnightly Review* in August 1870, it was reprinted three years

[23] Ibid. 211–12.

later in *Studies in the History of the Renaissance*, and it will serve well as a testing-point for my interpretation of Pater's criticism.

In the first paragraph of the essay Pater sets out what he calls 'the chief question' that a critic has to answer when confronted with the work of an artist: especially (Pater says) when he has to speak of a `comparatively unknown artist'. The question is this: 'What is the peculiar sensation, what is the peculiar quality of pleasure, which his work has the property of exciting in us, and which we cannot get elsewhere?'[24] On the face of it there could not be a clearer, a more forceful affirmation of aestheticism as a critical theory. The appeal to immediacy, the privilege afforded to pleasure, the subjective status of judgement, the repudiation of all collateral information—here we have in a highly compressed form all the ingredients of extreme aesthetic theory. Or do we?

Let us turn back to the Preface which Pater composed when he came to collect the essays that form *The Renaissance* volume, for here he drew up a number of questions that he suggested the aesthetic critic should put to himself, and these questions can be regarded as amplifying the question on which the Botticelli essay opens. Here they are:

What is this song or picture, this engaging personality presented in life or in a book, to *me*? What effect does it really produce on me? Does it give me pleasure? And if so, what sort of degree of pleasure? How is my nature modified by its presence, and under its influence?[25]

If we now substitute these question for that on which the Botticelli essay opens, the initial effect is that the aestheticism is even more emphatically asserted. We hear the italicised '*me*' as reinforcing the subjectivity of the approach, or the equation of critical judgement with the deliverance of private sensation. But now turn to another passage in Pater's writings where the same italicized '*me*' occurs, and there the implication is really rather different. The passage occurs in Pater's late essay on Notre-Dame d'Amiens, reprinted in *Miscellaneous Studies*. Pater proposes that the student of architecture, confronted by one of the great medieval cathedrals, should ask himself the question, 'What, precisely what, is this to *me*?'[26] However, what Pater thereby wishes him to raise is, it is clear, not simply the issue of subjective value, but a far profounder issue, which anyone who believes in the expressiveness of art has to consider. Croce raised the issue, but few philosophers of art have done so. It is this: what are we to make of works of art that are so susceptible to material corruption that their appearance is bound to change in a radical way over the years and the centuries? Should we equate their true aesthetic condition—that is, their true expressive value—with their pristine appearance, or with an appearance to which the most skilful restoration can return them—or with what? Pater's own

[24] Ibid. 50–51.
[25] Ibid. viii
[26] *Miscellaneous Studies*, 117.

suggestion is that works of art of such a kind are essentially temporal objects and that their aesthetic nature includes 'the visible result of time', and accordingly the judgement of each age, and so of every sensitive observer in each age, is a proper constituent of the overall judgement.

In point of fact, we can find ourselves worrying rather less about just how the questions that Pater enumerates in the Preface to *The Renaissance* are to be analysed, once we realize the role he assigns them. For, after enumerating the questions, he goes on, and without a break, to assert, 'The answers to those questions are the original facts with which the aesthetic critic has to do'. 'The original facts'.[27] In other words, Pater here reminds us that the answers to these questions are the starting-point of serious inquiry, not its terminus—a point that Pater anticipated when he wrote, 'In aesthetic criticism the first step towards seeing one's object as it really is, is to know one's own impression as it really is, to discriminate it, to realize it distinctly'.[28] Again, the first step, not the destination. In the next sentence Pater writes, 'As in the study of light, of morals, of number, one must realize such primary data for one's self or not at all'.[29] Assuming that these analogies—physics, ethics, mathematics—are carefully chosen, and any other assumption would be rash to make, we are forced to conclude that, for Pater, a form of inquiry that begins in subjectivity can readily transcend it. If we now wonder what the point is of the questions that Pater initially poses, their aim seems to be to get the critic to use his eyes. In what way, and to what ultimate end is another matter, and a matter on which the Botticelli essay has something to show us.

We might start with the question, Why Botticelli? We could easily go wrong. For Pater Botticelli is not an artist who offers easy surface delights. On the contrary: his Madonnas are 'peevish-looking', the abstract lines of the faces he shows us have 'little nobleness', the colour is 'wan', sometimes 'cadaverous', and 'cold'. If Pater in 1870 was prepared to deny Botticelli at once the beauty of piety that the later Pre-Raphaelites had seen in his paintings and the beauty of sin that excited Swinburne's interest, he was no less innovatory in the quality for which he admired him. Pater admired Botticelli for the power of expression, and he thought that it was precisely the absence of superficial attraction that allows us, in the study of his art, to penetrate to 'an under current of original sentiment, which touches you as the real matter of the picture through the veil of ostensible subject'.[30] Now, in asserting this view, Pater was going against the judgement of Crowe and Cavalcaselle, who were, by and large, Pater's mentors on the detail of Italian art. Comparing Botticelli unfavourably in this respect to Ghirlandaio, they had written that 'we look in vain for that deep expression of thought and subtlety which his biographer [i.e. Vasari]

[27] *Studies in the History of the Renaissance*, viii.
[28] Ibid.
[29] Ibid.
[30] Ibid. 50.

discovers and praises'.[31] Pater must have known this judgement and had these very words in mind when he wrote of Botticelli that, 'in the middle of the fifteenth century he had already anticipated much of that meditative subtlety, which is sometimes supposed peculiar to the great imaginative workmen of its close'.[32]

But nowhere in this essay is the rejection of straightforward aestheticism more evident than when Pater does come to talk about surface qualities. Our interest in such qualities should always be an interest in them as animated by something below the surface. From Botticelli's colour we can learn 'what imaginative colouring really is, that all colour is no mere delightful quality of natural things, but a spirit upon them by which they become expressive to the spirit'.[33]

How seriously are such phrases to be taken? Someone had an answer. In the early summer of 1877 Oscar Wilde submitted his first piece of art-criticism to the Dublin University magazine. It was a review of the opening exhibition at the Grosvenor Gallery in London; and in it Wilde talked of 'imaginative colour'. The editor had some difficulty with the phrase, and Wilde explained what he thought it meant. 'I have been obliged to explain what I mean by imaginative colour, and what Mr Pater means by it. We mean thought expressed by colour [. . .] I do not mean odd unnatural colouring. I mean "thought in colour"'. Wilde spoke without authority, for he hadn't met Pater then. They met through the review, which Pater liked, but what Wilde's letter certainly shows is that an intelligent reader of the period would not have taken Pater's turn of critical phrase as mere phrase-making.

IX

I end speculatively. Starting from philosophy, I conclude on pathology.

Walter Pater is ultimately disappointing as a critic of the arts. His output was limited, his characterization of individual works of art is tentative, and for someone so concerned with the personality in art he was mysteriously casual about attribution. His most successful analysis of an artist's work is not a piece of criticism but is enshrined in the Imaginary Portrait based upon Watteau: 'The Prince of Court Painters'. Interestingly enough, it is not until two-thirds of the way through the essay that the writer, who has brilliantly reconstructed Watteau's temperament, is allowed by Pater to see his paintings.

Pater's shortcomings can be partially explained by his willingness to be no more than exemplary. His grasp of what adequate criticism required may have helped him to see how unlikely these requirements were to be met. But, additionally, there

[31] J. A. Crowe and G. B. Cavalcaselle, *A New History of Painting in Italy* (London: John Murray, 1864), II, 415.
[32] *Studies in the History of the Renaissance*, 50.
[33] Ibid. 58.

is in his criticism an oppressive sense of inhibition as though, drawn as he obviously was to the visual, he discerned in it temptation and a source of illicit pleasure—and I am here referring to more than the affectations of the period. If this unease contributed to his insistence that the critic's eye should not rest uniquely on the surface of the painting, but should freely alternate between the surface and what lay beneath the surface, and was thus a benign influence, it also severely limited his efficacy as a critic.

I suggest that this limitation has something to do with an unconscious equation that Pater made between the perception of art and a refined species of voyeurism. If we accept this interpretation, it is surprisingly unproblematic where to turn for the scene on which we may suppose that Pater's eyes at once longed and dreaded to fall. Indeed, he describes it for us in remarkable detail at several points in his fiction. I end my account of Pater's criticism on what I believe accounts for its strangely attenuated character.

Pater's sexual inclinations were directed towards young men. Such inclinations met with his strongest disapproval when he encountered them in others and (we must assume) also in himself. The compromise formation on which his psyche fixed was one in which both components—the libidinal element and the element of self-castigation—were represented in a highly florid fashion. In phantasy Pater was a homosexual necrophile, and, familiar though the passage may be on which I intend to end, I think that it is worth introducing it into the seemingly alien context of Pater's deficiencies as a critic of the visual arts. The passage comes from the end of what is in effect one of Pater's Imaginary Portraits, 'Emerald Uthwart'. After telling the story of a young officer of great charm and chivalry, wrongfully disgraced, and whose reputation is redeemed too late, Pater appends a postscript by the doctor who carries out a postmortem.

> *Postscript, from the Diary of a Surgeon, August —th, 18—.*
>
> I was summoned by letter into the country to perform an operation on the dead body of a young man, formerly an officer in the army. The cause of death is held to have been some kind of distress of mind, concurrent with the effects of an old gun-shot wound, the ball still remaining somewhere in the body. My instructions were to remove this, at the express desire, as I understood, of the deceased, rather than to ascertain the precise cause of death. This however became apparent in the course of my search for the ball, which had enveloped itself in the muscular substance in the region of the heart, and was removed with difficulty. I have known cases of this kind, where anxiety has caused incurable cardiac derangement (the deceased seems to have been actually sentenced to death for some military offence when on service in Flanders), and such mental strain would of course have been aggravated by the presence of a foreign object in that place. On arriving at my destination, a small village in a remote part of Sussex, I proceeded through the little orderly churchyard, where however the monthly roses were

blooming all their own way among the formal white marble monuments of the wealthier people of the neighbourhood. At one of these the masons were at work, picking and chipping in the otherwise absolute stillness of the summer afternoon. They were in fact opening the family burial-place of the people who summoned me hither; and the workmen pointed out their abode, conspicuous on the slope beyond, towards which I bent my steps accordingly. I was conducted to a large upper room or attic, set freely open to sun and air, and found the body lying in a coffin, almost hidden under very rich-scented cut flowers, after a manner I have never seen in this country, except in the case of one or two Catholics laid out for burial. The mother of the deceased was present, and actually assisted by operations, amid such tokens of distress, though perfectly self-controlled, as I fervently hope I may never witness again. Deceased was in his twenty-seventh year, but looked many years younger; had indeed scarcely yet reached the full condition of manhood. The extreme purity of the outlines, both of the face and limbs, was such as is usually found only in quite early youth; the brow especially, under an abundance of fair hair, finely formed, not high, but arched and full, as is said to be the way with those who have the imaginative temper in excess. Sad to think that had he lived reason must have deserted that so worthy abode of it! I was struck by the great beauty of the organic developments, in the strictly anatomic sense; those of the throat and diaphragm in particular might have been modelled for a teacher of normal physiology, or a professor of design. The flesh was still almost as firm as that of a living person; as happens when, as in this case, death comes to all intents and purposes is gradually as in old age. This expression of health and life, under my seemingly merciless doings, together with the mother's distress, touched me to a degree very unusual, I conceive, in persons of my years and profession. Though I believed myself to be acting by his express wish, I felt like a criminal. The ball, a small one, much corroded with blood, was at length removed; and I was then directed to wrap it in a partly-printed letter, or other document, and place it in the breast-pocket of a faded and much-worn scarlet soldier's coat, put over the shirt which enveloped the body. The flowers were then hastily replaced, the hands and the peak of the handsome nose remaining visible among them; the wind ruffled the fair hair a little; the lips were still red. I shall not forget it. The lid was then placed on the coffin and screwed down in my presence. There was no plate or other inscription upon it.[34]

[34] *Miscellaneous Studies*, 243-6.

15

Review of *Problems of Art*, by Susanne K. Langer (1957)

We've included this short review of a publication by Susanne Langer not because of its substance, or even because in 1957 it predates any significant writings by Wollheim on aesthetics—though Art and Illusion *(1956) by Ernst Gombrich would prompt Wollheim's penetrating review of 1961 and the beginnings of his own theory of pictorial representation—but because it expresses, if schematically, why Langer, such a seminal figure in Anglo-American aesthetics, was largely discounted by Wollheim in subsequent writings. As in her* Philosophy in a New Key *(1941) and* Feeling and Form *(1953), she suggests that works of art are presentational symbols of 'non-discursive' communication that are not apprehended as combinations of individual, largely conventional elements, as in the grammatical and logical functions of language. Non-discursive symbolic artefacts have natural, non-conventional meanings, ones that manifest the 'life of feelings'. The big problem is that to consider artworks as symbols consigns their makers to the role of mere discoverers of symbols, as if they had their meaning independent of the activity; whereas artworks are things newly composed, their meanings made. The lesser problem highlights Langer's eagerness to accommodate criticism of her theory by verbal reformulation, which is a sign, as Wollheim sees it, of the blithe attitude that 'deep down inside [she] possesses the truth, if only [she] could bring it to the surface'. [Eds]*

In philosophy, too, there has of recent years been something of a Cold War: the main battle-ground once again America, and the enemy of Positivism. One of the best known figures in the campaign is Mrs Langer, whose *Philosophy in a New Key*, as the blurb to the present book says, 'reached an exceptionally large audience for a philosophic work'. One of the open secrets of her success is that to obvious high intellectual qualifications she is fortunate enough to conjoin the appeal of 'a defector'. Trained as a logician, the author of a classical work on the subject, she does not,

Uncollected Writings. Richard Wollheim, Gary Kemp, and Elisabetta Toreno, Oxford University Press.
© Bruno Wolheim 2025. DOI: 10.1093/9780191995767.003.0015

like her more ignorant allies, have to turn her back on Positivism, but can try her hand at turning Positivism against the Positivists.

She does so subtly. Her starting-point is the Positivist critique of language. This— by all standards the most shocking part of Positivist doctrine—is, she says, perfectly correct. It is, that is to say, perfectly correct as far as it goes. The trouble with it is where it stops. For while offering an absolutely impeccable account of discursive symbolism, it unfortunately overlooks the existence of non-discursive symbolism. Non discursive symbolism is symbolism characterised by three important traits. First it does not work by means of complex symbols made up out of simpler symbols as, say, language does with sentences made up out of words, but every symbol it is a unique unanalyzable unit; secondly, such meaning as it possesses belongs to it not conventionally but naturally or intrinsically; thirdly, its subject matter is distinct in that it is not about life of feeling, but the form of life, the life of feelings. Of such non-discursive symbolism Art, according to Mrs Langer, is a supreme example.

There are many dark and obscure passages in Mrs Langer's thought. But to dwell or insist on them would be mere pedantry; particularly so in that one can easily enough find passages of exemplary clarity by reference to which alone it stands condemned. I do not know whether Positivism can resist Mts Langer's attack on it: I am sure that Art cannot survive her defence.

For any theory which sees art as a form of symbolism, which, that is to say, sees individual works of art not as composed of but actually as individual symbols, ultimately degrades art by immediately degrading the artist. For on this revised view that artist ceases to be the inventor, and becomes no more than the mere discoverer, of the work of art. There may be certain temperamental conditions in an artist—as, say, there are in an archaeologist—that incline him to make this discovery rather than that, but in the last resort he can no more claim credit or responsibility for what he uncovers to the world than could, say, Schliemann for the wonders of Mycenae. And art itself, thus cut off from the human condition, purged of the marks of motive and desire, may at first seem ennobled and purified, but in the end it will prove to be a sickly and mutilated affair.

Art, Mrs Langer still insists, is still about human nature: but if it is not also by and out of human nature, I cannot see that the concession amount to much. Art on this interpretation is a sort of divine Writing on the Wall: as such, what it says may be interesting or moving or dramatic, but ordinarily we value art not for what it says but for what it is. Indeed, break the connection between art and human activity, and you destroy not only its value but ultimately its meaning. To put the point another way: as things are, does not a large part of the beauty, of the pathos, of the great monuments of religious art lie in the fact that gods and angels confronted by them would not understand them?

In *Problems of Art* Mrs Langer makes a number of concessions, mostly of a terminological or verbal kind, to critics of her earlier works. To some this will be the book's great merit. Personally I find the practice disquieting, since it suggests a

tendency on the part of the author to identify her aesthetic theory not with what she actually says but with what she wants or intends or hopes to say. I see her point, of course—but I am doubtful if aesthetics or any branch of philosophy can survive such self-lenience. For, after all, everyone feels that deep down inside him he possesses the truth, if only he could bring it to the surface. Is not the philosopher to be distinguished from the rest by the fact that he puts into words, that he actually says, what others feel dumbly?

16

Professor Gombrich [Review of *Meditations on a Hobby Horse*] (1964)

Ernst Gombrich was perhaps more than any other thinker the main inspiration, or rather the main point of departure, for Wollheim's theories of pictorial expression, representation, and style. For representation we have Wollheim's review of Art and Illusion *in* Arts Yearbook *of 1961. A draft of the review was read to the British Society of Aesthetics in June 1962, and an expansion of the same appeared the* British Journal of Aesthetics *the following year, which was reprinted in his volume* On Art and the Mind *of 1973. For style, aside from its many miscellaneous appearances in his work as well as 'Pictorial Style: Two Views', we have the three pieces in Part II of this volume. This essay concentrates on expression as described in Gombrich's essays in his* Meditations on a Hobby Horse *(1963). For all the praise Wollheim grants him—in particular for his laying out precise and therefore debatable theoretical claims rather than the frustratingly vague, if comforting, verbiage that is so often encountered in the field—he finds Gombrich struggling when it comes to that crucially important concept of expression. 'Expression' covers its many forms; Gombrich's maxim is that artistic expression depends on the 'spectator's capacity to anticipate to some extent the alternatives between which he has to choose'. This 'completely disregard[s] the existence of those elements which are charged by nature with physiognomic significance and which can be safely used by the artist in the certainty that they will effect a resonance in the spectator'; equally, it ignores the 'structure of the personality or ego'. Wollheim will go on to contribute to the topic the essay 'On Expression and Expressionism' (Chapter 19 in this volume), parts of* Art and its Objects, *'Expression' in his 1974 volume, and 'Correspondence, Projective Properties, and Expression in the Arts' in his 1994 volume, as well as putting the theory into practice in* Painting as an Art *of 1986. [Eds.]*

In certain circles Professor Gombrich is regarded as a great champion, perhaps the last great champion, of the exclusive claims of representationalism in art. Yet, as he himself has pointed out in the second edition of *Art and Illusion*, it was no part of

Uncollected Writings. Richard Wollheim, Gary Kemp, and Elisabetta Toreno, Oxford University Press.
© Bruno Wolheim 2025. DOI: 10.1093/9780191995767.003.0016

the aim of that book to argue for the supremacy of the figurative element or to suggest that fidelity to nature is the single criterion by reference to which every painting or sculpture should be judged. It was rather that as a historian of art he was also interested in the theory of the art whose history he wrote: and it is not his fault if the dominant theme in Renaissance and post-Renaissance art is the depiction of reality.

Nevertheless, the critics who misinterpreted Gombrich as an enemy of 'the modern' made a comprehensible error. For implicit in *Art and Illusion* is the suggestion that one of the reasons, and perhaps the most pressing, why artists of our day have come to abandon the representational idiom—namely, in the interests of expression—may prove to be self-defeating. For it is a condition of successful expression that there should be a situation in which a choice has to be made within a coherent set of alternatives: since it is only as a selection of this possibility in preference to that that a given action can be regarded as expressive at all. Now the representational assignment clearly provides the artist with a whole succession of such potentially expressive choices. Abandon it, however, and what can prevent painting from de-generating into a series of arbitrary, and therefore inert and inexpressive, marks? How can the saving context of choice be reconstituted within a non-figurative art?

What was merely suggested in *Art and Illusion* becomes the explicit theme of most of the essays in Professor Gombrich's new volume.[1] *Meditations on a Hobby Horse* is a worthy successor to the earlier books, exhibiting to a high degree their author's supreme merit as a theorist of art: this is not his erudition, nor his sensibility, nor his wit—though he has all these things: what really distinguishes his work and sets it apart from the mass of somnambulistic writing that ordinarily passes for comment on art is his capacity to make a point. And if there is anyone who has any doubts on this last score, the appearance of René Berger's *Language of Art*[2] in a lavish English edition is opportune.

In the course of 400 pages Berger makes many fresh and illuminating observations on artists as diverse as Duccio, Vuillard, Sodoma, Tintoretto, Domenico Veneziano and Van Gogh. But the theory which he promises us and to which all his particular observations are intended to stand as evidence or as applications never materialises. To look at a work of art properly, we must, we are told, take an aesthetic view of it. What is the aesthetic view? It is to see the work as constituted not of objects but of forms. But to talk of form suggests that in order to understand the work we should in our perception of it abstract certain elements as irrelevant. Are we then being encouraged to see in the structure of the work its true significance? No, Berger tells us, for structural lines and shapes have power only 'within the work of art they innervate'. Does this mean then that we ought still to try and study the forms and the relations between them, though all the while remembering that this must be done only in the context of a given painting? But no, even this, we

[1] E. H. Gombrich, *Meditations on a Hobby Horse* (London: Phaidon, 1963).
[2] René Berger, *The Language of Art* (London: Thames & Hudson, 1963).

are now told, is too ambitious. For in art all the parts are 'totally and organically interdependent', so that each form gets not merely its significance but its identity from its relations with all the other forms: of each of which, presumably, the same is true. So that even to talk of forms in the plural is, strictly, illegitimate. And so we never arrive at a real theory, for each concept in turn is so hedged round with qualifications, so pruned and improved upon, that it loses, first of all, its ordinary meaning and then, ultimately, any meaning at all.

It is a relief to turn to a work like Gombrich's which admits of serious and rational criticism. Which it should certainly be expected to receive. When Gombrich refers to Expressionist theory, it is to the kind that flourished in Central Europe in the Twenties. When he talks of abstract painting, it is Kandinsky or Ben Nicholson or Mondrian that he cites. Yet nothing can disguise the fact that *Meditations on a Hobby Horse* is directed against the kind of art which was most active and admired throughout most of the advanced parts of the world in the late 1940s and the 50s. Writing recently about three abstract painters (Louis, Noland and Olitski) Clement Greenberg remarked:

> It is for the sake of eloquence, not for the sake of 'symbols', that these artists have abandoned representational painting...And yet the colour, the verticality...are not there for their own sakes. They are there, first and foremost, for the sake of feeling, and as vehicles of feeling. And if these paintings fail as vehicles and expressions of feeling, they fail entirely.[3]

If Gombrich can produce arguments to show that such paintings fail necessarily, this would be a matter of major cultural importance. But first a proviso. At no point does Gombrich say outright that an abstract art cannot be expressive. He allows that the requisite state of doubt or hesitation which must pre-exist in the spectator's mind—will he (the artist) do this, or will he do that?'—might ultimately be induced. He feels that over the years the experience of seeing a great deal of abstract art might condition the public to hold certain expectations which the painter will then satisfy or frustrate. He throws out a favourable reference to the potentialities of the abstract film as providing a visual equivalent to music. Nevertheless it would be hard to think of Gombrich's attitude to all these possible developments as even sceptical.

But, it might be objected, do we not have here the central weakness of Gombrich's position: namely, the insistence that all expression must be successful, in the sense that what is expressed must be understood? The idea that a feeling be vented in a work of art yet the work remain incomprehensible finds little or no recognition in his book. For why else do we hear so much about the spectator, who

[3] *Clement Greenberg, The Collected Essays and Criticism*, ed. John O'Brian, 2 vols. (Chicago: University of Chicago Press, 1986).

seems surreptitiously to have been moved into the centre of the aesthetic situation, which he now dominates? On certain populist views, the spectator tells the artist what he ought to do. Gombrich goes further than that: on his view the spectator tells the artist what he is doing.

This objection, however, both meets and misses Gombrich's point. For it is certainly true that Gombrich regards the expression of feeling as an occasion for which at least two are required. But this would be obviously wrong only if what was being talked of was 'natural' expression. It would certainly be outrageous to say that a dog is not expressing pain if he squeals when his master steps on him unless his master first concedes that it is pain that the squeal expresses. But then Gombrich regards it as a point almost too obvious to make that if painting is expression, it is not so in the sense in which screaming is, or smiling, or a sad look in the eyes.

Gombrich makes this point by saying that if we imagine, as conventional theory tends to do, a spectrum running from expression, which is natural and is bound up with symptoms, to communication, which is conventional and uses a code, art lies between the two and probably closer to the latter. Accordingly, the demand that art should be expressive is really a demand, misleadingly phrased, that it should communicate emotion. And if this is so, we cannot deny the lessons Gombrich draws from communication theory, about how the artist must depend on the spectator's capacity to anticipate to some extent the alternatives between which he has to choose.

Of course, in many ways the distinctions that Gombrich employs are inadequate. In particular this would seem to be so in all situations where we distinguish between the manifest and the latent content of what is articulated. For instance, if we take the earliest instances of this kind that Freud investigated, is it not tempting to say that in a dream the dreamer expresses his wishes, whereas the man who makes an error communicates, albeit obliquely, the impulses he would rather conceal? But do we not say this simply because we think of the different ways in which the imagery of a dream and the words involved in a slip stand to their manifest content?

I think that Gombrich himself, however, would be the first to admit the ultimate inadequacy of his conceptual framework and would merely insist that it holds at least as far as to support his general point that expression demands that there should be some kind of parallelism between the possibilities that confront the artist and the expectations that lie in the spectator's mind. But some might deny that this involves a need for conventions, even of the most implicit kind. For does not Gombrich's argument completely disregard the existence of those elements which are charged by nature with physiognomic significance and which can be safely used by the artist in the certainty that they will effect a resonance in the spectator? Some of Gombrich's best pages are devoted to the limitations of physiognomic perception in art. What must always be taken into account is the aesthetic structure in which the elements occur and which can so often transform their 'natural' or

extra-artistic impact. 'What strikes us as dissonant in Haydn', Gombrich writes, 'might pass unnoticed in a post-Wagnerian context and even the fortissimo of a string quartet may have fewer decibels than the pianissimo of a large symphony orchestra.' Indeed might not art be conceived of—though I doubt if Gombrich would agree with me here—as a place in which many of the physiognomic aspects of the world, which can be as disturbing and pervasive as a pungent smell, are neutralised or subverted? And might not, by the same token, the failure of the film to graduate as an art-form be ascribed in part to its apparent incapacity to transcend the physiognomic?

But if it is important to know how far to carry physiognomic interpretation in art, it is vital to recognise those features to which it is in the first place inapplicable, being the purely institutional or traditional features which are not themselves expressive but within which expression occurs. Foremost amongst these is style, and in the review reprinted here of the *Social History of Art* Gombrich takes Arnold Hauser to task for refusing to see the extent to which art derives from art.[4] The methodological errors of Hauser's work are repeated, without any of its compensating virtues, in a work recently arrived from East Germany, Ernst Fischer's *Necessity of Art*,[5] whose particular brand of pietistic Marxism will make an obvious appeal to uneasy bourgeois critics. In 100 pages Fischer rewrites the history of art suppressing the true achievement whereby individual artists expressed themselves in their works, in favour of a grandiose vision according to which historical moments express themselves in universalised styles.

The last word has clearly not been said about expression. Nor would Gombrich wish it to be thought that it had been. Any new theory must pay greater attention to what it is that is expressed, and in this connection it seems to me likely that emphasis will be placed on the structure of the personality or ego rather than on stray or transient impulses and emotions. The late Ernst Kris, once a collaborator of Professor Gombrich's, remarked a propos of Freud's analysis of the great Leonardo composition of the *Virgin and Child with St Anne* [URL47] that our understanding would be considerably enhanced if, in addition to determining the roots of the artist's desire to unite Christ with two 'mothers', we were able to find a similar explanation for the particular pyramidal, shape in which the figures are merged. On such a suggestion a new (though still limited) art of physiognomy might be constructed.

[4] Arnold Hauser, *The Social History of Art* (London: Routledge and Kegan Paul, 1951).
[5] Ernst Fischer, *The Necessity of Art* (London: Verso, 2010).

17

Wittgenstein on Art (1966)

Ludwig Wittgenstein held that there is no essence to language, that it is held together by a complicated network of criss-crossing 'family resemblances'. Wittgenstein did not say outright that art is similar, but Wollheim says it—and Morris Weitz (1916–1981)[1] famously said something consonant with the idea some years earlier. It is structured by institutions, traditions, and conventions, and is intrinsically reflexive. The uniqueness of this marriage defies the logic of analytic philosophy, at least that which puts the judgement 'x is beautiful' (or 'x is a work of art') at the top of its list. Aesthetic queries, instead, should be involved with the constant negotiation between tradition, the very theory of art, and individual creation. In the book of lectures as transcribed by students known as Lectures and Conversations on Aesthetics, Psychology and Religious Belief, *Wollheim duly praises Wittgenstein's general outlook as just described, but finds disappointing his emphasis, if it was his emphasis, on the notion of 'appreciation' and of the 'peculiar impressions' one has of works of art. More promising, avows Wollheim, are the Wittgenstein-esque writings of Stanley Cavell (1926–2018).* [Eds]

A new book by Wittgenstein will naturally be felt to illuminate whatever topic or subject it treats of. Not that the present offering[2] is exactly a new book by Wittgenstein: for it is not a book by Wittgenstein at all. The first thing to be said about this book is that nothing contained herein was written by Wittgenstein himself. What we have instead is a compilation of notes, made by friends and pupils, on each occasion taken down immediately after Wittgenstein had spoken, either in private or in public—if, that is, we are to believe that this distinction survived for Wittgenstein. But so carefully have the notes been concorded, so meticulously have the different sources been indicated—in pleasing contrast to the examples of a more ruthless form of editing that has been inflicted upon Wittgenstein, such as

[1] Morris Weitz, 'The Role of Theory in Aesthetics', *Journal of Aesthetics and Art Criticism*, 15.1 (1956), pp. 27–35. [Eds]
[2] Ludwig Wittgenstein, *Lectures and Conversations on Aesthetics, Psychology and Religious Belief*, edited by Cyril Barrett (Oxford: Blackwell, 1967).

the *Remarks upon the Foundations of Mathematics*[3]—that we can use the text with a high degree of confidence about the extent to which we are listening to the original voice of a great philosopher.

The sense of expectancy to which anything new coming to us from Wittgenstein must give rise can only be heightened when the topic he takes is (amongst others) the nature of art. By some kind of coincidence, Cyril Barrett, the sympathetic editor of *Lectures and Conversations*, has almost simultaneously provided us with a reminder—in the form of an anthology of contemporary writings on aesthetics[4]—of the present incoherent state of the subject. [...] Barrett has not chosen unwisely. He set himself to provide a characteristic sample of work done in Philosophical aesthetics in the linguistic or analytic tradition, and—though I would scarcely agree with his claim that each of the Papers he has brought together makes a 'permanent contribution to aesthetics within the field that interests these philosophers'—he might be said to have reasonably succeeded in his aim. The fact remains that the most interesting contributions of recent years to our understanding of art have not come from this tradition. Compared to the insights of Valery and Adrian Stokes, of Gombrich and Alain and Merleau-Ponty and even Malraux, the work collected in the Present volume seems, somehow, tangential: many of the essays display high ingenuity, but they combine this with a crudity of assumption that makes it hard to understand how they should come to be the accredited representatives of a tradition that has made such exciting contributions to general philosophy in, for instance, the theory of knowledge and meaning.

A very broad explanation that might be offered of this fact is that analytical philosophy has not, on the whole, shown itself inclined, perhaps has even been ill-endowed, to generate statements of the order of generality that aesthetics seems to call for. Analytic philosophers have tended to produce in the first instance propositions of great generality: then, when these have been shown defective, they have fallen back on a detailed examination of particular cases. They have shunned, in other words, statements asserting that something or other broadly, or for the most part, holds good. Yet there is a special reason to believe that, in our understanding of art, statements of this form have a very significant part to play. For, on the one hand, art is an institution: it has a structure of its own, it is identified by rules and customs and conventions, making this permissible and placing that beyond the pale; it is heavy with tradition. On the other hand, art is also inherently reflexive: so that one work of art can become the subject-matter of the next. Put these two things together, and we have a situation in which what we can expect to find is a large number of resembling instances that are central to art, and then a limited number that are deliberately or self-consciously deviant. Art consists, we

[3] Ludwig Wittgenstein, *Remarks on the Foundations of Mathematics*, edited by G. E. M. Anscombe (Oxford: Blackwell, 1956). [Eds]

[4] Cyril Barrett, *Collected Papers on Aesthetics* (Oxford: Blackwell, 1965).

might say, in a broad highway, and then to one side there is a narrow track along which the cyclists and the trick-cyclists ride. The propositions of aesthetics need, in their logic, to match this situation.

That the inability of analytic philosophy to rise to the challenge of aesthetics is not peculiar to this country is attested to by another collection of papers that has recently appeared, this time from America. *Art and Philosophy*[5] is the most recent volume in the now familiar series of symposia held under the auspices of the New York University Institute of Philosophy. The volume opens with a discussion by Professor Meyer Schapiro, the distinguished art-historian, of certain notions that traditionally, at least since Aristotle, have been held to be, or to be part of, the criteria of excellence in art. They are notions that relate to the idea of unity, and Schapiro examines these notions, first on a more formalistic interpretation, and then as asserting a very special kind of union between form and content. In earlier papers, in connection with some of the great Romanesque sculptural ensembles of central France or the interior of Monreale, Schapiro has argued that the historical evidence alone compels us to recognise how complex or how manifold any viable notion of artistic unity must be, how many different historical variants there have been of the classical demand for order. Schapiro goes on to claim in the New York volume that the attribution of unity or order to a work of art is more in the nature of a hypothesis: it is the cumulative work of criticism over the generations, confirmable by many different perceptions. It is sad to see how little some of the philosophers made of this interesting speculation.

Wittgenstein's lectures on aesthetics, as we have them recorded in note-form in the *Lectures and Conversations*, open promisingly. At the very outset Wittgenstein appears to displace what in so much contemporary aesthetics has regrettably got moved into the centre of discussion: the evaluative judgment (which is often equated for some quaint reason with the judgment of beauty) and its logic. It is not hard to see how this distortion has come about. For the judgment of beauty as the proper object of inquiry has a threefold appeal to the analytical philosopher: it is a linguistic entity; it has, or can readily be thought to have, a marked resemblance to the moral judgment, which is regarded as the proper object of inquiry in most ethical philosophy of an analytical character; and it gives promise that its analysis might be carried out in that spirit of neutrality or indifference which has been widely insisted upon by analytic philosophers—the contrast here being with more substantive, some would say more pertinent, notions, like that of style-formation, which seem to call for a positive commitment to some of the specific values of art in their analysis. Yet though it is understandable how the emphasis in aesthetics has come to be placed upon the judgment 'This is beautiful' and its analysis, the consequences are none the less disastrous.

[5] Sidney Hook (ed.), *Art and Philosophy* (New York: New York University Press, 1966).

Art is, in its paradigmatic instances, a product of the interlocking of many pieces, some natural, some conventional: expression, order, tradition, work, the desire for comprehensiveness, projection, fantasy, the theory of art itself. In some of its marginal manifestations, one of these pieces may be missing—a topical example would be work in Duchamp's ready-mades—but its place will be so well preserved that, like a piece in a jigsaw puzzle, we can infer it from its silhouette. To understand art we need, then, to understand both the pieces and their fit. To this complex the judgment of beauty seems merely peripheral. It would not be surprising if Wittgenstein, who in his mature philosophy insisted so strenuously that we cannot understand what language is if we take it component by component and ask of each how it relates to reality, should be the person to preserve us from an analogous error in our attempts to understand art. Wittgenstein's contention, vis a vis language, was, roughly, that if we persist in the piece-meal approach, either we will get no answer to each of the several questions that we ask, or if we do get an answer, we will get one which presupposes that the whole of the rest of language functions in a way that is quite transparent to us.

It is difficult to be certain how radical Wittgenstein is in his rejection of the contemporary preoccupation in aesthetics. Is it that he rejects the preoccupation with the evaluative judgment because evaluation in the arts consists in so much more than mere judgment, and shows itself in the total way a man bears himself towards art? Just as a man's taste in clothes—to use Wittgenstein's own example—goes well beyond the praise or criticism he gives his tailor. Or has Wittgenstein something further to say—namely that evaluation itself is such a small part of our attitude to art, a part, moreover, that comes after so much else, that we do wrong to concentrate on it. To put it generally: when Wittgenstein is recorded as talking of 'the framework in which (*nota bene*) the actual aesthetic judgment is practically nothing at all,' how wide a view did he intend of this framework?

The lecture notes are not explicit on this point. Wittgenstein suggests that aesthetics should concern itself with the whole of our appreciation of the arts. 'The word we ought to talk about,' he says, 'is "appreciated". What does appreciation consist in?' One suggestion he makes, indeed that he takes up, is that, as part of such an inquiry, we should try and understand the 'peculiar impressions' we have in listening to a poem or a symphony: for these seem to be a large part of what passes for appreciation.

But what are they, and how are we to understand them? A wrong way of taking them is to regard them as associations we make to the work, and hence a wrong way of setting out to understand them is to try to establish laws of association in accordance with which such impressions arise in us on the occasion of certain stimuli. Wittgenstein constantly attacks psychological aesthetics, but in these lectures he does not really provide us with quite enough to see why he thought this approach so wrong. Important material for our understanding of his approach lies

in his discussion of the words 'particular' and 'peculiar' in the *Brown Book* of four years earlier.[6]

Confronted by certain works of art, we have certain peculiar impressions. Very often we are unable to describe these impressions. Why, we ask, should this be? An answer to hand is that the impressions are so peculiar—that's why they can't be described. This reasoning, Wittgenstein argues, is wrong, or misleading. The impressions, perhaps, are indescribable: but this can't be because they are peculiar. For, when we say that they are peculiar, we aren't saying that they are of a certain kind, from which it then might be thought to follow that they can't be described. We are, rather, already conceding that they can't be described—or, less mysteriously, that we can't describe them. We concede this when we pick them out as we do: that is, as whatever impressions go with this poem, or that symphony. It is possibly a tribute to art that the impressions to which it gives rise can't in fact be identified except by reference to the works that occasion them: but it cannot be an explanation of art that it gives rise to that sort of impression. For there is no such sort.

The error against which this argument is directed is recurrent in the theory of art. It is probably responsible for the critical dogma that poetry doesn't admit of paraphrase. An idiosyncratic development of Wittgenstein's ideas against this tenet of the New Criticism is to be found in an essay included in another recent (and most excellent) philosophical collection.[7] The author is a gifted and original philosopher from Harvard, Stanley Cavell. The article, which is entitled 'Aesthetic Problems of Modern Philosophy', has incidentally been criticised by philosophers of my acquaintance, because the author has allowed too much of himself to enter into it, in the form of its reverberatory style. The implication of such criticism is, presumably, that the dry and finicky style in which so much of contemporary philosophy is couched reveals nothing of the man. Could one imagine a less propitious augury than this for the development of what must be one of the props of any modern aesthetic: an adequate theory of expression?

Wittgenstein's discussion of Freud is illuminating: about Wittgenstein, that is, not Freud. Wittgenstein obviously admired Freud, and—no less obviously, I should say—feared him as a rival. His knowledge of Freud seems rather superficial, but what is disfiguring is a kind of astuteness that enters into his criticism of Freud. His tactic is to make out that for Freud analysis or therapy was primary, and the theory a mere super-structure. In this way analysis is treated as fundamentally a pragmatic affair, and a psychoanalytic interpretation is accordingly denied any claim to be a piece of understanding. By some irony Wittgenstein's philosophy has been similarly treated by its critics: as directed entirely to the dissolution of problems, however this may be achieved. Towards God Wittgenstein is (and we see why) more indulgent.

[6] Ludwig Wittgenstein, *The Blue and Brown Books* (Oxford: Blackwell, 1958). [Eds]
[7] Max Black (ed.), *Philosophy in America* (London: Allen & Unwin, 1964).

OTHER TOPICS

18

Sociological Explanations of the Arts (1956)

Sociological explanations of the arts seem to encounter difficulties if we take seriously the notion of explanation; they run afoul of basic Humeanism or statistical models of causation. This being from 1956—when Wollheim was in his early 30s and had so far made a name for himself primarily as political philosopher—one could well be surprised at the idea that is hinted at here, one that importantly emerges in the conclusion of his Painting as an Art *of 1986: that the value of art should be conceived in terms of human psychology (Freudian or Kleinian psychology, it will transpire in the years to follow). Notice also Wollheim's notion of 'seeing-in' in the second paragraph of section 2 (though it may not have been expressive of any serious commitment at this stage). Wollheim's prodigious reading is well displayed, not least in the copious footnotes.* [Eds]

I. To give an *explanation* of an event A is to cite another event B which stands in a certain relation to A such that its existence makes the existence of A intelligible.

II. There are *prima facie* various different relations in which B might stand to A that have this consequence, *e.g.*, B might be the cause of A, or the motive for A, or a whole of which A is a part. Corresponding to each different relation there is a *different type of explanation.*

III. The explanation of A is *sociological* when B is a social factor, *e.g.*, an economic fact, or a fact about class structure.

It has been claimed by a number of writers that the mark of any truly scientific or progressive art history is the use of sociological explanation.[1] It follows, however, from the nature of explanation that there could be more than one type of

[1] E.g. A. von Martin, *Soziologie der Renaissance* (Stuttgart: Ferdinand Enke, 1932), translated as *Sociology of the Renaissance* (London: Kegan Paul, 1944), particularly the author's preface to English translation; Frederick Antal, *Florentine Painting and its Social Background* (London: Kegan Paul, 1947); and 'Remarks on the Method of Art History', *Burlington Magazine*, 91 (Feb.–Mar. 1949), pp. 49–52 and 73–5; Arnold Hauser, *The Social History of Art*, 4 vols (London: Kegan Paul, 1951). It is to be noted that Antal's claims on behalf of 'sociological interpretation' (as he calls it) are more extreme in *Florentine Painting* than in the *Burlington* articles. In the latter he suggests that the sociological method is only among several, though undoubtedly the most 'progressive'. In the former, however, he argues for its absolute superiority: Cf. 'The time will undoubtedly come when the purely factual basis, no less than the method of sociological interpretation, will be much more solidly established than it is to-day, and when each detail will take its proper place and be *correctly* interpreted' (p. 9, my italics).

Uncollected Writings. Richard Wollheim, Gary Kemp, and Elisabetta Toreno, Oxford University Press.
© Bruno Wolheim 2025. DOI: 10.1093/9780191995767.003.0018

sociological explanation: a fact of which its advocates seem scarcely aware.[2] In this paper I want to argue that not only could there be more than one type of sociological explanation, but in fact there is: further, that it is important to distinguish between the different types since each involves certain presuppositions peculiar to it. For one is not likely to get far either in giving or in assessing any particular explanation until one is clear what general type of explanation is involved.

1. The first and simplest type of social explanation of art is *causal.* On this view works of art are explained as being determined by, or as effects of, the social conditions under which they are found. So for example Hauser seeks to explain the development of classicism in early Cinquecento painting as the effect of the struggle of the dominant elite to consolidate its social and economic position.[3]

The question arises of under what conditions we are entitled to claim that a given work of art is the effect of certain social conditions. More particularly, what justifies us in talking not just of the classicism of Raphael *and* a conservative society but of the classicism of Raphael *because of a* conservative society? Here, of course, we touch upon a central problem in the methodology of science, which cannot be discussed briefly: the analysis of causation. All I can do is to state quite baldly what seems to me to be incontrovertible: that is, that even if the empiricist analysis does not give us the whole answer, it certainly gives us part of the answer.[4] A necessary if not a sufficient condition for asserting a causal connection between an event B and an event A is the assertion of a regularity statement to the effect that whenever events of kind B take place, then events of kind A occur. From this it follows' that any explanation of a particular work of art as the effect of certain social conditions presupposes a correlation between similar social conditions and similar works of art.

It would appear, then, that causal explanation in art history commits one to a certain program of art-historical inquiry. Without wishing to prejudge the results of such empirical research, I should like to observe:

a. It is noteworthy that despite the intensive study of the arts that has gone on in the last seventy or eighty years, no historian has produced any correlation

[2] A glaring example of this is Antal's 'Remarks on the Method of Art History'. Antal, who was really an advocate of sociological explanation in the strictest Marxist sense, nevertheless claimed as supporters of this new method critics and historians as diverse in approach as [Ernst] Gombrich, Herbert Read, [Edgar] Wind, George Thomson, Meyer Schapiro, and [Anthony] Blunt. Equally significant in this context is Antal's misinterpretation of his own 'Observations on Girolamo da Carpi', *Art Bulletin*, 30 (June 1948), pp. 81–103. For in this essay Antal accounts for Girolamo's stylistic evolution partly by appeal to 'influences' (in an 'old-fashioned' art-historical way) and partly by appeal to the terms of Girolamo's patronage and the nature of his various commissions. But in summarizing the essay Antal says that he has tried to show how the style of the period 'was ultimately based on the social changes'.

[3] Hauser, *The Social History of Art*, 345–8.

[4] The best modern discussion of the problem of causation is to be found in G. H. F. von Wright, *The Logical Problem of Induction* (Helsinki: Helsingfors), [Eds.], 1941).

between social conditions and art forms except on the most general, and therefore most trivial, level.[5]

b. It is arguable that even if such correlations were produced, explanation in terms of them would not be satisfying. For in relating works of art *directly* to social conditions, we should be omitting all reference to psychological factors and so, by implication, asserting these factors to be of no relevance to the understanding of art. But such a suggestion must be repugnant to all. Indeed it seems that particular sociological explanations are likely to be acceptable only to the degree to which interpolation of psychological factors between the social conditions and the works of art is easy and natural: that is to *say*, to the degree to which as explanations they cease to be sociological.[6]

My point about causal explanation might be put by saying that the causal relation is not a particular but a general relation. It holds, that is, not between particular things but between classes of things. Or if in conformity with ordinary usage we allow it to hold between particular things we must insist that it holds between them solely in virtue of their belonging to the class they do.

[5] E.g. that nomadic tribes do not produce monumental works of art: R. Hinks, *Carolingian Art* (London: Sidgwick and Jackson, 1935), p. 209. On the poverty of the requisite correlations, see Meyer Schapiro, 'Style', in Alfred Kroeber (ed.), *Anthropology Today* (Chicago: University of Chicago Press, 1953), pp. 310–11.

[6] In other words, we are unlikely to accept an explanation of a work of art as the effect of certain social conditions unless we can see fairly straightforwardly how the social conditions might have induced a state of mind of which the work of art was a natural expression. This general view is borne out by consideration of particular cases. We can accept quite readily Plekhanov's explanation of Boucher's painting by reference to its alleged cause, the idleness and dissipation of the aristocracy, because we can understand how such an art might appeal to people in that position: see 'French Dramatic Literature and French Eighteenth-Century Painting from Sociological Standpoint', in G. Plekhanov, *Art and Social Life* (London: Lawrence & Wishart Ltd, [Eds.] 1953), pp. 153–4. On the other hand, Hauser's explanation of the transition from the naturalistic style of Paleolithic art to the geometrical style of Neolithic art by reference to the transition from a bunting to a nomadic economy seems quite empty as an explanation because we do not see how this economic change could have been connected with a change in artistic style; that is to say, how the economic change could have led men to change or modify their style; see Hauser, *The Social History of Art*, 35–43. An amusing commentary on this issue is provided by Hauser's attempt to explain the rise of portraiture by reference to the development of commerce. Sensing the lack of explanatory value in this mere correlation, Hauser interpolates a psychological link in order to give it plausibility; he says that commercial life, by setting a premium on the ability to sum up a business partner, increases the interest in human psychology and this leads on to portraiture (pp. 261–2). In this case the psychological interpretation is obviously strained, so we suspend judgment on Hauser's explanation irrespective of the truth of the correlation he cites. It is to be noted, however, that Hauser would resist this interpretation of his practice: for he explicitly rejects the value of psychological over sociological explanation; see his whole treatment of chivalric love, pp. 219–21, particularly the following: 'But illuminating as is a psychological analysis of the equivocal nature of these emotions, the psychological facts are a product of historical circumstances which in turn require explanation and can only be explained sociologically. The psychological mechanism of this attachment to the wife of another, and of this intensification of emotion through the freedom with which it could be expressed, could never have been set in motion without the force of ancient religious and social taboos having first been weakened and the soil prepared for such an exuberant growth of erotic feelings by the rise of a new emancipated upper class. In this case, too, psychology, as so often, is only unclear, disguised, incompletely worked-out sociology.'

This point has been inadequately grasped by determinist historians of culture who often write as if a causal connection between a certain cultural product and its social environment could be not merely suggested, but conclusively established, by a close examination of these two phenomena in isolation: without, that is to say, any investigation of similar phenomena.[7] Such an approach is partly clue to a metaphysical view of the causal nexus prevalent among determinist historians;[8] but partly it is that historians who are causal in their language are not always causal in their thought. Though they may talk of 'social determination,' what they have in mind is some other, non-causal type of sociological explanation.

2. Another type of sociological explanation of art is what might be called expressive. On this view (which is undoubtedly widespread) works of art are seen as expressing, as reflections of, the social conditions under which they are found. So, for instance, Antal writes: 'However much Giotto's art may be considered a great personal achievement, it must never be forgotten that it was at the same time the artistic expression of the widespread rule of the Florentine upper middle class at their ideological zenith.'[9]

[7] Plekhanov, having analyzed the social situation in France at the end of the eighteenth century, concludes: 'Having established the social causes which gave birth to the school of David, it is not difficult to explain its fall': *Art and Social Life*, 158.

[8] For the Marxist view of causation, see particularly Lenin, *Materialism and Empiro-Criticism* [unknown; the following edition of the work is one of many available: Moscow: Progress Publishers, 1972, Volume 14; Eds.], ch. 31, section 3.

[9] Antal, *Florentine Painting and Its Social Background*, 165. Cf. 'Like the contemporary work of Giovanni da Milano in the Riuuccini chapel, these frescoes [i.e. those in the Cappella Spagnuola] eminently reflect the transitional phase of upper middle class decline and the growing influence of the lower middle class (ibid. 200). The interpretation of a society's culture as the 'reflection' or 'expression' of its economic basis is found in the great classics of Marxism, although undoubtedly official theory favors causal explanation; see, for example, Engel's interpretation of European religious history in the special introduction to the English translation of *Socialism Utopian and Scientific* (London and Chicago, C.H. Kerr; [Eds.], 1912), e.g., 'His [i.e. Calvin's] predestination doctrine was the religious expression of the fact that in the commercial world of competition success or failure does not depend upon a man's activity or cleverness, but upon circumstances uncontrollable by him.' Cf. Plekhanov's interpretation of Diderot's aesthetic as a 'reflection' of the revolutionary aspirations of the French Third Estate (*Art and Social Life*, 149).

Antal, though by profession a social determinist, employs a method which is a subtle and somewhat ambiguous variant of the expressive type of explanation. He characterizes it as follows: 'We can understand the origins and nature of co-existent styles only if we study the various sections of society, reconstruct their philosophies: and thence penetrate to their art' (ibid. 4). In other words, the correct explanation of a work far consists of two steps: first showing that the work of art is intimately connected with the literary, philosophical, religious, economic ideas of a certain class, generally by means of certain thematic resemblances, and secondly, showing that these ideas are somehow intrinsic to the class as such. The first step is unexceptionable, although it has been forcefully argued that Antal in carrying it out is often inaccurate or slipshod; see reviews of *Florentine Painting* by Millard Meiss, *Art Bulletin*, 31 (June 1949), pp. 143–50; and by Theodor E. Mommsen, *Journal of the History of Ideas*, 11 (June 1950), pp. 369–79. But the second step of the explanation is open to the difficulties inherent in any expressive type of explanation. Yet it is clearly an essential step if the explanation is to be truly sociological. For to relate works of art to ideas that happen to be held by a social class would not be to give a sociological explanation; cf. the case where kinds of art are correlated with blood groups, and division into blood groups happens for no apparent reason to coincide with class divisions.

Antal clearly show himself aware of the problem that confronts him when he writes: 'Co-operation between the various branches of historical science is still in a rudimentary stage; the number of books on the psychology of the different social classes, particularly those which take the historical

The question now arises as to under what conditions we are entitled to claim that a given work of art is the expression, or reflection, of given social conditions. More particularly, what justifies us in talking not just of Giotto's painting *and* a prosperous upper-middle-class rule but of Giotto's painting *because of* a prosperous upper-middle-class rule? Now, the answer to this question differs I think from that given to the earlier question, in that here it seems possible to claim that we *observe* the connection, that we *see* that the art expresses its society or that we see the image of the society in its art. Accordingly we do not need knowledge of instances of similar art or, for that matter, knowledge of any other art at all. We see the society in its art as we see a man in his portrait, or his character in his handwriting: directly.

But, even if the expressive type of explanation, in contradistinction to the causal type, does not presuppose any general correlation between kinds of art and kinds of society, it is not without presuppositions of a general kind. For in order either to employ or to assess it, we need a general and consistent method of reading off social conditions from works of art so that every particular work tells us uniquely of one set of social conditions. Such a method most naturally takes the form of a general theory about the function of art in society, e.g., that art depicts society, or that it idealizes society, or that it is a compensation for society.

In this connection, I should like to observe:

a. Whereas the correlations required by causal explanation are hard to find, theories of art are abundant. The trouble is indeed that there are so many plausible theories in circulation that, between them, they allow one to see any form of society in any given work of art.[10]

development genuinely into account is very small' (*Florentine Painting and its Social Background*, 128). But in the main text of the book he ignores these difficulties. So we find him writing, for instance, of 'Arnolfo's "classic" style, springing from an upper middle class mentality' (p. 128); or that 'The whole of Daddi's composite style [...] corresponded exactly to the mentality of the Florentine upper middle class of this generation' (p. 182). If Antal means here by 'Florentine upper middle class mentality' merely the mentality that the Florentine upper middle class happened to possess, his explanation is not sociological; if, however, he means that which it necessarily possessed, he has to explain by what right he thinks that it did possess it necessarily.

Meiss in his review calls Antal's class concepts 'ideal concepts'—in that they do not coincide with the actual contours of class groupings. This doubtless is true. What is also true—and in some ways a more fundamental point—is that they are what might be called 'classificatory' rather than 'referential' concepts.

[10] Plekhanov provides a very good example of this kind of trivialization. He held that the role of art in society can be explained in terms of one or other of two principles: the principle of *imitation* (inherited from Tarde) and the principle of *contradiction* or *antithesis*; see 'Letters without Address' in Plekhanov, *Florentine Painting and its Social Background*, 31–50. It is difficult to see how this does not in practice amount to saying that works of art either copy social conditions or do not copy them.

Other sociological historians are less explicit about their theories of art, although one can usually glean what they are from the way particular works are interpreted. The following passage from Antal, *Florentine Painting and its Social Background* seems to contain implicitly two theories: 'They [the Florentine upper middle class of the fourteenth century] liked to have their own religious ideals

b. Whereas correlations between forms of art and social conditions deliberately ignore all psychological factors, theories of art pay a rather dubious lip-service to them. For to talk of the purpose of art half-suggests that one is talking of the purposes of artists: though it is noticeable that when theories of art are recast in their form, their plausibility diminishes.

3. The third type of social explanation of art is what might be called *anecdotal*. On this view there is no single relation sought for as holding works of art and social conditions: but in the case of each particular work of art a story is told which has as its first term some social or economic fact and as its last term the genesis of the particular work. As an example of this type of explanation, one might quote Meiss's effort to relate the style of religious painting current in Florence and Siena in the third quarter of the Trecento via a number of links to certain social and economic disasters that overtook the two cities in the 1340's and 1350's.[11]

Of this type of explanation it might be observed that

a. Unlike the two other types of explanation it involves no general presuppositions. For the connection that each incident in the anecdote has (or is supposed to have) with its predecessor and its successor satisfies merely the common-sense demand of congruity or relevance.
b. Unlike the two other types of explanation, this third type lays no claim either to exclusiveness or to finality. For, on a common-sense level, one account of a particular event does not necessarily enter into competition with other accounts of it. Claims to definitiveness emerge only when we claim to pierce the surface of things and find them 'underlying' or 'ultimate' explanations.

portrayed—for example, the pious friar (usually in the guise of a friar saint), charity (often in the form of a good work)—by which the justification of their own everyday life was elevated into the stable, religious sphere. Such representations helped to make their ideals convincing and binding for the other social classes as well' (p. 121). And another theory seems implied in this passage: 'The ideology of these illustrations [cassone panels of the early fifteenth century] is of the feudal-classic variety suited to this kind of patron and to this type of picture: they were commissioned from workshops, often employing artisan-like methods, by the wealthy, aristocratising, not over-progressive, yet to some extent cultured, middle class on the occasion of their marriages, and bore their coats-of-arms. Antiquity is here thought of as something at once archaic and distinguished, and appears in these cassoni as an especially elegant, aristocratic dream world' (p. 369).

[11] Millard Meiss, *Painting in Florence and Siena after the Black Death* (Princeton, NJ: Princeton University Press, 1951). On the distinction between the first and second types of sociological explanation and the third type, there are some suggestive remarks in E. Gombrich's review of Hauser, *Social History*, in *Art Bulletin*, 35 (Mar. 1953), pp. 79–84.

19

On Expression and Expressionism (1964)

A substantial but provisional and exploratory article that begins by considering the now largely forgotten book by Marion Milner which, however, won some attention in its time, On Not Being Able to Paint *(1957). Before the more decisive advances of* Art and its Objects, *the essay 'Expression' (in* On Art and the Mind*), and the definitive theory given in the essay 'Correspondence, Projective Properties' (in* The Mind and Its Depths, *of which a condensed version appears in* Painting as an Art*), it is most instructive to see Wollheim at work on what would prove to be for him one of the most vital, difficult, and enduring issues. He does not mention Robin Collingwood or indeed the view of Leo Tolstoy (1828–1910), which was the basis for the dual counterfactual account of expression in* Art and its Objects, *but he does mention Ernst Gombrich—critically—and (very briefly and you might say dismissively) Susanne Langer. At the end of detailed argumentation which lays bare the weaknesses of Gombrich's view, as well as of some views which are commonly, not to say naïvely held, he stresses, with a nod to Ludwig Wittgenstein, 'the extreme intimacy of the connection between an emotional state and the natural process of expressing it [e.g. crying being expressive of sadness]: an intimacy we might characterise by saying that there is no gap.' In the case of art, by contrast, 'success or failure in expression is not uniquely determined by what the painter does. In order for his efforts to attain success, they must be ratified by that other party to the pictorial situation: the spectator.' This is—here in bare outline, but eventually won through by close argument—the view he would elaborate more substantially in later writings.* [Eds]

1. In *On Not Being Able to Paint* the psycho-analyst Marion Milner describes certain puzzling experiences that came to her when she first began to paint. She would settle down in front of a certain scene: she would feel some particular emotion that was appropriate to the scene: but the painting or drawing that she did in no way expressed that emotion. A drawing of a girl in an underground train, who suggested to her a rapt intensity of feeling, turned out looking *gauche* and feeble. A Downland scene, sketched on a hazy June morning, with its aura of peace and calm, resembled in the finished drawing an angry and turbulent heath-fire. And

Uncollected Writings. Richard Wollheim, Gary Kemp, and Elisabetta Toreno, Oxford University Press.
© Bruno Wolheim 2025. DOI: 10.1093/9780191995767.003.0019

another summer scene, of beech trees, evoking feelings of tranquility and state-liness, became transformed, as she worked on it, into a wild, blasted landscape of snow and stunted bushes. 'I could not at this stage' Marion Milner writes 'bring myself to face the implications of the fact, though recognising it intellectually, that the heath fire and blasted beeches and girl in the train drawings all expressed the opposite of the moods and ideas intended.'[1]

What are the implications of this fact? Obviously there are many. In her odd and penetrating book Marion Milner addresses herself to some of the psycho-logical implications. In this article I want to consider some of the philosophical implications.

2. Let us ignore one aspect of the matter: and that is that in the drawings that so dissatisfied Marion Milner, it is not merely the emotion that comes out wrong, it is also the subject-matter. Let us assume that this is not so. Let us assume that the pic-ture of the girl did look like a girl not an old woman: that the picture of the Downs did look like the Downs not like a heathfire: that the picture of the overarching beech trees did look like beech trees and not like blasted bushes. Let us concentrate on the fact that it is the feelings of stillness, of peace, of tranquility, that are system-atically distorted in the various pictures, so that in each case it is their opposites that get expressed.

But then what is surprising about this? For Marion Milner was at this stage a very inexperienced artist, and why should it not be that she was as yet unable to express the feelings that she had? And furthermore (or so it would seem) when she tried to express them, found herself expressing feelings that she didn't have.

And here we seem to have a difficulty. For when a man is amused and laughs, or is sad and cries, we say that in laughing he expresses his amusement or in crying he expresses his sadness. And our ground for saying this would appear to be that when he laughs, he is amused and doesn't keep it to himself. In other words, there seems to be no separate problem, once we have determined what a man's emotions or feelings are, what emotions or feelings his laughter or crying express: for they express just those emotions or feelings. (Although why this is so is a problem to which we shall have to return later.)

Yet in the case of Marion Milner's paintings there does seem to be a separate problem, and it is just because there is such a problem or at any rate she thinks there is one, that she finds the pictures so dissatisfying. She is in a certain emo-tional state, and she tells us what this is: *ex hypothesi*, she doesn't keep this to her-self: yet not merely are the paintings found by her not to express the emotional state she was in, but she claims that they express the 'opposite' emotional state.

Yet a consideration of the cases of laughter or crying should suggest a way out of this. For why cannot we simply insist that the painting, say, of the Downs on a June

[1] Marion Milner, *On Not Being Able to Paint* (London: Routledge, 1957), pp. 7–8. The first edition of this book appeared in 1951 under the pseudonym of 'Joanna Field'.

morning must express feelings of peace and calm because these were the feelings that Marion Milner experienced when she drew the picture? We would, of course, allow that she might not have expressed these feelings because she might have kept them to herself. But given that she did express her feelings, then she could only express the feelings that she had.

Now it is obvious that Marion Milner would not accept this account of the matter. And I think that she might say that one has only to see the picture she drew to see that the account is unacceptable.

3. Does this mean therefore that the parallel between the two cases totally breaks down, and that the sense in which the painting of the Downs might (though in Marion Milner's case unfortunately didn't) express the feelings of the painter, is quite different from that in which laughter expresses the feelings of the man who laughs or crying expresses the feelings of the man who cries?

Nothing so far impels us to this conclusion, though it may ultimately prove true. For if we go back to the cases of laughter or crying we seem entitled to extract from them the following formula: x-ing expresses y-ness, if when a man is y and doesn't keep it to himself, he xs. But is it so apparent that the painting case contravenes this formula?

Everything, of course, is bound up in the phrase 'keeps it to himself.' For might it not be perfectly possible to say that when Marion Milner experienced feelings of peace and calm in front of the Downland scene, and produced a drawing that expressed turbulence, she kept the feelings of peace and calm to herself? And in case this seems like a trick to save the parallelism between the two cases, it must be pointed out we don't ordinarily think it sufficient to show that a man didn't keep some feeling to himself, that he both experienced that feeling and at the same time did something. For otherwise anything that a man did when in the grip of a certain feeling, would count as an expression of that feeling.

In other words, when we say (as I said above) that crying expresses sadness because when a man cries he is sad and doesn't keep it to himself, I shouldn't be taken to mean that our reason for saying that crying expresses sadness is that crying is something that the man does when he is sad, or even that if he does anything when he is sad, crying is what he generally does. For a man might boil an egg when he is sad: or it might even be the case that in so far as he is not inactive when sad, he generally boils an egg. But none of this would make us say that boiling an egg expresses sadness.

Of course in the case of Marion Milner, it isn't just that she is in a certain emotional state and does something. For the something that she does is to express herself. And so we might think that we have good reason for equating what she does with not keeping that emotional state to herself. But a moment's reflection will show that this is not so. For a man might be in more than one emotional state at a given moment or experience a variety of feelings simultaneously: and to say of him that he expresses himself is obviously compatible with maintaining that he keeps

some of these emotions or feelings to himself. A man may feel shame, and may express himself: hut he may keep the shame to himself, for it may be that he also feels jealousy, and it is the jealousy that he expresses.

But equally we must not go the whole way and crudely identify 'not keeping a feeling to oneself' with 'expressing that feeling.' For otherwise we would totally trivialise our original formula, in that it will now read 'x-ing expresses y-ness if when a man is y and expresses it, he thereby xs'.

4. Suppose therefore we say that when a man expresses y-ness by x-ing, he not merely is y and xs, but he 'puts his y-ness into the x-ing.' And it is worth noting that the only one of the drawings that Marion Milner did at this period that she found satisfactory, she describes by saying of it that 'the anger had apparently gone into the drawing.' And she concludes 'So it seemed that here at least was an expression of a mood'.[2]

But, of course, to talk of putting a particular feeling or emotion into an object or activity is highly metaphorical: unless (perhaps) we take the phrase as Marion Milner herself seems to take it, and use as our criterion for its application the fact that after the x-ing the feeling or emotion is no longer experienced. 'When the drawing was finished' she writes, 'the original anger had all vanished'. But understood in this way, the phrase has obviously no relevance for our problem. One way of trying to elucidate the phrase might be to ask, For a given y, can we put y into any x? Or is there for any particular feeling or emotion a range of activities by means of which alone we can express it?

At one point Wittgenstein asks us if we can imagine ourselves using one phrase and meaning another by it (e.g. saying 'It's cold here' and meaning 'It's warm here').[3] And if we say we can (which we probably would say), we might go on to consider whether we could read out one whole paragraph and mean another by it. And to this at any rate we should have to say that we couldn't. And if we were asked why we couldn't, we would find ourselves saying something like that we couldn't mean the second paragraph in reading out the first, because that wasn't what the first paragraph meant: and then doubtless we should have to try to find some reason why we could get over this difficulty in the case of the single short sentence. And our explanation would probably take the form of alleging that as we say the word 'cold' out aloud, we say the word 'warm' to ourselves. Or that we treat our utterance of the word 'cold' as though it were a slip of the tongue for the word 'warm'.

Now, we might find here a suggestion as to how the present question about the limits of expression is to be answered. For it might seem that a man can express y-ness by x-ing, only if x-ing stands to y-ness in a relation which is, or is analogous to, that of meaning. If x-ing does not stand in this relation to y-ness, then no matter

[2] Ibid. 5.
[3] Ludwig Wittgenstein, *Philosophical Investigations* (Oxford: Basil Blackwell, 1953), §510; *The Blue and Brown Books* (Oxford: Basil Blackwell, 1958), p. 42.

how deeply a man experiences *y*-ness, or how hard he wishes to express it, he will not be able to put it into his *x*-ing. And we can see immediately one advantage of this theory: namely, that it suggests an explanation of why Marion Milner failed to express her feelings of peace in the Downland landscape that she produced. She failed to do so because (roughly) the kind of picture that she drew does not 'mean' peace.

5. A view somewhat of this kind has been expounded with great subtlety by E. H. Gombrich. In Gombrich's case, however, it is advanced not as a general theory of expression but as an account of how feeling or emotion gets into painting or how a painting can become emotionally charged. Indeed as a prolegomenon to the exposition of his own views Gombrich sets up a distinction between Expression (which is associated with concepts like 'symptom' and 'natural') and Communication (which is associated with concepts like 'code' and 'conventional'),[4] and he then indicates how in his opinion emotion is related in painting by placing the relation at least as much on the side of the latter as of the former.

Gombrich's views might be expressed in three propositions. First of all, the painter's emotion does not naturally or spontaneously overflow into the particular painting or drawing which, as we say, 'express' the emotion. On the country, we must see the painter as specifically choosing a form or colour which will correspond to or reflect the emotional state that he wishes his work to convey. Secondly, this choice, whether consciously or unconsciously made, always occurs within a set of alternatives that could, to a greater or lesser degree of completeness, be enumerated. These alternatives, which are provided by the style either of the age or of the individual artist, constitute the structure within which alone the conveying of emotion can occur. 'No emotion however strong or however complex can be transposed into an unstructured medium.'[5]

Thirdly, it is only when we are acquainted with these alternatives that we as spectators can understand what emotion the picture is intended to convey. 'We cannot judge expression without an awareness of the choice situation.'[6]

As an example of this last point—which, as we shall see, is probably the vital element in the thesis—Gombrich cites Mondrian's *Broadway Boogie-Woogie* [URL22]. If we looked at this picture totally ignorant of its origins, would the stark forms and pure cold colours necessarily suggest the mood of 'gay abandon' that Mondrian, witness the title, intended them to convey? Once, however, we know Mondrian's style, and we can fit this particular picture into the range of possibilities that were open to him as the painter that he was, then we can say how, since they come out of the vivacious end of that range, they were chosen to discharge this function. Suppose, though, we were told that the picture was by Severini

[4] E. H. Gombrich, *Meditations on a Hobby Horse* (London: Phaidon, 1963), p. 57.
[5] Ibid. 68.
[6] E. H. Gombrich, *Art and Illusion* (London: Phaidon, 1960), p. 86.

[URL23],[7] with whom we naturally associate complex and animated forms. Then since this painting would fall at the extreme static end of *his* scale, we would be compelled to attach to it a quite different emotional significance.

6. Gombrich associates the idea of Communication with the concept 'conventional', as opposed to the association of Expression with the concept 'natural'. But it would be quite misleading to say that his account of how feeling or emotion can get into a work of art makes the relation between the two 'conventional'. For it is quite true that on his view if we are confronted with, say, a particular expanse of colour, e.g. grey, out of context, we cannot ask 'What emotion does that convey?', or more specifically, 'Does that convey gloom?' In order to answer this question we need to know what were the alternatives out of which the painter selected grey. If, for instance, he selected grey of the range black-grey, our answer would be quite different from what it would be if we knew that the alternatives that confronted the painter were grey or white. 'The more we know of his palette, the more likely we are to appreciate his choice.'[8]

Now what range of alternatives confronts a given painter might be said to be a conventional matter. But given that a certain range of alternatives confronts him, it seems to be on Gombrich's view not a conventional matter which alternative (i.e. as opposed to some other) conveys a certain feeling or emotion. Indeed when we consider what he says about the *nature* of our hesitation on being confronted with a certain colour and then asked of it whether it conveys a certain emotion, we see that there is implicit in his view a belief in some non-conventional congruence between ranges e.g. of colour and ranges of emotion. For what is significant is not so much that we are held up in answering the question until we know what the alternatives are, as that when we know what these alternatives are, we are no longer held up.

This seems to be the model: We are asked what emotion an element c (say, a colour) 'express[es]'. More specifically, we might be asked whether c conveys (emotion) X or (emotion) Y. Now, Gombrich's contention is that until we know what were the alternatives to c we cannot answer the question. But as a corollary of this, as soon as we are told that c was picked out of the range a, b, c, or, alternatively, out of the range c, d, e, we know the answer; and the answer will, of course, be different in the two cases—say, X in the first case, and Y in the second. But this can be so only on the assumption that the elements a, b, c, d, e, can be ordered as a series $a \dots e$ such that we can legitimately talk of the X end of the series and the Y end of the series. And these appellations would not themselves be conventional.

7. We might now go back to the question raised earlier. Is there for any particular feeling or emotion a range of activities by means of which alone we can express it?,

and see what sort of answer we should give it, within the domain of art, if we accept a Gombrich-like account of the relation between emotion and painting.

Now, the question has to be answered in two stages. First of all, given a particular set of conventions, there is an obvious restriction upon the activities by means of which a given emotion can be conveyed: indeed just this is what is intended by talking of conventions at all. But we must now go on to ask whether anything determines the conventions themselves, or whether painters are free to adopt this or that set at will. And to this second question, we already have the sketch of an answer. For it would appear to be Gombrich's view that though, on the one hand, we are free to assign any emotional significance we please to any activity taken in isolation, once, we have assigned a particular significance to the activity, this is likely to determine what significance we must assign to the other activities that are permitted by the conventions.

Now this might be put by saying that though in Gombrich's eye expression in painting is a conventional matter, it has a 'natural' basis. But the word 'natural' here requires scrutiny. For when we talk of natural expression we tend to think of things like laughter and crying. Now I argued in §2 that we say that laughter expresses amusement and crying expresses sadness because we are in a position to associate laughter with unrestrained amusement and crying with unrestrained sadness. The association, I argued, suffices for us to say that the activity expresses the emotional state: there is no further or 'separate' question that needs to be raised about the connection between the two.

Now what I had in mind when I talked of 'separate questions' was something like whether the activity was appropriate to, or congruent with, the emotional state. So here we seem to have a paradox: namely, that we call laughter and crying natural forms of expression, just in virtue of there *not* being a specific kind of link between them and what they express; whereas we say that the expressive activities of painting are also natural but just in so far as there *is* this specific kind of link between them and what they express. Let us call the link 'the physiognomic link'.

8. But before we pursue this question, which is obviously of the first importance, there is another point that requires our attention since it has already given rise to certain terminological difficulties. For in discussing expression outside the context of art I have taken activities as the natural objects of inquiry, and in doing so have surely been in line with ordinary thought: for it is surely activities that people would ordinarily think of as being expressive. And as examples of activities, I have quoted things like laughing, crying, or boiling an egg. However in discussing painting, and particularly in discussing Gombrich's views on this subject, I have used the phrase 'elements' and have talked as though what we need to give an account of is how elements in a painting can be expressive. And as example of an element I have quoted the colour grey. And here once again I think I am in line with ordinary thought, for within the domain of painting it is surely things like colours or shapes that are reckoned to have expressive significance.

Yet in the last section I reverted to the terminology of activity. And it seemed that I had to, because unless I did, there would be no way of formulating some of the questions to which we seem to need an answer. For instance, it would be absurd to ask whether we could regard grey as the natural expression of gloom purely on the basis of our capacity to associate grey with unrestrained gloom: because to talk of associating grey with unrestrained gloom in the relation of expressed to expression would be meaningless. The only thing that we can meaningfully talk of associating in this sense with a certain emotional state is an activity or process.

But it might be said the alleged difficulty here can very readily be circumvented. For there is an easy transition between the terminology of elements and the terminology of activity in that for any given element we can construct a corresponding activity which is that of bringing into being, or creating, that element. And then about this activity we can ask the relevant question. So, for instance, the question that we need to ask in connection with the colour grey we can ask about making a grey mark or applying a stroke of grey to the canvas.

Of course we *can*. And so far the suggestion is perfectly in order. But if it is also implied that when we do this, we will always get the answer we require, certain large assumptions are being made. For it is by no means self-evident that we can make the transition back from the terminology of activity to the terminology of elements and simply assert inside the one what we assert inside the other *salva veritate*.

9. The problem is this: It may be that to attack the canvas with great panache is an expression of confidence: but surely we cannot legitimately conclude from this that the marks thereby made on the canvas are expressive of confidence. Equally (within a given convention) an expanse of grey can be regarded as expressive of gloom or sadness: but does it follow from this that the activity of applying grey paint to a canvas can be regarded as an expression of gloom or sadness?

The transmission of expressiveness from activity to trace has been an underlying assumption of a great deal of post-war expressionist painting: but here perhaps we need to differentiate the pure from an impure version of the theory. On an impure view the mark left behind by an expressive activity may be regarded as expressive, but only indirectly or obliquely so: in that by looking at the mark we are able to reconstruct the activity. 'The action on the canvas became its own representation.'[9] But this theory could have only a very limited application in that with paintings of any reasonable degree of complexity it must be that only the last stages of work are actually reidentifiable.

But if we abandon this comfortable view, with what right can we claim that the actual mark itself is necessarily as expressive, and expressive of the same things, as the activity that generates it? And here we must distinguish between the mark

[9] Harold Rosenberg, *The Tradition of the New* (London: Thames and Hudson, 1962), p. 27n.

being a souvenir and being an actual expression of the emotion in question. For let us imagine a child stamping its foot in rage: now its gesture we would naturally regard as an expression of anger. But suppose that the floor on which it stamped its foot was malleable, and so the gesture left behind a trace—in this case, a footprint. With what right could we say that the footprint was itself expressive? For suppose that we tried to taunt the child with it, and we said, pointing to the footprint, 'look what you've done!' Now the child might be ashamed of itself, because of the damage it had done. Again it might be ashamed of itself because it had been angry and the footprint recalled the anger to it. But could it justifiably feel that it had also brought into the world something that expressed anger or that was (in the sense in which some music is 'sad') 'angry'?

Well, let us imagine for a moment that we do regard the footprint as 'angry' or as expressive of anger. Now, in so far as we are not relapsing into the 'impure' theory, this must have something to do with the physical characteristics of the footprint: its depth, the sharpness of the contours, etc. But these characteristics depend on the specific degree of the malleability possessed by the floor, and there is no absurdity in supposing that this might change from time to time. Surely with each such change, we would have to decide afresh whether we thought the resultant footprint was or was not expressive of anger. And we cannot determine in advance what our opinion would be. Since there is at least a good chance that for some degrees of malleability we might give a negative answer, and yet in all cases the gesture itself would be equally expressive, we must conclude that there is no necessary transmission of expressiveness from activity to trace.

10. However it might be argued that though expressiveness is not necessarily transmitted from activity to trace, the transmission in the opposite direction, from trace to activity, is more securely grounded. And in support of this contention, appeal might be made to the two examples that I quoted in the first paragraph of §9. For it might be said, whereas evidently the mark left by a confident attack on a canvas may not itself be expressive of confidence, still, if a certain grey mark on the canvas is expressive of gloom, it cannot be doubted that so also is the activity of setting that grey mark.

But in so far as this argument has plausibility (which it undoubtedly has in some measure), the ground for it can be easily misunderstood. For the acceptability of thinking of the activity as derivatively expressive, i.e. as having an expressiveness that derives from its trace, is simply a reflection of the fact that the activity has been described in a way that is itself derivative: for the activity has been described, it will be observed, by reference to the trace in which it issues. For the activity merits the description 'setting a grey mark on the canvas', solely in so far as on its completion there *is* a grey mark on the canvas. It is, we might say, only because nothing of the activity is caught or fixed by the description except its outcome, that we can safely concede that expressiveness passes from the outcome to the activity so described. For this concession is virtually empty of all content.

In this respect we may contrast the way the activity was described in the second example with the description given in the first, i.e. 'attacking the canvas with great panache.' For here the activity is picked out by reference to part of the behaviour in which it consists, and we could identify such an activity simply by observing the painter in action. The difference between the two descriptions might be brought out by imagining the canvas to be totally porous so that the paint vanished as it was applied. In such an eventuality, it would still make sense to talk of someone 'attacking the canvas with great panache', but it would never be true any longer to describe someone as 'setting a grey mark on the canvas', and the phrase itself, we might imagine, would survive only obliquely inside such complex phrases as 'trying, or hoping, or intending, to set a grey mark on the canvas'.

Once we know what marks are set by the painter on the canvas, we are likely to describe his activity in what might be called a *transparent* way: that is to say, in a way which permits us to see straight through the gesture and focus solely on its trace. We say, for instance, that a painter sets down a grey mark on the canvas. When, however, we are as yet uncertain what the trace will be i.e. how the marks will fall, we have no alternative but to describe the activity in terms that are logically independent of its outcome: that is to say, in a way that makes explicit reference to the painter's behaviour. We say, for instance, that the painter attacks the canvas with great confidence. It is the existence of these two ways of describing the activity involved, and the different conditions for the appropriateness of each, rather than any general asymmetrical relation that holds between gesture and mark that encourage us to think that expressiveness can be transmitted from the latter to the former though not from the former to the latter.

11. Before returning to the general question of the physiognomic link, there is another point that has become uncovered by our settling for elements in the picture rather than activities in the making of the picture as the basic candidates for expressiveness. For in §7 I wrote that once we have assigned a particular significance to one activity this is likely to determine what significance we will attach to the other activities that are permitted by the conventions. But translate 'activity' into 'element', and the falsehood of this dictum will become immediately apparent. For suppose a particular expressive role is attached to a certain range of colours: nothing surely is determined by this about what expressive role any given shape or form will fulfil: although, of course, what feelings or emotions the other colours are capable of expressing probably will be determined.

Once, therefore, we substitute pictorial elements for pictorial activities as expressive particulars, we need to sort these out into different series before we can talk of expressive dependence or independence. Elements belonging to the same series would then be said to be expressively interdependent, those belonging to different series would be expressively independent one of another.

Gombrich has many interesting things to say about how a skilful artist can work by using the elements belonging to one series or 'gamut' to reinforce or counteract those belonging to another.[10]

He furthermore suggests ways in which an artist might establish a hierarchy of gamuts, so that the elements of one gamut (called the 'classifier'), e.g. subject-matter, would be basic and those of another (called the 'modifier'), e.g. scale, would operate within the broad categories established by the former.

But Gombrich has to admit that any such model would be 'abstruse', not so much because it demands that we attend to very complex inter-relations between the different gamuts which we might ordinarily think to be beyond our discrimination, as that it presupposes that we can sort out elements into these exclusive categories called gamuts. Furthermore it assumes that the painter can do this too, for Gombrich is not just offering us a way of interpreting pictures expressively: he is by way of offering us a way of understanding them expressively.

It was presumably to circumvent difficulties like this that Suzanne Langer resorted to the extreme expedient of calling works of art presentational or non-discursive symbols.[11] But this, so far from indicating a specific way in which works of art possess significance, simply makes their possession of significance a mystery.

12. To assert that there is *no* physiognomic link between crying and sadness—or, at any rate, that there is not a link here in the sense in which, say, there is between the black end of the black-grey-white range and sadness—might suggest that we could equally well regard, e.g. laughter as the natural expression of sadness if only it so happened (which it doesn't) that we laugh when we are sad and unrestrained. But to this there is an obvious retort, in that some people do laugh when they are sad but we don't regard them as thereby expressing their sadness.[12] We regard them as defending themselves against sadness, or, alternatively, as denying their sadness. And if to this it is replied that this is so because they are only one amongst many, and that if everyone started laughing when they were sad we should take a different view of the matter, this reply can be shown to be inadequate in two ways.

For in the first place, we could imagine laughter becoming universally the behaviour of those who were sad, without our thinking that laughter expressed their sadness: for there is surely no absurdity in supposing there to be pathognomic disturbance on a massive scale. Secondly, what does seem absurd is to suggest that the embarrassment a man might feel who laughs when he is sad arises out of the eccentricity of his behaviour. For surely it is not his *behaviour* by which he is embarrassed at all; it is himself.

[10] *Meditations on a Hobby Horse*, 63–9.
[11] Su[s]anne Langer, *Philosophy in a New Key* (Cambridge, MA: Harvard University Press, 1942), ch. 4.
[12] Ernst Kris, *Psychoanalytic Explorations in Art* (London: George Allen & Unwin Ltd., 1953), pp. 231–4.

For the only situation in which such a man might maintain that all that was untoward was his behaviour would be one in which he could say of his laughter, 'That is my way of crying'. But, we might ask, when could he reasonably say this? A minimal suggestion would be when laughter felt to him like crying: for how could laughter feel exactly as it does now and yet serve as a vehicle for sadness? Yet there is also a difficulty in this suggestion. For since crying is grounded essentially in the eyes and tear-ducts, and laughter in the respiratory system and the intercostal muscles, how could the two processes feel the same? But it will now be said that what is intended is not that one of these two processes should give rise to the same sensations as the other, which is obviously impossible, but that the sensations to which one of them (laughter) gives rise should take on the quality normally attached to those to which the other (crying) gives rise. But how is the quality that is normally attached to the sensations of crying to be characterised except as sadness? But, now, do we have a way of identifying a sensation as sad where this doesn't mean simply the kind of sensation that is attached to the process that expresses sadness?

I simply raise these questions as a way of bringing out how difficult it is to isolate laughter from amusement in such a way that we could as a *Gedanken-Experiment,* imagine it transferred intact to some other emotion which it could then he held to express. This difficulty testifies to the extreme intimacy of the connection between an emotional state and the natural process of expressing it: an intimacy we might characterise by saying that there is no gap between the two. Now my suggestion is that it is only where there *is* such a gap that we can talk of a physiognomic link which then bridges it. It is only where expressed and expression are discrete that we can endeavour to match one against the other and see whether the latter corresponds to or does justice to the former.

13. It would be useful at this point to say something about the grounds we might have for accepting a view like Gombrich's of the nature of expression in art. For why shouldn't someone in the grip of some strong emotion simply apply paint to the canvas as he wishes and then announce, as he surveys his work, 'In that I have put my emotions'? Now one obvious difference between this case and that of the man trying to read out one paragraph of a book and mean another by it, is that we could surely imagine that a man might make such a claim and believe it to be true: whereas it is impossible to see how a man who said that in reading out one paragraph he meant the other, could think that this was so. But if we allow the claim of the man who has expressed himself 'arbitrarily' to be honest, with what right can we dispute its truth? For surely if the claim could be true—and is this not implied by saying that it is honest?—then who could be in a better position to know whether it actually was true than the painter himself? And so ultimately we might be forced to allow that Gombrich's account of the way in which emotion can 'get into' painting is no more than *one* account of the matter, and that there may well be other ways no less efficacious?

But arguments about what a man can honestly claim are notoriously treacherous. For we might concede a man's right to maintain that some proposition was true, without admitting that that proposition was true or even that it could be true. For everything must now turn on whether the man means by the proposition what we mean by it, or, perhaps better, what we take it to mean. For if we think these two diverge, then clearly nothing follows about the truth, actual or possible, of the claim, from our concession of his right to make it: for in talking about the truth-value of the claim we are talking about the claim in the sense in which *we* understand it, whereas in talking about the man's right to make the claim we are talking about the claim in the sense in which *he* understands it.

Actually this last point needs qualifying: for if a man's understanding of a certain claim diverged grossly from what we take to be its proper understanding and we at the same time thought him justified in making the claim in the sense in which he understood it, we couldn't put this by saying that we conceded him the right to make the claim. For instance, if a man meant by 'God exists' that the seasons of the year have their cycle, we couldn't, just because we believe that the seasons of the year *do* have their cycle, say that he was justified in claiming that God exists. We must be able to sympathise with his understanding of the claim even if we don't think it correct.

Now, to return to the case of the man who claims to have put his emotions into a picture which he has painted 'arbitrarily,' and whose claim we find it impossible to reject. I want to argue that he means by these words something other than they mean—hence we cannot accept his claim as true—but we can see why he meant this by them—hence we can concede his right to make the claim. And I think that both these two points can be brought out simultaneously by asking, What evidence would the painter appeal to in support of his claim? That he experienced the emotion very strongly at the time of painting the picture: that he directed the emotion on to the picture: that the emotion abated when the picture was complete: that the picture will always be associated in his mind with that particular emotion. And yet we know from the case of Marion Milner and the Downland landscape that turned out wrong that none of these things guarantee the picture expressiveness, or at any rate the right kind of expressiveness. And yet the man might ask, What more could I have done?

14. To the question 'What more could I have done?' raised by the painter who is told he hasn't expressed himself, the answer must be Nothing. For he has done everything he could. There is nothing in the way of feeling or willing or trying in which he showed himself deficient.

How, then, can we deny that he succeeded in expressing himself? How can we attribute failure to a man when he couldn't have done more? And the answer must be that ultimately success or failure in expression is not uniquely determined by what the painter does. In order for his efforts to attain success, they must be ratified by that other party to the pictorial situation: the spectator.

But why should the spectator be brought in at this stage? But before we answer this question, we must be quite certain we know what it is which is said to be conditional upon the spectator's verdict. It is nothing to do with the genuineness of the painter's feeling: nor with the sincerity of his desire to express those feelings: nor with the efficacy of the painting to evoke these feelings in him or others. It is simply to do with whether the painter did in fact express his feelings: or to put it another way, whether the painting is expressive of his feelings. And the test is, whether the spectator by looking at the picture can tell what feelings it expresses.

There is, of course, no need in all this to insist on a difference of person between painter and spectator. Indeed in some ways the point is sharpened by thinking of these as two roles that a single individual successively assumes. What is characteristic of the move from the role of painter to that of spectator is that the individual puts out of his mind the particular events that constitute the history of the painting and asks, Does it signify any feelings? And if this question doesn't mean, Are there any feelings that the painting recalls?—which it can't, since *qua* spectator the individual has ruled himself out of answering this—it must mean, Are there any rules or conventions in virtue of which this picture signifies certain feelings? And if to this, which is the typical spectatorquestion, the answer is No, what can the individual fall back on when *qua* painter he wishes to reiterate his claim that he has expressed himself in his painting?

Another way of making the point might be to say that unless the individual was prepared to abandon the painter's role and assume the spectator's role vis-a-vis his own work, the only test he could apply as to the expressiveness of his work would be, whether at the time of its creation he was or was not experiencing a certain emotion. But then wouldn't this make a judgment about expressiveness simply a historical judgment (not an aesthetic one) about the work?

15. I now want to suggest an association between what we have identified as two aspects of expression in art: the existence of a physiognomic link between the emotion that is expressed and the expression of it, and the privileged character of the spectator's verdict. Now on the face of it, one might think that these two aspects were incompatible. For surely if there is a physiognomic link between *a* and *b*, this exists independently of what the spectator decides. The spectator will be required to recognize this link, but his verdict has no special authority to it: for his opinion is relevant only in so far as it is true of the link.

Now I do not know whether there are any cases of a 'pure' physiognomic link or what might be called a physiognomic 'tie': which is such that physiognomic considerations uniquely correlate *a* with *b*. But we have already seen in §§5 and 6 that in the domain of art it is absurd to think that there is more than a 'natural basis' to the language of expression. As Gombrich puts it, 'If there is anything in this doctrine of natural signs, it only applies to the relationship of alternatives.'[13] Interpreted in this

[13] *Meditations on a Hobby Horse*, 61.

attenuated sense, the physiognomic connection between emotion and mark no longer seems inconsistent with what might be called briefly 'spectatorsupremacy.'

But the point I wish to make here is more limited, and it is simply that the two characteristics attributed to expression share a necessary condition: and that is the absence of that intimate connection between expressed and expression which holds wherever it is legitimate to talk of natural expression. We have already seen that the physiognomic link does not hold in such cases. But equally, what could we mean by saying that when a man is sad and cries, whether he expresses his sadness by crying is determined by whether in principle a spectator would classify his tears as an expression of sadness?

16. Wittgenstein has taught us how difficult it is to know what we mean by talking of someone following a rule. What is a rule? When is one guided by a rule, and when is one's behaviour simply in accordance with it? How does one establish a rule?

All these difficulties assert themselves in the field of aesthetic expression, and an account like Gombrich's cannot hope to be adequate until it is supplemented by some attempt to resolve them. For there is the embarrassing question: Given that a man cannot express his feelings in a painting simply by standing in front of the canvas with these feelings and then trying to put them into the painting, what is the difference between the man who is in this position and a man who has rules to aid him? Why cannot the man insist that by doing whatever he does, he lays down the necessary rules? Or to put it another way: what is the check imposed by the spectator when the painter and the spectator can be one? The spectator must recognise that the painter was guided by rules: but what is it to say that the painter was guided by rules save that the spectator will recognise that this was so? And where painter and spectator are one, recognition or lack of recognition do not constitute an empirical test.

Furthermore, in the field of art these problems seem additionally complicated by the fact that it could never be claimed that the whole of a painting can be legitimately scanned for significance. We have in painting therefore a problem whose analogue in the field of speech would be that of a man who emitted a large number of noises only some of which could possibly be rule-directed: so that the question we ask of him 'Is he talking sense?' would be settled by deciding that an adequate number of noises satisfied the criteria of significance. Would we have to know in advance which ones this might be true of? Or could we just say 'This one wasn't rule-directed, therefore it wasn't intended to be'?

20

Neurosis and the Artist (1975)

Is art the result of neurosis? Wollheim's 'Neurosis and the Artist' is a criticism of this thesis. He was an expert on Sigmund Freud, having written the book Freud *(1971), and having peppered his writing on the mind and art liberally with references and allusions to his work. The notion that Freud associated creativity with neurosis emerges from a range of misinterpretations of his seminal 'Creative Writers and Day Dreaming'. For Freud, neurosis is a condition that does not spare any of us. The difference is in degrees of intensity. Since there is of course a certain relation between art's contents and the maker's psyche, the role of the psyche might be thought to provide a link between art and neurosis. But first, Freud did not have an account of the formal properties of art. Second, it is implausible that a pathology can be aware and willing to accommodate the dynamics surrounding the work of art, including its reception. Third, Freud recognised that one manifestation of neurosis is its monotony of involuntary routines and repetitions, in contrast with the voluntary and ever-renewed actions of the maker of art. Neurosis tends away from reality, art moves towards it. Further, Wollheim challenges the widely promoted idea of art as a therapeutic way out of neurosis. The problem is that art-therapy lacks a serious account of art, thus rendering insubstantial the theory that art and neurosis are intimately related; it 'lacks any clear or principled conception of the means that it advocates. What art is goes by default.' Nor can art be 'learned' mechanically. Wollheim considers the remarks of Yvor Winter (1900–1968) on Macbeth's final speech, in which Winter argues that its unsuccessful poetry mirrors the protagonist's madness. Again, the parallel is facile, assuming that the 'correspondences between mental state and aesthetic form can be mechanically stated'. In his concluding statements, Wollheim reminds the reader that Freud understood art as a phenomenon distinct among human activities, and that neurosis is not in general a thing to be celebrated. Yet especially after the Second World War, with the art market demanding a system of commercial and bureaucratic sophistication, 'vulgarized views about the sickness of the artist have contributed somewhat to the sickness of art itself'. [Eds]*

Uncollected Writings. Richard Wollheim, Gary Kemp, and Elisabetta Toreno, Oxford University Press.
© Bruno Wolheim 2025. DOI: 10.1093/9780191995767.003.0020

In 1941 Edmund Wilson published a volume of essays under the title *The Wound and the Bow* in which he put forward a powerful but not altogether unambiguous thesis about the nature of art and the artist. The title is a reference to the Greek warrior Philoctetes, who was forced to live in isolation because of the appalling stench from his open wound but was then sought out by his fellow countrymen because of his unerring bow; and the thesis consists in the assimilation of the artist to this mythical figure.

The ambiguity of the thesis can be seen in its interpretation of the original myth. On the most obvious reading of the myth, all that the thesis is entitled to assert of the artist is that he suffers and that he has special gifts; and the moral to be drawn from this would be that no part of the artist's personality should be ignored and that critical truth lies in the totality. Explicitly, this is just what Wilson asserts: 'Genius and disease, like strength and mutilation, may be inextricably bound up together.' But a bolder reading of the myth leads to a stronger thesis, and it is with this stronger thesis that *The Wound and the Bow* has been generally identified. The truth about Philoctetes is no longer exhausted by the bare conjunction that he was wounded and that he could draw an unerring bow. For now his ability to draw the bow, perhaps his possession of the bow, is thought to depend upon his wound; unmutilated he would not have had the strength that makes him indispensable to his countrymen. And of the artist it can now be asserted that he suffers, that he has special gifts, and that he owes these gifts to his suffering. His art is his sickness.

Little, except a century, separates the thesis, thus strengthened, from the Romantic conception of the artist. Like that conception it appeals to the ambivalent feelings that art famously arouses. But for the midtwentieth-century reader it was possessed of a quite new authority. It spoke, or seemed to speak, with the voice of psychoanalytic testimony.

If we turn from *The Wound and the Bow* to the *Minutes of the Vienna Psychoanalytic Society*—and there is really nowhere better to turn if we are interested in what Freud really thought about a topic on the frontiers of psychoanalytic concern, for in these weekly discussions he was intellectually at his most immediate—we shall find that the thesis that art is neurosis came up for debate on a number of different occasions. Each time it drew from Freud the most forthright disclaimers. Freud had little love for Karl Kraus, but when Wittels read a paper on what he called 'the *Fackel-Neurosis*', Freud was led to remonstrate: 'We forget too easily that we have no right to place neurosis in the foreground, wherever a great accomplishment is involved' (12 January 1910).

If that does for the stronger thesis of *The Wound and the Bow*, something very like the weaker thesis had been discussed at an earlier meeting and it is interesting to observe just what Freud made of it. Sadger had been reading a paper on Kleist, in which he brought to his audience's attention some of the poet's abnormalities, and Freud asked why it was that, even if all the assertions involved were correct, an approach like Sadger's to a creative artist was bound to leave a strange impression. It is, he concluded, because 'One might just as well have written a pathography not

of a creative writer, but of anyone else you could think of, someone unknown to us who—by the way!—left a number of works of creative writing.'

In other words, for Freud the significance of seeing genius and disease, art and neurosis as, in Wilson's phrase, 'inextricably bound up together', is, if properly carried through, that it should lead us to revise our assessment not of the genius, the art, but of the disease or the neurosis. For those aspects of a writer's personality which might be pathological in another kind of person may very well turn out to be benign in the context of creativity. And in addition, Freud contended, there have been artists who were exemplary of normality; and he instanced Schiller.

But if this is what Freud thought, why should the thesis that art is neurosis have been widely associated with Freud? Why should we find this, not just in *The Wound and the Bow* but, in a highly sophisticated form, in the writings of a great European man of letters, who was linked to Freud by a bond of mutual esteem; Thomas Mann?

In part the answer lies, as it always does when misunderstanding of a great thinker occurs, in infelicity of expression on the writer's side and inattention to the text on the reader's side. Take, for instance, the essay 'Creative Writers and Day Dreaming', the *locus classicus* for Freud's equation of art with the phantasy of the unhappy or the unsatisfied. But how generally is it realized that so far as the direct equation is concerned Freud was talking of a rather special kind of literature; not, as he puts it, that 'most highly esteemed by the critics' but a 'less pretentious' kind, which has 'the widest and most eager circle of readers of both sexes'? But then to approach 'high' literature through the romantic novel, suspecting that there is 'an uninterrupted series of transitional cases'—is that not to invite misunderstanding?

However, there is also a weightier explanation, and it consists in the way in which certain strands in Freud's thinking fit together to constitute a view he never held.

First, there is the distinction, all-important for the theory but easily neglected, between neurosis and neurotic. For Freud a neurosis is a constellation of desires, beliefs and dispositions, with a structure of its own, rooted in the past, which present experience can neither permeate nor dissolve. Because of this structure the question whether the concept is instantiated, whether there is a neurosis, is a determinate issue. By contrast, the concept of neurotic essentially admits of degree. Someone can be more or less neurotic, and whether he is neurotic enough to be a neurotic is, by and large, a pragmatic issue. Most of the time Freud adhered to the view that someone was a neurotic if his neurosis excluded him from love and work. But in other, more 'philosophical' moments, Freud was not above suggesting that we are all neurotic, we are all sick.

Secondly—and this is a related point—those beliefs, desires, and dispositions which constitute the neurosis are present in us all; though outside the neurosis they differ in strength, in amenability, and consequently in influence. And this is so because the neurosis represents in effect a stopping-point in the common

development of the psyche. The neurotic stays put—or rather reverts to—somewhere we have all been.

Thirdly, there is a tendency in Freud's writings on art for him to concentrate upon the content, or some piece of the content, of the work and to trace it to a hidden desire or belief in the artist's psyche; or to a combination of desire and belief, to a wish. In part this is to be explained by the fact that Freud had developed, in the context of the dream and the symptom, such a powerful diagnostic tool for the understanding of content, for the uncovering of the hidden, that it seemed to him reasonable to use it wherever it promised results. And in part the explanation is that in nearly all cases Freud's consideration of works of art had an ulterior motive; a motive, that is to say, that went beyond art and its appreciation. So in writing about Leonardo da Vinci and Dostoevsky, Freud was illustrating a fragment of his developmental theory. And in the essay on Jensen's *Gradiva* in which he produced interpretations of fictional dreams, he set himself to make the subtle point that one need not have to have heard of psychoanalytic theory to believe in it; for the dreams that Jensen inserts into his fiction lend themselves to a Freudian interpretation which actually advances the progress of the novel—even though Jensen had never read or been told about Freud.

It is not difficult to see how these three strands put end to end might seem to lead one inexorably back from art to neurosis. The line runs from the work of art to the hidden wish; from the hidden wish to the constituents of the neurosis; and from the constituents of the neurosis to the neurosis itself. But such reasoning omits two very important issues.

In the first place, there are those elements in the work of art which Freud, by and large, made no attempt to interpret, and it is possible that an interpretation of these elements might lead one in a very different direction. These elements are the formal elements of art and, since they are generally regarded as being that which is specific to art, their indications could barely be ignored. And, secondly, there is the fact that it is the intensity and inflexibility of a wish, not just its object, that brings about the existence of a neurosis. Freud, in point of fact, put these two issues together to form a demonstration that not merely is art not identical with neurosis but it is incompatible with it. For the very fact that the artist can mould or shape his 'neurotic' material into a form that commands our interest and excites our curiosity is testimony to the fact that the material is not of pathological strength; or, to put it in a way which increasingly appealed to Freud, that it is not stronger than his ego can contain. The view that the artist's aesthetic capacity to manipulate his hidden wishes shows his freedom from neurosis fits in well with a famous formulation of Freud's: that the neurotic repeats what he cannot recall. For to recall is associated in Freud's thinking with a certain freedom, a certain mobility, the capacity to make sense of what in a pathological condition haunts the mind with a gloomy, statuesque monotony.

However, on the ruins of one over-simplified psychological view of art, the foundations of another have been shoddily laid. For, if aesthetic creativity in itself guarantees freedom from neurosis, why—runs the argument I now want to consider—should it not be possible to free oneself from neurosis through artistic creativity? The exit from the thesis that art is neurosis can seem to serve as the entrance to the thesis that art is therapy.

The thesis that art is therapy has found many practical applications in our society, and most of them have, I am sure, been prolifically benign. And yet these results cannot effectively disguise its theoretical weakness. In a famous essay Charles Lamb asserted a necessary connexion between wit, or the poetic gift, and sanity: 'It is impossible for the mind to conceive of a mad Shakespeare'. Now it would be absurd for someone to argue from this that a good way of not going mad would be to be another Shakespeare. I don't want to suggest that the thesis that art is therapy is necessarily committed to the same grotesque miscalculation about the accessibility of the means. But it cannot defend itself against such a charge. It cannot do so, because precisely what it lacks is any clear or principled conception of the means that it advocates. What art is goes by default. In practice this deficiency becomes a virtue. For within the actual domain of art-therapy art comes to be defined through therapy rather than—as was the original premise—therapy realized through art. Just as the thesis that art is neurosis has a blurred conception of the neurosis, so the thesis that art is therapy has a blurred conception of art; and both theses have, Philoctetes-like, found in their characteristic weaknesses the source of their success.

If, however, the thesis that art is therapy contains a lacuna, the question that arises is whether it can fill this lacuna out of its own resources. In other words, given that artistic creativity is some kind of sign of freedom from neurosis, can this fact be used to determine any of the essential features of art? Freud, as we have seen, regarded the capacity to manipulate the hidden material of the psyche as evidence that this material lacked pathological force. But this, of course, leaves quite open the question of what this manipulation consists of. The hope of a number of writers, building on Freud's theory, has been that they might be able to show a correspondence between the mechanisms by which the ego retains its control over archaic desires and beliefs and the manipulation characteristic of, indeed essential to, art. It is the fulfilment of such a hope that I had in mind by suggesting that the thesis that art is therapy might fill the lacuna at its centre out of its own resources.

It is, of course, idle to think that this programme could ever be completed in detail. To do so would be to ignore the inherently institutional aspects of art. Nevertheless, it is possible to imagine some progress along these lines. But the price of such progress is that the thesis will inevitably lose many of its distinctive characteristics. It will, for instance, seem about as significant to say that art is a

form of therapy as to say that life is; and our intuition will have been restored, that one is not much easier to undertake than the other.

There is also much that is likely to dispel the facile optimism that the thesis initially exuded. I want to mention just one such factor. And that is that the correspondences that can be made out between the integrative processes of the mind and the formal properties of art are not capable of mechanical formulation. They cannot, for instance, pass through the kind of 'dictionary' of symbolism that Freud, for far more complicated reasons than are generally recognized, thought could be applied in the interpretation of content. They cannot therefore be learnt and then practised; rather they have to be created anew by every significant artist. A truth most deftly illustrated in an essay that comes out of the literature of psychoanalysis; Marion Milner's *On Not Being Able to Paint*.

For the view that states of mind can find a direct expression in the compositional features of a work of art, Yvor Winters coined the phrase 'the fallacy of imitative form'. The last speeches of Macbeth, Winters argued, are bad poetry because Shakespeare falsely believed that internal confusion can be adequately expressed by broken metre and syntactical deviation. A reader of Winters is likely to find his general contention plausible and his example implausible. And the reason for this is interesting. It is that Winters falls into precisely the same error—though in a subtler form—as those whom he attacks. For he, too, thinks that the correspondences between mental state and aesthetic form can be mechanically stated; though his version of how this is to be done differs from the conventional account. He thinks that if both can be brought under the same description—for instance, if both mental state and aesthetic form can be described as anguished, or violent— the correspondence is inexpressive. But any assessment of the correspondence must surely be settled by an examination of the work itself. Edgar Wind, borrowing Winter's argument, used to claim that 'Guernica' was a failure because Picasso tried to express inner torment through tormented forms; but the truth must lie not with what Wind can say about the painting but with what Picasso did in it.

Freud's thought about art occurred against the background of two assumptions. The first is that art is a distinct phenomenon, separable from other, perhaps related activities. The second is that neurosis is an intolerable burden from which man will seek liberation. Little of what he said makes sense if either of these assumptions is dropped. It is, however, characteristic of much of the discussion that has gone on in recent years around the topics of this essay that these assumptions have receded into the background.

What is culturally interesting is not simply that both assumptions have in this way been disregarded, but that their disregard has most likely a common origin. For the massive struggle for new markets for art that has been such a distinctive feature of the postwar years would seem to have imposed on art a new mission; that of carrying the comforting message, that nothing is really disturbing, that the

pathological has its charms. It was a perception of some such process at work that led Freud to be so distrustful of Surrealism, with its mixed offerings of the raw and the bland. But Freud could have had no reason to anticipate the vast organizational forces—commercial and bureaucratic—that would come to have so strong an interest in propagating such an art of illusion. If he had, he might have reflected ironically on the way in which vulgarized views about the sickness of the artist have contributed somewhat to the sickness of art itself.

21

On the Question 'Why Is Painting an Art?' (1984)

*A reader of Wollheim—a paragon of twentieth-century aesthetics—
might well ask: But where is his definition of art? The lack of a straight-
forward answer is largely due to what Wollheim calls the 'essential
historicity' of art (though Wollheim's student Jerrold Levinson has indeed
made it into a proper theory of art). In describing this, Wollheim points
out the inadequacies of the Institutional Theory (Danto and Dickie) and
the Ideal Theory (Croce and Collingwood): both these answers are silent
on what a painting 'is or is like' (the former explicitly sets no constraints;
the latter conceives them as determined by the artist's intention). By con-
trast, to ask seriously 'What is it about painting that makes it an art?' is
to ask a 'question the answer to which [. . .] must cite a feature or aspect
that painting possesses'. In broadest terms, that feature is that a painting
carries meaning, which Wollheim explains as 'a matter of appropriate-
ness or fit', between the artist's intention and the look of the painting, cor-
roborated by the artist and informed spectator. Indeed, 'when painting is
practised as an art, no work of painting is produced except with some fit
in mind' (which may be implicit). But there are 'no restrictions upon how
the spectator is allowed to gain the information that he requires if he is
to sense the fit are in place'; any information may be required, including
being explicitly told what it expresses, in order for the spectator rightly
to perceive the work. Historicity meanwhile obtains because what is re-
garded as fitting by an audience at a given time may well not be avail-
able to an artist at the same time (in 2024, one can perform Mozart, but
cannot compose like him). The availability of roads forward is explained
by (first) the 'repleteness' of painting: it possesses an indefinite number of
properties; (second) by its 'relexiveness', by 'thematization'—that proper-
ties 'that had not been previously pressed into the service of fit will swim
into the awareness of the painter, and a function will be assigned to them'
(readers will sense an affinity with Danto's 'Artworld'). This is an undis-
covered gem in Wollheim's output: in a bracingly small space, he puts
forward a view, albeit schematically, of the nature of painting—and, by
analogy, of art—which can explain why it is important and, at least in
outline, why it changes so much. It will strike some readers as dogmatic,*

Uncollected Writings. Richard Wollheim, Gary Kemp, and Elisabetta Toreno, Oxford University Press.
© Bruno Wolheim 2025. DOI: 10.1093/9780191995767.003.0021

but we want to say, to wiser readers, not so much. It very much anticipates the main themes of Painting as an Art. [Eds]

1. In this paper I shall talk about just one art: painting. I shall talk about painting as an art, but I shall in doing so talk about painting as a characteristic art. That is to say, I shall endeavour to talk about painting in such a way that, *mutatis mutandis*, everything that I say will deliver truths about the other arts. Then by extension it can be applied to art itself.

What I shall say will be ethnocentric to this extent: that I shall base myself on painting as we have it in Western culture. I take it to be an unresolved question how many features different cultures have necessarily in common, and how far what look like irremoveable differences should, and should for just this reason, be treated as surface features with deep explanations in terms of common factors.

What I say is part of a larger polemic: against what I think of as 'spectator-based aesthetics'.

2. Taking painting as a characteristic art, I want to ask of it the question, Why is painting an art? A somewhat more specific question is, What is it about painting that makes it an art? To an ear unconditioned by philosophy, there might seem to be no appreciable difference between what the two questions ask, and therefore it might seem surprising that I should find it significant to insist that the first question, Why is painting an art? should be answered through answering the second question, What is it about painting that makes it an art? Yet the fact of the matter is that two powerful theories in philosophical aesthetics answer the first question in such a way as to leave the second question unanswered, and at least some of their adherents regard this as a merit. The two theories I have in mind are the Institutional theory and the Idealist theory. (I mention no names.)

(I should make clear that in each case I am thinking of a version or formulation of the theory that takes it upon itself to answer questions of the form, Why is such-and-such a practice or activity an art? For in their standard or more familiar versions these theories set themselves questions of the form, Why is such-and-such an object a work of art?)

The Institutional theory has it that what makes painting an art is the say-so of institutionally privileged persons: the decisive factor is the voice of authority. The Idealist theory has it that what makes painting an art is the motivation that causes it to be undertaken: the decisive factor is the will to art. Now it is to be observed of both these answers that the explanation they offer why painting is an art in no way draws upon what painting is or is like. To grasp the plausibility to which these answers aspire does not require us to remind ourselves even in the very broadest terms of the characteristics that the practice of painting displays.

I should by now have made explicit how I think the two questions differ from one another. To ask 'What is it about painting that makes it an art?' is to ask a question the answer to which must cite something about painting. It must cite a feature or

aspect that painting possesses. And my claim is that any attempt to say why painting is an art that does not take this route is wrong, and wrong just for this reason.

That painting is an art, which I take it to be, must have something to do with how painting is. And in this respect supremely painting is a characteristic art.

3. However if what makes painting an art is something to do with how painting is, it is not one single simple thing about how painting is. I shall in this talk concentrate on one single, though not one simple, thing about painting, and therefore I shall not profess to do more than produce part of an answer to the question, What makes painting an art? If there is that much modesty to my answer, it is also an answer that aims to put the issue in a fresh light. It aims to bring new considerations to bear. It is to that degree ambitious.

4. Something that an artist will do in painting a painting—I am prepared to say that it is a mandatory aspect of painting practised as an art—is to require that his painting carries meaning. There are two ways in which a painter might form such an aim. He might want his painting to assert something: he might want his painting to say that things are a certain way—for instance, that Delft looks like this in a certain light [Fig. 21.1]. Or he might want his painting to express something: he might want his painting to convey a certain mood or feeling—for instance, that

Fig. 21.1 Johannes Vermeer (Dutch, 1632–75), *View of Delft*, c.1660–61. Oil on canvas, 96.5 × 115.7 cm. Photo © Mauritshuis, The Hague (92).

war is horrible, or that adolescence is full of anguish. He might want to connect his painting with either the outer or the inner world, and, as likely as not, he will want to do both. And in these aims he may succeed. His painting may indeed say how Delft looks in a certain light or it may convey the horrors of war or the anguish of adolescence—although it is important to realize that it will not do these things just because the artist forms such aims. Nor, for that matter, will it do them just because the artist forms such aims *and* his aims are recognised or discerned. What a painting says or conveys is a matter of how it actually is.

But how can it be that the artist succeeds? In saying that a painting carries meaning, assertoric or expressive, I thereby seem to assimilate a painting to a sentence in a natural language. But in one crucial respect the two differ.

Characteristically when a sentence in a natural language means something, it does so in virtue of a meaning-rule or a set of truth-conditions. Some philosophers of language will add further conventions to account for the pragmatics of a sentence, but the point I wish to make remains, the contrast stands, which is that when a painting means something, this is not a matter of a meaning-rule or a set of truth-conditions or any other kind of convention, it is a matter of appropriateness or fit.

5. The appropriateness or fit of a painting to what it either asserts or expresses is something to which both artist and audience have access: though, as we shall see, there is differential access. It guides the artist in what he does: it leads him (if circumstances are propitious) from what he wants the painting to mean to the painting itself and what it should look like. And it guides the audience in its response: it leads it (if circumstances are propitious) from the painting and what it looks like to what it must mean. Because both artist and audience have access to fit, the audience can up to a point understand what the artist has done, and the artist can have some confidence that this is what the audience will do. And because fit is not dependent on rules, which would have to be taught and learnt, the accord between artist and audience is not confined to a single cultural community, which is where the teaching and learning of rules goes on, but is in principle ecumenical. The accord between artist and audience that fit promotes is not, even in the first instance, provincial like the accord between speaker and hearer that language rules generate: and that it is not provincial is one of the reasons we have for thinking that fit is not rule-based. For the speaker-hearer accord to be carried across the confines of a cultural community, a second language has to be learnt. The popularity of museums shows us that there is no parallel in art. Art is not free-er of misunderstanding than speech but the reasons in the two cases radically differ.

6. Appropriateness or fit occurs outside art as well as inside art. Its antecedents are in life. One example of fit is provided by the way in which we can see animals in clouds, another by the way in which we can see a person's moods or feelings in his face. There is a fit between the look of the cloud and, say, a whale, or between the lie of a human face and, say, grief.

Fit then is rooted in a broad perceptual capacity that is part of human psychology.

7. Fit in painting—the fit of painting to what it asserts or expresses—is relative to time and place in a special way. It has a historical dimension. At a given cultural moment it will seem to a particular artist that to paint in a certain way, to paint *this,* will result in a painting that will carry the very meaning he asks of it. So he paints accordingly. So we have Vermeer's *View of Delft* or Goya's *May the 2nd 1808 at the Puerta del Sol* [URL48]. Of course, such thoughts will not occur to the artist explicitly, and they are likely to evolve even as the painting itself comes to form itself on the support. And to other painters of the same period, of the same culture, but with different styles setting their horizons, different though related thoughts will emerge to guide their work.

Then at a later cultural moment just such a way of fitting works to meaning will no longer seem right. It will not be available. And one reason why an artist might no longer find it appropriate to work in this way is just because this is how Vermeer or Goya did work.

But at this moment, when later artist diverges from earlier artist, artist and audience also diverge. For even when no artist, who wished to convey what Vermeer or Goya wanted to convey, will find it possible to work as Vermeer or Goya worked, the fit that motivated Vermeer or Goya will be as accessible to an audience as it ever was in Vermeer or Goya's day. Perhaps more so.

That is one aspect of the relativity of fit. Another aspect emerges when we ask this: Granted that for Picasso the way of fitting work to meaning that Goya employed so as to express the horrors of war was no longer available, therefore, in order to express the horrors of war, he had to work differently, with *Guernica* [URL24] the outcome—suppose that nevertheless Picasso *had* painted a painting that looked exactly like *May the 2nd*, what would that painting have meant? If an audience applied to such a painting the very same sense of fit that led it equally from Goya's *May the 2nd* and Picasso's *Guernica* to the horrors of war, to what meaning would it be led? Would it be led to something other than the horrors of war?

I think that the right answer to this question is that it presupposes what is no possible starting-point. The Picasso *May the 2nd* is not a possibility within painting as an art, given only the barest outlines of the history of painting as it passes through Goya to Picasso. No-one, I take it, would really think otherwise, and the only question is Why is this so? Out of what materials is an adequate explanation to be constructed? And my claim is that it is to be constructed out of the very materials required to understand fit.

8. An approach to this problem might be effected through a maxim that Gombrich employs in a more limited context, to account for the fact that representational art has a history. The maxim is, Making and matching: more specifically, Making precedes matching. Put like that, the maxim might suggest that the process of representation is conducted sequentially. First, a configuration is realized on a

support: then the artist tries to match this configuration against the outer world, so that whatever it best matches, it means—or in the context of Gombrich's discussion, it represents. I am not saying that this is Gombrich's view but his words could be taken to express such a view. But it is in contrast to such a view that I want to insist that, when painting is practised as an art, no work of painting is produced except with some fit in mind: the artist paints what he does with the aim of producing something that fits whatever it is that he wants his painting to carry. Another way of putting the matter which does justice to the crucial fact that, when painting is practised as an art, paintings are not produced in a one-off manner would be to say that no style—no individual style—is formed in an uninterpreted fashion. The rules of a painter's style are evolved so as to turn out work that has an assertoric or expressive meaning.

If this is so, if all works of painting are produced to fit, then later artists will not, with one fit in mind, produce works that exactly or even closely resemble works that earlier artists produced with another fit in mind. For if they did then both works, the earlier and the later, would be unavailable for the audience's sense of fit. For there is no coherent sense of fit that would allow one and the same audience to sense the fit between the earlier work, say Goya's *May the 2nd*, and some meaning, and also the fit between the later work, say, Picasso's *May the 2nd*, and some different meaning. Diachronically the fit of work to meaning can be manyone. But it can't coherently be one-many.

The upshot is that the possibility exemplified by Picasso's *May the 2nd* cannot be realized. Or if it can be, it can be realized only marginally.

9. A word or two on the spectator's access to fit. This is, of course, no more than a *capacity* that persons have—like the artist's access to fit. For this capacity to be realizable further conditions have to be satisfied: maturation, the development of interest in art, the acquisition of skill—in general, what certain writers have called *taste*. Furthermore to realize this capacity in any given case—that is, in the case of some of one given painting—background information relevant to that painting has to be acquired. No limits can be set in advance on how much background information will be necessary for a given spectator to sense the fittingness of a given painting to what that painting asserts or express[es]. The information may have to include just what it is that the picture asserts or expresses. For a spectator to sense the fittingness of *Guernica* to the horrors of war, he may to be told that *Guernica* expresses the horrors of war. But after he has been told this, there is still the fit for him to sense. Equally no restrictions upon how the spectator is allowed to gain the information that he requires if he is to sense the fit are in place. Specifically a traditional restriction—that the spectator should gain the information from perception of the painting—is quite unjustified.

This last point shows something which elsewhere I have argued for. That is, that a revision is called for in one traditional picture of what the role of a spectator consists in. The traditional picture that I have in mind is tripartite. Stage one: the

spectator gains information about the painting from scrutiny of the painting. Stage two: the spectator puts all this information together. Stage three: the spectator infers to the meaning of the work. The picture which I substitute for this traditional picture is bipartite. Stage one: the spectator gains all the information that he finds necessary for understanding the painting from whatever source is open to him— from scrutiny, from scholarship, from hearsay, from comparison with parallel cases. Stage two: the spectator uses all this information as background information in discerning or sensing to the fit of the painting to what it means. The spectator's role is perceptual, but the preparations he makes to prepare himself for it need not be perceptual. The traditional picture, it will be observed, reverses this. It makes the task inferential but insists that the preparation for it is perceptual. And all this in the interests of the autonomy of art.

10. The relativity of fit in painting exhibits, if I am right, the following characteristics.

 i. at any given cultural moment, a fit that seems appropriate to an artist is accessible to an audience;

 ii. a fit that is available to an artist working at one cultural moment will not be available to an artist working at another moment;

 iii. a fit that is no longer available to an artist remains accessible to an audience: *and*

 iv. work that at one cultural moment was produced so as to enter into a certain fit will not be available at later cultural moments—except perhaps marginally.

11. The question that now arises is this. How does it come about that painting exhibits fit in just this way: that is, with these broad characteristics and these complex refinements?

The answer to this question is twofold. It comes on two levels: on the micro level, and on the macro level. On the micro level the answer is to be found in a certain mechanism that characterizes painting, and this mechanism exploits a further characteristic of painting. (You will perhaps now appreciate my remark that I am trying to explain why painting is an art in terms of something about painting).

What is this mechanism, and what is the characteristic of painting that it exploits?

The characteristic that the mechanism exploits is the repleteness of painting. Painting is replete in that any given painting possesses an indefinite number of properties. Painting is replete in further sense in that painting, though not any given painting, exhibits an indefinite number of kinds of property. At any given cultural moment, only certain kinds of property will be pressed into the service of fit. In consequence, or in likely consequence, certain properties that given paintings have—that is, the properties of *other* kinds—will not be pressed into the service of fit. They will from this point of view be idle. So much for repleteness.

The mechanism that exploits repleteness is reflexiveness. And by reflexiveness I mean that with the continuing practice of painting, kinds of property that had not been previously pressed into the service of fit will swim into the awareness of the painter, and a function will be assigned to them, though not necessarily the same function in the work of different artists, in the generation of it. Reflexiveness fixes on a kind of property which up until then has been idle, and from now onwards properties of this kind possessed by given paintings will be thematized.

As examples of reflexiveness at work, we may consider the following: the discovery and thematization of facial expression in the High Renaissance painting of Central Italy; the discovery and thematization of the brush mark in Cinquecento Venetian painting; the discovery and thematization of cast shadow in early seventeenth century painting; the discovery and the thematization of the edge of the support and how it crops representational forms in the work of Degas and some contemporaries; and the discovery and thematization of applied material in Cubism.

Reflexiveness is the mechanism by which painting as an art moves forward— though not necessarily upwards. In much contemporary art-theory—I distinguish art-theory from aesthetics—reflexiveness is acknowledged, but not as such. It is acknowledged but misidentified when painting is said to be essentially *about itself.* This seems to me false as an observation about painting, and in error as a characterization of reflexiveness. Reflexiveness has nothing directly to do with what a painting is about. Loosely put, it has to do with *how* painting is about what it is about. More precisely, it is to do with fit, which is a more specific notion than what painting is about. Fit is a notion that, in so far as it relates to painting, belongs to a consideration of painting as an art: what a painting is about is a notion that belongs to the broader study of painting, or of painting not necessarily practised as an art.

Reflexiveness has two consequences for the history of fit. The first is that personal expression, or an artist's own sense of fit, is permanently a source of challenge to the artist, it is never (like, say, a system of projection or perspective) a given: the second is that earlier ways of securing personal expression are not necessarily lost, for the properties on which they relied are often preserved in later art. In Degas, for instance, we can still discern, in a transformed way, the very resource on which Leonardo and Raphael depended so heavily for fit: that is, facial expression. The audience can still respond to fit based on facial expression, and it is possible for an artist to rediscover and re-employ fit of this sort, he could rethematize facial expression, but it would be a different kind of use to which it was now put—as indeed we can observe when just this happened, when facial expression was rediscovered in the work of the German and French expressionists. So much for the micro level.

On the macro level, the answer to the question, How does it come about that painting exhibits fit and relativity of fit in the way that I have been sketching should be basically an evolutionary answer, and it is, to my mind, an answer of striking

simplicity that is called for. It is this that I had in mind when I said that my paper aimed to put the issue in a new light.

The survival of painting as a central feature of a culture depends on its capacity to generate fit in the form I have been trying to characterize. The production of fit, of appropriateness that is perceptually available to artist and audience, is a condition for the persistence of a practice as an art, and it is a condition that painting meets: hence we have painting practised as an art. Since we have painting, since painting persists, we ought not to be surprised that painting exhibits fit and relativity of fit. What by contrast should surprise us is to be told, for instance, that Picasso, at some point in his career, after his style had been formed, had regularly painted paintings that looked like Goya's *May the 2nd* or Vermeer's *View of Delft*. There is, of course, nothing in the mere activity of painting to make this odd or surprising. Copiers, forgers, and art students of a certain bent of mind do it all the time. The oddity and the surprise that would attach to this eventuality would attach to it if it occurred when painting was practised as an art. Nevertheless there is a moral to the evolutionary argument. There is something that it suggests to us that we should do—if, that is, we are interested in the survival of painting as an art. We should see that painting is not subjected to pressures that make the generation of, and access to, fit harder. For then painting would become opaque and it would not survive as art, though it might survive as decoration.

Just what this moral asks of us, and just what steps we should take to safeguard painting as an art is another matter on which I shall have nothing direct to say. It is the vexed question of the predicament of modem art, and my only observation would be that, if art is in jeopardy, this comes from outside art rather than inside art. It comes from dealers, collectors, and, above all, theorists of modern art. It does not come from modern artists.

12. I conclude with some observations on the status of what I have been saying. What I have been saying is not conceptual analysis. It is not conceptual analysis, because the phenomena towards which my remarks have been directed are conceptualized in a way that runs across the division between art and not-art. Painting, meaning, representation, expression, and fit run across the art/non-art frontier. It is for this reason that early on I was able to give the examples of fit that I did. For they were examples of representation and expression, but they came from outside art. To talk about these phenomena as such would be, (rather) *could* be, conceptual analysis, but to talk about them solely as they occur within art could not possibly be conceptual analysis. What is it then? Is it mere empirical description?

I think that is isn't, but to defend this is not possible unless a bold claim is made about art. And the claim would be to the effect [that] art regiments in a certain way the perceptual, affective, and cognitive powers and abilities of man with the result that phenomena like representation and expression and fit take on a distinctive character when they appear within art. And this distinctive character is not susceptible, or readily susceptible, to surface description for two distinct reasons.

The first reason is that each of these phenomena gets tied in with all the other phenomena of art. Take, for instance, representation. Within art representation, or the representational task set the painter, is sensitive to a variety of considerations close to and not so close to representation itself, e.g. the carriage of information; the outlook and attitude of the artist; the position of the spectator (or lack of it) relative to the represented space; the use of the medium, and the proportion between the size of the brushstroke and the size of the support; the effect of the momentary and the sense of the enduring; the attainment within the medium of singular (as opposed to general) reference. The second reason why phenomena that appear within art do not admit, or do not readily admit, of surface description is that, once such a phenomenon does appear within art, it takes on the essential historicity of art, as we have seen in the case of fit.

If that part of aesthetics which I have been talking about is neither conceptual analysis nor surface description, how is it to be thought of? I don't know. But I know this: that we should not think of it as falling outside philosophy just because it is neither of these two things. A parallel may soften the blow: it is like the philosophy of mind when it studies not just the phenomena of psychology but the phenomena of human psychology.

22

Art, Interpretation, and the Creative Process (1984)

The essay appeared in the journal New Literary History. *Experts on Wollheim will recognize that the argument not only echoes the slightly earlier 'Criticism as Retrieval', one of the six supplemental essays of the second edition of* Art and Its Objects *of 1980 (pp. 124–36), but is largely repeated in his 1994 essay 'Art, Interpretation, and Perception'. It is a borderline case whether there are enough differences from the 1994 piece to justify reprinting the present piece, but we leave it to the reader to judge. The target is what he calls the 'popular thesis' of criticism as scrutiny, which has its recognizable precursor in (a certain reading of) Kant but with distinctive modern manifestations in the 'New Theory' of literary criticism—especially as intended for art generally as in Wimsatt and Beardsley—and in certain variants of formalism or modernism—such as those of Roger Fry or Clement Greenberg (Wollheim also connects the view with presentationalism, a stalking horse in the main argument of* Art and Its Objects). *The thesis is simple: that the artistic meaning of a work of art is confined to what is available to perception of the work alone—to the perception of one who approaches the work with a 'beginner's mind', free of preconceptions or knowledge (which tends to divert attention away from the work). The problem is that of the 'cognitive stock': the spectator's cognitive resources cannot be null, but how substantial must they be? Wollheim argues that there is no non-arbitrary place to draw the line. Scrutiny must give way to 'retrieval', which grants that artistic meaning must be experiential, but the experience may presuppose, in order to have it, non-trivial knowledge of history, conventions, style, genre, the artist, and the artist's work. In painting, for example, one has to see an item for it be an item of meaning—but a great deal of conceptually informed prompting may be required. The three-way dilemma between 'intentionalism', 'anti-intentionalism', and 'hypothetical intentionalism' does not appear, but one can fit this discussion easily into more recent debates.* [Eds]

My starting point is a thesis about the correct method of criticism in the arts. A name for this method suggests itself. I shall call the thesis the Scrutiny thesis, and, rather

Uncollected Writings. Richard Wollheim, Gary Kemp, and Elisabetta Toreno, Oxford University Press.
© Bruno Wolheim 2025. DOI: 10.1093/9780191995767.003.0022

than offer a general formulation of it, I shall introduce it by seeing what it has to say about criticism in the various arts. The Scrutiny thesis, then, asserts that (1) in criticising a poem the critic should confine himself to what he can come to know through reading the sequence of words on the page; (2) in criticising a piece of music the critic should confine himself to what he can come to know through listening to the sequence of notes and chords and rests that comply with the score; (3) in criticising a painting the critic should confine himself to what he can come to know through looking at the marked surface of the support—and so on through the various arts

The Scrutiny thesis does not provide an overall view of the critical operation. To arrive at this, we have to join the Scrutiny thesis with the instruction that, before the work is subjected to scrutiny, it is restored—either in reality or in the mind or imagination of the critic—to its best condition. The best condition of a work of art will generally be equated with its pristine condition, but not invariably. (Works designed to decay or acquire a patina provide the exceptions.) So the overall view of the critical operation to which the Scrutiny thesis belongs is expressed by the maxim: First restore, then scrutinise.

2. Indubitably, the Scrutiny thesis has natural appeal. It commands immediate support. But is it correct? A crucial fact is that, as it stands, the Scrutiny thesis is indeterminate. It is indeterminate in a vital respect and thus requires supplementation. Supplement the thesis in a way that coheres with its natural appeal, and also that its proponents assume, and it is not correct. Supplement it in a way that is required for it to obtain plausibility on reflexion—reflexive plausiblity, I shall call it—and the thesis loses that character which at once suggests its name and lends it natural appeal. The reflexive plausibility of the thesis and its natural appeal—and, for that matter, the appropriateness of the name—vary inversely; but all this is apparent only once its indeterminacy has been spotted, which is what its natural appeal conceals. *This is the central claim of this essay.* But in pressing this claim I hope also to show that some part of the natural appeal of the Scrutiny thesis is based upon an erroneous view of the role of perception in criticism. Once we have supplemented the thesis to the point at which it becomes reflexively plausible—and also utterly unrecognizable as a Scrutiny thesis—then it will be time to try to relocate perception within the critical operation.

3. The Scrutiny thesis is, it must be emphasised, a thesis about method. Now if we are to settle a claim about method or decide whether a particular method is appropriate to a certain inquiry, what we have to determine is what the end of this inquiry is. For the appropriateness of method to inquiry rests in large part on the capacity of the method in question to advance the end that the inquiry pursues more effectively than any other rival in the field. This fact is often overlooked in the humane sciences, and a method is preferred just because it can be applied.

The great German philosopher-clown Valentin had an act which went as follows: In the great tent the lights go down, and, as they do, a solitary street lamp in the middle of the arena lights up. It casts a small circle of light around it, and

Valentin can be observed walking round the perimeter of the illuminated area, seeming to look for something. His eyes are riveted to the ground. A stranger appears. He observes Valentin; he asks him what he is doing; Valentin says that he has dropped a coin and is looking for it. The stranger offers to help him, and, the offer is accepted, the two men walk round and round the lamp-post in opposite directions, now not just one pair of eyes, but two pairs, riveted to the ground. After some minutes of vain search, the stranger stops. He asks Valentin if he is absolutely sure that he dropped the coin *here,* pointing to the ground. 'Oh no,' says Valentin, 'I dropped it over there,' pointing into the darkness. 'Then why,' says the stranger impatiently, 'are we looking here?' 'Because,' says Valentin, 'this is where the light is.'

What Valentin's act illustrates is the attachment to a method just because the method can be applied, irrespective of whether the application of the method is calculated to produce results of the desired kind or indeed results of any kind. Method and the end of the inquiry have become unstuck.

4. What then is the end of criticism?

For the purposes of this paper I shall assume what I in fact take to be beyond question: that the aim of criticism is, in some broad sense of those terms, to understand, or to grasp the meaning of, the work of art. There are however two interpretations of meaning, which divide theorists. On one interpretation, meaning is thought of as something that adheres to the work of art and is to be discovered; on the other interpretation, meaning is something to be constructed by the critic and then imposed on the work. On the first interpretation, meaning derives from the original creative process; on the second interpretation, it originates in an autonomous critical process. I shall call the two conceptions of the critical aim that are generated by these two interpretations of what the meaning of a work of art is that of criticism as retrieval and that of criticism as revision. Where meaning is thought of as something to be discovered, criticism is retrieval; and criticism is revision where meaning is thought of as something to be constructed and imposed—and this to be done afresh from age to age.

However it cannot be emphasised too strongly that, if the two interpretations of meaning, if the two conceptions of the critical aim, are conceptually distinct, this does not mean that in practice the constraints they impose on the critic are readily distinguishable or that for each there is a clear-cut operational equivalent. On the contrary, there will be many cases where it will be extremely hard to tell the difference between what one interpretation of meaning, one conception of the critical aim, requires, and what pertains to the other. Much complexity arises from this consideration. A critic, inspired by the demands of retrieval, has still to present what he has retrieved to a contemporary public, and in doing so he may legitimately find himself saying exactly what a critic, motivated by the demands of revision, finds it natural to say.

5. I return to my claim that the Scrutiny thesis in its original formulation is indeterminate. The reason for the indeterminacy is that the thesis (as it stands) fails to

recognise the interconnection between perception and cognition. Or rather, it fails to recognise one crucial way in which perception and cognition are connected. For it recognises that perception gives rise to cognition—indeed, it explicitly makes use of this fact—but it fails to recognise the way in which cognition can influence perception.

To see this last point, let us first sharpen the relevant notion of perception. To do so we may think that on any given occasion what I perceive is decided in the following way. Suppose that I utter the words 'I perceive that' Then what I perceive is delivered by the longest sentence that I can insert after *that* and thereby make, overall, a true sentence. What I perceive is what the longest sentence of the general form 'I perceive that p' says that I perceive. Now what the Scrutiny thesis overlooks is that when I scrutinise something, what I actually perceive—or the correct filler for the opaque context in a perceptual judgment—depends not only on the visual stimuli that I receive from the scrutinised object, but also on the knowledge, belief, and conceptual holding that I bring to bear on the visual stimuli. It depends in part on what I shall call my current cognitive stock.

This truth is readily apparent from cases that fall outside the perception of art. Let me give an example. Suppose that I look at a row of trees, and the trees are oaks; then I shall be able to perceive that there is a row of oaks in front of me only if I possess the concept 'oak' (in addition to the concept 'tree') and some beliefs about how oaks look. (Some philosophers will maintain that there is just one condition here, not two.) Of course, even if I possess all this, I still may not, in looking at the row, perceive that there is a row of oaks in front of me. For I may fail to bring the concept to bear on the visual stimuli, and for this there might in turn be a variety of explanations.

That the Scrutiny thesis does indeed ignore the influence of cognition upon perception is evident from the fact that, in insisting that the critic should confine himself to what he has come to know through scrutinising the work, it omits to say anything about the cognitive stock upon which the critic is allowed to draw when he scrutinises the work. For unless this omission is a mere oversight in formulation, which I take it not to be, it is a clear indication that the theory assumes that what the critic will perceive is independent of his cognitive stock. Only this assumption would justify the omission. And, because there is no such independence as the thesis assumes, the thesis is indeterminate.

However, it is certainly open to the Scrutiny thesis to gain determinacy, and it can do so by specifying the cognitive stock to which the critic is entitled. In this way the thesis is supplemented. Now just how the stock is to be specified will be a matter of reasoned disagreement, and we may think of there being as many plausible versions of the Scrutiny thesis as there are plausible specifications of the cognitive stock. This being so, the central point of this essay may now be reformulated as follows: There are versions of the Scrutiny thesis which preserve the natural appeal of the thesis. They are those which are very hard on the cognitive stock or specify

it parsimoniously. But they are also those in which the thesis lacks reflexive plausibility. By contrast, there are versions of the thesis in which it acquires reflexive plausibility, and they are those which are easy on the cognitive stock or specify it generously. But they are also those in which the thesis has an ever-diminishing right to be called a Scrutiny thesis.

6. The most parsimonious specification of the cognitive stock upon which the critic is entitled to draw in scrutinising the work specifies the stock as zero. In reading or listening to or looking at the work of art, the critic should forego the contribution that any knowledge or belief or conceptual holding that is his might make to what he perceives. This view is associated with what I think of as a presentationalist view of art. It has been widely held in this century, and it derives historically from Kant—though, significantly, not from what Kant thought about art and its adherent beauty but from what he thought about nature and ornament and the free beauty that they exhibit.

The attractions of this way of specifying the cognitive stock—if this can be called a way of specifying it—are closely connected with what I have been calling the natural appeal of the Scrutiny thesis (though I'll return to this point later). They are that it ensures, in the first place for criticism, secondly for the work of art itself, a certain self-subsistence. Consequently, it guarantees democracy of entry into art. The work of art can speak for itself; it stands in no need of ancillary information; and a consequence of this is that no one will be debarred from the appreciation of art through any kind of cognitive lack.

However, the zero-stock version of the Scrutiny thesis is vitiated by a fundamental misunderstanding of the influence of cognition upon perception, to which it tries to do justice. For it is not just that perception varies with cognitive stock, so that 'Different cognitive stock, different perception,' but perception requires cognitive stock, so that 'No cognitive stock, no perception.'

7. Once we recognize, however, that any viable version of the Scrutiny thesis must specify the critic's cognitive stock at higher than zero, then a whole varied range of knowledge, belief, and concept will press for inclusion, and each kind of knowledge, of belief, each kind of concept that we admit gives rise to its own version of the Scrutiny thesis. Let us look at these pressures.

It seems impossible to reject either the claim of general truths about the world or that of the prevailing conventions of art. With general truths about the world, the difficulty is to conceive what it would be like to reject them. What sense could we make of *War and Peace* or Venetian portraiture if we denied admission into the critic's cognitive stock of the facts of psychology, history, and human anatomy? With the prevailing conventions of art, the difficulty is somewhat different. We can see only too readily what absurd misperceptions would be generated if a critic purged his cognitive stock of the facts of artistic convention. Erwin Panofsky amusingly illustrated this point when he observed how the right wing of Rogier van der Weyden's *Blaedelin Altarpiece* [URL49] could be gravely misread if the critic

ignored the convention that a human figure represented as if standing in the sky is to be seen as an apparition manifesting itself to those kneeling on the ground. The Infant Christ is not a claypigeon for the Magi. But once we admit general truths about the world and the prevailing conventions of art, other truths, other beliefs, other concepts will seem plausible candidates for inclusion in the cognitive stock, and if we try to assess each claim by going back to the end of criticism—that is to say, understanding the work of art—and seeing how that would prosper with the critic's cognitive stock correspondingly increased, each new claim is likely to get looked on with favour. The line does not get drawn.

However, the really hard cases, or cases which will certainly seem hard to someone who has once experienced the appeal of the Scrutiny thesis, arise when we turn our attention from information external to the particular work of art and ask about truths internal to that work. Why do those latter truths present more of a problem, or how is it that their exclusion from the critic's cognitive stock recommends itself more forcefully?

The thinking would go something like this: The artist, in making a work of art, makes it against a certain background. This background will influence how he works, often without his realizing it. Now, the critic will almost certainly need to know something of this background, but there seems no reason why the artist should have to make it available to the critic. Indeed, in many cases it will have been beyond his reach to do so. Accordingly it is reasonable, at any rate on reflection, that the critic should have to discover the background for himself, and it is no defect in the work of art, no indictment of the artist, that this should be so. But (the thinking goes on) when we turn from the background to the work to the work itself, the situation changes. If some truth which is specific to the work of art itself, or what I have been calling a truth internal to the work, is necessary for the critic's understanding of the work as a whole, then the critic can reasonably expect to gain it from the work. If he can't, then this seems like an indictment of the work. To give a simple example: The critic of *Othello* needs to understand the English language, but there is no reason why he should be expected to gain this from scrutiny of *Othello;* but the same thing surely cannot be claimed on behalf of the nature of Othello's jealousy or the hold that Iago has over him. If such claims were made out, would not the autonomy of *Othello* be sacrificed?

However reflection shows that this argument does not, in point of fact, warrant the conclusion in support of which it is invoked: namely, that all truths internal to the work of art should be denied entry to the critic's cognitive stock. In fact, it doesn't warrant any conclusion about what should or what should not be let into the cognitive stock. For all it bears upon is the issue, which is different, how entry into the cognitive stock should be effected. What it supports is that entry into the cognitive stock should be effected only through perception. In other words, a critic who has come to learn some internal truth about a work of art through scrutinising it may then, perfectly justifiably, include it in the cognitive stock upon which he

will draw in further scrutiny of the work. What (on this argument) *is* denied to a truth internal to a work of art is that it should be included in the cognitive stock with which the critic first approaches that work: it must not be any part of the critic's *initial* cognitive stock.

But if this is the conclusion that is warranted, it is not unproblematic, for two reasons. In the first place, it may seem a reasonable restriction upon any piece of knowledge or belief that is included in the critic's cognitive stock that it should be perceptible (I shall return to this point). But if this restriction seems reasonable, it is a further and (I would say) unjustified demand that the knowledge or belief should actually have been acquired through perception. The causal history of the knowledge or belief, or how the critic got hold of it, cannot be relevant, surely. And this, I think, comes sharply into focus when it is appreciated that there are truths about a work of art that are perceptible but which even a highly trained critic could not perceive unless his cognitive stock tells him that there is such a truth for him to perceive. Once he knows that there is such a truth, then scrutiny can reveal it to him; but otherwise he would not come to know it, no matter how hard he scrutinized the work. If this seems counterintuitive, an example, again from outside the perception of art—familiar to us all, I am sure, from childhood—should make it acceptable. I am thinking of those line drawings made for the amusement of children in which representations of animals are buried in the contours of trees and vegetation, and often so cunningly that the child, or anyone else, cannot make them out until they are pointed out to him—and then (this is the point) he can. With average luck, after the finger of someone in the know has traced the outline of the animal—'here are its eyes, here is one ear, this is the tail'—the child will then be in a position not just to *say* but also to *see* that there is a squirrel upside down in the bole of the tree, or that the clump of grass is, in part, a rabbit. A parallel case in the perception of art occurs in the case of attributions. Once we have been told who a painting is by, we can often see that this is so, though we might very well not have been able to do so without first having been prompted. We can now see that the Dresden *Sleeping Venus* is by Giorgione [URL50], though, if Morelli is to be trusted, before he pointed this out no one was able to.

Secondly, if it is now conceded that, as well as truths external to the work of art, any truth internal to that work may be included in the cognitive stock with which a critic approaches the work, provided only that it is perceptible, the question arises: Perceptible on the basis of what cognitive stock? And it arises forcefully, that is, unless an answer is given it, indeterminacy returns to the Scrutiny thesis. So the thesis needs further supplementation. And at this point there seems no reason why we should place any restriction on the critic's cognitive stock—so long, that is, as the end of critical inquiry remains constant. So long as we are committed to reaching an understanding of the work of art, there seems no reason at all for restricting the cognitive stock on the basis of which the critic comes to perceive how the work of art is.

8. So far the argument of this paper has proceeded by (1) accepting the Scrutiny thesis or its central tenet—that criticism must be grounded in the results of scrutiny—then (2) pointing out that if the theory is to be determinate, it requires to be supplemented by saying something about the cognitive stock on which scrutiny is based (just because there is an inescapable dependence of scrutiny or perception generally on cognition), and finally (3) progressively expanding the scope of the cognitive stock in order to achieve for the thesis reflexive plausibility. Anyone who has gone along with the argument should by now be in a position to accept my general point: that, if we think of the thesis as realized in different versions, each version corresponding to a particular characterization of the cognitive stock, the reflexive plausibility and the natural appeal of the thesis vary inversely. The more parsimoniously the stock is fixed, the greater the natural appeal of the thesis; but the more generously the stock is fixed, the greater is its reflexive plausibility.

However I also said that some part of the natural appeal of the thesis rests on an erroneous view of the place of perception in criticism, and that is something to which I now want to turn my attention. I shall do this via a direct challenge to the Scrutiny thesis, or to the view that criticism must be grounded in the results of scrutiny. Why, I shall ask, should there not be truths which are critically relevant, but which the critic could not come to know on the basis of scrutinising the work, no matter how enlarged a cognitive stock he has—even if, for instance, his cognitive stock includes the information that such truths hold of the work?

This challenge to the Scrutiny thesis might best be evaluated by considering one kind of truth about works of art whose perceptibility is at least problematic and whose critical relevance is the topic of a sizeable literature: that is, truths about the artist's intention. Much of this literature is, it must be said, muddied by the fact that no stable interpretation is placed upon the key term *intention,* which is used sometimes narrowly, rather in the ordinary-language signification of the term, and sometimes very broadly, to take in virtually the whole of the creative process or the biographical dimension of the work.

A well-known thesis about the critical relevance of the artist's intention is contained in a better-known article by Wimsatt and Beardsley. The thesis, which I shall call the antiintentionalist thesis, runs like this: An artist, in making a work of art, will form certain intentions. These intentions are in the course of time wholly fulfilled, wholly unfulfilled, or partially fulfilled, partially unfulfilled. If, or insofar as, these intentions are fulfilled, they are of no critical relevance. But to the extent to which they are fulfilled, they can be recovered from the work of art by scrutiny, and the only circumstances in which they can't be recovered from the work by scrutiny are when they are unfulfilled and hence critically irrelevant. Accordingly, that artists' intentions are sometimes critically relevant does nothing to upset the central tenet of the Scrutiny thesis. It does nothing to upset the central tenet of the Scrutiny thesis just because artists' intentions are never critically relevant per se. They are critically relevant, when they are, only because of the consequences they have.

But this antiintentionalist thesis has great difficulties.

In the first place, it is true that, insofar as the artist's intention is fulfilled in the work, it is perceptible there. But it may very well be perceptible only by those who already know what it is: it may be perceptible in, but not recoverable from, the work. In other words, it may belong to the same category as the animal representations in the children's drawings we have already considered. This is because the work provides evidence for fulfilled intention only in those parts which are themselves intentional. An example would be brushwork and the evidence it provides for the intention of the artist: the visible stroke is evidence for the intention of the artist, but only if its visibility is intentional. So for the critic to be able to infer from the brushwork to what the artist intended, he has to know that the visibility of the brushwork is not accidental.

But secondly, and more damagingly, if artists' intentions are ever critically relevant, it seems wrong to think that they are irrelevant just because they are unfulfilled. On the contrary, they are relevant so long as they have any bearing on the outcome. And they are limiting cases where they have no bearing on the outcome. Consider The Idiot. In this work Dostoevski set out to portray a perfectly good man. He failed. Prince Myshkin is not a perfectly good man. But in order to understand how he is portrayed, we have to understand the portrayal as the failed portrayal of a perfectly good man. Similarly, it can be crucial for the understanding of a work of art to have knowledge of an intention that was not merely unfulfilled but was actually abandoned. When an artist switches from one intention to another, the intention changed from as well as the intention changed to may provide insight into the nature of the work. An example is Rodin's statue of Balzac [URL51], which was originally planned as a male nude and was then realized as a heavily draped figure. Knowledge of the original intention, which could not, as far as I can see, be perceptual knowledge, is bound to bear on our understanding of the statue just because it allows us to grasp Rodin's notions of the heroic and the monumental.

This challenge to the Scrutiny thesis, this claim that there are truths that are critically relevant for a work of art but which aren't recoverable from it and may not, even in the most extended sense, be perceptible in it, requires two provisos: one restrictive, one ampliative.

The first, the restrictive, proviso derives from the end that critical inquiry sets itself, which I have identified as understanding. More specifically, it derives from that conception of the critical end which I have called retrieval. And it is this: No truth is critically relevant to a work of art simply because it permits the critic some new understanding of the work. For the new understanding might be a misunderstanding of the work. A truth that is critically relevant is one that allows the critic a correct understanding of the work—that is to say, an understanding that is appropriately related to the creative process out of which the work emerged.

The second, the ampliative, proviso derives from the fact that understanding a work of art—correctly understanding a work of art—can take two forms: it

can take the form of perceiving certain things in the work, and it can also take the form of perceiving the work in certain ways. A critic who recognises that the peculiar shape at the bottom of Holbein's Ambassadors is an anamorphic representation of a skull sees something in the work that another critic might not. However, a critic who experiences Monet's great paintings of the Seine at Vetheuil [URL52] as expressive of bereavement, mourning, and recovery sees these works in a way that another critic might not. The second proviso, then, is this: A truth is critically relevant to a work of art if it permits a critic either to perceive something in the work of art or to perceive the work in some way, which he might otherwise have overlooked—subject always to the first proviso, or the constraints of retrieval. In other words, critical relevance is conferred upon a truth only if, in permitting the critic to perceive something in the work or to perceive the work some way, which he might otherwise have overlooked, it permits a perception of the work as it is: the critic, that is, either perceives something that is actually there in the work or perceives the work in some way it actually is.

9. I return to the change of direction that this essay has recently taken, the change from supplementing the Scrutiny thesis to criticising it. So long as I did not question the view that criticism must ground itself in perception, but only pointed out that all perception presupposes a cognitive stock and then made suggestions about what the critic's cognitive stock should include, I was merely supplementing the Scrutiny thesis. But once I questioned the view that criticism should ground itself in perception, I showed myself a critic of the Scrutiny thesis—but, as it turns out, not a straightforward critic.

It is by being a critic, but not a straightforward critic, of the Scrutiny thesis that I reveal my disagreement with proponents of the thesis about the role of perception in criticism. Let me explain. I would be a straightforward critic of the Scrutiny thesis if I agreed with pro- ponents of this thesis about the notion of critical relevance, or what it is for something to be critically relevant, but disagreed about what things are critically relevant. But this is not my position. On the contrary, what I disagree with proponents of the Scrutiny thesis about is the notion of critical relevance or what it is for something to be critically relevant, and this disagreement at once makes me an unstraightforward critic of the Scrutiny thesis and reveals what I think about the role of perception in criticism.

According to the Scrutiny thesis, a truth is critically relevant if, in effect, it qualifies as evidence on the basis of which the meaning of the work of art can then be determined. In other words, understanding the work of art, which is the end of criticism, is conceived as an activity which is essentially inferential: it consists in arguing from certain premises to a conclusion which captures the meaning of the work of art. The role of perception in criticism is to supply the premises from which the argument, or inference takes off. Premises that aren't supplied by perception make criticism unsound.

Now the view of critical relevance that I would oppose to this starts off from a different conception of what it is to understand a work of art. Understanding a work of art is not an inferential activity or a matter of arguing from certain premisses to a conclusion: it is an activity of perception—and this indeed is the primary role of perception in criticism. Perception is what gives us understanding of the work, which therefore may be thought of as understanding not by description but by acquaintance. Accordingly, it cannot be the case that what it is for a truth to be critically relevant is for it to qualify as evidence for an inference to a conclusion which gives the meaning. For no such inference belongs to criticism. What is it, then, for something to be critically relevant? It is this: A truth is critically relevant to a certain work of art if it belongs to the cognitive stock that permits the critic to perceive the meaning of the work. Information that is critically relevant may have been supplied by perception—this would be a secondary role of perception in criticism—but it need not have been. And when it is supplied by perception, it is not this fact about it that makes it critically relevant.

To sum up my divergence from, or my unstraightforward criticism of, the Scrutiny thesis: According to the Scrutiny thesis (supplemented) we have (1) a cognitive stock on which the critic is entitled to draw in arriving perceptually at (2) critically relevant evidence, from which the critic may then (3) infer the meaning of the work. But on my view we have (1) a cognitive stock or a stock of critically relevant information, arrived at perceptually or by any other means, on which the critic may draw in (2) perceiving the meaning of the work. Instead of cognitive stock, critically relevant evidence, and inference to meaning, we have critically relevant information serving as cognitive stock, and perception of meaning.

Finally, I look at the way in which the natural appeal of the Scrutiny thesis—or rather, some part of it—is bound up with the mistaken role that the thesis assigns to perception in criticism. (I say some part of the natural appeal of the Scrutiny thesis, for I don't include that part of the appeal of the thesis which comes from its guaranteeing, or seeming to guarantee, the democracy of art.) For some part of the appeal that the thesis has for many comes from its preserving, or offering to preserve, criticism from arbitrariness. By grounding criticism in perception, the Scrutiny thesis prevents the critic from assigning meaning to a work of art on grounds that are at a remove from the work itself. But those whom the thesis reassures on this score are just those who fail to see that the very process of understanding, or assigning meaning to, a work of art, being a perceptual process, ensures such non-arbitrariness. Failing to see this, they look for reassurance in the way in which the 'premisses' or 'evidence,' from which the meaning of the work is allegedly inferred, have been gathered. But that is a will-o'-the-wisp. By contrast, once it is recognised that understanding a work of art is a perceptual activity, then the requirement of any constraint upon the cognitive stock, other than that nothing false should enter it, loses all force. For the worst that can happen is that, for some reason or other, the cognitive stock may seduce a critic into saying something about the work of

art that he does not see, hence into saying something about a work of art—either about something in it or about some way it is—which may not be there to be seen. Two 'mays,' neither of which may come about. But if this does come about, it is because the critic has departed from the proper method. In such cases something is wrong not with the method but with him. And, after all, no method guarantees its observance.

23

The Core of Aesthetics (1991)

This was originally presented at a 1990 conference sponsored by the Interpretive Studies Colloquium and the Interdisciplinary Humanities Center of the University of California at Santa Barbara, focusing on Reconceptions in Philosophy and Other Arts and Sciences *by Nelson Goodman and Catherine Elgin (Goodman's seminal* Languages of Art *appeared in 1968). It begins with a reflection on the evolution of aesthetics concerned with generic appraisals of beauty into a discipline concerned specifically with art—or rather, into a discipline which seeks to tame the motley of perceptual reactions to a work of art. Wollheim's is a less-than-laudatory account of the 'three or four dismal decades analytic aesthetics' running to the 1960s: 'The problem was that [... because of the Kantian focus on beauty] the phenomena of art were invisible,' that 'for it the distinctive character of art was irrelevant' (though one might pose John Dewey ((1859–1952), Susanne Langer, or Arnold Isenberg (1911–1965) in opposition; one might also protest that this ignores Kant's theory of art—of 'aesthetic ideas', which unlike the beauties of nature are cases of dependent beauty). The culprit was the Kant-related idea that we all possess aesthetic judgement placed on the individual, the viewer. Among the first texts to re-direct the nature of aesthetic questions was Goodman's* Languages of Art *(1968), which attempted to create 'a general theory of symbols'— artefacts with symbolic meaning, thereby focusing aesthetics squarely on works of art rather than the spectator's experience. Wollheim skips over Goodman's eminently questionable claim that 'autographic' arts—arts such as painting whose origins are essential, and therefore capable of being forged—are really amenable to being treated as a type of language. Rather, he focuses on the question of whether 'allographic' arts, such as poetry and music, are really identified as Goodman thinks by their being inscribed sequences of words or notes; or whether by contrast they are identified by involving their circumstances of production. Wollheim thinks that common sense strongly favours the latter, and gives the example of a Southern Californian youth who happens to write a poem word-for-word the same as a well-known—though not to him of course—medieval quatrain.* [Eds]

Uncollected Writings. Richard Wollheim, Gary Kemp, and Elisabetta Toreno, Oxford University Press.
© Bruno Wolheim 2025. DOI: 10.1093/9780191995767.003.0023

The core of aesthetics is the study of art: of art in general, and of the general aspects of works of art in particular. If this now seems obvious, it did not seem obvious in the late sixties when *Languages of Art* was being written and Goodman's formidable philosophy of art was maturing.

It is true that there are many things that prepare us for art: our interest in our inner states and the way they manifest themselves; our involvement with nature and the way we project ourselves upon it and it impinges upon us; our curiosity about others and how they see the common world we inhabit; and our delight in human ingenuity, which often seems to please us as much in others as it does in ourselves. I do not think that aesthetics can deal with its proper subject matter unless it can find something to say about these topics, but these topics are *not* its proper subject matter.

That the proper subject matter of aesthetics is the nature of art, was, I have said, not something at all obvious in the late sixties, and it is interesting to reflect why this was so. The reason did not lie just in the way in which aesthetics was defined or conceived. If it had, then there would have been nothing easier than to redefine, to reconceive, aesthetics and then to see whether this caught on. The problem was that, from a philosophical viewpoint, the phenomena of art were invisible: hence there was no available way of redefining aesthetics as the study of these phenomena. The phenomena of art had been submerged in the general mass of inanimate nature, and they needed to be dredged to the surface and identified before a philosophical inquiry could take them as its subject matter. Before aesthetics could be redefined, art had to be re-discovered: re-discovered, that is, for philosophy.

Let me expand: aesthetics was defined as the study of the aesthetic judgment, a judgment being what is asserted by a well-formed string of words. The string of words associated with the aesthetic judgment was, as a matter of general agreement, identified as being of the general form 'x is beautiful,' or some near-variant upon it. Now, though such a judgment was recognized to be applicable to works of art as well as to tamed or untamed nature, this did not seem to anyone to constitute a good reason for aesthetics to concern itself with the distinguishing properties of art. For, after all, the predicate 'beautiful' is (it was said) univocal over art and nature—so why worry about what is distinctive about one part of its extension? The claim of art to the attention of aesthetic philosophy would be rather like someone rising up and claiming that perceptual theory could make no further progress until we had established distinguishing properties of lions against tigers. Why is that necessary? it would be asked. Because seeing lions is significantly different from seeing tigers. No, the reply would run, seeing lions is, from a philosophical point of view, insignificantly different from seeing tigers. In both situations 'see' is used univocally. Not perception itself but the philosophy of perception is and must be lion-blind and tiger-blind. Similarly aesthetic philosophy is and must be art-blind. How this situation had come about was through the desire to generalize what was taken at the time to be the triumphs of analytical moral philosophy in

its self-set task of analysing the moral judgment. Today those triumphs may seem dubious, They did not seem so then, and the task, therefore, was to find for aesthetics a mission comparable to that which moral philosophy was in the process of accomplishing. Nothing easier: aesthetics was to analyse the aesthetic judgment. But here, even at this early stage, the task starts to curl back upon itself. For, if the analysis of the aesthetic judgment was taken to be a task promisingly parallel to the analysis of the moral judgment, the analysandum, the aesthetic judgment itself, was something, if not altogether conjured into existence, then artificially sustained far beyond its vital resources, just in order to support the parallel.

The artificiality of the aesthetic judgment, or its notional character, comes out very clearly in what were held to be the points of similarity to and of difference from the moral judgment: that is, in the comparison upon which the identity of the aesthetic judgment was based. The two kinds of judgment were held to differ in what they were about and in what follows from them. The aesthetic judgment was about the inanimate, and it had no consequence for action, whereas the moral judgment is about the human and has practical consequences. However, it is the similarities between the two kinds of judgment that are the singularly telling and the singularly contrived part of the story. Neither judgment being factual, the relationship in each case of the judgment to fact was held to be tenuous. In the case of the aesthetic judgment in particular, there was a powerful alliance between positivism or verificationism, on the one hand, and, on the other, a Kantian commitment to the democracy of aesthetic pleasure so that, no matter precisely how the judgment was interpreted, one thing that was felt to be clear was that it did not presuppose, indeed it renounced any assistance from, special knowledge. In this way, aesthetics was further immured, it was doubly locked up, in the conviction that *for it* the distinctive character of art was irrelevant. In the eyes of that very branch of philosophy which, if I am right, should take art as its subject matter, at whose core it resides, art, quite simply, did not exist.

The conception of aesthetics and its subject matter that I have been sketching remained the dominant ideology within analytical philosophy for three or four dismal decades, and it should be apparent that rescuing aesthetics involved, in the first instance, rescuing art; and it is, I believe, in this connection that the historical significance of *Languages of Art* is to be located. It pulverized analytical aesthetics as it had been practiced, and in doing so, it brought art this side of the philosophical horizon.

In more substantive terms, *Languages of Art* did two things. It demoted the spectator, whose immediate responses, whether to nature or to art, could no longer be accepted as the raw starting point of philosophical inquiry. And it restored to art one crucial property that had been denied it: meaning, or content. These two maneuvers clearly interlock. Indeed each precipitates the other. For once we cease thinking of the spectator's reactions to what is before him as that which is of primary importance, then our interest is likely to turn from these reactions and

to address that to which he reacts; and then the difference between nature and art, hitherto philosophically insignificant, is likely to show up; and, when it does, the fact that art has meaning or content, however art may come by its meaning, whereas nature doesn't, will seem a large part of that difference. Alternatively, if we start from the other end, once we credit art, in contradistinction to nature, with meaning, then we shall no longer be inclined to think of the immediate, let alone the uninformed, responses of the spectator to art as matters of primary importance, and we are likely to attend to these responses only insofar as they are mediated by whatever it takes to understand art.

Two phrases in the above need detain us: 'however art may come by its meaning,' 'whatever it takes to understand art.' For there are two broad routes along which art might be thought to acquire meaning. The meaning of a work of art might be teleological; alternatively, the meaning of a work of art might be semantic. (Either way round, there would be more to aesthetics than the analysis of the aesthetic judgment.) However, any appeal to purpose in the domain of art has always been found, even in the ablest hands, massively underdeterminative of meaning. Not merely are there some works of art that are evidently without purpose, but, even if we confine ourselves to those which have a purpose, this purpose is adequate to explain only the grosser properties they have. I am thinking of Renaissance altarpieces or the great dynastic cycles of sixteenth- and seventeenth-century European art. If works of art have meaning, it must be semantic. This is Goodman's view, and I am in wholehearted agreement with him. Does our agreement stop at this point? This is the question to which I shall devote the rest of this essay.

It was in keeping with the broad approach I have sketched—that, just as art lies at the core of aesthetics, so does meaning lie at the core of art—that I was led in 1984 to try to work out, admittedly for just one art, the art of painting, an account of artistic meaning.[1] Let me stress the point that, though this account was indeed worked out exclusively for painting, it can be, with sufficient sensitivity, sufficient ingenuity, generalized over the other arts: or such was and is my hope. It can be, for instance, generalized over the literary arts. The point of making this point at this stage is the following: the literary arts are, of course, in language. Accounts of linguistic meaning are available. But it seems to me error to conclude that even a good account of linguistic meaning is the proper point of departure for an account of artistic meaning in the literary arts. Understanding a poem is not a mere matter of understanding the words or sentences out of which the poem is constituted, nor is understanding a poem a natural expansion of understanding these words and sentences. We can't understand the poem unless we understand the constituent words and sentences, but understanding what it is to understand language could still leave us totally in the dark about what it is to understand poetry. This very

[1] Richard Wollheim, *Painting as an Art: The Andrew W. Mellon Lectures in the Fine Arts, 1984* (Princeton, NJ: Princeton University Press, 1987).

simple idea is not, I believe, accepted by everyone: and I mention it here only to indicate how I think any generalization of what *Painting as an Art* has to say about meaning would go. I want to suggest the level at which such generalization would be negotiated.

And now back to what *Painting as an Art* does have to say about artistic meaning. I shall try to formulate in a few propositions the basic nature of that account and, in doing so, I shall be influenced by an idea that I take to be ultimately traceable to Frege. The idea is that, within any such account, we cannot separate the issue of what it is for something to have meaning from the issue of what it is that has meaning. An account of meaning will have something to say about both issues.

With this in mind, the overall account of artistic meaning embodied in *Painting as an Art* could be set out as follows:

1. Each work of art has its own, its one and only, meaning;
2. this meaning is fixed by the fulfilled intentions of the artist, where intention is used broadly to refer to the desires, beliefs, emotions, phantasies, wishes—conscious, preconscious, and unconscious—that cause the artist to make the work as he does;
3. the artist's intentions are fulfilled insofar as the work of art that they cause him to make causes in a suitably sensitive, suitably informed spectator the appropriate experiences; and
4. the work of art that is the bearer of meaning thus fixed is identified in part by its history of production.

Now on the face of it an account of artistic meaning framed through those four propositions is surely one that is inconsistent with Goodman's philosophy of art. He cannot agree with it. However, there is a kind of disagreement in philosophy that is either fundamental or largely illusory, and in such cases it is often difficult to tell which. The explanation of such disagreements is in turn, often enough, that the two positions that confront one another arise within different metaphysical frameworks. Something which interests me deeply, and has done so since my first public discussion with Goodman on his philosophy of art in December 1969,[2] is how far Goodman's views are fused with, and how they are separable from, his irrealism and his nominalism.

Let me, first, label the four propositions that I advocate. The first proposition, or that each work of art has its one and only meaning, I call the *Principle of Integrity*.[3]

[2] 'Nelson Goodman's *Languages of Art*', *Journal of Philosophy*, 72.16 (20 Aug. 1970), pp. 531–9, reprinted in a much-expanded form in Richard Wollheim, *On Art and the Mind* (London: Allen Lane, 1973; Cambridge, MA: Harvard University Press, 1974).

[3] I have preferred the term 'integrity' to the word 'univocality', which I used at the Reconception Conference. 'Univocality' appeared to deny ambiguity, and the artist might certainly make his work ambiguous.

The second principle, or that meaning derives from the fulfilled intentions of the artist, I call the *Principle of Intentionalism.* The third principle, or that the intentions of the artist are fulfilled in the appropriate experiences of the spectator, I call the *Principle of Experience.* And the fourth principle, or that all works of art possess intrinsically a history of production, I call the *Principle of Historicity.*

Now I have no difficulty whatsoever in seeing how Goodman could, out of his developed philosophy of art, argue against these four propositions. I imagine him arguing in the following fashion: First, he would maintain that there is no good reason to believe in the Principle of Integrity unless we also believe in the Principle of Intentionalism, for what else could possibly fix one meaning, or one right interpretation, for each and every work of art except the intention of the artist who made it? But (Goodman might continue) the Principle of Intentionalism must be rejected, if only for this reason: that it requires something close to the Principle of Historicity to be true—it requires, in other words, that each and every work of art has intrinsically an artist or an author, whose intentions contribute to the meaning of the work. But (Goodman would continue) the Principle of Historicity is false: certain works of art, i.e., works in the so-called allographic arts, in virtue of the kind of thing that they are, cannot have intrinsically a history of production. By this stage of the argument, the Principle of Experience looks woefully isolated. And all that Goodman has to do is to insist that the Principle of Experience is gratuitous in that what it seeks to achieve is better explained by the functioning of the symbol system to which the work belongs, and further, it is impotent in that what it presses into explanatory service is compromised if we are appropriately irrealist about the mental.

So I can imagine the argument going. But the question is, Need it? In other words, is there any point at which the untenability of the conclusion might lead Goodman to retrace his steps and reconsider the premises from which the conclusion is derived? And, if there is, could those premises be adjusted without major disruption of his system of the arts as a whole? I should like for the purposes of these exchanges to raise two points.

The *first* point is this: For me it is unthinkable that we should reject the Principle of Historicity. I shall in a minute come back to the reasons. Now, if I am right in my reconstruction of Goodman's thought, all that stands in the way of its being accepted within his philosophy of art is the particular way in which he lays down criteria of work-identity for the multiple arts. Within those arts work-identity is established solely through a syntactical description of a text or score plus the semantic notion of compliance. But why could not we append to any such identification of a work an ineliminable reference to the work's history of production, i.e., author and date? Admittedly this would run counter to the informal way in which Goodman introduces the allographic arts: that is, as those arts where the possibility of forgery does not arise. But the addition that I suggest could readily be accommodated to the more formal account, which is that on which Goodman relies.

I have proposed emending the conditions of work-identity for the multiple arts along the lines suggested in the interest of preserving the Principle of Historicity; so the question arises, What is the appeal of this principle? The intuitive appeal of the principle rests on two closely linked considerations. First, there is the fact that, in the normal course of events, we think that the relationship between a piece of music and its composer, or between a poem and its poet, is in no way less intimate than that between a painting and its painter. Second, the way we characteristically judge or esteem works of art—singular *and* multiple, autographic *and* allographic—in fact presupposes that there is in all cases an equally intimate relationship. We presuppose such an intimate relationship when we say that a certain work of art is original, or that it shows signs of immaturity, or that it is a characteristically late work, or that it repudiates the values in which the artist was raised, or that it is an attempt to placate enemies or recapture early successes or discomfit rivals.

To the first of these two considerations Goodman gives, as I see things, no answer. To the second he would reply that the judgments that I cite can be made even if works of art are not identified by reference to their history of production. All that is necessary is that works of art actually have a history of production. And according to him all works of art *do* have a history of production: autographic works are identified by reference to it, whereas allographic works have it contingently. And here it may very well be that metaphysics obtrudes into the issue. For many philosophers, including myself, if a multiple work does not have a history of production essentially, it is hard to see how it can have one at all. For, if it is not identified in part historically, it will collapse into a sequence of notes, a string of words, a succession of steps, etc.; and these surely are eternal or timeless objects without a history of production. But not so for Goodman. For at this stage, as Catherine Elgin has pointed out to me, Goodman's nominalism—more specifically, his inscriptionalism—comes to his rescue. For what we call a sequence of notes is, for Goodman, a class of inscriptions, and a history of production can now be recaptured for the work by equating it with the history of the first inscription. Whether this method of historicizing multiple works always gives them the right history of production, or the history that would justify judgments of originality, lateness, etc., is another matter.

Something that Goodman has against the Principle of Historicity—though whether this is something that motivates him or is for him a bonus of his position is uncertain—is that this principle concedes the possibility of there being two different multiple works of art, syntactically identical and distinguished solely by their histories of production. But is it so clear that this is the monstrosity that Goodman takes it to be? Is it even so clear that it is something we should reject?

The discussion of this point has often been obscured by the consideration of far-fetched cases: supremely in Borges's celebration of Pierre Menard, author of the second (and superior) *Don Quixote*. Goodman fuels his argument by going back

to this very example. Consider by contrast the following case. A late medieval poet wrote the great lyric:

> Western wind, when will thou blow
> The small rain down can rain?
> Christ, that my love were in my arms
> And I in my bed again.

And now imagine that, five centuries later, today in fact, a southern Californian poet, a one-time English major with a self-conscious love of the deathless parts of the language, someone torn between sunbathing and lovemaking and who allowed the weather to arbitrate between his two great pleasures, should, at the end of a day's endeavour, after many false starts, many scratchings out, write out on his pad of yellow paper a quatrain that, word for word, comma for comma, line for line, reduplicated this great medieval poem—which, incidentally, no one had introduced him to in his college days. Couldn't he rightly claim that the words he had written down constituted a poem that *he* had written—though they also constituted another poem that another poet had written all those years before? And couldn't we, knowing these two histories of production, find in the two poems different sources of pleasure and edification? If someone—Goodman, say—were to ask, at this stage, how we could distribute different inscriptions (different tokens as I would say) between the two different poems (the two different types), I should again appeal to history of production: this time, of course, to the different histories of the inscriptions. I should, in other words, appeal to the intentions of the typesetter or the publisher.

And now to the *second* point that I want to raise. It is this: Goodman, I have suggested, would reject the Principle of Integrity on the grounds that he found no reason to accept it in the absence of strong support for the Principle of Intentionalism. Now, it is true that for someone who rejects intentionalism it is permissible to reject the Principle of Integrity. But why take advantage of this permission? Goodman offers the following argument: 'Multiplicity of meaning, subtle and complex ambiguity, is frequently a positive and vital feature of literary, as opposed to scientific, discourse. We disparage *Ulysses*, or even *Ozymandias*, if we suppose that it can be correctly construed in just one way.'[4] I do not see that what Goodman wishes to preserve for the arts requires rejecting the Principle of Integrity. What is necessary is to grasp what this principle does (and does not) require of us, and then to see how this stands to our critical needs. Let us first distinguish between, on the one hand, a single interpretation that attributes ambiguity to a work of art and, on the other, two or more rival and incompatible interpretations

[4] Nelson Goodman and Catherine Z. Elgin, *Reconceptions in Philosophy and Other Arts and Sciences* (Indianapolis: Hackett, 1988), p. 55.

each of which seeks exclusively to give the meaning of the work. Now, there is no reason why the one and only meaning that the work has to itself should not be shot through with ambiguity. There is no reason why this meaning should not be layered; and there is no reason why, once these layers have been excavated, it should be clear how they fit together.

The Principle of Integrity can allow all of this, and what it cannot allow, or that there should be two incompatible interpretations both of which are correct, is surely something for which we have no critical need. But even here we must be circumspect and distinguish carefully between the meaning of a work of literature and the formulation of this meaning or how it is presented or packaged for this or that audience, for this or that generation. There may well be pressing historical reasons why the one and only meaning of a work of art (ambiguous or otherwise) has to be reformulated over time if the work is to continue to make the appropriate impact upon the spectator's experience.[5] And, once again, the Principle of Integrity finds no difficulty in all this.

For critics the Principle of Integrity is permanently an uneasy matter. It threatens their livelihood. For artists it is the only hope in a world given over to carelessness, indifference, indolence, and envy. It is their lifeline. One of the many, many reasons why I looked forward to the performance of *Variations*[6] was to observe which way Goodman would leap when his own work was at the mercy of the interpreters and the misinterpreters. Goodman the artist versus Goodman the philosopher! For this multiplicity of roles we honour him.

[5] I have emphasized this and related points in Richard Wollheim, *Art and its Objects, 2nd edn with Six Supplementary Essays* (New York: Cambridge University Press, 1980), Essay IV, 'Criticism as Retrieval'.

[6] *Variations* was an 'illustrated lecture concert', built around Goodman's lecture on 'Variations on Variation: Picasso Back to Bach'. [Eds]

24

Why Is Drawing Interesting? (2005)

This article reproduces a talk that Wollheim gave in September 1998 at Loughborough University. The question of the title is one of the chief aims of Wollheim's writings on art to answer. He first defends essentialism, not of art per se but of the individual arts: 'Mere designation, designation of some practice and its materials as art', he says, 'settles nothing, whatever certain thinkers say.' We must rather advert to 'a corpus of serious work, issuing from some recognizable and repeatable process, and expressing some worthwhile human meaning in an accessible form' (though Wollheim is quick to add that the ways in which they conspire to produce meaning are relative to history). In the case of each art, art materials are turned into media that resonate with human psychology. In the case of drawing in particular—after a quick explanation of the role of seeing-in—comes a surprising and deeply compelling link with style, in the bodily sense discussed in other essays in this volume: Reminiscent of Croce, he says: 'We do not merely draw with the eyes: we draw for the eyes.' Aside from strict 'delineation'—the rendering only of outline shape—drawing must be 'understood through the co-operation between artist and spectator [which crucially includes the artist himself], and, in both cases, it is ultimately the hand of the artist that has to respond to the eye of the spectator'. The substance of this can only be learned 'patiently looking at drawings'; here we see the 'triumphs […] of the embodied mind'. [Eds]

1. The question that I want to consider in this talk is: Why are drawings interesting? More precisely, I want to ask: Why are interesting drawings interesting?, because, as you all know, there are many drawings that are completely without interest. And still that doesn't quite get to my question. For there are a number of ways in which a drawing might be found interesting: as a social document, as a transcription of a landscape now vanished, as a memento of a great man, as a reminder of an old love. These are not my concerns. So my question is really: What makes drawings, some drawings, interesting *as drawings*?

2. In asking this question, I have chosen the word 'interesting' carefully. Let me explain. To find a drawing interesting is to evaluate it, and there are, I believe, two

Uncollected Writings. Richard Wollheim, Gary Kemp, and Elisabetta Toreno, Oxford University Press.
© Bruno Wolheim 2025. DOI: 10.1093/9780191995767.003.0024

broadly different ways in which we can evaluate works of art. There are two different kinds of artistic evaluation. Traditional aesthetics has clung to the view that there is only one kind of artistic evaluation, and that is evaluation that issues in judgements of beauty. Modernist aesthetics has been fixated on the second part of this tradition, and has, rightly, faulted this emphasis on beauty for its narrow-mindedness. To treat all art as aspiring to the condition of the beautiful is in effect to impose upon the artist a quite absurd restriction as far as the subject-matter that is open to him. It would exclude much of the material that has inspired the artist of the last hundred and fifty years: the modern city, and its teeming chaos, the life of the poor and the outcast, sexuality in all its varieties, violence, suffering and war, and the mute tribute exacted by quiet domesticity.

But my argument against traditional aesthetics goes beyond this particular criticism. Traditional aesthetics is not simply in error over the criterion of evaluation: more fundamentally, it overlooks the diversity of evaluation.

3. What then are these two kinds of evaluation to which works of art are subject? *There is a kind of evaluation that issues in a judgement of quality, and there is a kind of evaluation that issues in a judgement of interest.*
If this seems a clumsy way of putting the matter, it is designed to avoid what is still a common error. For reasons that are internal to the development of philosophy, there has been, in much twentieth-century aesthetics, specifically in that part of it called analytic aesthetics, a tendency, dogmatically supported, to equate evaluation, which is surely a complex internal process, involving various parts of the mind, or different faculties, with a judgement, with, that is, something that we say. This seems to me a dangerous simplification, or abbreviation, for though, in many circumstances, this process is likely to culminate in something that we say, there are circumstances in which it will not. And what we say, the judgement we make, will never exhaust the process.

However, while distinguishing between the evaluative process itself, and any judgement that we might make on the basis of it, I go along with the view that I am rejecting to this degree: that an effective way we have of identifying the two kinds of evaluation is by reference to the content of the judgement in which they might issue.

That is why we can, I maintain, think of one kind of evaluation as an evaluation of quality, and the other kind as an evaluation of interest.

4. So now to the two kinds of evaluation. What are they, and how do they differ? Evaluations of quality have two distinguishing characteristics. They are responses either to specific points of craft or execution in a work, or to some overall effect it induces, and these responses are sensuous responses tinged by a specific kind of pleasure.

These two characteristics are not independent of one another, for it seems clear that the kind of pleasure invoked cannot be understood without reference back to the things responded to. In other words, in explaining the pleasure, we would have to say something like, 'It is the kind of pleasure that things like skilful

craftsmanship, or fineness of execution, or a poignant effect, can prompt. . .'. However, there is also more to be said about the pleasure than what prompts it, and what more there is to be said frees the account of *narrow* circularity. The first thing to be said is that the capacity to feel such pleasure is something that we can acquire, and we acquire it through exposure to those things which ultimately prompt it, such as skilful craftsmanship, or fineness of execution, or poignancy of effect. Secondly, the things through which this capacity can be acquired are not confined to works of art. Indeed they are not confined to human artefacts. Nature is a nursery in which we learn to respond to the quality of art.

Evaluations of quality then at once range over all the arts (and more), and they do not presuppose any specific knowledge, or understanding, of the art to which the work in which quality is found belongs. In traditional terminology, not to be despised, evaluations of quality are exercises of taste: taste signifying, not, as is sometimes assumed, a precocity of response, but a full-blooded sensuousness.

5. Something very different is the case with evaluations of interest. When a work of art is evaluated as interesting—and, in this context, interesting and boring are the relevant opposites—what is specifically taken into account is the extent to which the methods and the resources of the particular art to which the work belongs have been fruitfully exploited. And exploited here can only mean that the method, the resource, has been put to some use that the artist has in mind. It is when this kind of exploitation occurs that the work acquires interest.

I stress this last point because there circulates another view of the matter according to which interest accrues to a work when one of the resources of the art to which it, or the work in question, belongs is *asserted* or *made conspicuous*: it is not necessary for the artist to make any use of it. An example of this view of the matter is to be found in Clement Greenberg's claim on the part of the painting of his day that it asserted the flatness of the surface. Fortunately for the enduring reputation of the New York School, some of its members in their art went beyond what Greenberg seems to have thought sufficed for interest.

Evaluations of interest have then a less immediate connection with our sensibility, and with pleasure—though here I stress the word 'immediate', for, in someone devoted to the art in question, the connection can be as strong—and such evaluations are made within, and are intended only to hold within, the framework of a given art. Works of art are interesting or boring *qua* works of a certain art.

Finally, I shall claim that, though this claim goes massively against the contemporary grain, it is not at all clear how evaluations of interest can be accorded sense unless we simultaneously take an essentialist view of the arts. I do not mean an essentialist view of art itself: though that too may be required. I mean an essentialist view of each particular art.

6. What is it to take an essentialist view of the arts? The fundamental commitment involved in taking an essentialist view of the arts is to hold that, for every art,

there are certain necessary truths, certain truths that could not be otherwise, that do not derive from mere stipulation, or from the definition of the term for the art. On the contrary, there are truths about each art that arise from its nature, or from what makes the art the very art that it is and not another art.

Now, if there are such truths, at once necessary and non-trivial, whence do they arise, or—the same question—how are they grounded?

I believe that the clearest way of answering this question, or of demonstrating essentialism about the arts, goes somewhat as follows:

At the core of every art, there is a medium. What is meant by a medium is a set, perhaps an open set, of materials, whose use has, in very broad terms, been codified. Codifying how certain materials are to be used includes things like the following: Saying what properties of the materials count, and why, and how these properties are, in the most general way, to be organized. So, for instance, within painting, the look of the paint counts, but its smell, and its taste, don't: and marks of paint are to be organized laterally on a support, and in a way that is, to some degree, under the influence of the hand. Within music, by contrast, only the acoustic properties of notes count, and notes are organized temporally. In each case, the codification of the medium comes with a rationale. Things are ordered as they are in painting, because painting is addressed to the eye, and things are ordered as they are in music, because music is addressed to the ear.

However, if there is, for each art, a medium that is its core, it certainly does not follow that the art can be equated with the medium. In fact, in no case can it be. An art arises only when a medium is inserted into a cultural, or human, context, and is appropriately related to human nature or psychology. In fact, the medium needs to be related to human nature twice over. It needs to be related, in the first place, to the artist, and his psychology and, secondly, to the spectator, and his psychology. It needs to offer the artist, or allow him to find, ways of realizing intentions that he values, and it needs to offer the spectator, or encourage him to have, experiences that, in addition to the value that they have for him, will match the artist's intentions.

The necessary truths about each art, which underpin essentialism about the arts, arise from the complex interaction between (i) the nature of the medium, (ii) the nature of human desire, as this seeks realization, and (iii) the nature of human perception, as this sets limits upon what is intelligible to the senses.

In one important respect, I lay myself open to a misunderstanding, which I wish to anticipate. It is crucial to recognize that, for each art, there are some necessary truths that hold only at a certain place or at a certain time: they are culturally, or historically, conditioned. That this should be so derives from a necessary truth about the arts, which is itself ahistorical: namely, that all arts have a history. The need for improvisation, central to the arts if they are to continue to speak to us, drives them forward, at whatever pace.

I am now in a position to turn to drawing to illustrate, necessarily in a very superficial way, what I have been saying about evaluations of interest, and the way they are grounded in an essentialism about the arts.

7. I hesitate. For I know that I cannot totally ignore the resistance that, I am sure, is building up against what I have been saying. I know that there will be many ears to which it will sound strange to hear someone at the end of the twentieth century engaged in defending essentialism in the arts. The conventional view is that, at some crucial moment in the course of these last hundred years, essentialism in the arts was refuted. Some will give the credit for this achievement to Picasso, some to Wittgenstein, some to Duchamp, others to others. However, though these different attributions in turn presuppose very different conceptions of what this refutation involved, or indeed of what was refuted, there is general agreement that it was a conclusive refutation. And here am I, talking as though no such thing had happened.

However, it seems to me evident that a great deal of the history of twentieth-century art requires the very essentialism that so much of current so-called theory rejects. Take just one strand in that history. In the last few decades, we have witnessed the arrival on the art-scene of a miscellany of different practices and procedures, on the part of which strenuous efforts have been made to get them accepted as art-forms. I am prepared to take these efforts seriously, and at their face-value. That being so, as far as I can see, the only framework within which this whole discussion makes sense, and could be rationally resolved, is that provided by essentialism.

If we wonder whether assemblages, installations, earth-art, performance-art, conceptual art, video-art, will survive, not just as hobbies, not just as technology, but as art, we all know that there is nothing for it but to wait and see. But, when we do, the big question is: What are we waiting for? What will there be to see which will convince us, or convert us when it heaves into sight?

On this score, there are, I believe, two things to be noted.

The first is this: Whatever it is that happens of which we can say that it is what we have been waiting for, it will most certainly not be, as some would have it, the *fiat* of some institution or somebody of empowered critics. Mere designation, designation of some practice and its materials as art, settles nothing, whatever certain thinkers say. The only thing that can settle the issue will be a corpus of serious work, issuing from some recognizable and repeatable process, and expressing some worthwhile human meaning in an accessible form.

Secondly, the process must be structured in the way that, as I see it, essentialism requires: that is, it must generate a medium, which is appropriately related to human nature. Nothing follows if the work results from certain material processes, but we have no confidence whatsoever about how these materials will be used in the future, and equally no confidence that they can continue to be the bearers of meaning.

8. So at last to drawing. The simplest way in which the medium of drawing can be used is to make a mark. However, special circumstances apart, making mere marks, or making marks that are made merely as such, and are intended to be seen merely as such, is preparatory to the art of drawing. But it is not itself drawing. It is not itself drawing, just because it is as yet quite unrelated to human nature.

The most common way in which the medium of drawing can be related to human nature is when (i) an artist makes marks so as to *represent an object*, and (ii) an appropriate spectator can *see that object in the marks*. When this happens, it is important to realize that what I have set out as two things are standardly not two independent things, nor is the convergence between what the artist does and what the spectator sees a happy coincidence. On the contrary: The convergence is anticipated in the very posture that the draughtsman traditionally adopts when he draws—that is to say, he faces the sheet, with his eyes open, and his eyes follow the progress of his pencil across the sheet, and the deposit that it leaves. For this traditional posture at once facilitates and explains the convergence. In adopting the posture, the draughtsman makes this commitment: that ultimately nothing will count for him *qua* artist as realizing his intention to represent a certain object unless *qua* spectator he has the experience of seeing that object in his emergent drawing. Indeed nothing will count for him as even trying to represent a certain object unless he is prepared, at every moment, to modify what he does, or how he moves the pencil across the sheet, so that what he sees when he looks at the sheet comes to tally with what he intended.

One way of characterizing the traditional posture is to say that it clarifies the role of the eyes in drawing.

If it is said that we use our eyes in drawing, that is true, but there are many things that we do in which we use our eyes. And how our eyes are recruited to the task can vary greatly. In some cases, such as dressing in the morning, we use our eyes, but only after the fact. We use them only to check on what we have already done without our eyes. Next there are cases where the use of the eyes is less minimal. When we drive a car, we couldn't do what we do without simultaneously, and in concert, using our eyes. We couldn't, without mishap, drive first, and look after-wards. In such cases, we do what we do *with our eyes*. But there are cases that go beyond this, and this is where drawing comes in. When we drive a car, the criterion of success for what we do is laid down independently of the eyes: we have to keep the car on the road. But, in the case of drawing, it is the eyes that determine the criterion of success. We do not merely draw with the eyes: we draw *for the eyes*.

9. I return, with this last thought much in mind, to the drawing of an object. I start from what is in effect the most basic way of representing an object, which is that of making visible its shape. Often referred to as delineation, it depends upon a degree of co-operation between artist and spectator, and their psychologies, which often goes unrecognized.

The artist begins by banishing from his attention any kind of spectator except one, and that is the spectator who sees every line that the artist makes as having the function of rendering the silhouette of the object that he is endeavouring to represent. Then, for the benefit of this spectator, he tries to show what in the real world the object would occlude, or obscure from view. To do this, he gets as close as he can, correcting his drawing when he thinks he is departing from it unduly, to the practice that a number of theoretically minded Renaissance artists used as a means of introducing the rules of single-point perspective. In other words, he imagines the sheet of paper in front of him to be a piece of transparent glass inserted, at right angles to his line of vision, between him and the object that he is representing, and on it he then proceeds to draw, as best he can, the outlines of the object as he would see them through the glass.

Delineation and its aims and limitations are neatly enshrined in one of the various ancient myths about the origins of the visual arts, recounted by Pliny, which traces them back to the potter's daughter, who tried to retain her lover by drawing round the edge of the shadow that he cast upon the ground.

In its pure embodiment, this mode of drawing is unlikely to be found satisfactory either by artist or by spectator. Only in rare circumstances—and then, as often as not, by conspicuously omitting what it thereby recognizes as important—will it convey everything that the artist is concerned to transmit about the object, or everything that the spectator would wish to know. Drawing, the medium of drawing—will be the prevailing feeling—has been underutilized.

The next natural step is to devise ways in which delineation can be supplemented so that it is more fully implicated with human intentions and human expectations, hence the status of drawing as an art can be more firmly grounded. Various drawing procedures can be found that fulfil this role in that they do better justice to the third-dimensional aspect of the object represented: what we might call the *form*, as opposed to the mere *shape*, of the object.

These procedures can be arranged on a spectrum running from, on the one hand, those that still involve no more than line, though line is now released from the sole function of rendering the edges of objects, or silhouette, and is put to such uses as cross-hatching, to, on the other hand, procedures that replace line, and employ tone. Procedures that are at one end of this spectrum take on the task of trying to render the different planes within the confines of the object, something which silhouette ignores even when these planes abut onto the edge of the object, while procedures at the other end of the spectrum are, in the main, concerned with the modelling of form by reference to the relative illumination of the surface, going from light, to half light, to shadow.

10. But I want to bracket these different ways of supplementing delineation, important though they are, and turn to what is thought of—and rightly, to my mind—as a new mode of drawing, and hence as an *alternative* to delineation: though it is

important to recognize that there is a broad band of borderline cases, which resist clear classification.

Within this new mode, the most interesting procedures, though also the most puzzling, are those where, not only is line paramount, but line is still used predominantly to render the edges of the object. But now line (i) no longer is intended by the artist simply as a way of giving the silhouette of the object, and (ii) is seen by the spectator as showing where the form of the object turns away out of the viewer's sight, and continues unseen into depth.

One term for this mode of drawing is form-drawing, and the kind of line on which it frequently depends is called sculptural line, and it is important to recognize that the shift from delineation to form-drawing has much in common with the earlier shift from merely making marks to delineation. It is an outreach to further, if still basic, human interests and needs. And, since I have already invoked Pliny, let me do so again. For it is interesting to find that a classical author, and, if he is to be believed, some classical artists, were fully aware of the sculptural line, and the lift that it gave to visual art. Pliny writes:

> Merely to paint a figure in silhouette is no doubt a great achievement, yet many have succeeded thus far. But where an artist is rarely successful is in finding an outline that shall express the contours of a figure. For the contour should appear to fold back, and so to enclose the object as to give assurance of the parts behind, thus suggesting even what it conceals. Preeminence in this respect is conceded to Parrhasios by Antigonos and Xenocrates, writers on painting, who indeed not only concede but insist upon it.

But what, we may ask, is sculptural line?

We may take, as a starting-point, a variety of suggestions that come down to us from the practice of the great Italian artists and others about how to produce the sculptural line. So, from a study of their drawings, we may cull the following ideas: The sculptural line results only when the lines corresponding to the opposite edges of the object are subtly adjusted to one another. No matter how faithful each line—say, that giving the right-hand edge, or that giving the left-hand edge, of the object—is to the silhouette of the object, without some reciprocity between them there will be a flattening of the form that they aim to enclose. Secondly, every line that corresponds to an edge must indicate where different planes within the object meet the edge, even if they do so without any interruption of the silhouette. Often this difference between the planes is indicated by the artist's inserting a break in the line, or by allowing the line to cut back into the form. Thirdly, the nearer edge of the object may be represented by a more continuous, or more emphatic, line than that which corresponds to the edge that is farther away. And, fourthly, a sculptural line may be generated by a multiple line, or a series of redundant contours, as if to show how arbitrary is any particular placing of the line that surrounds an object.

It may now be objected that these are merely recipes for the production of the sculptural line, and, until we know what the sculptural line is in itself, we shall not be able to evaluate them. But the truth is that, though it is absolutely right not to identify the sculptural line with any one of these suggested ways of drawing the edge of an object, the sculptural line can be identified with the *power to produce the visual effect that these ways of drawing induce*. In other words, form-drawing, like delineation, has to be understood through the co-operation between artist and spectator, and, in both cases, it is ultimately the hand of the artist that has to respond to the eye of the spectator. The eye of the spectator has, we might say, the upper hand.

Before I turn, as I now want to, to one case out of several where, by contrast, the eye is subservient to the hand, I want to guard against one powerful misunderstanding of what I have been saying about the verdict of the eyes.

When the spectator—and let me remind you that this includes, indeed it gives priority to, the draughtsman *qua* spectator—acts as a check upon the artist, the test that he runs is whether he can see the represented object in the drawing. In other words, from the very beginning, he looks, not for an object, but for a drawing of an object: and he recognizes that seeing the object in the drawing differs from seeing the object face-to-face. The misunderstanding that I am trying to combat is most tersely enshrined in the habit of using the word 'illusion' as equivalent to representation. There is, as I see it, no overlap between representation and illusion, and the further point that I should like to stress is that some of the greatest achievements of representational drawing are effected through the spectator's recognition of the materials that the artist uses. Consider, for instance, the amazing effect of solidity that a great artist can induce when he uses the bottom layer of his drawing, or its physical base, to convey the most forward point of the object that he represents, or where the highlight falls.

11. However, I should like to conclude this talk with a whole, and extremely important, dimension of drawing where what the artist does sets the standard to which the spectator's eye attempts to conform. It is here that we begin to see the true greatness of drawing, which will fall out of human culture only to its great detriment.

Drawing and painting, we do well to record, are not only visual arts: they are also manual arts. The material residues of which the eye takes stock have been deposited by the movements of the hand. And it is the experience of these two arts, over the centuries, and indeed over cultures, that, when an artist has been effectively apprenticed to his art, the hand adds value. In fact, it adds two kinds of value. It gives a unity to the work, and it carries the imprint of a personality. These two values are brought together for us in the term 'style', under which both shelter. Style, individual style, does each of these things through doing the other.

Now, of course, when the hand unifies the drawing, or expresses the draughtsman, it requires the co-operation of the eye. Here too the artist is, to

some degree, dependent upon the spectator. But by now the issue of degree has become important. For, though we evidently have from outside drawing, or prior to drawing, a very broad idea of what pictorial unity is, just as we have a very broad idea of what it is for personality to find expression in the external world, drawing, and the experience of drawing, give a totally new, and unpredictable, spin to these ideas. The specific ways in which style permits achievements of this sort is something that we can learn only from patiently looking at drawings. And, when we do so, these achievements turn out to be triumphs of the mind: triumphs, let me stress, of the embodied mind.

If there are recording angels, they cannot record through drawing. Ethereal creatures, they find the co-ordination of hand and eye too effortless to wring from it objects that we might evaluate as truly interesting.

List of Artworks Discussed but not Reproduced, with URLs

The URLs listed below were last accessed 9 March 2024.

No.	Title and details	URL	Page(s)
1	Minor White (American, 1908–1976), *Forms: Head and Arabesques*, 1962. Gelatin silver print, 29.8 × 23.3 cm. MoMA (New York), Inv. No. 128.1962.	https://www.moma.org/collection/works/46703	10
2	Willem de Kooning (Dutch-American, 1904–1997), *Untitled II*, 1979. Oil on canvas, 195.5 × 223.5 cm. Daros Collection, Schweiz (Switzerland).	https://www.daros.ch/willem-de-kooning-kopie.html	13
3	Paul Cézanne (French, 1839–1906), *Still Life with Faience Jug and Fruit*, c.1900. Oil on canvas, 73.7 × 101 cm. Oskar Reihart Collection 'Am Römerholz', Winterthur (Switzerland).	https://www.roemerholz.ch/sor/en/home/museum/the-collection/periods/france--19th-and-early-20th-century--impressionism/paul-cezanne--still-life-with-faience-jug-and-fruit-c--1900.html	14
4	Edgar Degas (French, 1834–1917), *A Cotton Office in New Orleans*, 1873. Oil on canvas, 73 × 92 cm. Musée des Beaux-Arts de Pau, Pau (France), Inv. No. 878.1.2.	https://mba-pau.opacweb.fr/fr/notice/878-1-2-un-bureau-de-coton-a-la-nouvelle-orleans-a34ae3d8-633e-455e-a682-078068a34fa4	21
5	Jacob van Ruisdael (Dutch, 1628/29–1682), *Peasant Cottage in a Landscape*, 1646. Oil on canvas, 105 × 163 cm. The Hermitage, St Petersburg (Russia), Inv. No. ГЭ-939.	https://www.hermitagemuseum.org/wps/portal/hermitage/digital-collection/01.+paintings/44499	31
6	Jacob van Ruisdael (Dutch, 1628/29–1682), *Landscape with Cottage*, 1646. Oil on canvas, 71.8 × 101 cm. Hamburger Kunsthalle, Hamburg (Germany), Inv. No. HK-159.	https://online-sammlung.hamburger-kunsthalle.de/de/objekt/HK-159	31

No.	Title and details	URL	Page(s)
7	Jacob van Ruisdael (Dutch, 1628/29–1682), *The Banks of a River*, 1649. Oil on canvas, 134 × 193 cm. The National Galleries of Scotland, Edinburgh (Scotland), Inv. No. NGL 033.84.	https://www.nationalgalleries.org/art-and-artists/8679	31
8	Jacob van Ruisdael (Dutch, 1628/29–1682), *Three Great Trees in a Mountainous Landscape with a River*, c.1665–70. Oil on canvas, 138.1 × 173.1 cm. Norton Simon Museum, Pasadena (California), Inv. No. F.1971.2.P.	https://www.nortonsimon.org/art/detail/F.1971.2.P/	31
9	Jacob van Ruisdael (Dutch, 1628/29–1682), *River Landscape with a Castle on a High Cliff*, 1670s. Oil on canvas, 101.1 × 125.6 cm. Cincinnati Art Museum, Cincinnati (Ohio), Inv. No. 1946.98.	https://cincinnatiartmuseum.org/art/explore-the-collection?id = 11296660	31
10	Jacob van Ruisdael (Dutch, 1628/29–1682), *Mountainous Landscape*, 1670s. Oil on canvas, 99.5 × 137 cm. The Hermitage Museum, St Petersburg (Russia), Inv. No. ГЭ-932.	https://hermitagemuseum.org/wps/portal/hermitage/digital-collection/01.+paintings/44421	31
11	Jacob van Ruisdael (Dutch, 1628/29–1682), *Landscape with a Ruined Castle and Church*, c.1665–70. Oil on canvas, 109 × 146 cm. National Gallery, London (UK), Inv. No. NG990.	https://www.nationalgalleryimages.co.uk/asset/2001/	33
12	Jacob van Ruisdael (Dutch, 1628/29–1682), *Hilly Wooded Landscape with a Falconer and Horseman*, 1650. Oil on canvas, 101 × 127.5 cm. Private Collection. Ex-Wertitsch collection, Vienna.	https://en.m.wikipedia.org/wiki/File:Jacob_van_Ruisdael_-_Hilly_Wooded_Landscape_with_a_Falconer_and_a_Horseman.jpg	34
13	Jacob van Ruisdael (Dutch, 1628/29–1682), *Dune Landscape in Evening Light with a Man Driving an Ass*, 1647. Oil on canvas, 71.7 × 95.3 cm. Museum der Bildenden Kunste, Leipzig (Germany), Inv. No. 1055.	At the time of writing, the Museum der Bildenden Kunste has yet to digitalise this painting. An image of it is available at:https://www.wikidata.org/wiki/Q20968723#/media/File:Jacob_van_Ruisdael_-_Dunes_with_a_mule_driver.jpg	36

No.	Title and details	URL	Page(s)
14	Jacob van Ruisdael (Dutch, 1628/29–1682), *Dune Landscape with a Steep Winding Path*, 1647. Oil on canvas, 69.7 × 91.7 cm. Alte Pinakothek, Munich (Germany), Inv. No. 1022.	https://www.sammlung.pinakothek.de/en/artwork/ZMLJrkwLJv/jacob-van-ruisdael/sandhuegel-mit-baeumen-bewachsen	36
15	Jacob van Ruisdael (Dutch, 1628/29–1682), *Le Buisson*, 1649–50. Oil on canvas, 68 × 91.5 cm. The Louvre, Paris (France), Inv. No. 1819.	https://collections.louvre.fr/en/ark:/53355/cl010060804	36
16	Jacob van Ruisdael (Dutch, 1628/29–1682), *Landscape with a Footbridge*, 1652. Oil on canvas, 98.4 × 159.1 cm. Frick Collection (New York), Inv. No. 1949.1.156.	https://collections.frick.org/view/objects/asitem/items$0040:253	39
17	Jacob van Ruisdael (Dutch, 1628/29–1682), *Edge of Forest with a Grainfield*, *c.*1656. Oil on canvas, 104.1 × 146.1 cm. Kimbell Art Museum, Worcester College, Oxford (UK), Inv. No. AP 2014.01.	https://kimbellart.org/collection/ap-201401	40
18	Jacob van Ruisdael (Dutch, 1628/29–1682), *The Great Wood*, 1655–60. Oil on canvas, 139 × 180 cm. Kunsthistorisches Museum, Vienna (Austria), Inv. No. Gemäldegalerie, 426.	https://www.khm.at/en/objectdb/detail/1653/	40
19	Paul Cézanne (French, 1839–1906) *Château Noir*, 1900/1904. Oil on canvas, 74 × 97 cm. National Gallery of Art, Washington, DC, Inv. No. 1958.10.1.	https://www.nga.gov/collection/art-object-page.45866.html	44
20	Claude Monet (French, 1840–1926), *Poplars on the Epte*, 1891. Oil on canvas, 82 × 81.4 cm. National Galleries of Scotland (UK), Inv. No. NG 1651.	An example from the series mentioned by Wollheim: https://www.nationalgalleries.org/art-and-artists/5195	45
21	Nicolas Poussin (French 1594–1665), *The Birth of Venus (the Triumph of Neptune)*, 1635–6. Oil on canvas, 97.2 × 108 cm. Philadelphia Museum of Art, Philadelphia (Pennsylvania), Inv. No. E1932-1-1.	Wollheim speaks of a painting made by Poussin in 1637, using the title *Triumph of Neptune*. How he describes it points to:https://philamuseum.org/collection/object/102996	48

No.	Title and details	URL	Page(s)
22	Piet Mondrian (Dutch, 1872–1944), *Broadway Boogie Woogie*, 1942–3. Oil on canvas, 127 × 127 cm. MoMA (New York), Inv. No. 73.1943.	https://www.moma.org/collection/works/78682	73, 261
23	Gino Severini (Italian, 1883–1966) *Sea = Dancer (Mare = Ballerina)*, 1914, oil on canvas, 100 × 80.5 cm. Guggenheim (New York), Inv. No. 76.2553.32.	https://www.guggenheim.org/artwork/3924	73, 262
24	Pablo Picasso (Spanish, 1881–1973), *Guernica*, 1937. Oil on canvas, 349.3 × 776.6 cm. Museo Nacional Centro de Arte Reina Sofía, Madrid (Spain), Inv. No. DE00050.	https://www.museoreinasofia.as/en/collection/artword/guernica	xxvi, 76, 83, 283
25	Ansel Adams (American, 1902–1984) *Evening Cloud, Ellery Lake, Sierra Nevada, California*, 1938 (negative); 1978 (print). Gelatin silver print, 27 × 31.7 cm. Philadelphia Museum of Art, Philadelphia (Pennsylvania), Inv. No. 1976-213-93.	https://philamuseum.org/collection/object/123537	118
26	Parmigianino (Francesco Mazzola, Italian, 1503–1540), *Madonna and Child with Angels* (*Madonna with the Long Neck*), 1534–40. Oil on panel, 216.5 × 132.5 cm. Le Gallerie degli Uffizi, Florence (Italy), Palatina n. 230.	https://www.uffizi.it/en/artworks/parmigianino-madonna-long-neck	122
27	Jean-Auguste-Dominique Ingres (French, 1780–1867), *Madame Moitessier*, 1856. Oil on canvas, 120 × 92.1 cm. National Gallery, London (UK), Inv. No. NG4821.	https://www.nationalgallery.org.uk/paintings/jean-auguste-dominique-ingres-madame-moitessier	122
28	Paolo Uccello (Italian, c.1397–1475), *The Battle of San Romano*, c.1438–40. Egg tempera with walnut oil and linseed oil on poplar, 182 × 320 cm. National Gallery, London (UK), Inv. No. NG583.	https://www.nationalgallery.org.uk/paintings/paolo-uccello-the-battle-of-san-romano	123
29	Édouard Manet (French, 1832–1883), *Street Singer*, c.1862. Oil on canvas, 171.1 × 105.8 cm. Boston Museum of Fine Art, Boston (Massachusetts), Inv. No. 66.304.	https://collections.mfa.org/objects/33971	126

No.	Title and details	URL	Page(s)
30	Joseph Mallord William Turner (English, 1775–1851), *Slave Ship (Slaves Throwing Overboard the Dead and Dying, Typhoon Coming On)*, 1840. Oil on canvas, 90.8 × 122.6 cm. Museum of Fine Arts, Boston (Massachusetts), Inv. No. 99.22.	https://collections.mfa.org/objects/31102/slave-ship-slavers-throwing-overboard-the-dead-and-dying-t?ctx = 1c534a08-dfc8-452b-b96a-5761e8846573&idx = 0	135
31	Henri Matisse (French, 1869–1954), *The Green Line (Portrait of Madame Matisse)*, 1905. Oil on canvas, 40.5 × 32.5 cm. Statens Museum for Kunst, Copenhagen (Denmark), Inv. No. KMSr171.	https://www.smk.dk/en/highlight/portrait-of-madame-matisse-the-green-line-1905/	139
32	Henri Matisse (French, 1869–1954), *Woman with a Hat*, 1905. Oil on canvas, 80.65 × 59.69 cm. San Francisco Museum of Modern Art, San Francisco (California), Inv. No. 91.161.	https://www.sfmoma.org/artwork/91.161/	139
33	Titian (Tiziano Vecellio, Italian, c.1490–1576), *Emperor Charles V at Mühlberg*, 1548. Oil on canvas, 335 × 283 cm. Museo del Prado, Madrid (Spain), Inv. No. P000410.	https://www.museodelprado.es/en/the-collection/art-work/emperor-charles-v-at-muhlberg/e7c91aaa-b849-478c-a857-0bb58a6b6729	140, 196
34	Edgar Degas (French, 1834–1917), *Edmondo and Thérèse Morbilli*, c.1865. Oil on canvas, 116.5 × 88.3 cm. Museum of Fine Arts, Boston (Massachusetts), Inv. No. 31.33.	https://collections.mfa.org/objects/32404/edmondo-and-therese-morbilli?ctx = 193c5369-2ef1-4f2b-b9d6-4e6fb7695ac5&idx = 1	140
35	Édouard Manet (French, 1832–1883), *The Execution of the Emperor Maximilian*, 1868–9. Oil on canvas, 252 × 302 cm. Kunsthalle Mannheim (Germany), Inv. No. M281.	https://sammlung-online.kuma.art/node/627	140, 189
36	Édouard Manet (French, 1832–1883), *Portrait of Madame Brunet*, c.1861–3, reworked by 1867. Oil on canvas, 132.4 × 100 cm. Getty Museum, Los Angeles (California), Inv. No. 2011.53.	https://www.getty.edu/art/collection/object/109HJK#full-artwork-details	144
37	Barnett Newman (American, 1905–1970), *Vir Heroicus Sublimis*, 1950–51. Oil on canvas, 242.2 × 541.7 cm. Museum of Modern Art (New York), Inv. No. 240.1969.	https://www.moma.org/collection/works/79250	147

No.	Title and details	URL	Page(s)
38	Jean-Auguste-Dominique Ingres (French, 1780–1867), *Jupiter and Thetis*, 1811. Oil on canvas, 324 × 260 cm. Musée Granet, Aix-en-Provence (France), Inv. No. FNAC PFH-499.	https://www.museegranet-aixenprovence.fr/en/collections/collections/french-19th-century-painting-granet-ingres-provencal-painting	149
39	Pieter Paul Rubens (Flemish, 1577–1640), *The Judgement of Paris*, c.1632–5. Oil on oak panel, 144.8 × 193.7 cm. National Gallery, London (UK), Inv. No. NG194.	https://www.nationalgallery.org.uk/paintings/peter-paul-rubens-the-judgement-of-paris	157
40	Hugo Van der Goes (Netherlandish, c.1440–1482), *Adoration of the Shepherds with Angels and Saint Thomas, Saint Anthony, Saint Margaret, Mary Magdalene and the Portinari Famoly* (*Portinari Altarpiece*), c.1477–8. Oil on panel, 253 × 304 cm (central panel); 253 × 141 cm (each wing). Gallerie degli Uffizi, Florence (Italy), Inv. No. 1890 nn. 3191, 3192, 3193.	https://www.uffizi.it/en/artworks/adoration-of-the-shepherds-with-angels-and-saints-recto-annunciation-verso	160
41	Diego Rodríguez de Silva y Velasquez (Spanish, 1599–1660), *Las Meninas*, 1656. Oil on canvas, 320.5 × 281.5 cm. Museo del Prado, Madrid (Spain), Inv. No. P001174.	https://www.museodelprado.es/en/the-collection/art-work/las-meninas/9fdc7800-9ade-48b0-ab8b-edee94ea877f	194
42	School of Antoine-Jean Baron Gros (French, 1771–1835), *Charles V received by Francis I at the Abbey of St. Denis*, 1811–16. Oil on canvas, 269 × 167.5 cm. Louvre, Paris (France), Inv. No. INV 5062.	https://collections.louvre.fr/en/ark:/53355/cl010062569	196
43	Frans Hals (Dutch, 1582/83–1666), *The Banquet of the Officers of the St George Civic Guard*, 1627. Oil on canvas, 179 × 257.5 cm. Franz Hals Museum, Haarlem (Netherlands), Inv. No. os I-110.	https://www.franshalsmuseum.nl/en/art/banquet-of-the-officers-of-the-st-george-civic-guard/	197
44	Georges Seurat (French, 1859–91), *A Sunday on La Grande Jatte*, 1884–6. Oil on canvas, 207.5 × 308.1 cm. Art Institute of Chicago, Chicago (Illinois), Inv. No. 1926.224.	https://www.artic.edu/artworks/27992/a-sunday-on-la-grande-jatte-1884	200

No.	Title and details	URL	Page(s)
45	Kazimir Malevich (Russian, 1879–1935), *Suprematist Composition*, 1916. Oil on canvas, 88.5 × 71 cm. Private collection.	A panting, which fits Wollheim's description, can be seen published in a 2014 Guardian review of "Malevich: Revolutionary of Russian Art," *Tate Modern* (London, 16 July–26 October 2014): https://www.theguardian.com/artanddesign/2014/jul/04/kazimir-malevich-liberated-painting-tate	201
46	Meindert Hobbema (Dutch, 1638–1709), *The Watermill with the Great Red Roof*, 1662–5. Oil on canvas, 81.3 × 110 cm. Art Institute of Chicago, Chicago (Illinois), Inv. No. 1894.1031.	https://www.artic.edu/artworks/869/the-watermill-with-the-great-red-roof	204
47	Leonardo da Vinci (Italian, 1452–1519), *The Virgin and Child with Saint Anne*, 1503–19. Oil on poplar panel, 168 × 113 cm. Louvre, Paris (France), Inv. No. 776.	https://collections.louvre.fr/en/ark:/53355/cl010066107	243
48	Francisco de Goya y Lucientes (Spanish, 1746–1828), *The 2nd of May 1808 in Madrid* (*The Fight Against the Mamelukes*), 1814. Oil on canvas, 268.5 × 347.5 cm. Museo del Prado, Madrid (Spain), Inv. No. P000748.	https://www.museodelprado.es/en/the-collection/art-work/the-2nd-of-may-1808-in-madrid-or-the-fight/57dacf2e-5d10-4ded-85aa-9ff6f741f6b1	283
49	Rogier van der Weyden (Netherlandish, *c.*1399–1464), *Bladelin Altarpiece*, *c.*1450. Oil on panel, 91 × 91 cm (central panel), 93.5 × 41.7 cm (each wing). Gemäldegalerie, Berlin (Germany), Inv. No. 535.	https://recherche.smb.museum/detail/871762/middelburger-altar	293
50	Giorgione (Italian, 1477/78–1510) and Titian (Tiziano Vecellio, Italian, *c.*1490–1576), *Sleeping Venus*, *c.*1508–10. Oil on canvas, 108.5 × 175 cm. Gemäldegalerie Alte Meister, Dresden (Germany), Inv. No. Gal.-Nr.185.	https://skd-online-collection.skd.museum/Details/Index/294844	295

No.	Title and details	URL	Page(s)
51	Auguste Rodin (French, 1840–1917), *Monument to Balzac*, 1898. Bronze, 270 × 120.5 × 128 cm. Musée Rodin, Paris (France), Inv. No. S.01296.	https://www.musee-rodin.fr/en/musee/collections/oeuvres/monument-balzac	297
52	Claude Monet (French, 1840–1926), *The Seine at Vétheuil*, 1880. Oil on canvas, 60.3 × 100.3 cm. Metropolitan Museum of Art (New York), Inv. No. 30.95.271.	https://www.metmuseum.org/art/collection/search/437109	298

Index